D1631823

Matthew Ritchie

More than the eye.

Texts

Klaus Kertess

Thom Mayne

Matthew Ritchie

Carter Scholz

Jonathan Lethem

Elizabeth M. Grady

Shelley Jackson

Ander Monson

RIZZOLI
NEW YORK

In 1654, the Archbisho[p]
that the creation of t[he]
Saturday, October 22, 4[004 BC,]
in the evening. In 200[4,]
the universe is 13.7 bil[lion years old.]
nature, age, and origin[...]
unknown.

p of Armagh estimated

e universe began on

004 B.C. at nine o'clock

, NASA estimated that

ion years old. The true

of the universe remain

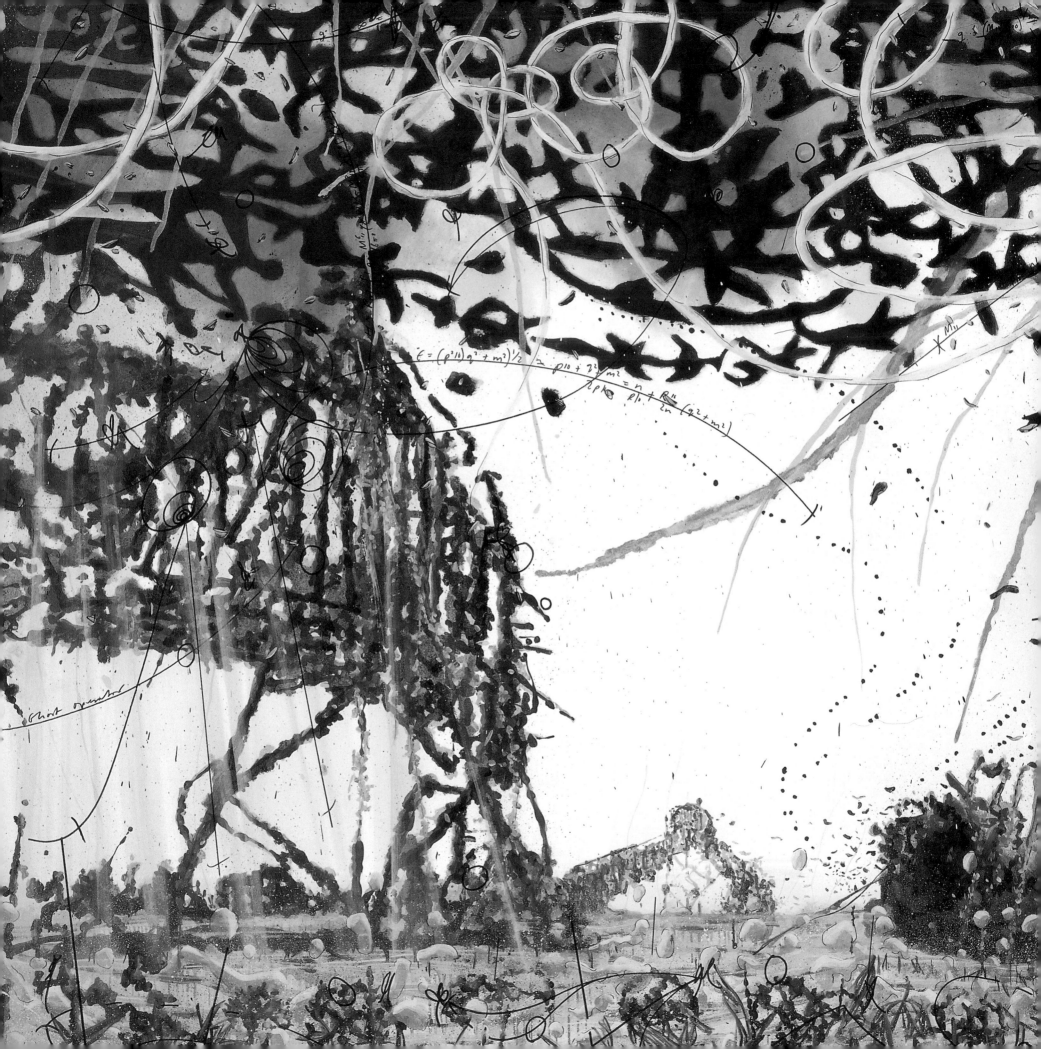

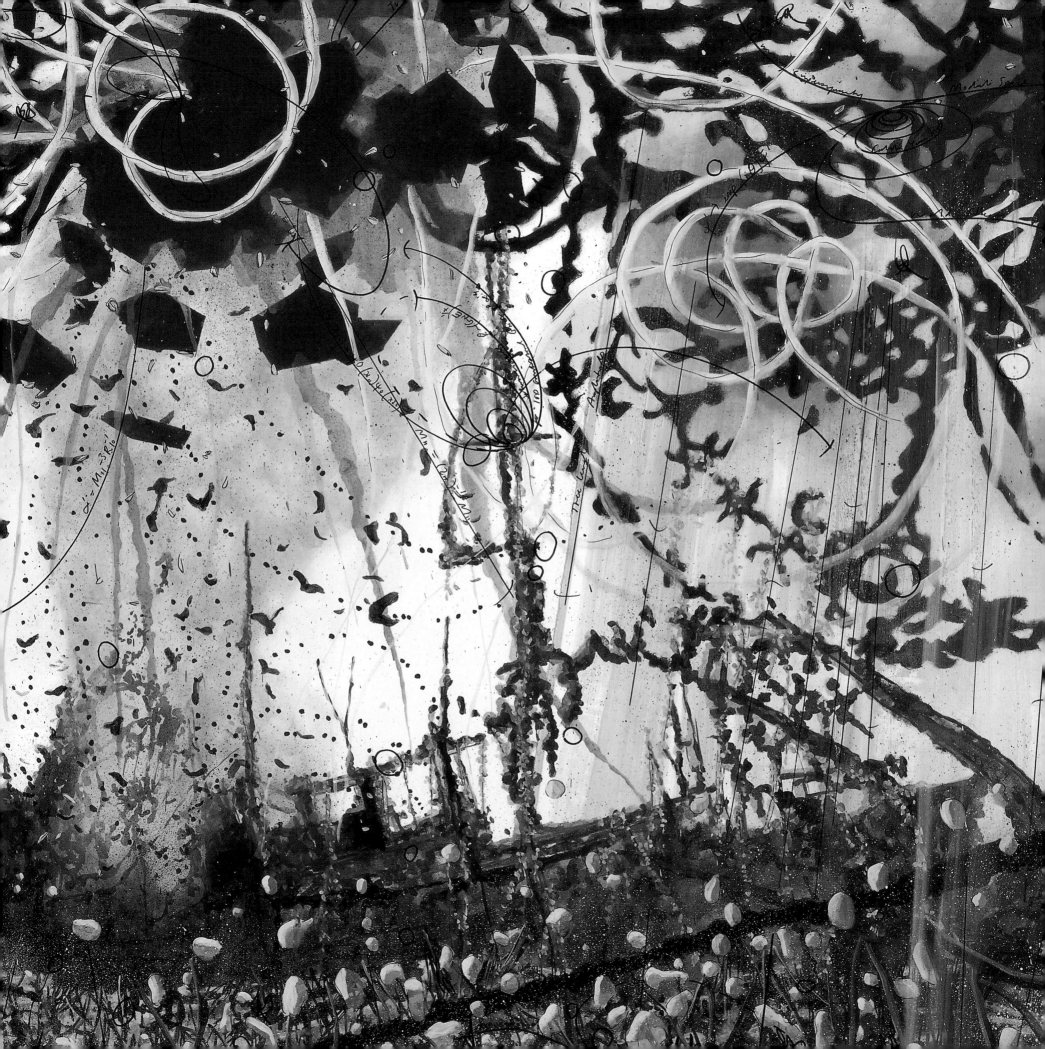

Klaus Kertess

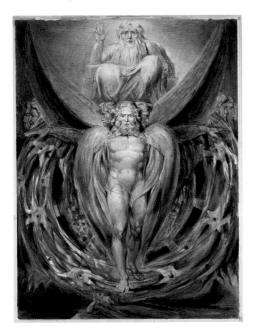

William Blake, *The Whirlwind: Ezekiel's Vision of the Cherubim and Eyed Wheels (Illustration to the Old Testament, Ezekiel I: 4–28)*, c. 1803–05. Pen and watercolor over graphite on paper. 15½ x 11⅝ in. (39.4 x 29.5 cm). Museum of Fine Arts, Boston

PAINTING AS INFORMATION JAZZ

Even before entering *Universal Adversary*, Matthew Ritchie's exhibition in New York in 2006, I am confronted by a text on the building's facade that forewarns me of the apocalyptic storming within.

Their appearance and their work was as if a wheel within a wheel; as for their rings, they were so high they were dreadful and their rings were full of eyes, round about them four. And when the living creatures went, the wheels went with them for the spirit of the living creature was in the wheels. Ezekiel I: XVI–XX

Ezekiel's words still ringing in my ears, I walk into the main room of the gallery to be engulfed by Ritchie's light-suffused paintings and a black, folded latticework sky suspended above me. A painting on the end wall seethes with the gushing surge of a crackling brown network of sharp lines and shapes interspersed with whiplash spirals of white and pointy shards of rust raining down on a hapless, possibly sinking ship. Paint as rage, rage precisely calculated, engulfs the plane. *We Leave Today* this expanse of almost twelve feet is titled. "Too late," I think, as I'm drawn evermore into this cruel beauty. Three more sagas of liquid violence roil the long side wall of the gallery. *God of Catastrophe* pulses with circular detonations, the largest of which has sucked a boat out of the waters below; one can see a ring of eye-like shapes that recall Ezekiel's prophecy as well as the rings of eyes found in William Blake's similarly themed *The Whirlwind: Ezekiel's Vision of the Cherubim and Eyed Wheels* (1803–05). The other two paintings in the exhibition, *We Will not Be the Last* and *Personal Virtue*, are no less enflamed with apocalyptic skies wreaking havoc on the waters below.

A steep ladder, like one that might be found in a large ocean-going vessel, leads me up to a platform in the latticework sky, where I can look into an oculus that features a projection titled *Ezekiel I*; a not quite film of a not quite possible future, quite dire, flickers, while an ominous voice utters cryptic warnings. Connecting the two levels is an illuminated, double-story lightbox with images of slender figures drifting and floating in a landscape awash in soothing luminosity. The scene calls either to the possibility of a future healed earth or to the myth of the Edenic garden wiped out by the Deluge. If a promise, it is as slender and fragile as the figures it contains, perhaps just a taunting mirage.

Ritchie named this remarkable installation *Universal Adversary* after the collective title given by the United States government in 2005 to the fifteen scenarios classified as major threats to the U.S. population (none of which included income disparity, pandemic disease, resource depletion, or radical climate change). The opening quote from the Book of Ezekiel was probably written about 500 B.C. during the exile of the southern Israelite kingdom in Babylon. Ezekiel was a giver of oracles and warned of the destruction of Jerusalem because of the Israelites' misdeeds. Ezekiel's dreadful rings full of eyes are the Ophanim, angelic forces integrated into the throne of Yahweh, which is the physical manifestation of the universe. Some commentators believe that the text, which includes the famous "valley of dry bones," describes the end of Israel as a political force and its rebirth as a spiritual nation. Others have seen in Ezekiel's texts the symptoms of schizophrenic hallucinations. Not by coincidence, Babylon's ancient ruins exist today some fifty-five miles south of Baghdad and suffered further damages by U.S. forces invading Iraq in 2003. The explanation of the title's meaning, like the contextual information for most of Ritchie's exhibitions, was readily available to all viewers and serves, like the others, as cues to the visual. The title of the installation and the quote from Ezekiel I that Ritchie chose to appear at the entry of his show framed the works between the sixth century B.C. and 2005–06, and layered Ezekiel's prophecies with the violent reckoning being enacted by global warming and terrorism in our present time.

Long before Ritchie's invocation of Ezekiel's prophesies in his work, William Blake (1757–1827) had looked to Ezekiel as his own spiritual ancestor. Ezekiel became the inspiration for Blake's major unfinished work begun in 1797, *The Four Zoas*, which traced the fall of Albion (the oldest name for Great Britain). While Ritchie has not localized his apocalyptic visions, he has long admired his British predecessor's visionary art and verse.

Ezekiel, Blake, and Ritchie may seem a rather mismatched trio but on further reflection, I realized what they shared: they were all visionaries and givers of oracles, and does not many an artist, including my present subject, aspire to giving oracles? Further, Ritchie, following contemporary scholarship, understands the bearers of Ezekiel's "wheels"—a lion, a calf, an eagle, and a man—to be not only the first representations of the four evangelists but also the four cardinal signs Leo, Taurus, Scorpio (frequently seen in early esoteric texts as an eagle), and Aquarius. Ritchie interprets Ezekiel's wheels as depicting the solar system, beloved predictive tool of the Babylonians, and so finds in Ezekiel's visionary science a parallel to contemporary visionary cosmology, such as string theory, which purports to be a final unification of the four forces that constitute the universe. All three—Ezekiel, Blake, and Ritchie—favor seeing with the imaginative eye. And, as much science continues to move ever further from the physically observable into the speculative and the imagined, scientists have increasingly become visionary prophets.

The visual and narrative clarity and drama so apparent in Ritchie's *Universal Adversary* installation were not yet apparent when I viewed his first one-person exhibition in 1995. The show was titled *Working Model* and a sheaf of explanatory notes, in the form of a press release, as well as charts and graphs painted directly on the wall or presented as painting, conspired to make me spend more time reading than viewing. The simple geometric

Their appearance and their work
Was as if a wheel within a wheel.
As for their rings, they were so high
They were dreadful.

And their rings were full of eyes.
And when the living creatures went
The wheels went with them.
For the spirit of the living creatures
Was in the wheels.

Ezekiel 1: XVI XX

forms and bright clear colors seemed to have turned the space into a kind of 1960s Minimalist playroom. And where would I begin? I was annoyed and a bit disoriented; I wasn't sure I wanted to play in this room. I remember a pedestal from which emerged seven rods each holding three or more round or nipple-like shapes in varying colors. They looked vaguely like the dreidls Jewish children play games of chance with at Chanukah.

On the wall behind them was a chart with a vertical row of seven colors, each followed by seven sets of attributes, symbols, and signs; they included, "Lucifer," "free will," and "p," for example. Across the top of the chart ran a horizontal row of shapes—the same shapes seen in various colors and combinations rising from the pedestal. Ritchie titled the table *The God Game*.

What Ritchie had created in 1995 was a kind of game board, the eponymous *Working Model* that encouraged the free association and combinative play so crucial to the creative process—whether in the creation of a painting, a sonata, or a scientific theory. For *Working Model*, Ritchie had made a grid of forty-nine elements that interested him, ranging from DNA to solitude. Each of the forty-nine elements was represented on the grid in seven ways, through scientific symbols, laws, colors, shapes, emotions, characters from esoteric traditions, and narrative functions. The grid could be used as a map, the map could be turned into a story, the story turned into a game—a kind of universal game of multidimensional Scrabble played with a set of colored shapes with multiple potential meanings. Ritchie had inverted the systemic graphs and grids endemic to the visual and mathematical certainties of so much painting and sculpture of the 1960s and early 1970s into a freely associated grid warped by unseen, often unknowable complexity. Some time was necessary for me to understand that this working model was for the formation of a wholly new, personal, and hopefully universal mythology. More like a index of artistic possibilities than a painting exhibition, this undertaking announced the arrival of an artist not unwilling to admit to playing the god game—and in his game, the stakes would be very high. In an interview from that same year, Ritchie stated he was seeking a symbolic language "as pure form in itself and as a bridge between various pre-existing symbolic vocabularies."[1]

A look back to Ritchie's beginnings will help fill in the aesthetic distance between the eleven years that separate these two installations. At the beginning of his artistic maturity, Ritchie wanted to build a universally decipherable visual language comprised of configurations, symbols, and equations potentially accessible to a vast and varied audience. In order to achieve that, he first had to build a universe. With cavalier disregard for historical cohesion, he commenced to mix, match, and fuse myth, religion, science, pop culture, and art. The as yet empirically unknowable theories of visionary science, such as string theory, and the empirically unknowable visual hallucinations found in visionary art, such as that created by Blake, and the visionary

theology of the Bible's Book of Ezekiel are but a few of the resources Ritchie has mined. And as he married disparate traditions and bodies of knowledge, the artist's sense of humor and play remained ever-present.

Ritchie was not alone in his construction of new mythologies. While in London's Camberwell School of Art (from 1983 to 1986) he had been duly impressed by Joseph Beuys's self-mythologizing metaphors of survival based on his World War II experiences, as well as his interest in art as a political and didactic tool. Sigmar Polke's often gleefully mysterious forays into metaphors of alchemical transformation also impacted Ritchie's art ponderings. When he moved from London to New York in 1987, Ritchie continued his education, though in decidedly less formal circumstances. These first ten years in New York—when he took a job as a building superintendent in SoHo, a time he often refers to as his "rebuilding" years—began a remarkable period of self-education abetted by the many textbooks he found discarded by students in the environs of New York University. He may not have been making art, but he did become the custodian of a remarkable body of knowledge that included science, religion, mythology, and history.

It was also during the 1980s that Ritchie witnessed the free-for-all of new liberties being taken in the wake of the erosion of modernism's hegemony that had started in the late 1970s—ranging from Julian Schnabel's jubilant portraits created with smashed crockery as surrogate brushstrokes to Susan Rothenberg's figuration brimming with a reinvigoration of drawing as painting to Carroll Dunham's retrieval of Surrealist psychosexuality found in the paintings of Matta, Tanguy, and Dalí, so long suppressed by late modernism's disdain for subjective imaginings. And, in the realm of photography, Sherrie Levine's appropriations questioned the value of uniqueness so endemic to modernism. Historical artworks re-entered contemporary dialogue, and imagination reclaimed lost territory.

The return of self-contained historical narratives—now wildly and willfully fabricated—would mark the beginning of the 1990s and inspire Ritchie to begin writing art criticism, and he was invited by Francesco Bonami to write regularly for *Flash Art*. He was strongly impressed by Kara Walker's intensely acerbic and uproariously ribald re-viewing of the antebellum South's racism surprisingly rendered in Walker's retrieval of the genteel art of the cutout silhouette. And he was similarly impressed by Matthew Barney's brilliant mythology—a hybrid of football lore, Houdini, reproductive biology, classical mythology, tabloid serial killers, and more, much more—realized in film and sculptural installations most often featuring Barney as one or another of his protagonists.

By 1995, Ritchie was prepared to step into this arena as an artist—his concerns cosmological, his context and material the information age; his aim was to make paintings that are "pictures of thinking."[2] Of course, all paintings that lay claim to success are

pictures of thinking, but the self-enclosed narratives of Barney's, Walker's, and Ritchie's art look back to and reinvent the grand historical narratives that preoccupied so many artists from antiquity well into the nineteenth century. While the meaning of Barney's fabulist narratives are not always immediately evident, both his and Walker's works unfold in clear narrative sequence, whereas Ritchie's tales are derailed, layered, and frequently rife with nonsequiturs resulting from spontaneous interruptions, games of chance, and combinative play.

As his project continued to develop, Ritchie favored a kind of multimedia *gesamtkunstwerk* evolving around several paintings. He regarded painting not so much as a construction of space but as a continuous flow of slowed down information—multiple strands of overlapping information that might readily interrupt and or threaten to cancel each other out. These overlapping, intertwining strands of flow mimic the flow and upheavals of the universe and as readily mimic the countless trails of neurons racing through the human brain—not to mention the stops, starts, and false starts twisting through the process of a painting.

The Big Bang is a continuous subject of Ritchie's art; indeed, in his imagination, he sees one continuous painting bringing the Big Bang, or moment of genesis, into the present moment. The paintings of this writhing knot of currents and countercurrents of energy, painted in the seven colors seen in the chart in *Working Model*, have frequently been the centers of Ritchie's installations. He has, on occasion, also created paintings of luminous and vaporous invented landscapes more conventionally configured with ground and horizon, as well as paintings that combine both this mode and the swirling knots. Some works are painted directly on the wall; in addition, he has created mosaic-like wall-bound and/or floor-bound accumulations of shapes cut from the soft plastic material Sintra.

Until now, most of the writing charting Ritchie's quest for a universal language of painting has focused on the vast body of knowledge that informs his work, rather than the actual work itself. Ritchie himself has added to—and one might say interpolated—this writing with his own occasional printing of pamphlets to accompany exhibitions that present neo-noir tales shuffling time, plot, and characters with both humor and literate dexterity.

For this essay, I have chosen instead to focus on the visual embodiment of Ritchie's ideas. His visual repertoire is large and varied. I will examine the affinities of Ritchie's work with the history paintings created by J.M.W. Turner as well as with Jackson Pollock's flung and dripped painting and the illuminated manuscript pages of the *Book of Kells*. This inquiry is undertaken as much to make clear the similarities as to highlight the quite radical differences. The concept of affinities more than that of direct influences is stressed here. And the journey will zigzag through Ritchie's recent installations—a landscape tour, landscape as information.

I will begin with J.M.W. Turner (1775–1851). The nineteenth

century, in both Europe and America, witnessed an astounding outburst of landscape painting growing out of and extending many of the conventions of Dutch landscape painting of the seventeenth century. While that tradition was marked by secularity and largely created for middle class burghers, some nineteenth-century painters, such as the German Caspar David Friedrich, sought to imbue landscape with a pantheistic sublime. In the United States, some painters depicted the still vast stretches of virgin landscape as the new Eden. Among these painters, Thomas Cole perhaps most avidly pursued suffusing landscape with religiosity, as can best be seen in his four paintings depicting the Voyage of Life (1839–40) in which tiny figures are dwarfed by virgin landscape as they are guided through Childhood, Youth, Manhood, and Old Age by an angel. Friedrich, Cole, and his American peers were all heirs to and continued a traditional European realism. Turner's work, however, marked a radical shift in landscape painting, and in his hands it metamorphosed into history painting. The drama of urging light into darkness and vice versa that took place in a stormy diaphanous vortex configured many of Turner's paintings; he had a particular predilection for storms at sea, frequently incorporating "deluge" in the title. One such painting, *Light and Colour (Goethe's Theory)–The Morning after the Deluge, Moses Writing the Book of Genesis* (1843) finds the spectral figure of the seated Moses emerging from a whirlpool of color and light. Beneath Moses hovers the coiled snake on a staff (a prefiguration of the Crucifixion) found by Moses in the wilderness in the Book of Exodus. Still lower and still more fugitive churn bodies washed up in the Deluge.

Something akin to the Deluge was also found on the wall when I entered Ritchie's installation *Universal Adversary*. Stormy, watery, indeterminate, and threatening, his shattered imagery enveloped in shifting light and dark, Ritchie's tonalities of cataclysm are not unrelated to Turner's. Growing up in London, Ritchie was intimately familiar with Turner's remarkable paintings, but when chroniclers of modernism counted Turner's directness of execution and pursuit of light as color as a precursor of Impressionism, thereby assigning his achievement solely to the domain of formal issues, they suppressed his overarching intent of painting history into the landscape. Aesthetic similarities aside, Ritchie is more in tune with Turner's larger purpose. Further, Turner's conflation of biblical events—both recorded (the Deluge) and imagined (Moses writing the Book of Genesis)—with contemporary scientific theory (Goethe's theory of color) sets a precedent for Ritchie's habitual, willful conflation of events. Though it must be noted that Turner was more likely to depict events in sequential time, whether historical or contemporary, his radical transformation of landscape into history painting, with its consequent downplaying of the figure, finds a contemporary parallel in Ritchie's painting. And, like Turner, Ritchie views painting not so much as a personal expression as part of a public discourse.

Perhaps Ritchie's most radical invention may be found in his

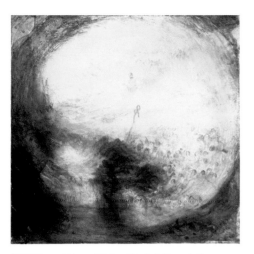

J.M.W. Turner, *Light and Colour (Goethe's Theory)—The Morning after the Deluge, Moses Writing the Book of Genesis*, 1843. Oil on canvas. 30⅞ x 30⅞ in. (78.5 x 78.5 cm). Tate Gallery, London

knot paintings, comprised of unraveling tangles of information. Some strands of these knots seem to provoke the rage in the sky of the seascapes discussed above. They began toward the turn of this century, when he urged his paint to congeal into a precisely rendered open knot—something like a writhing orgy of octopods—that often spill out onto the floor and/or surrounding wall and ceiling, as could be seen in his installation *The Fast Set* for North Miami's Museum of Contemporary Art in 2000. Interspersed in the tangle of tentacles frequently are found scientific equations and symbols related to the subjects of thermodynamics, the science of change, as well as eyes, tiny figures, and written words and phrases that often invoke games of chance, such as betting odds. This tangle is like the visual embodiment of the outrageously layered and tangled fragmented narrative that motivates the installation. In *The Fast Set*, a large amorphous blue-and-gray shape is identified as The Swimmer, which is the headless corpse of Lucifer now become Infinity and cloaked in yellow to become the visible universe in a story line that "encapsulates the history of thermodynamics as seen through Gnostic mythology."[3] And that's a radical abbreviation of what ensues.

In his even more elaborate installation *Proposition Player* (2003) exhibited at the Contemporary Arts Museum, Houston, eleven variants of these raveling and unraveling—even reveling—paintings of knots are included in the large exhibition space. Now denser, richer, and visually more complex than those in *The Fast Set*, these writhing serpentine members/feelers/forces/sensors hover in a kind of nowhere space, neither deep nor flat nor grounded—with one exception: in *The First Sea* (2003) the knot seems to rise out of the sea at the bottom edge of the canvas. In *Snake Eyes* (2003), the churning knots seem to be self-propelled and self-sustaining phenomena, at once vast and flat, dense and transparent high-voltage tangles of energy, often, as here, with eyes bobbing in the wild profusion of tendrils. Occasionally miniature simian figures and scientific equations emerge from the twisting snarl of linearity.

Also revealed in *Proposition Player* is the re-looping of narrative progression found in comics, articulated in the work's reversible narratives that unfold across several panels and in the interchangeable and mercurial natures of their protagonists. *Snake Eyes* refers to the throw of dice resulting in one pip per die, the lowest possible roll in many a game of chance—seemingly unpredictable chance, bad luck, and loser. *Snake Eyes* is also the name of one of the ninja-powerful heroes fighting in Vietnam featured in the GI Joe comic book series. The graphic directness and clarity, as well as the propensity for explosiveness regularly found in adventure comic books, whether Japanese anime or American Marvel, are also an integral part of Ritchie's visual vocabulary.

Chance plays a significant role in *Proposition Player*. Ritchie wanted to collapse all stories, categories, and characters from his previous works into one moment—"a moment where the viewer can enter or begin to play the game him or herself."[4] And so each viewer was given a card from a deck including Ritchie's forty-nine original characters; the cards are divided into four suits representing the four basic forces of the universe (more on this below). The card was given to a "dealer" at a gaming table who then handed the viewer digital dice cast from prehistoric elk bones in the Museum of Natural History (meant to simulate the first dice ever made and remind us of the origin of the "throwing of the bones"). As a game of craps was played by the viewer, sensors in thc dice registered the cast and triggered an animation on the surface of the table; these images evolved through more throws to progressively recapitulate all the paintings in the exhibition.

Winding through the exhibition space was a flat, raised, black, perforated powder-coated aluminum fretwork pierced with rods topped by something cubistically head-like rising through its interstices called *The Fine Constant*. Each one of these heads was based on a sculpture made by young students in Houston who participated in a workshop with Ritchie. The heads were scanned in 3-D and decimated by 95 percent because "we can only see 5 percent of the universe. We've called another 25 percent 'dark energy' and the remaining 70 percent 'dark matter.'"[5] In spite of this reduction, they were still recognizable as heads. And so one learned how little of the universe we can actually see and how even that 5 percent is loaded with sufficient information to negotiate our lives. The painter Alex Ross, a mutual friend of both Ritchie's and mine, refers to this kind of metaphorical play so typical of Ritchie's work as "information jazz," and I have appropriated it as an apt title for this text.

Ritchie is a fan of certain forms of jazz, especially the melding of the twin meteors of bebop and cool jazz in Miles Davis's electric *On the Corner*, which uses a form of polyphony that has both flatness (cool jazz) and superheated knots passing through, under, and around each other—knots as jazz. It has both an underlying hard structure and a looping, sprawling circularity.

The Fine Constant became a physical embodiment of *The Hierarchy Problem*, a vast black arabesquing linearity painted on the wall that seemed to grow out of and extend and interconnect the paintings of swirling knots. On the floor under the fretwork was placed an undulating mat of rubber and Tyvek called *The God Impersonator*, configured in a kind of psychedelically colored reprise to the aluminum fretwork. All these elements resulted in a lyric opera of painterliness transforming the wall and floor into a profoundly complex and pleasurable visuality. A new form of landscape painting; a new form of history painting.

The pale backgrounds and yellows and blues that predominate in the knot paintings for *Proposition Player*, as well as their relatively open configurations, contribute to the lightness and playfulness of the installation's festive casino mood. However, the four knot paintings that constitute *The Measures* (2005) from four years

later, together with the central fretwork cupola-like structure *The Universal Cell* and the black mark-making that extends from the paintings onto the wall each is centered upon, are endowed with a sterner bearing. Many of the serpentine linear contortions now have a metallic, somewhat foreboding appearance; other arabesquing swirls are a brackish brown, prickly and thorny. A large human skeleton head emerges from the lower right side of the twisted layering in *The Measures I* and a smaller skeleton rises to the top of the knotting/unknotting of *The Measures IV*. The bobbing eyes in all four of the paintings now seem likely to be involved with surveillance. A harsh beauty, vivid and dynamic, rules these tense paintings that, for me, count as some of Ritchie's most compelling works.

"What are *The Measures*?" I inquired of the artist, a question to which I received a lengthy reply. They are "the four universal constants of free space–the speed of light, the gravitational constant, the Planck limit, and the force constant which are carried by the four aces in *Proposition Player* … *The Measures* also refer to the punishments of the four half-divine traitors of Tartarus painted in the Titian cycle *The Damned*."[6]

From this truncated version of Ritchie's explanation, it is obvious that *The Measures* are not, cannot be literal representations of The Damned or those scientific phenomena known as the universal constants. They are leaps of Ritchie's imagination, just as Blake's rendering of Ezekiel's wheel within a wheel required a leap of his imagination. Ritchie created visual realizations of these scientific phenomena–The Measures might be seen as the Four Apostles of Modern Science. They are far more unlikely to be rendered "accurately" than, for example, the Four Apostles of the New Testament whose immediately recognizable symbols and masculine gender identify their varying incarnations through the ages. When I saw these paintings in Ritchie's studio, he was going through the final throes of revision–re-vision–that depended upon his visual intelligence fueled by his scientific knowledge but not beholden to it, or else how could Tartarus have entered the fray of the paintings?

In conversation, I mentioned to Ritchie that the meticulously detailed and rendered layered arabesquing linearity of the knot paintings looked not unlike a digitalized version of Jackson Pollock's (1912–1956) flung and dripped, layered whiplashes of paint seen in his works between 1947 and 1951, that, while courting accident, never eluded Pollock's magnificent control. However, Pollock's (in)famous proclamation, "I am nature," subsumes the universal into the personal whereas Ritchie seeks to build the opposite. He proposed the *Book of Kells* as a parallel comparison.

The illuminated manuscript containing the four gospels in Latin of the *Book of Kells* was created some time around 900 A.D. by Celtic monks. Its illustrations pulse with staggering intricacy and precision of layered, often foliate spirals and curling arabesques intertwined with dragons, cats, and birds, et. al. The illustrations were penned with a quill, and their making would likely have been aided by rulers, set-squares, compasses, and possibly a French curve, but without benefit of magnifying glasses. The minute and elaborate process defies imagination.

Although rooted in Judeo-Christian myth, Ritchie identifies Celtic culture and its legacy in European culture as another significant element in his own history. He has said: "The Celts, the first transnational European culture, were shape-shifters, speakers of tongues … I grew up with their stories of endless change: the wounded king and his wasted land, the green man and the severed head … They called it 'tuirgin', the transmigratory cycle of investigative experience."[7] Ritchie was deeply influenced by the Celtic "belief that the world is derived from experience, not rationalization," as the competing Greco-Roman culture believed.[8]

Empiricism, of course, does not rule out imagination, even leaps of the imagination, in art or in science. Dark matter, for instance, is of unknown substance that does not emit or reflect sufficient electromagnetic radiation to be observed directly; however, its presence has been inferred, by knowing scientists, from the gravitational effects on visible matter. A leap of scientific imagination brought the unknowable within the realm of the understanding. The unthinkable can be thought. For Ritchie, dark matter becomes a metaphor for the unknowable, the visibly absent, his quest is to imagine the unknowable into painting thought. Ritchie's Celtic-description continues: "Their sign was the unraveled knot that twists into a labyrinth, that grows into a serpent, that consumes itself. DNA, the coiled dimensional instruction book that can build a living world from dust and as easily dissolve it back again."[9]

The references are clear: the severed head, a frequent symbol in Ritchie's work, was used by the Celts as an oracle. The wasted land and the green man are symbiotic, as seen in the *The Measures* and the landscapes. The serpent could be Jörmungandr, or Uroboros, as the Romans called him, the circular archetypal image of eternity.

Pollock's line, drawn from the same Jungian depths, is a lyrical layering in the terms of knot theory, the mathematical branch of topology that studies knots, but it is not a knot. Although Ritchie certainly wouldn't contest Pollock's astounding achievement and though he frequently cites *One: Number 31, 1950* as the greatest picture of the twentieth century, Ritchie's particular interest in lines and knots has more to do with what can be woven together, what knots can bind.

This is an issue with special relevance for Ritchie's now frequent collaborations with architects, scientists, and institutions where his approach must adapt to the information that comes with each new project. An example of this is his recent commission to create work for the Wayne Lyman Morse U.S. Courthouse in Eugene, Oregon, designed by Thom Mayne of Morphosis.

Unlike a gallery or museum installation, Ritchie was required to deal with the constraints inherent to a specifically themed

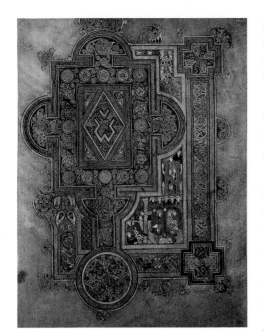

Luke I, ornamental treatment of the first word of Saint Luke's Gospel (MS 58, fol. 188r), from the *Book of Kells*, c. 900. Trinity College, Dublin

government commission. He was initially presented with a laundry list of points to be dealt with, as well as with a presiding judge/patron considerably more conservative than Ritchie. In the end, the tree of justice blossomed. "What does justice look like?" Ritchie asked a group of young local students in Eugene. A dog, a monkey, an eagle, and a crown (echoes of Ezekiel) were some of the figures the students responded with. Using techniques similar to the ones described earlier in *The Fine Constant*, the heads of the figures made by the students were rendered and placed on top of pylons that held up a black powdered-aluminum drawing that Ritchie created on the terrace of the third floor where the building's six courtrooms are located. This drawing, again like *The Fine Constant*, is a raised undulating fretwork that incorporates multiple strands of information. The sculpture is titled *Stare Decisis*, a Latin legal term meaning "to stand by that which is decided," and the foundational principal of constitutional jurisprudence. It loosely maps the Willamette river system that runs through Eugene and includes abstracted fragments of text citing the precedents for the United States Constitution and gyroscopically turning rings that equal in number the articles and amendments of the Constitution. The river becomes a metaphor for a legal system at once established in the past and fluid in its responses to the continuous changes wrought on its terrain. The idea of fluidity parallels the courthouse itself. Completed in December of 2006, the courthouse is composed of stately but embracing curves. The septet of curves configuring the aerial view of the building is meant to represent the seven articles of the federal Constitution. The configuration's accuracy of profile notwithstanding, Ritchie's map with its tangle of curves disrupts any one reading.

A small circular section of Ritchie's map even flows through the glass windows onto a bench into the curving interior lobby, where Ritchie created three large lightbox murals called *Life, Liberty, and Pursuit*. The images were printed on film and mounted on lenticular prismatic acrylic panels creating two shifting views as the viewer passes: the landscape of Oregon facing the actual landscape of the state seen through the windows of the lobby, and a more abstract landscape inscribed with names and landmark cases from the evolution of law over the last four thousand years or so. The murals' shifting views vibrate with a lyric lightness of touch; they become literal and figurative reflections on landscape. They also raise enticing questions about the relationship of climate and topography to the evolution of law.

The local response to a building certainly unconventional as courthouses go, was overwhelmingly positive judging by the jubilant opening-day celebrations. Local officials were imagining the building as their Bilbao, expecting a revival of downtown Eugene and a new influx of tourists. The complex narrative—the story of law—told by the works had been seamlessly integrated into the project. The "site-specific" information Ritchie was asked to represent in collaboration with architect Thom Mayne translated into the visual vocabulary he had independently developed, absorbing the information and re-rendering it into his own language in an architectural context. The entire history of law was now included in Ritchie's system and would immediately be put to use in *Ezekiel I*, the projection in *Universal Adversary* mentioned at the beginning of this essay.

This universally inclusive property distinguishes his narrative strategies from many of his peers and runs deep in his other collaborative projects, such as *Games of Chance and Skill* at MIT (2001), *We Want To See Some Light* (2006) at Portikus, and *The Morning Line*, a new structure unveiled at the Seville Biennial in 2008, which is a traveling performance space that contains countless layers of structure. It intertwines Milton's *Paradise Lost* with the most recent advances in physics and cosmology through scores played and sung by rock gods, modernist composers, and you and me, if we are fortunate enough to be in Venice, Seville, or London.

In all of these projects, and indeed his entire body of work, Ritchie has created a visual vocabulary that binds a variety of subjects with visual tropes that have proven to be remarkably versatile in his quest for the universal, or semasiographic, painting system he has been developing for the past decade, where the parts cannot only be intertranslated between works but also adapted to absorb any form of content. He has achieved this without sacrificing visual pleasure or visual variety. And his vaulting ambition is tempered by his deep intelligence, his humor, and his willingness to play. And it's just the beginning.

Notes
1. Owen Drolet, "Matthew Ritchie Interview," *Urban Desires: A Magazine of Metropolitan Passions* (March/April 1995).
2. Thyrza Nichols Goodeve, "Reflections on an Omnivorous Visualization System: An Interview with Matthew Ritchie," in *Matthew Ritchie Proposition Player* (Houston: Contemporary Arts Museum, 2003).
3. Ibid., 98.
4. Ibid., 44.
5. Ibid., 46.
6. E-mail from the artist to the author, January 3, 2008.
7. E-mail from the artist to the author, December 19, 2007.
8. Ibid.
9. Ibid.

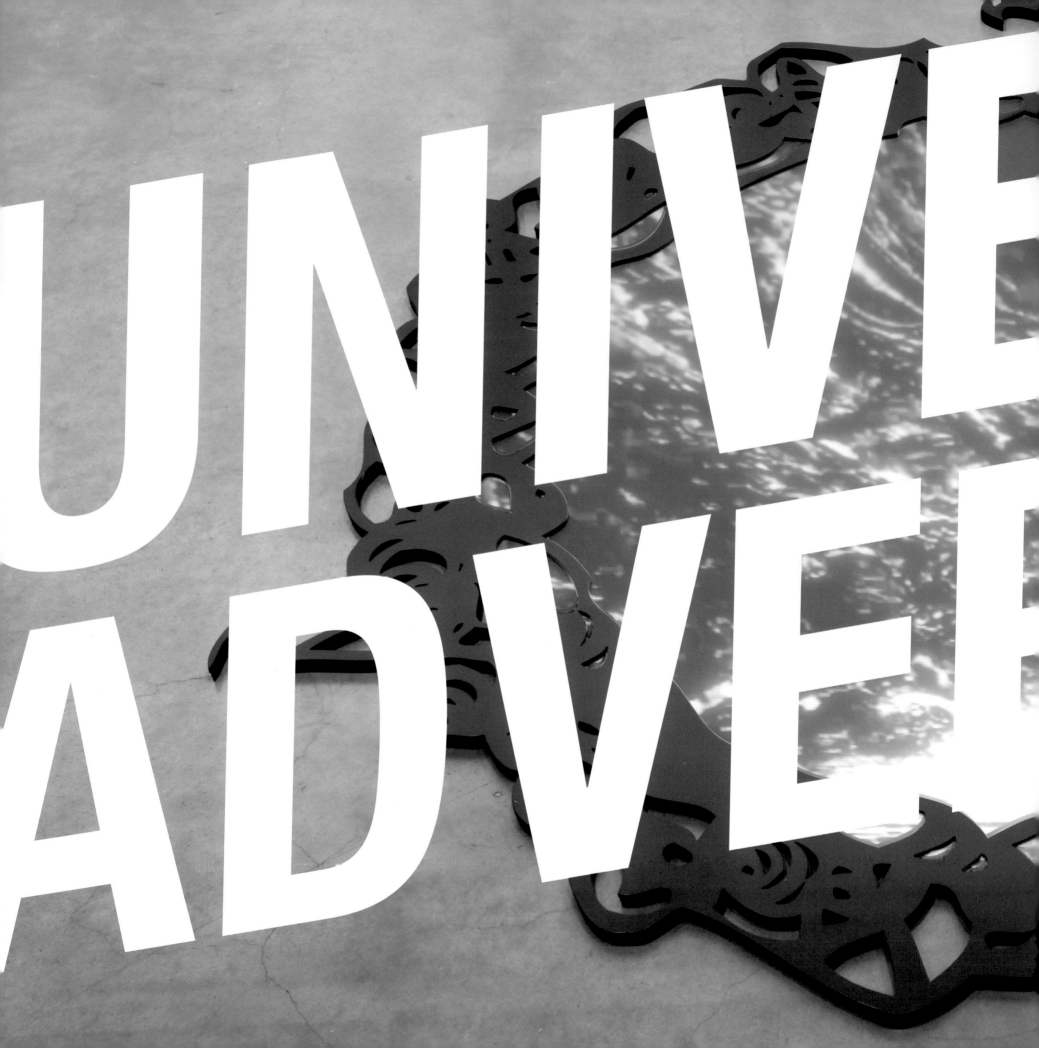

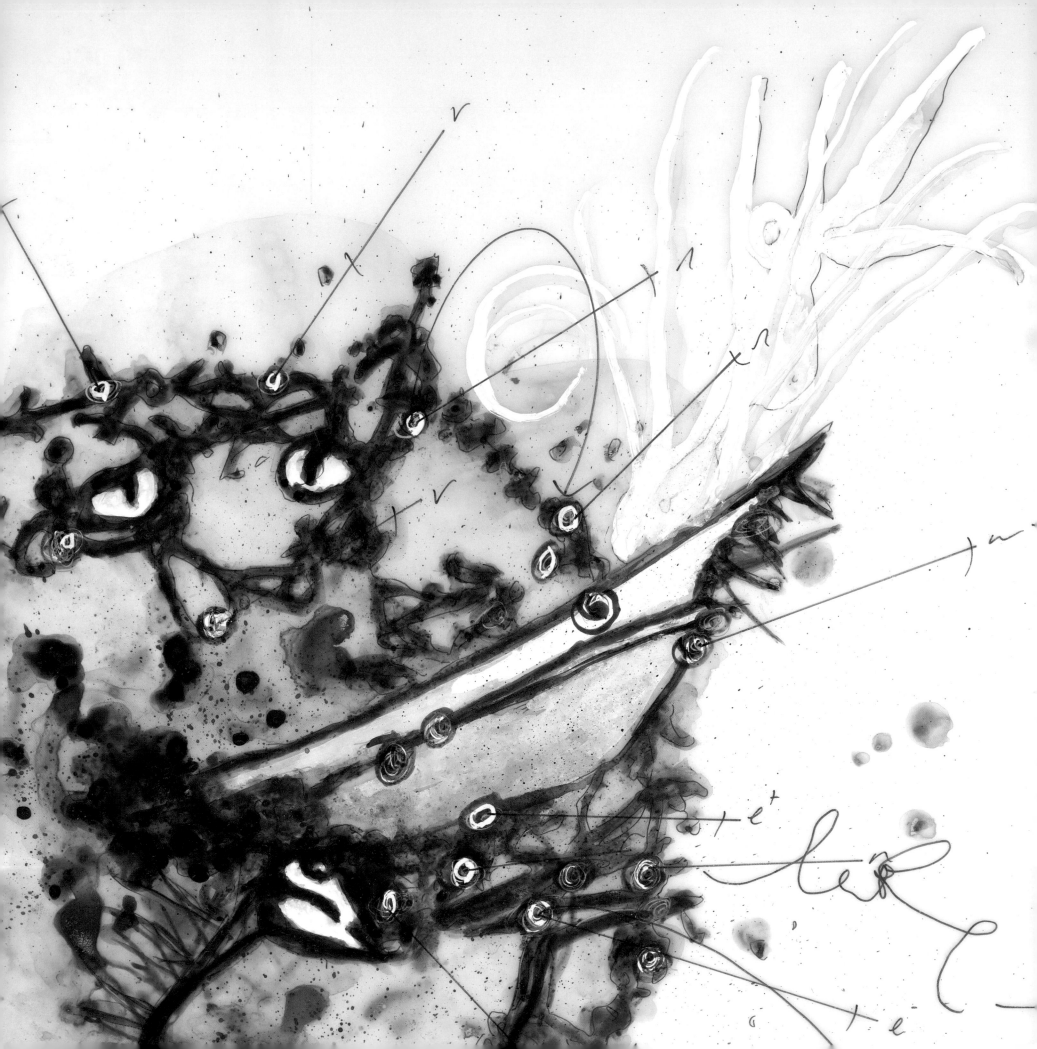

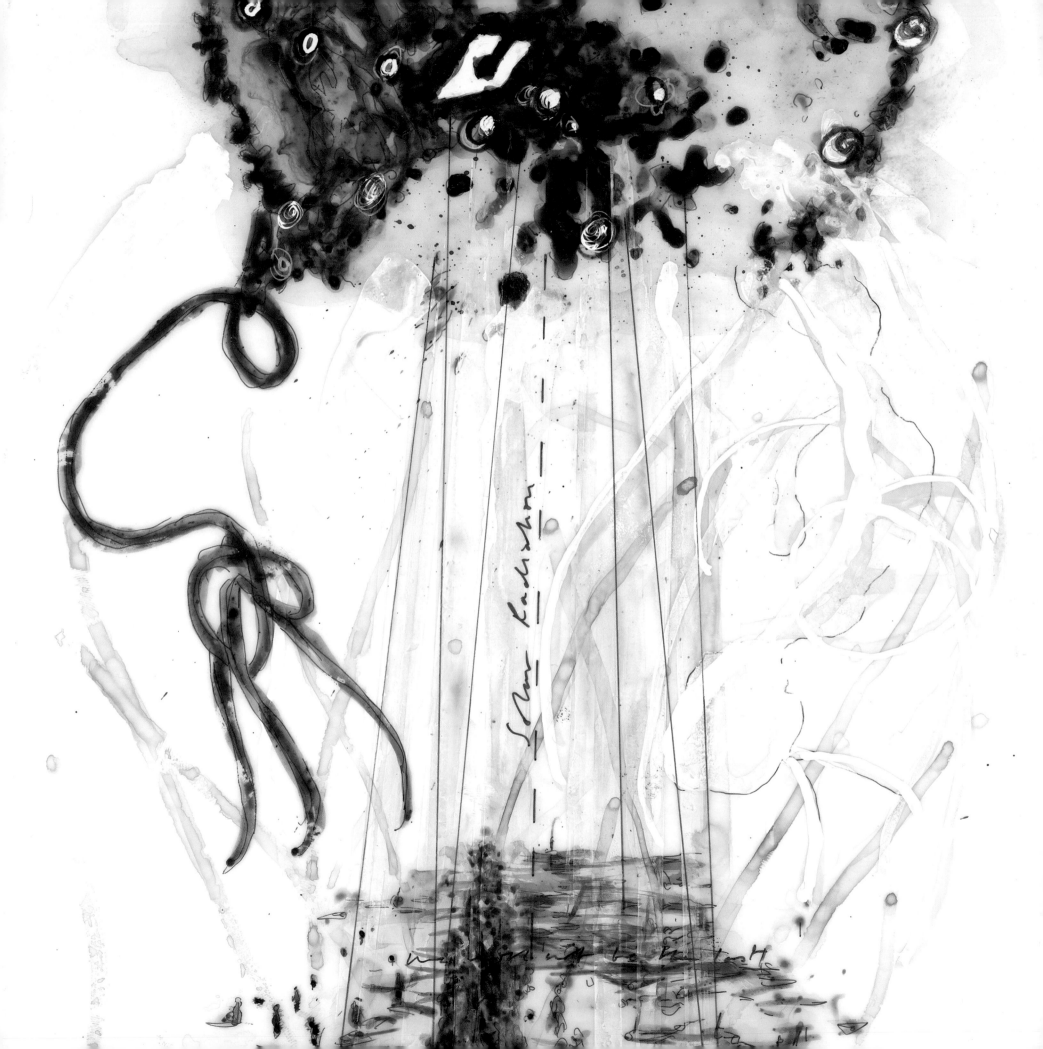

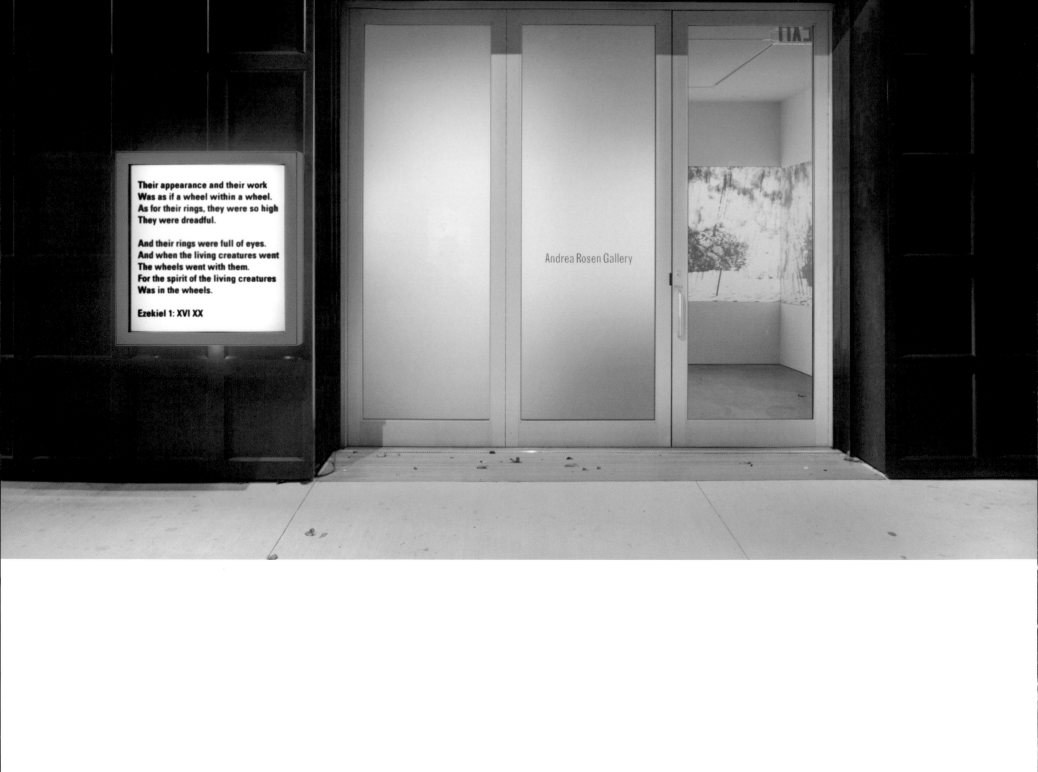

Their appearance and their work
Was as if a wheel within a wheel.
As for their rings, they were so high
They were dreadful.

And their rings were full of eyes.
And when the living creatures went
The wheels went with them.
For the spirit of the living creatures
Was in the wheels.

Ezekiel 1: XVI XX

Andrea Rosen Gallery

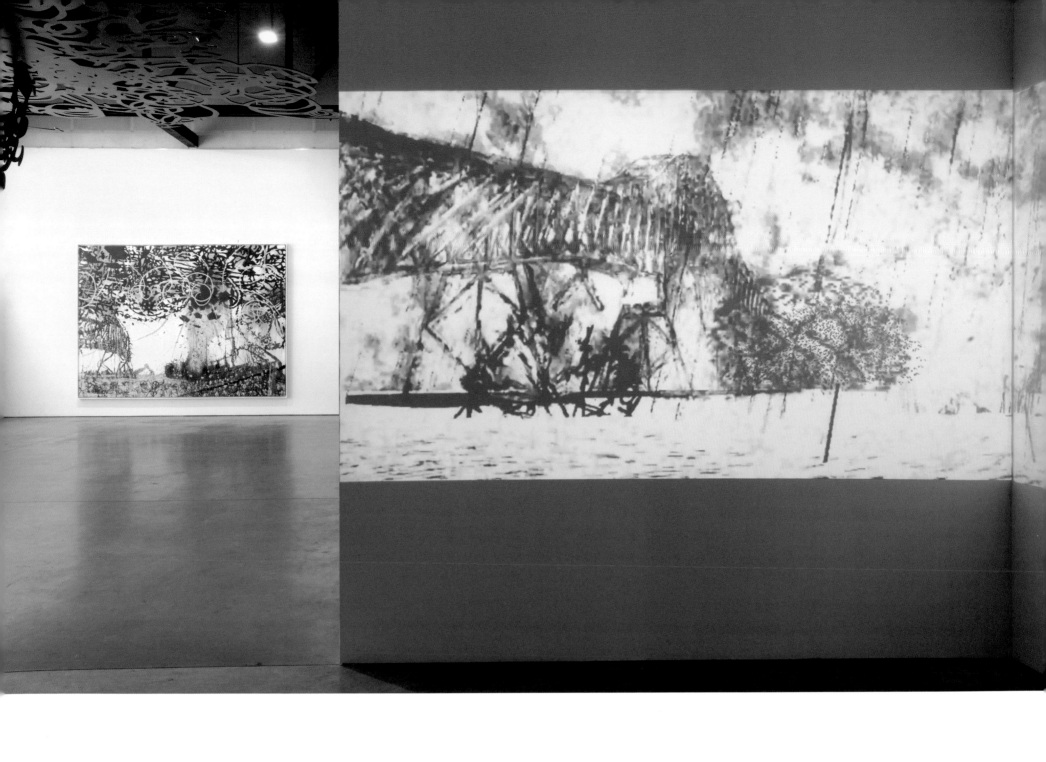

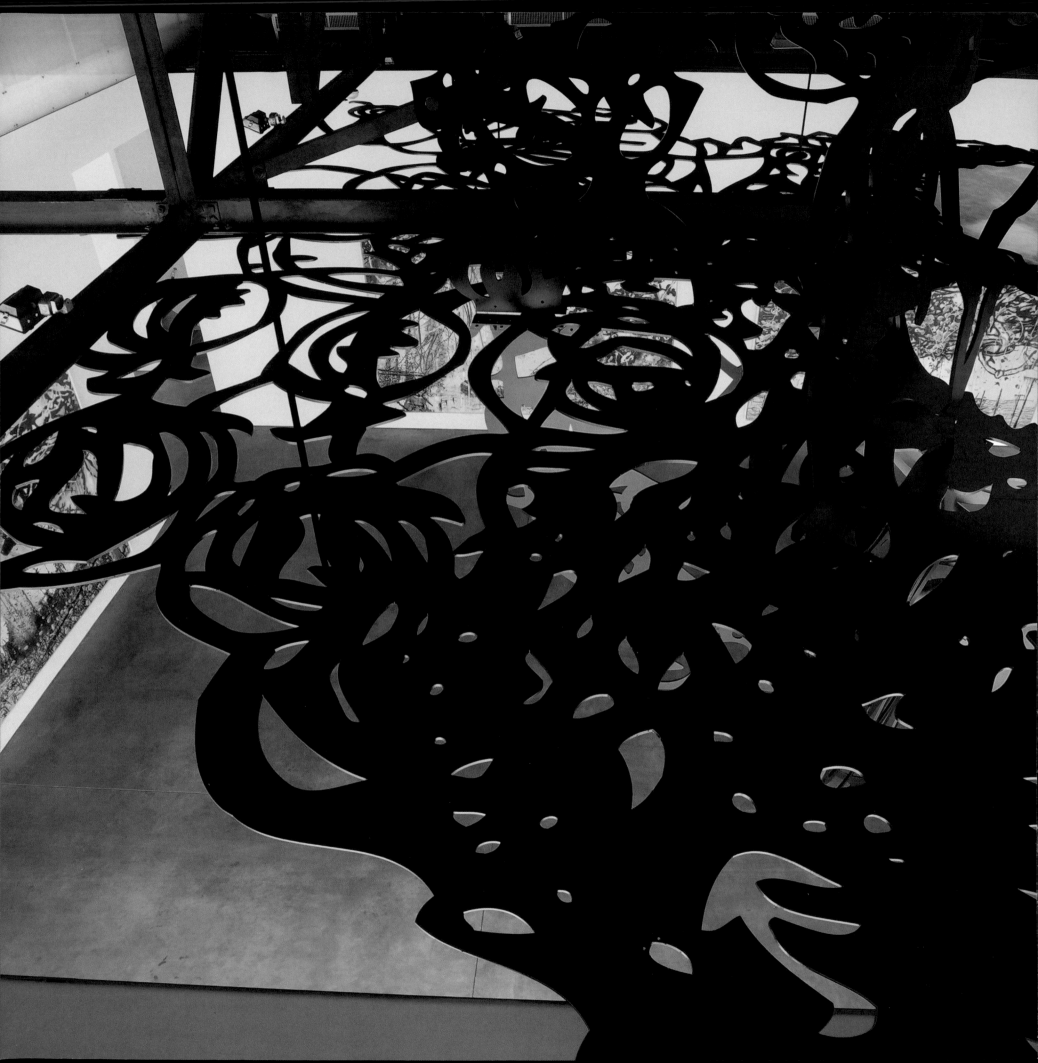

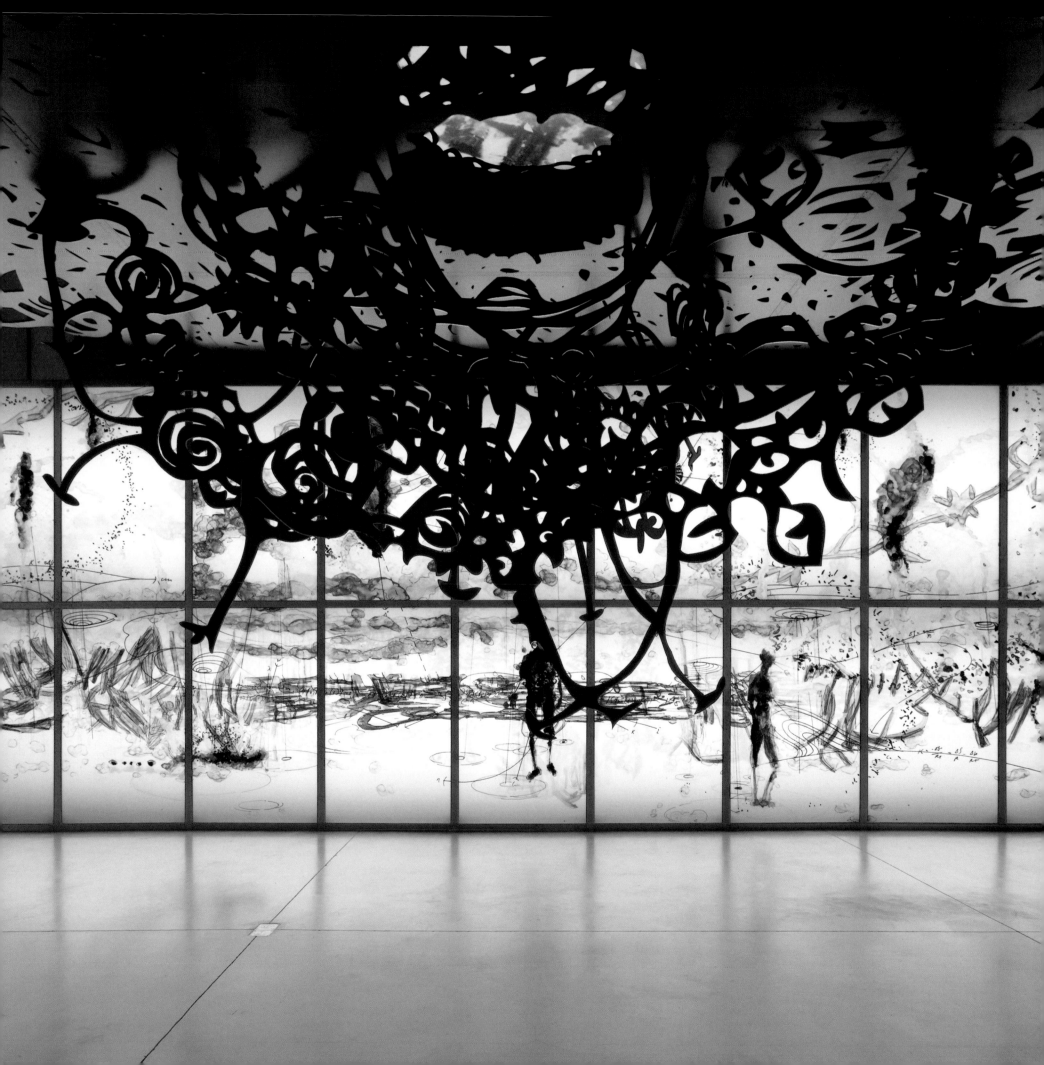

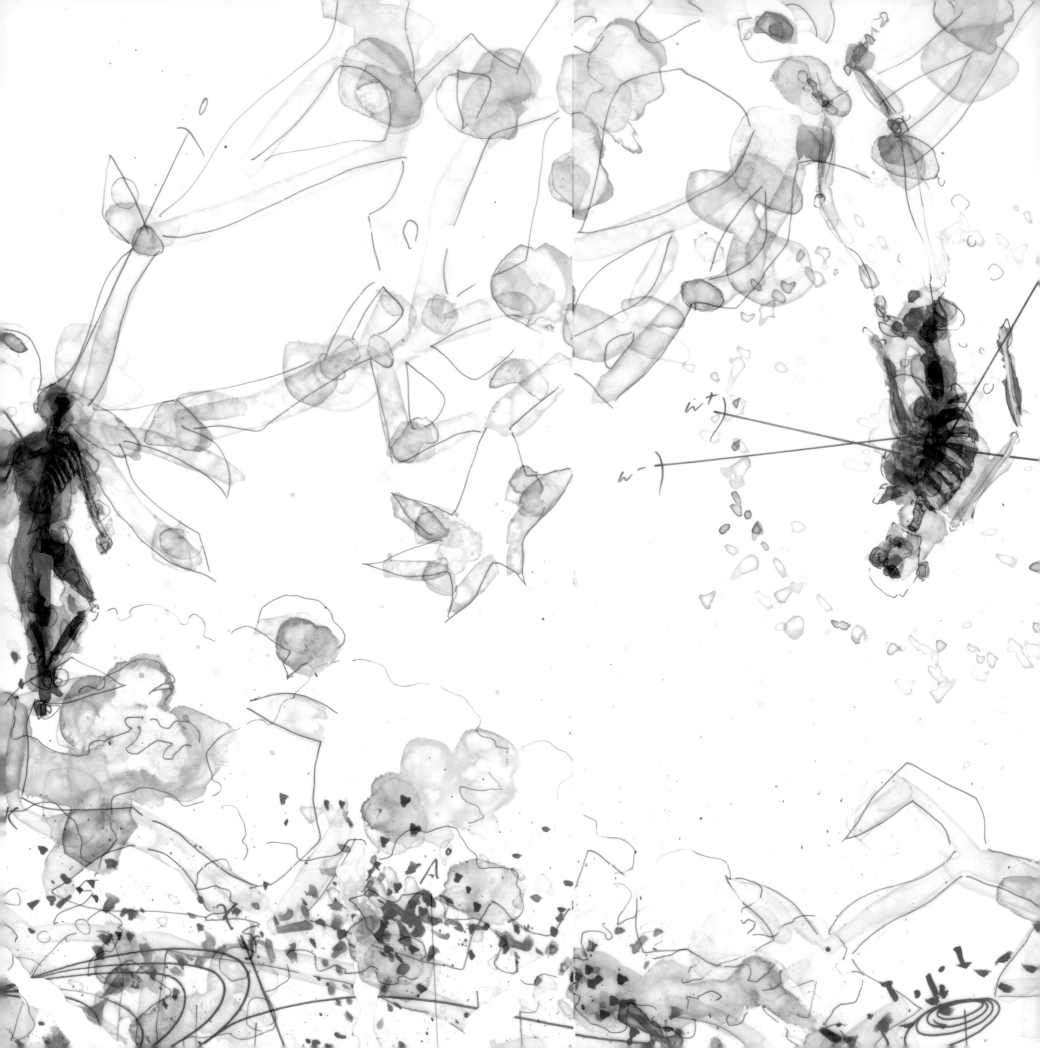

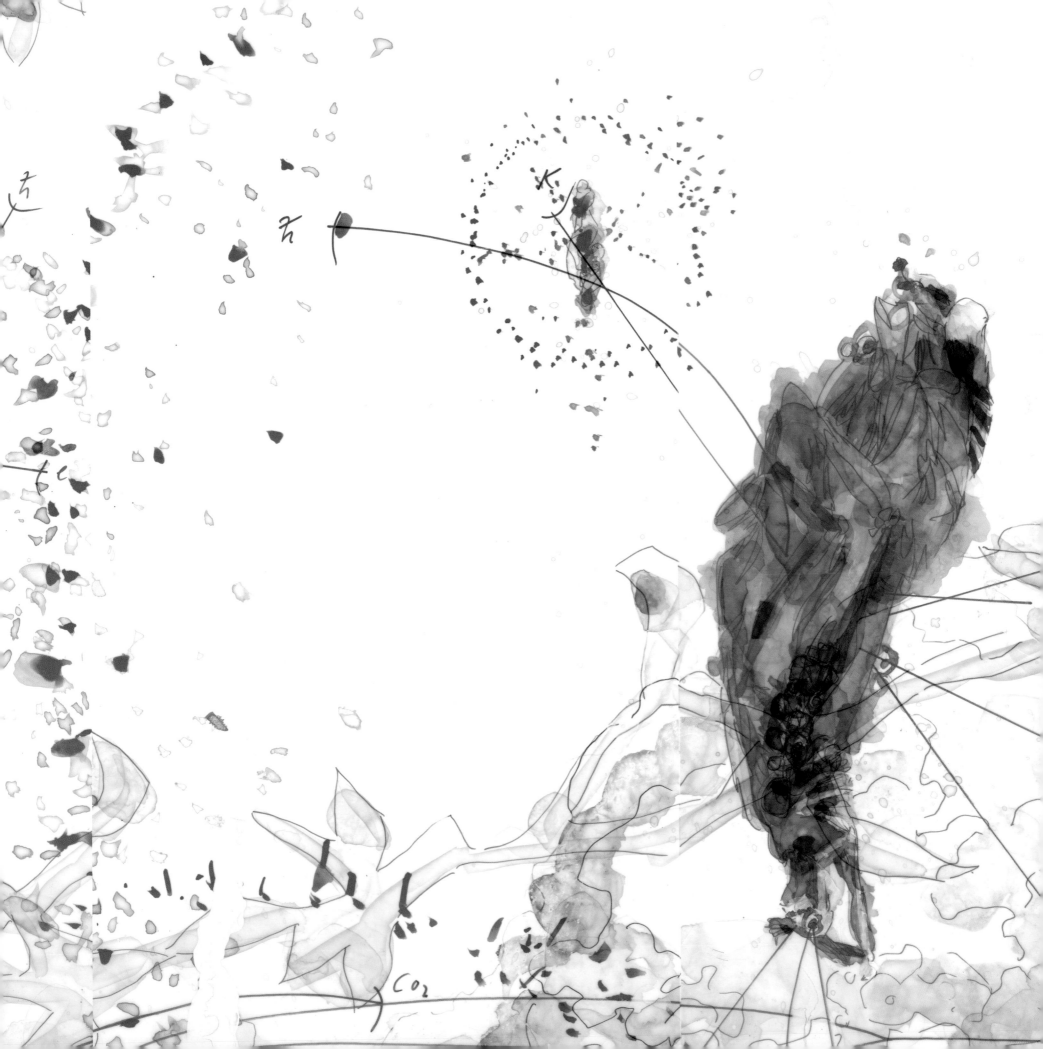

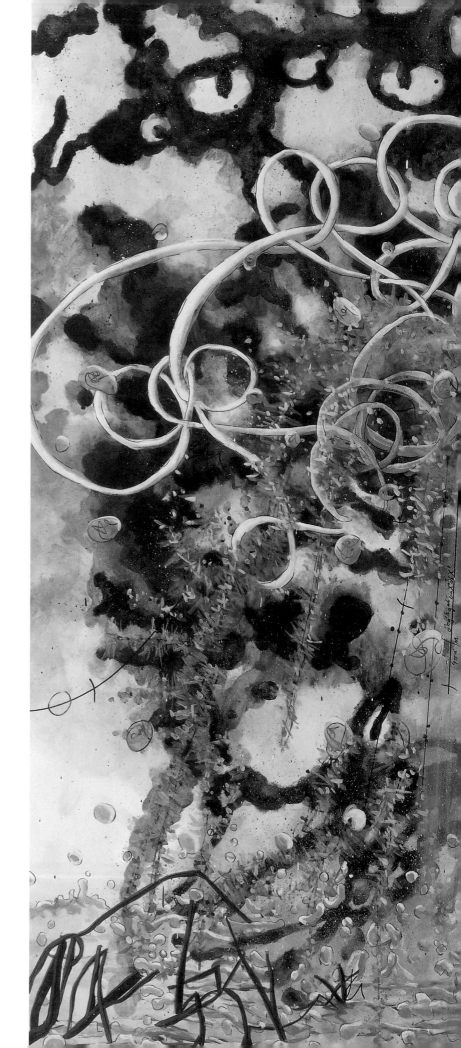

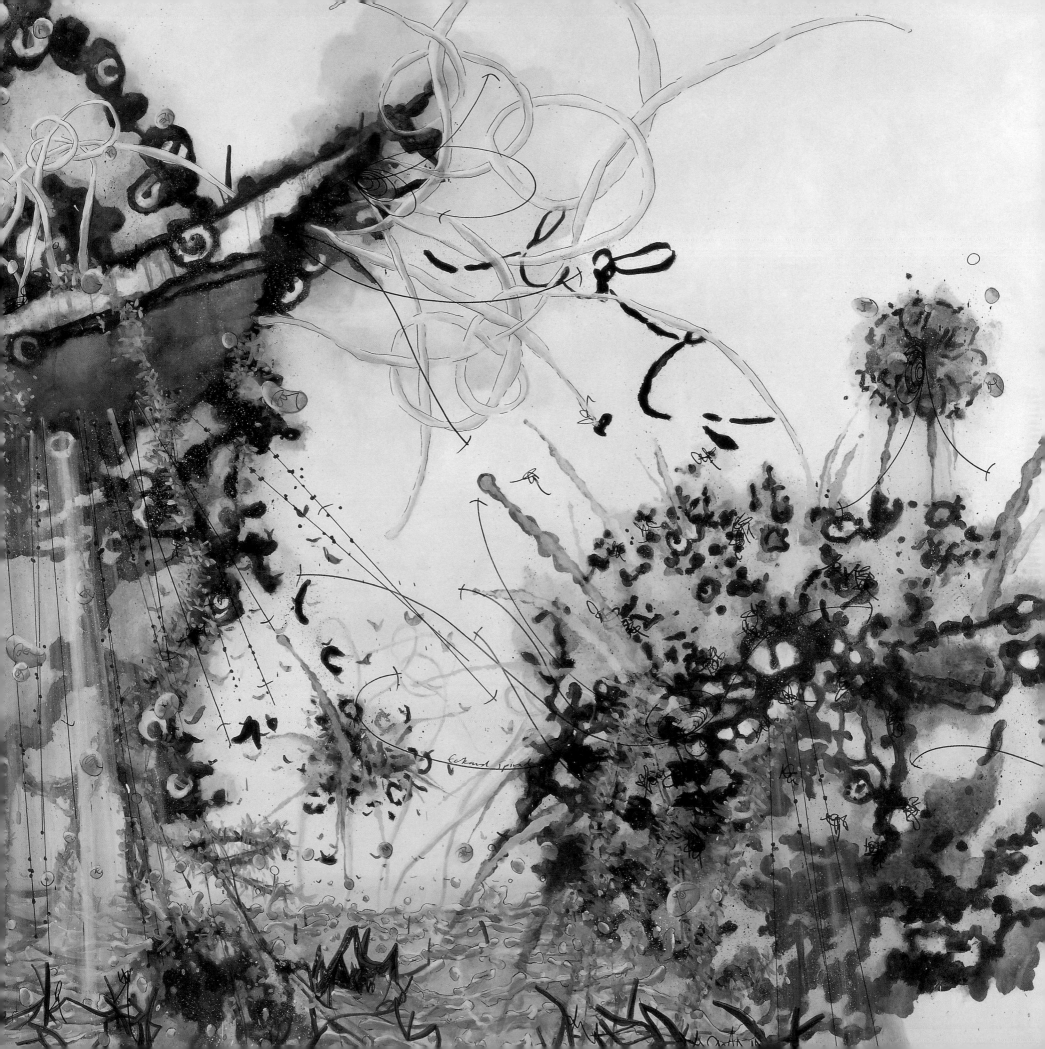

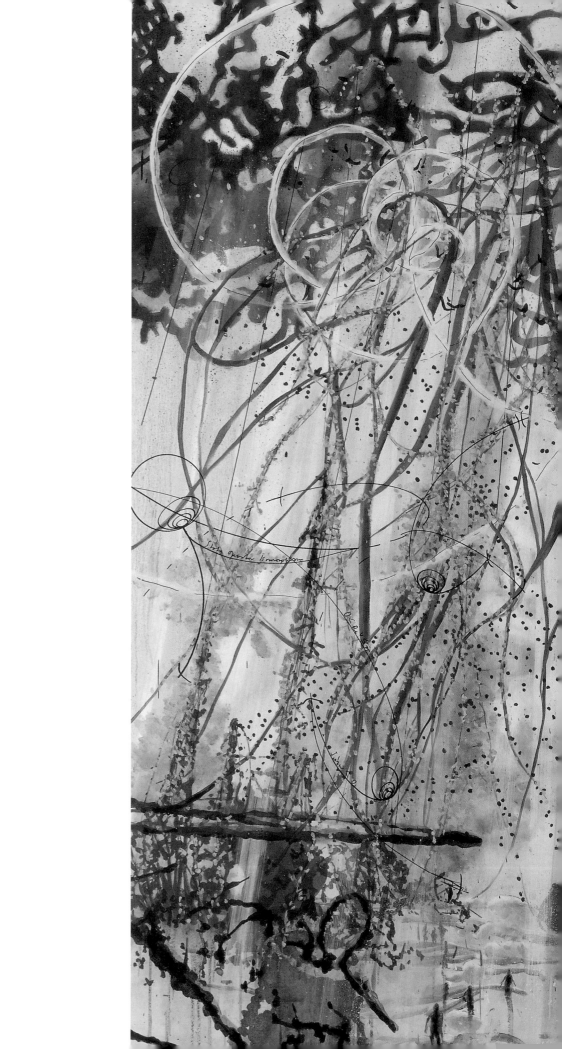

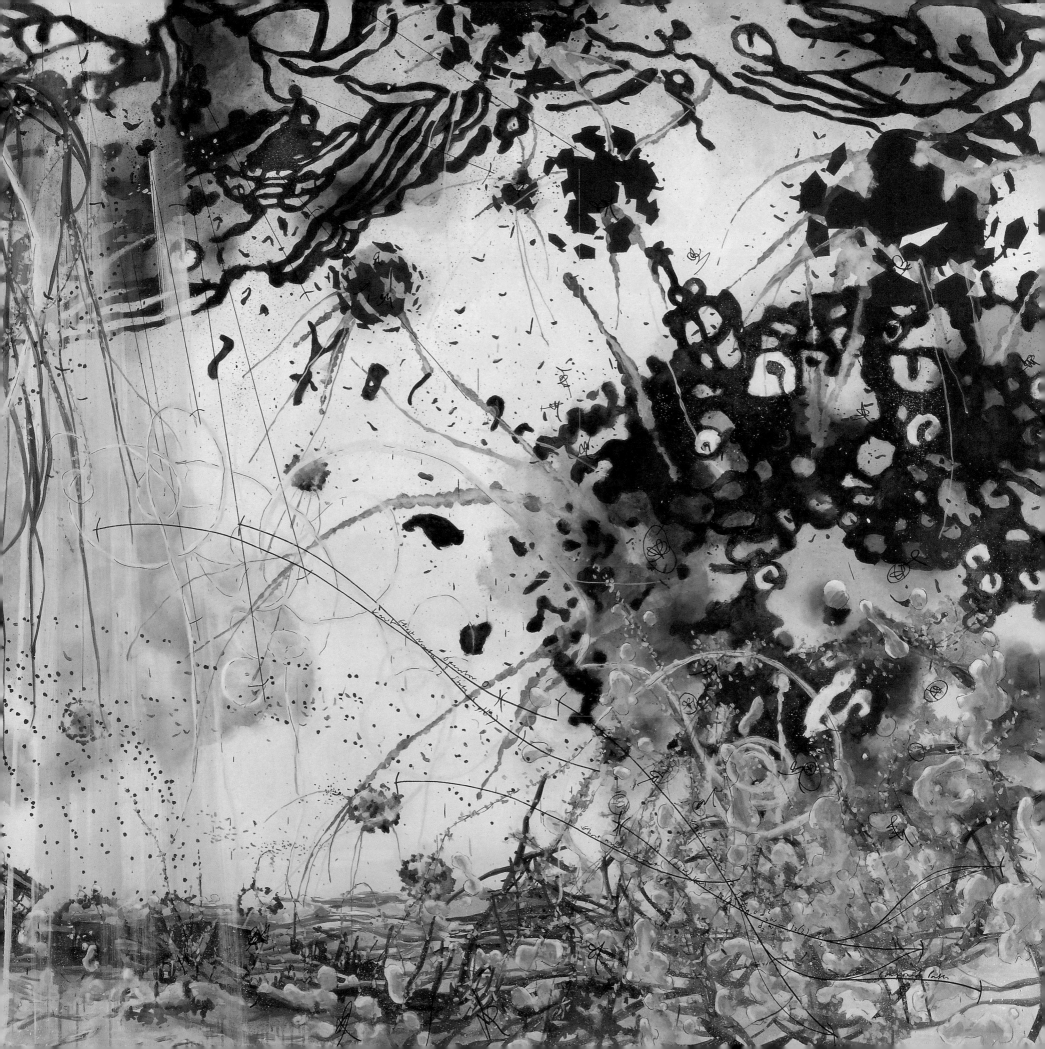

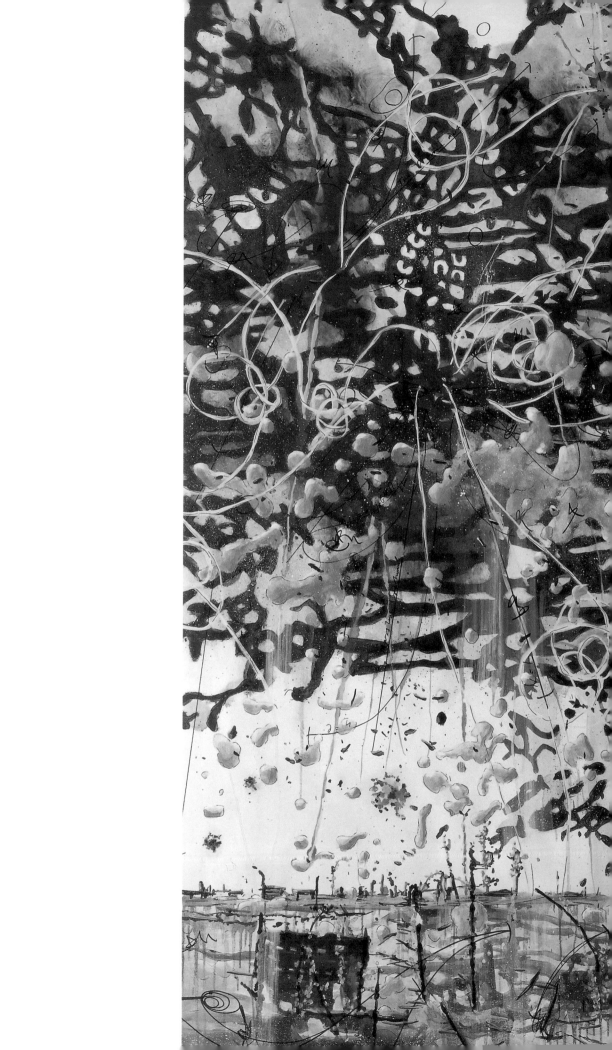

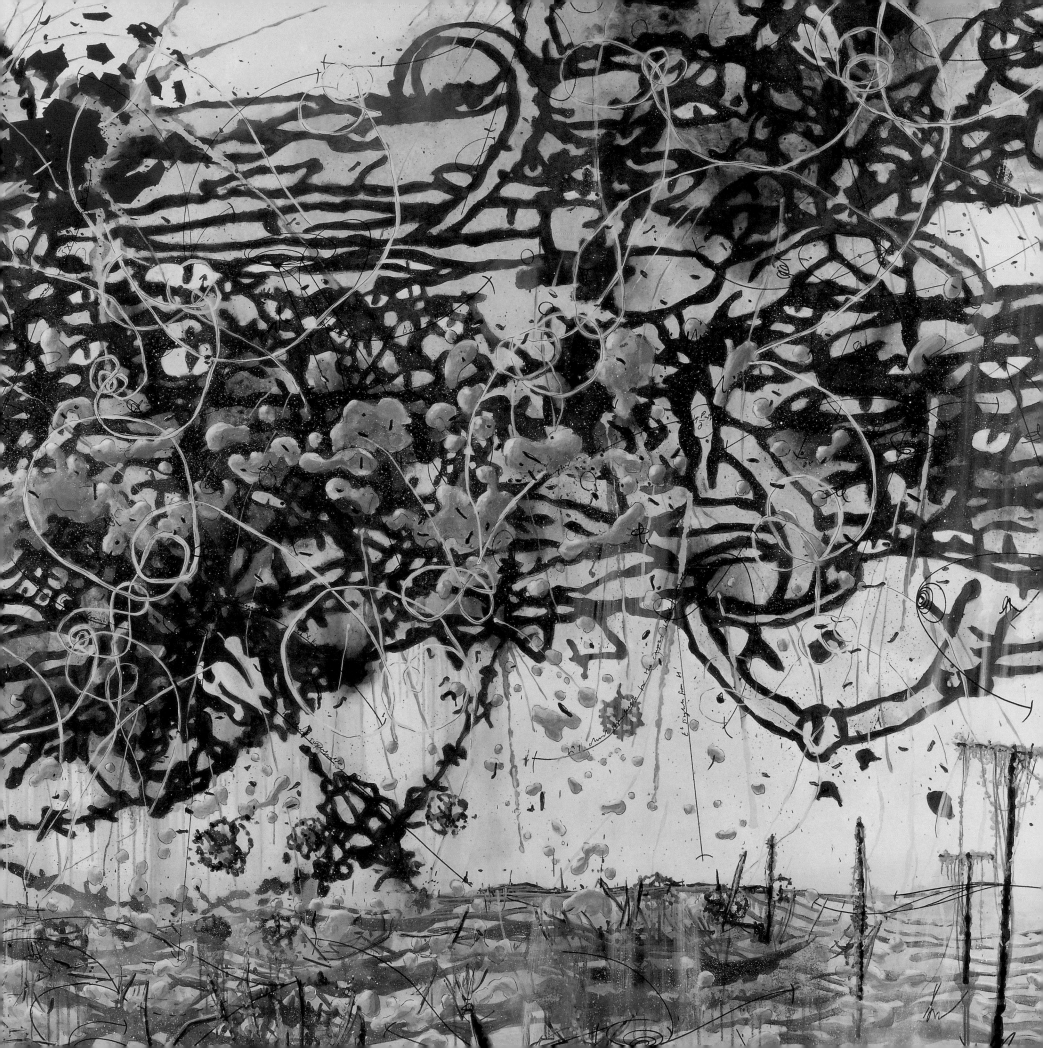

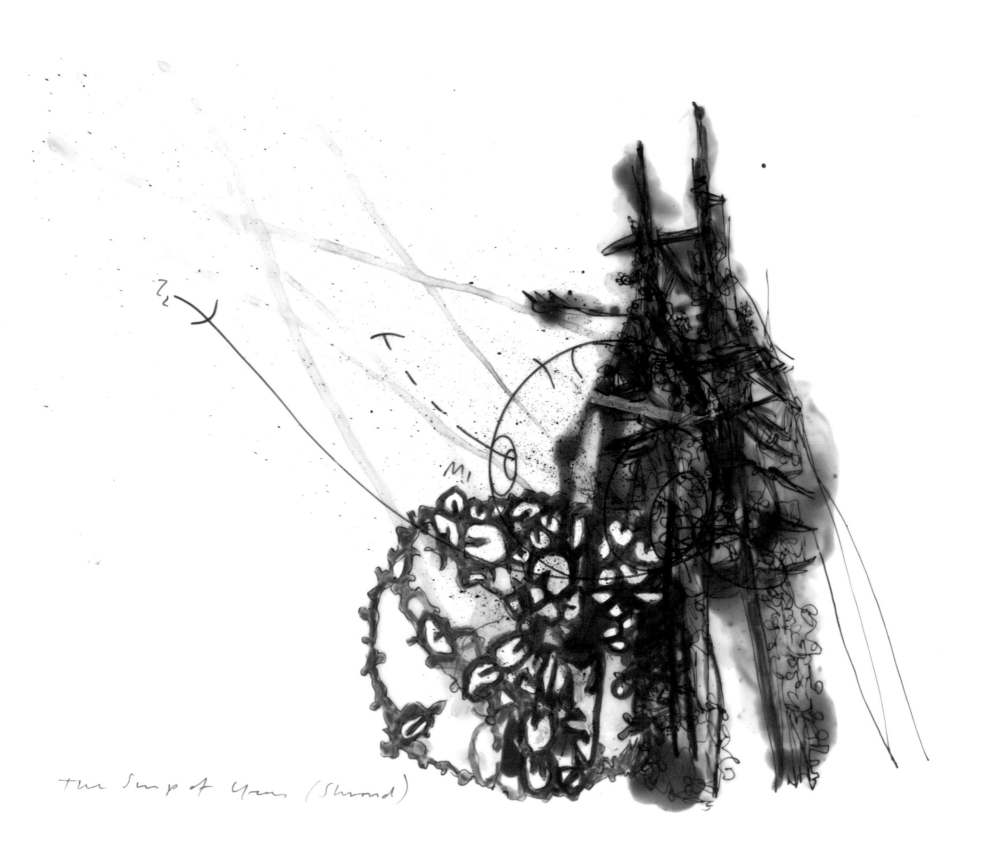

the Soup of Years (Shroud)

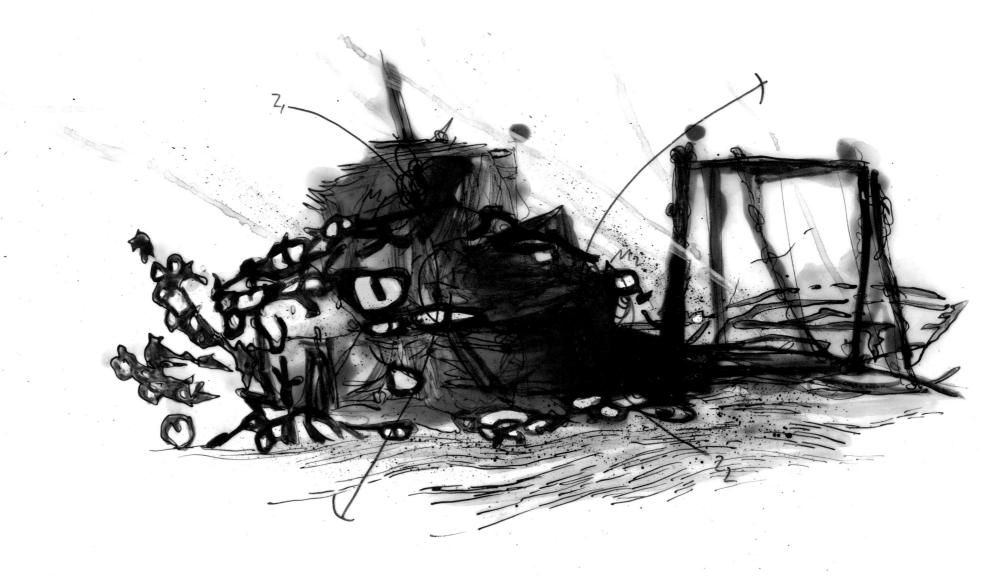

The Ship of Years (Transom)

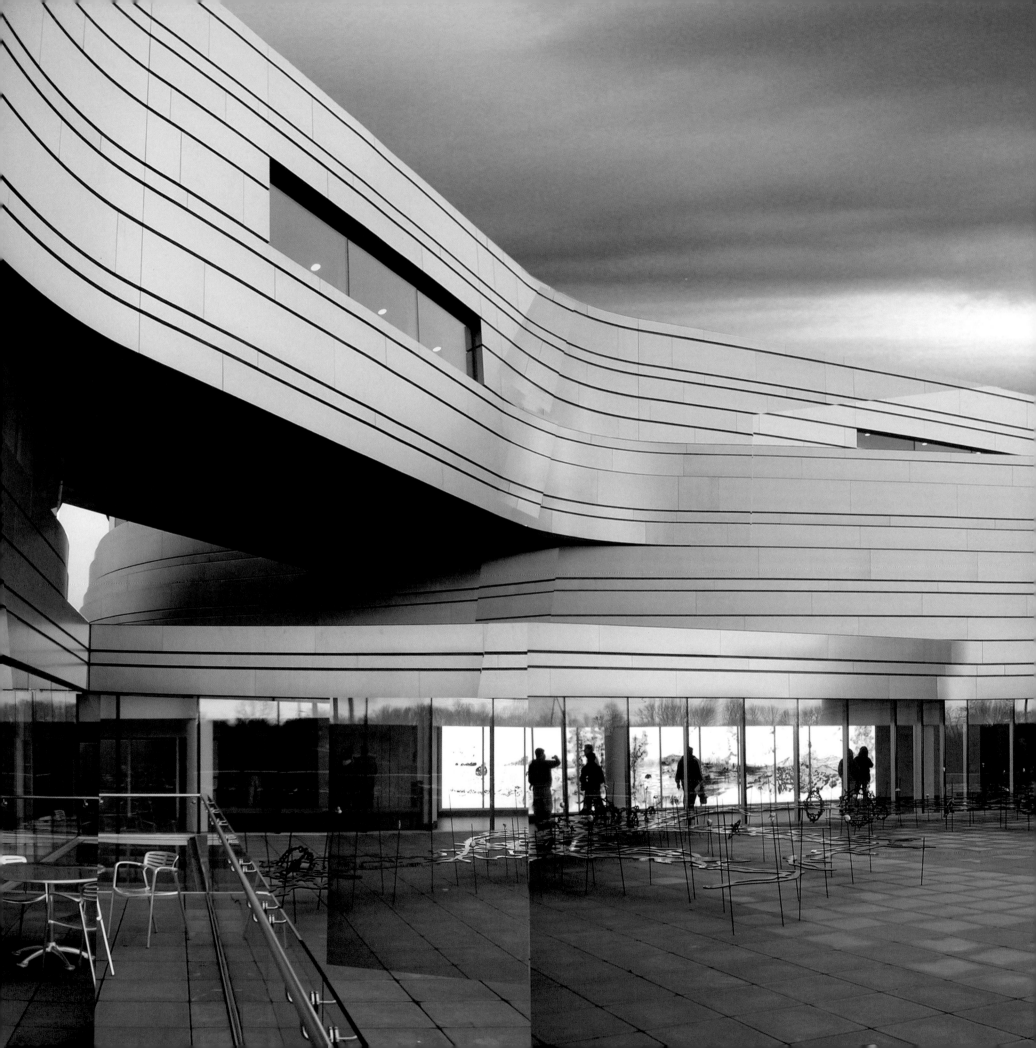

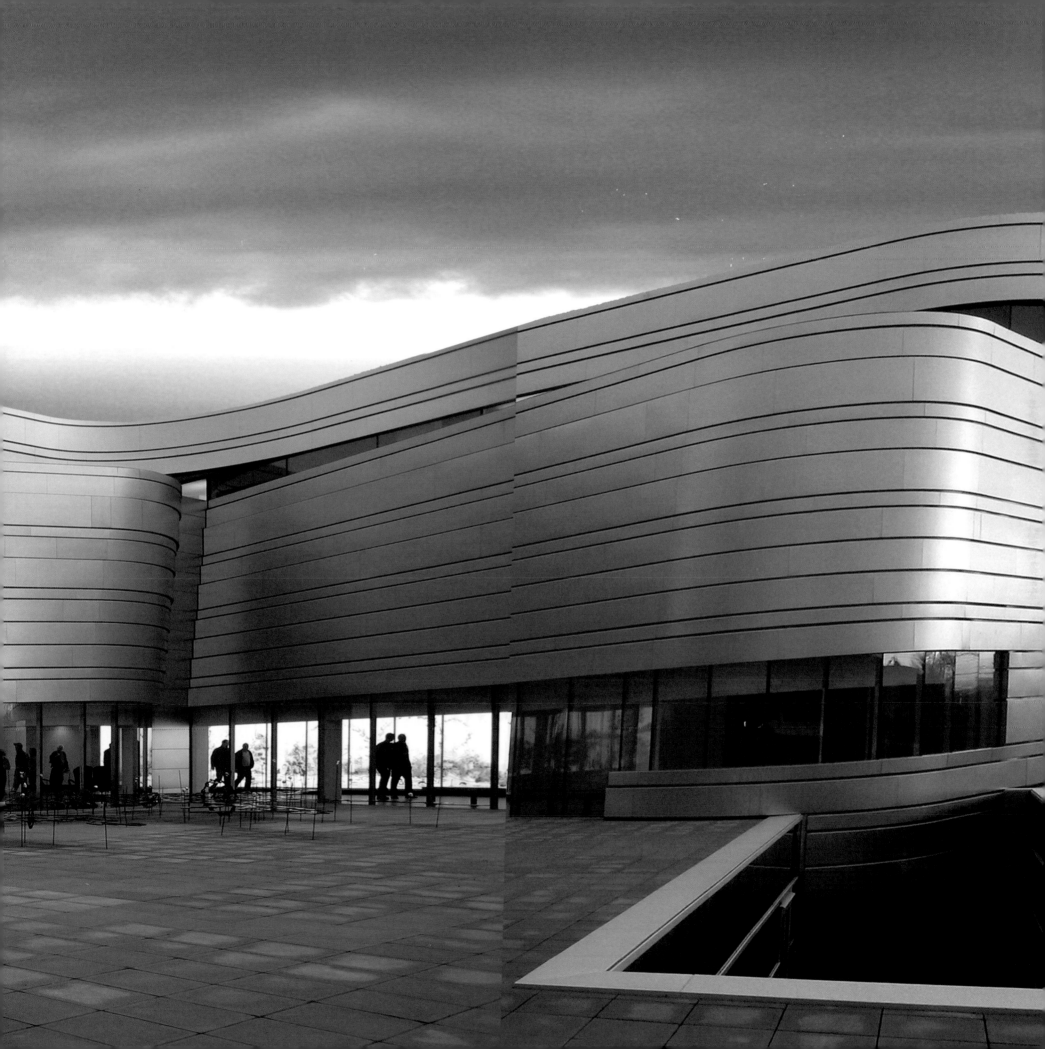

Thom Mayne

"When the observer moves, the environment is set in apparent motion. Mass, space, light, surface, and detail pass by in continuous transformation … [complex movements] can throw the entire scene into a choreographic wonder."
–Donald Appleyard, *Motion, Sequence and the City*

I remember years ago seeing a vast Caravaggio compressed into a small nook in the back of a church. You were never quite afforded sufficient viewing distance to see it completely, with no more than a few meters between you and the tremendous presence of the painting. Similarly, slipped into a narrow hallway, Matthew Ritchie's *Stare Decisis* can never be perceived in its entirety—you experience it in fragments.[1] The piece reveals itself sequentially as you move past it. This dynamic shift becomes part of the movement of the observer through the building's fluid forms. The effect is almost synaesthetic—static image transposed into haptic experience.

Though titled *Stare Decisis*—the Latin maxim for "to stand by things decided" that states that precedent judicial decisions are not to be departed from—the work insists on open interpretation. William O. Douglas, who served as Supreme Court Associate Justice from 1939 to 1975, argues against *stare decisis*: "this search for a static security … is misguided. The fact is that security can only be achieved through constant change."[2] In Ritchie's piece, as the viewer's perspectival position changes, lenticular film gives the work an illusion of constant shift. It is persistence of vision, the phenomenon where the retina retains an image for a moment after it disappears (which allows us to perceive flip books and film projections as continuous rather than distinct images) that allows us to comprehend the shift. The art, like the architecture that houses it, employs a conceptual strategy that reinforces both the necessity of persistence and the openness and freedom afforded to law and architecture by interpretation.

The glowing imagery materializes a mind map of facts, ideas, places, and histories, translated into a visual lexicon of intertwined color, line, forms, and symbols. While Ritchie's layers of information draw from legal history, the viewer need know nothing of this philosophical context to experience the work—sense perception supersedes intellectual understanding.

1. *Stare Decisis* is the overall name of Ritchie's work and the individual name of the lightbox work referenced is *Life, Liberty, and Pursuit*.
2. William O. Douglas, "Stare Decisis," *Columbia Law Review* vol. 49, no. 6 (June 1949): 735–58.

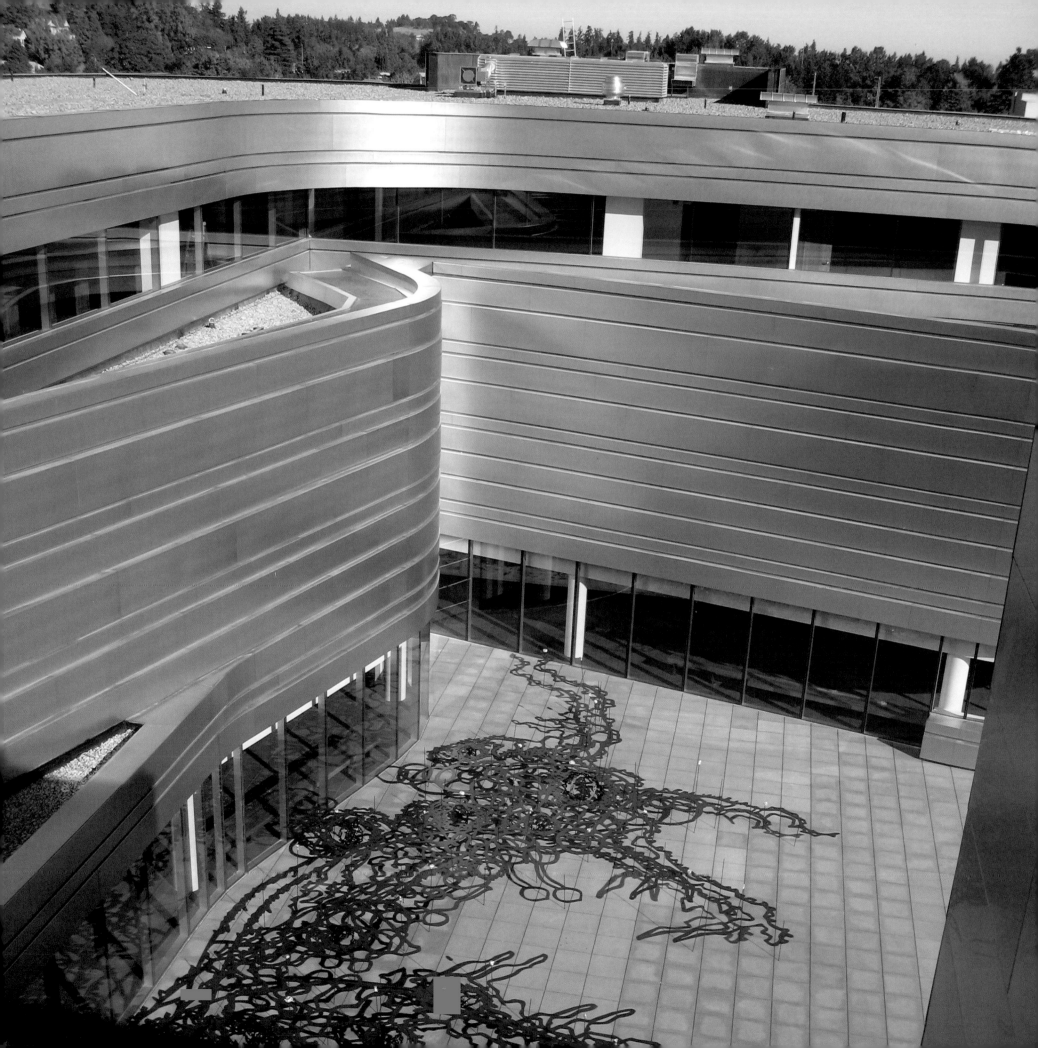

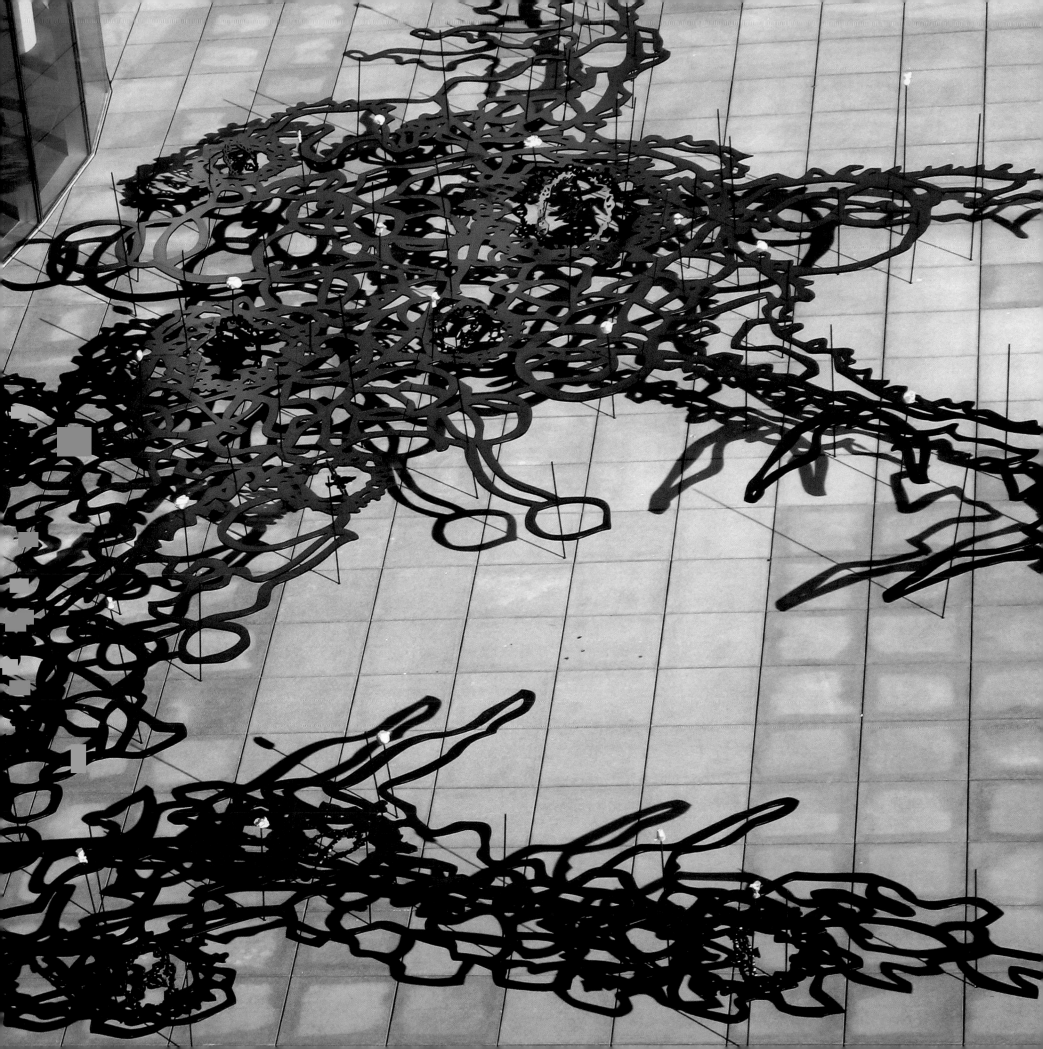

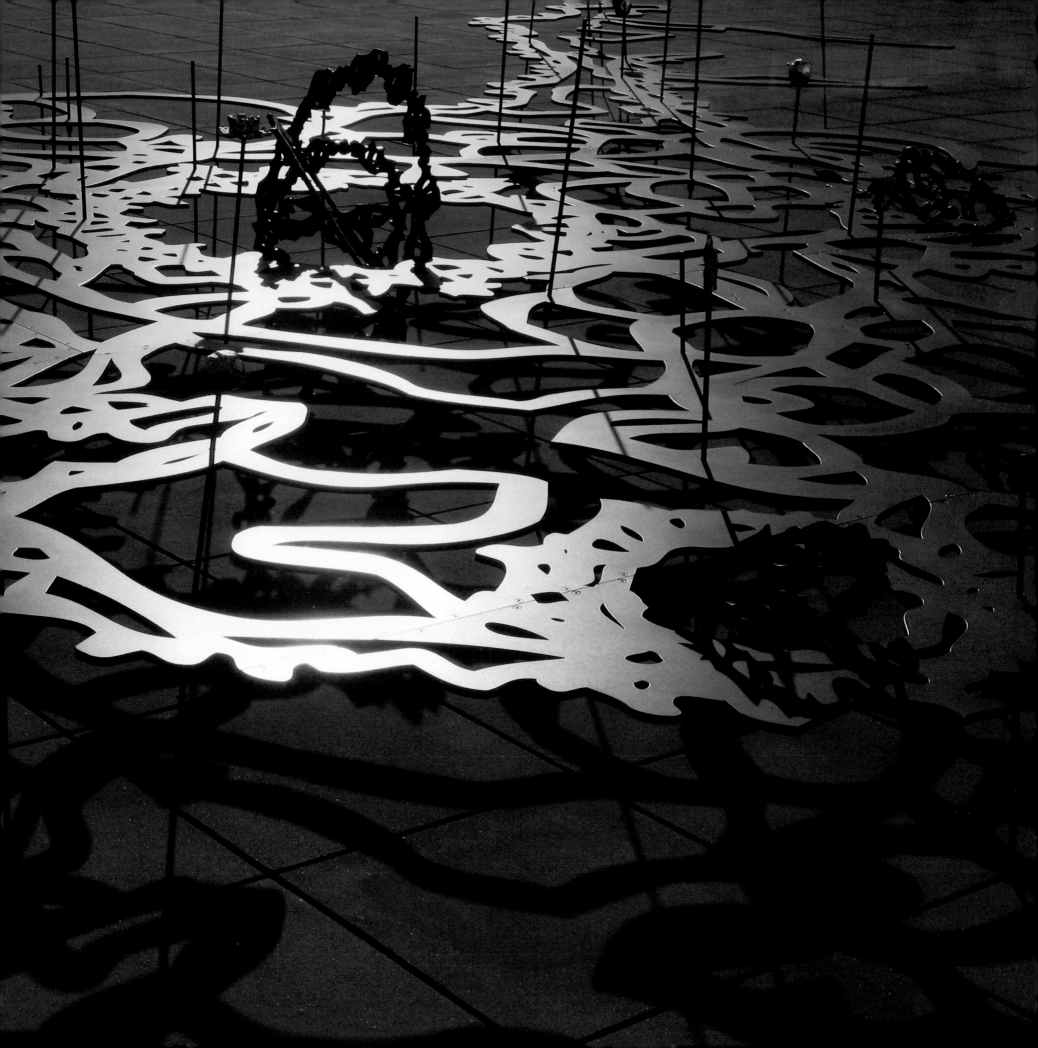

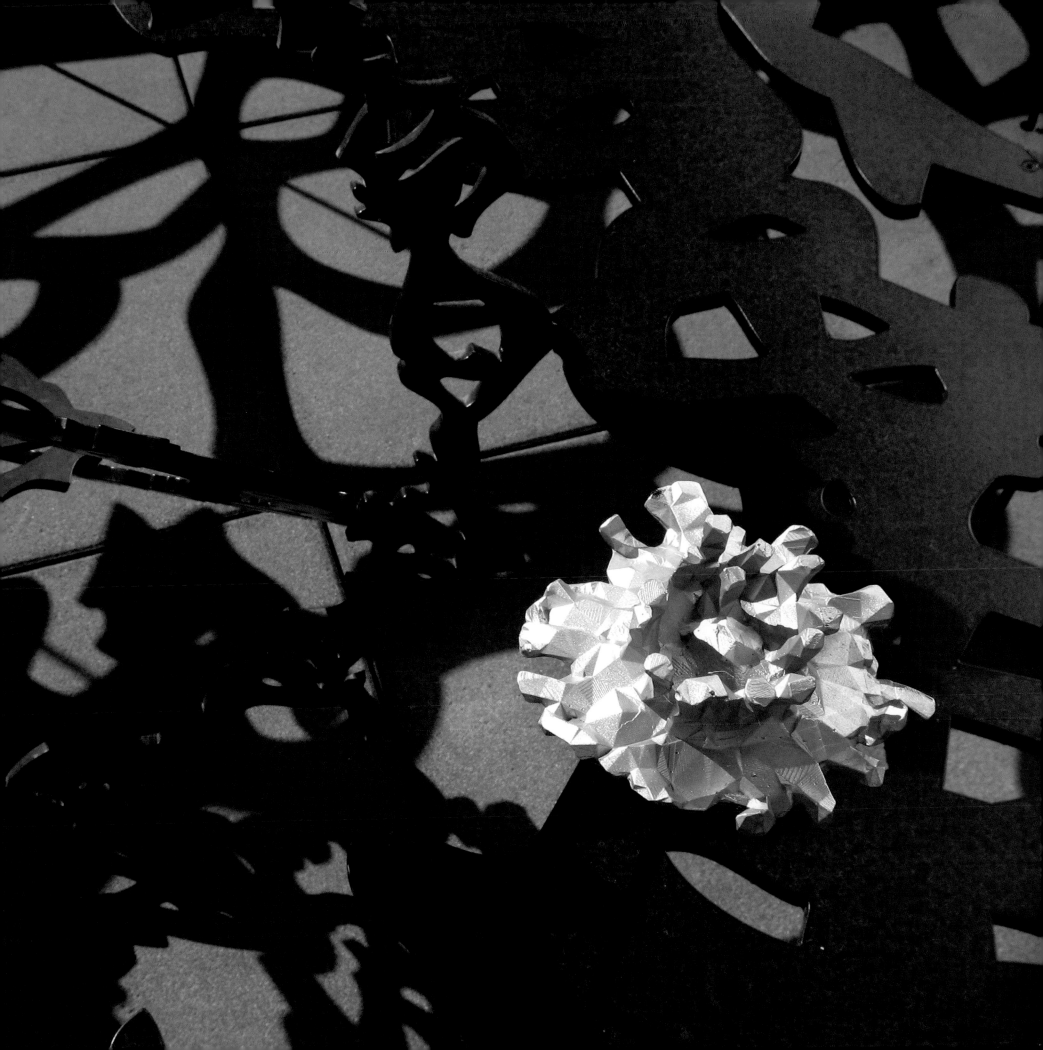

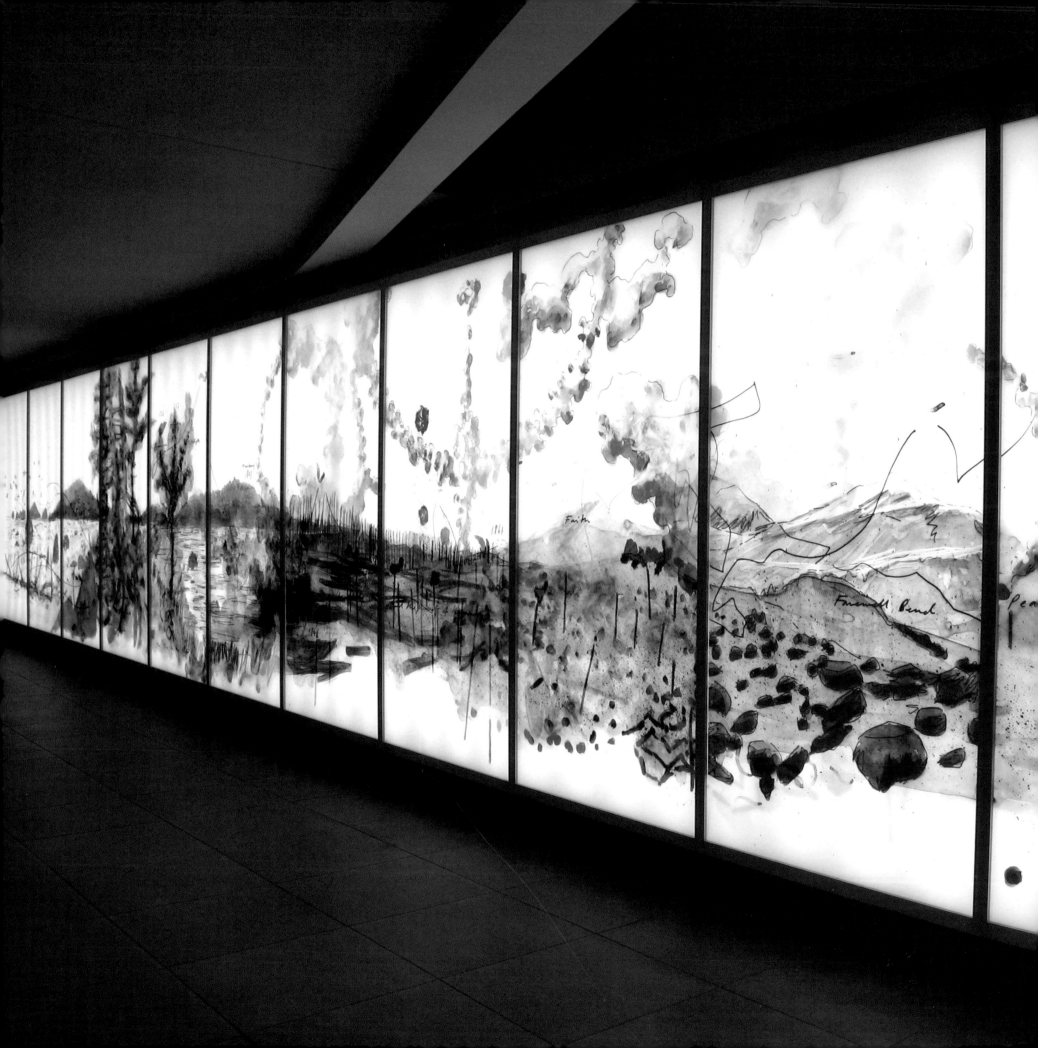

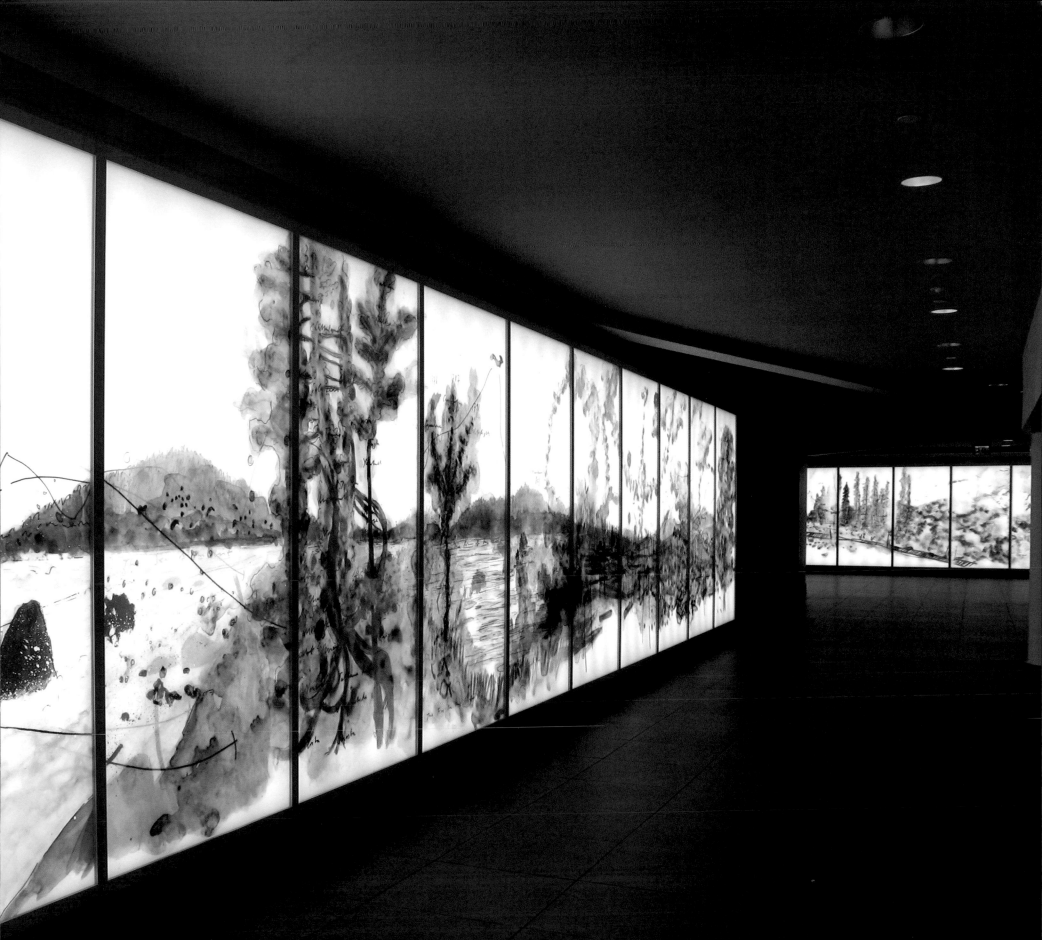

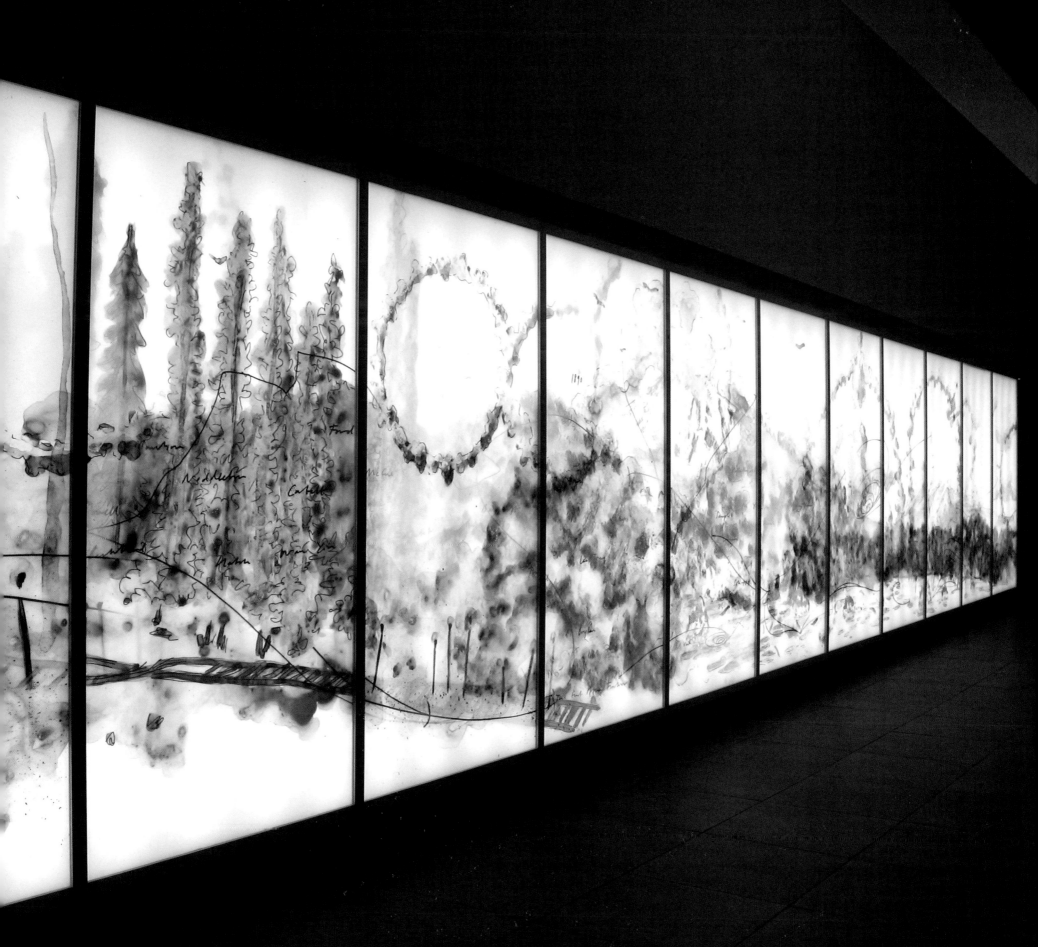

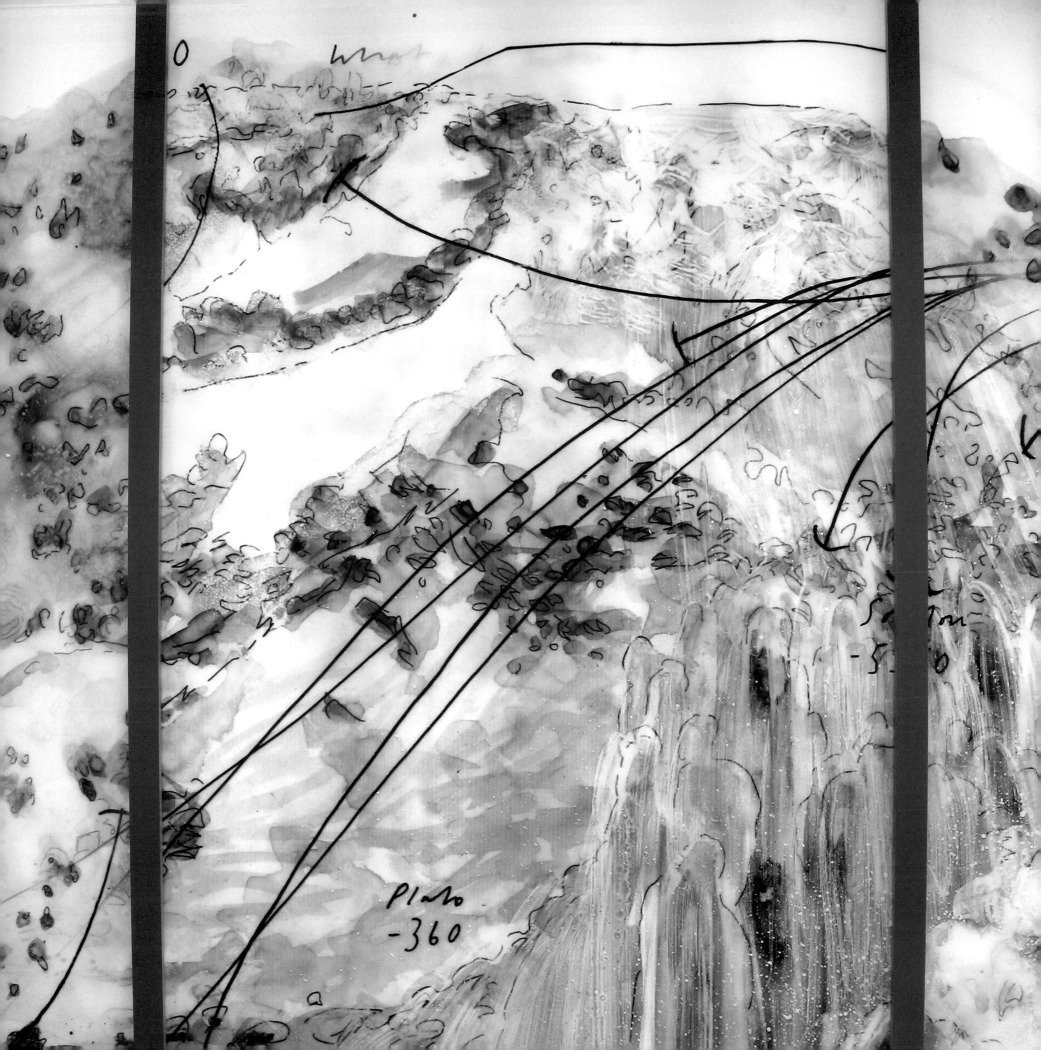

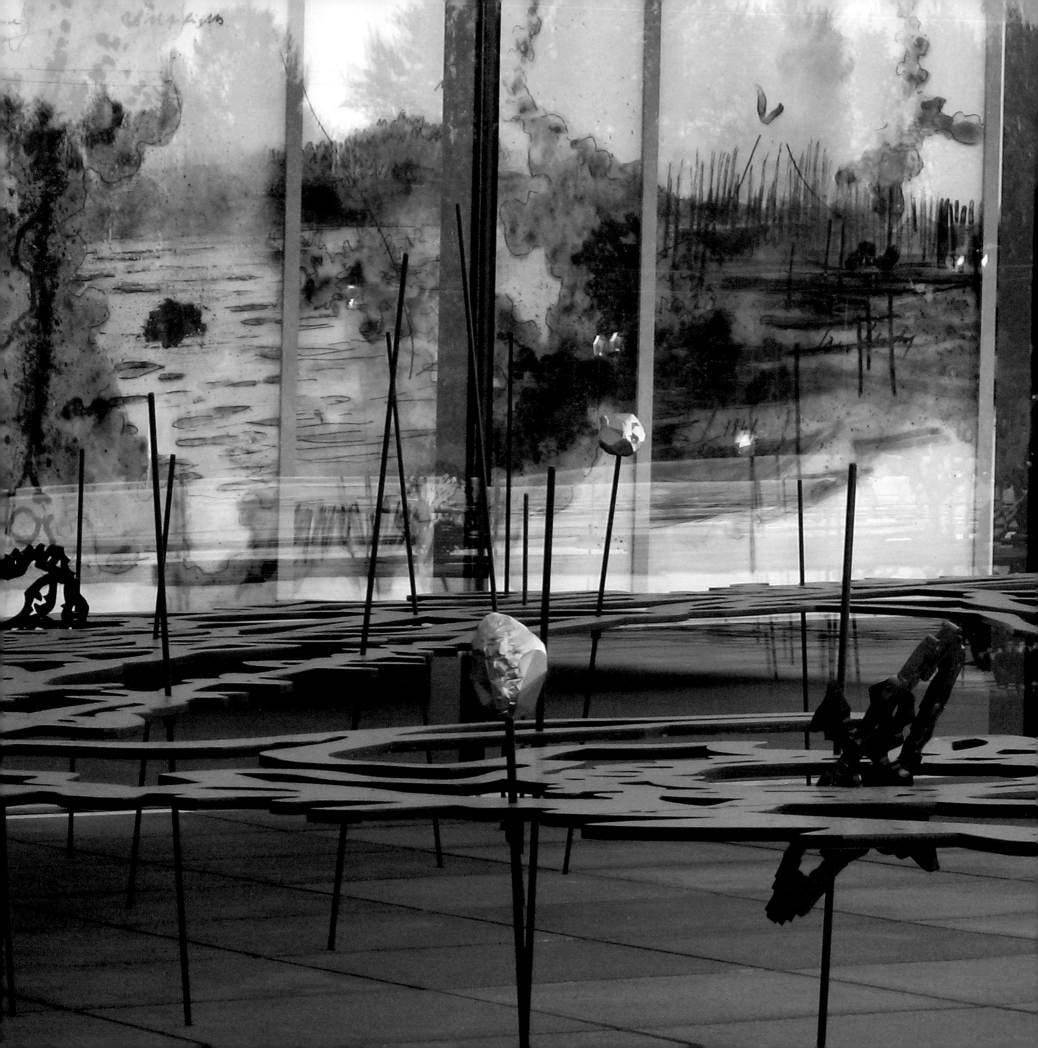

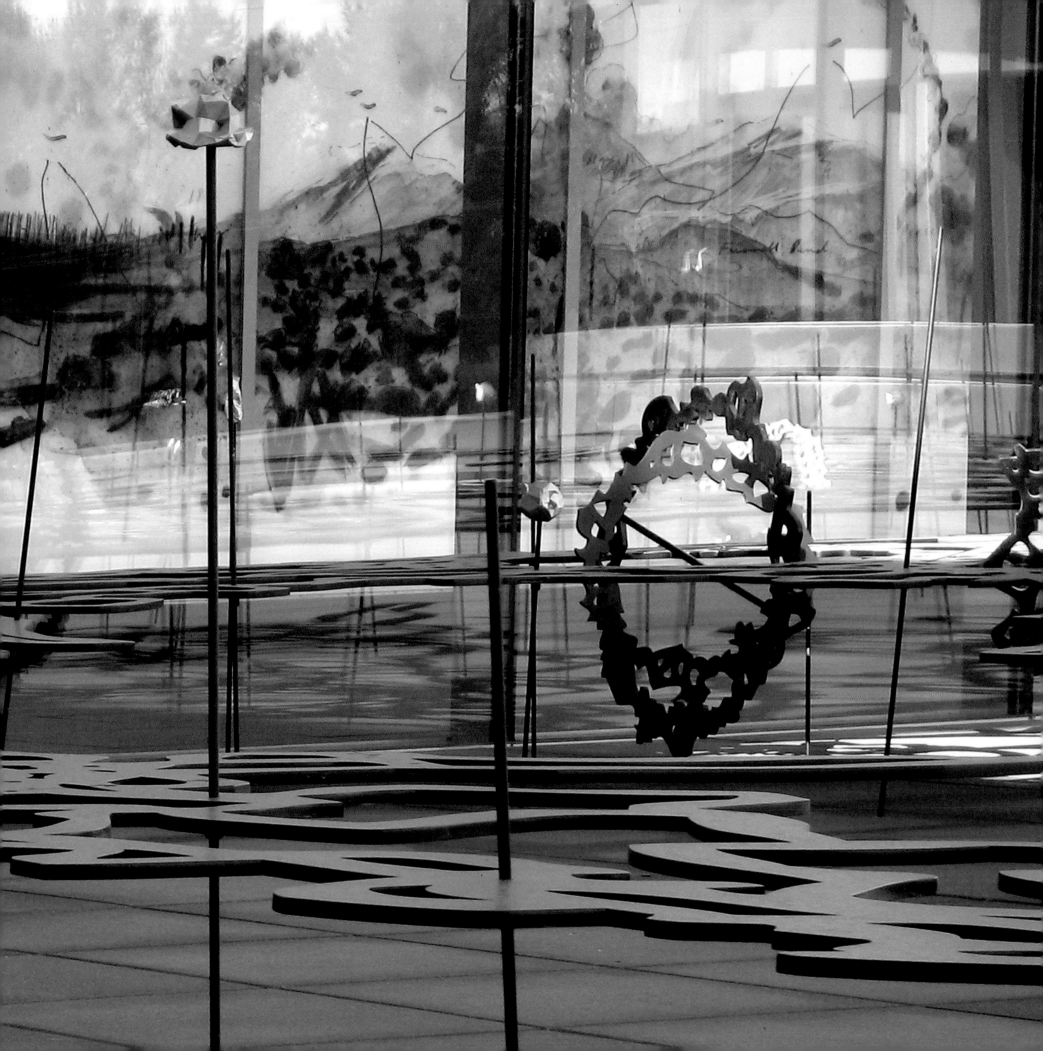

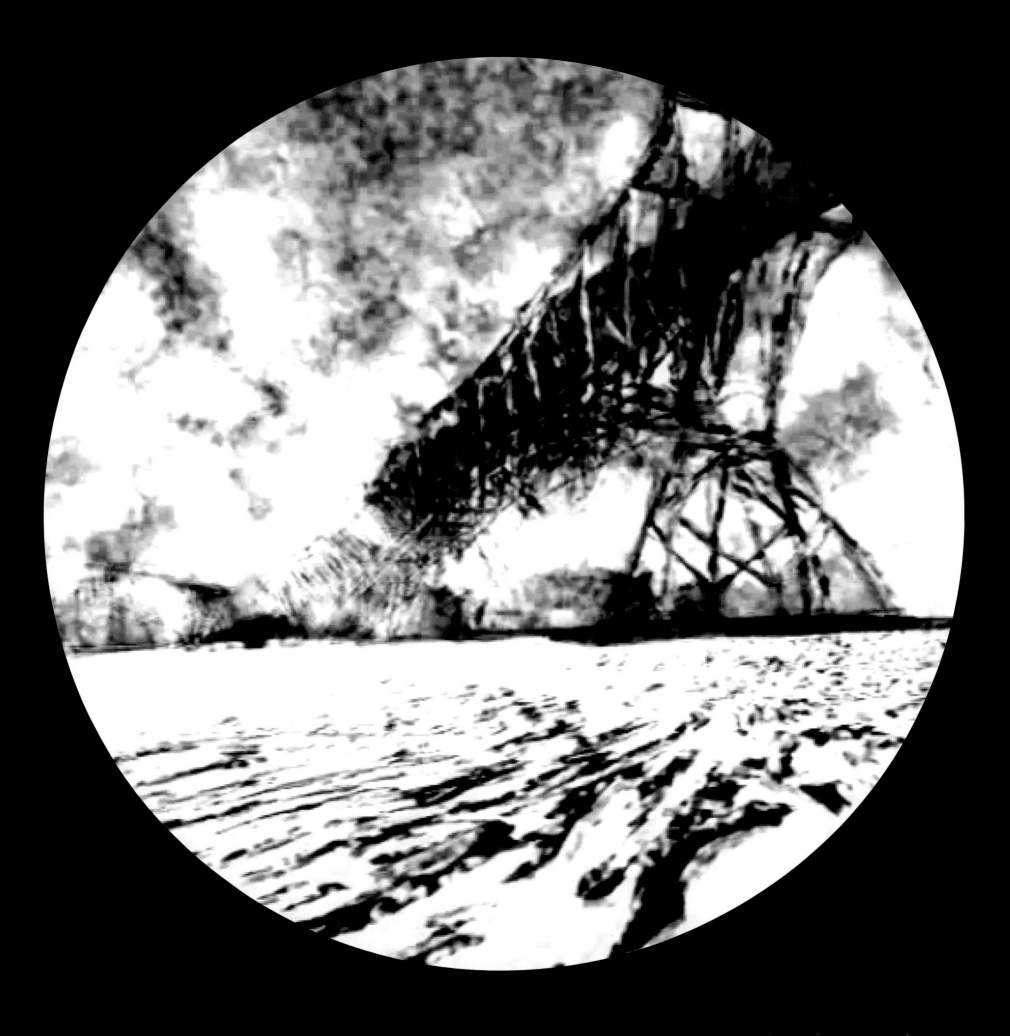

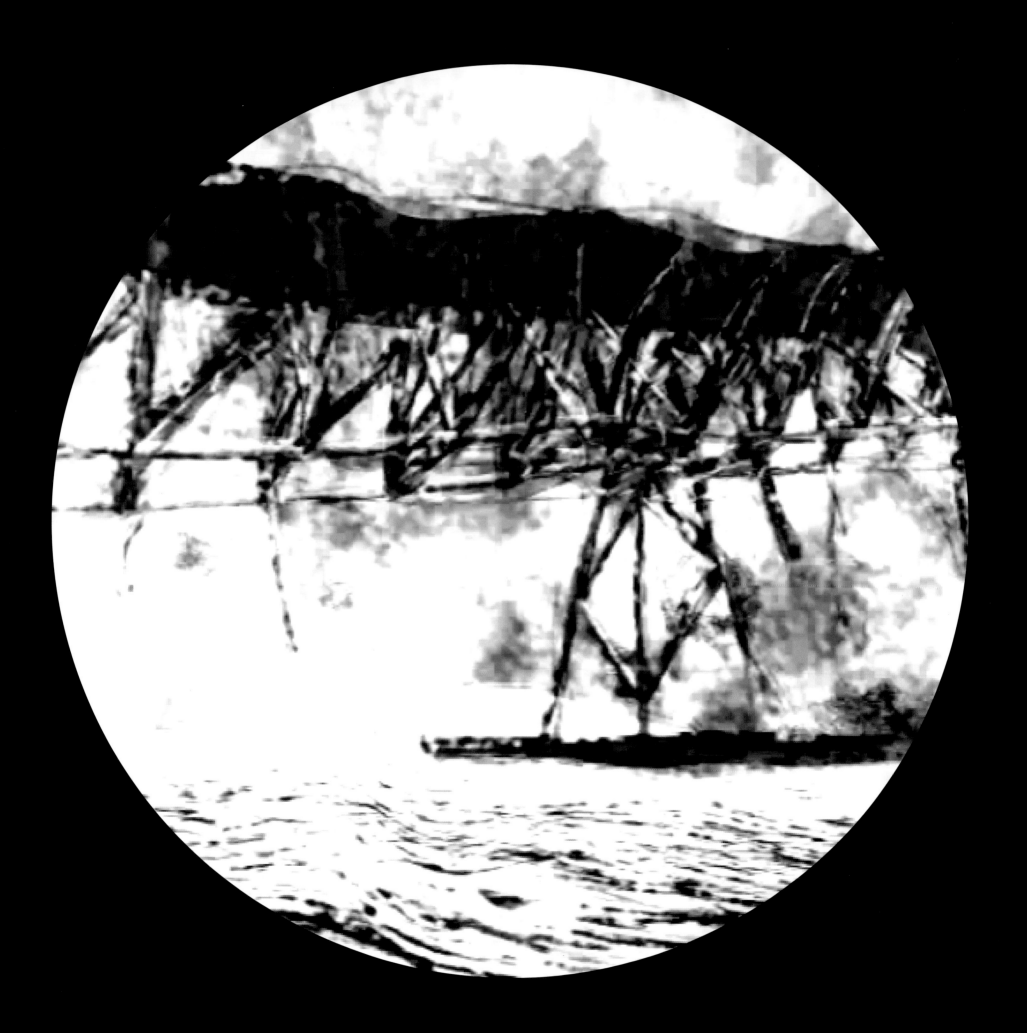

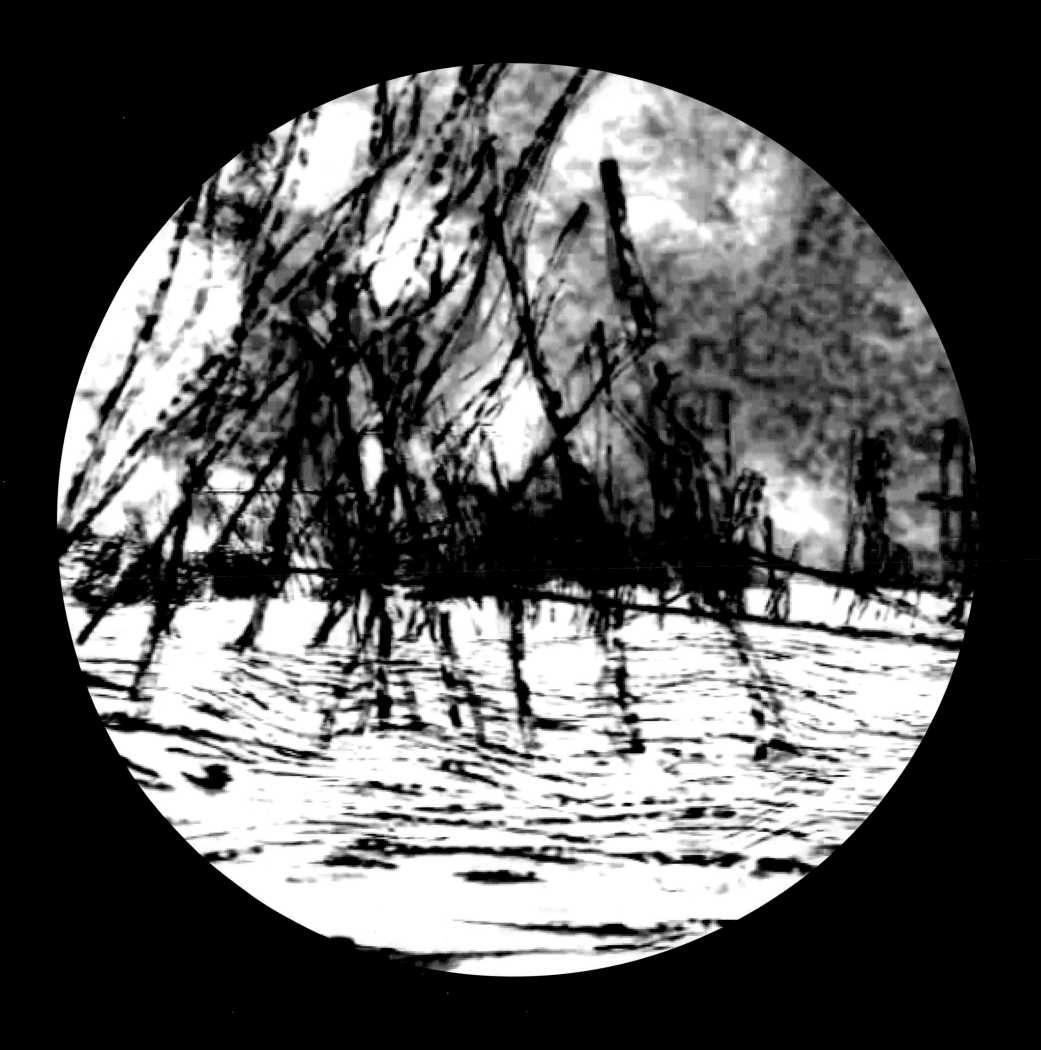

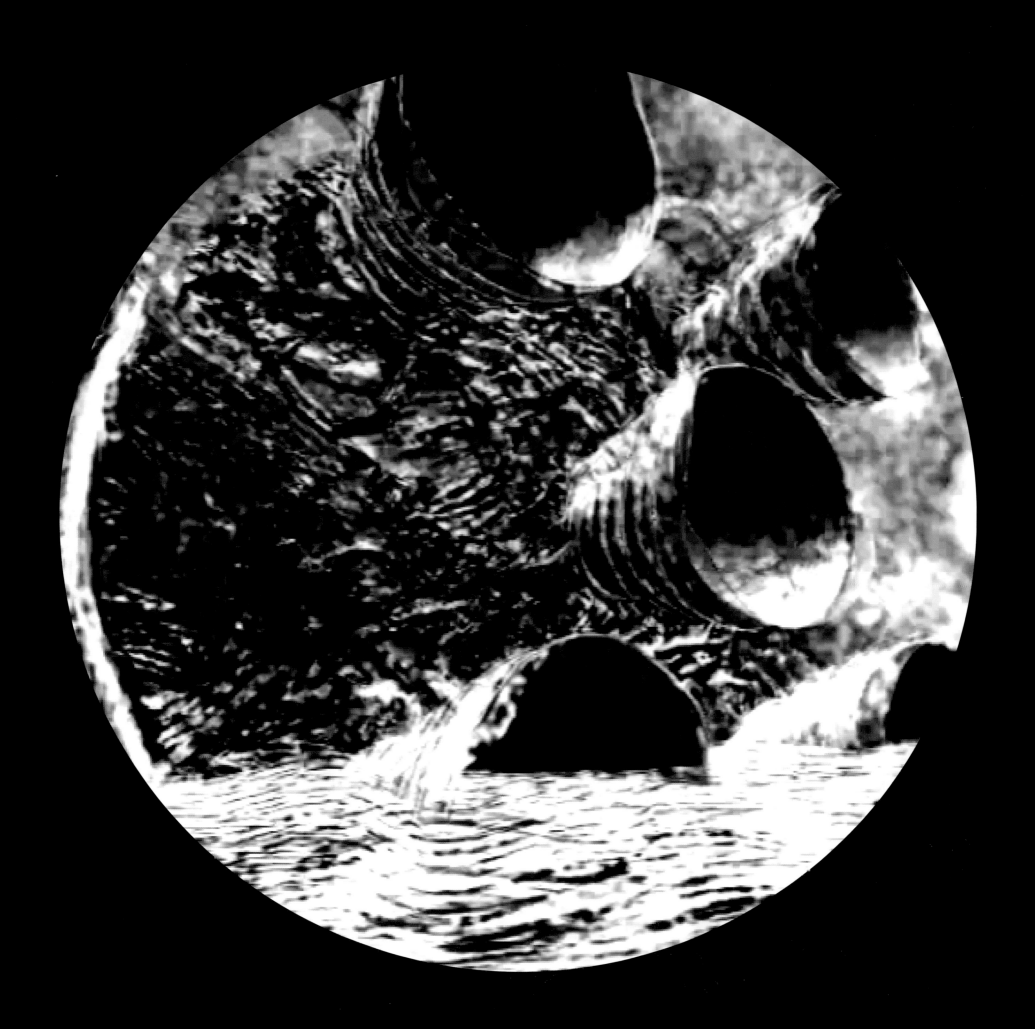

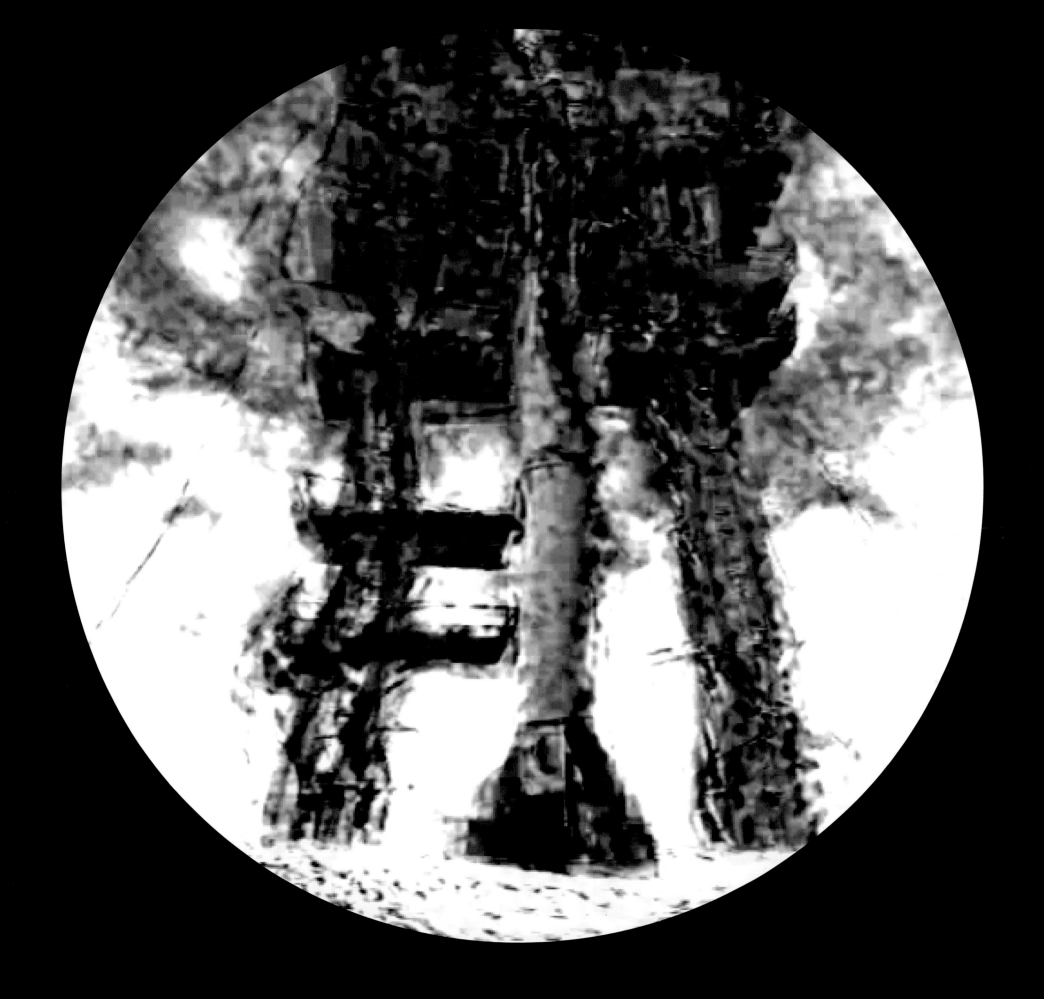

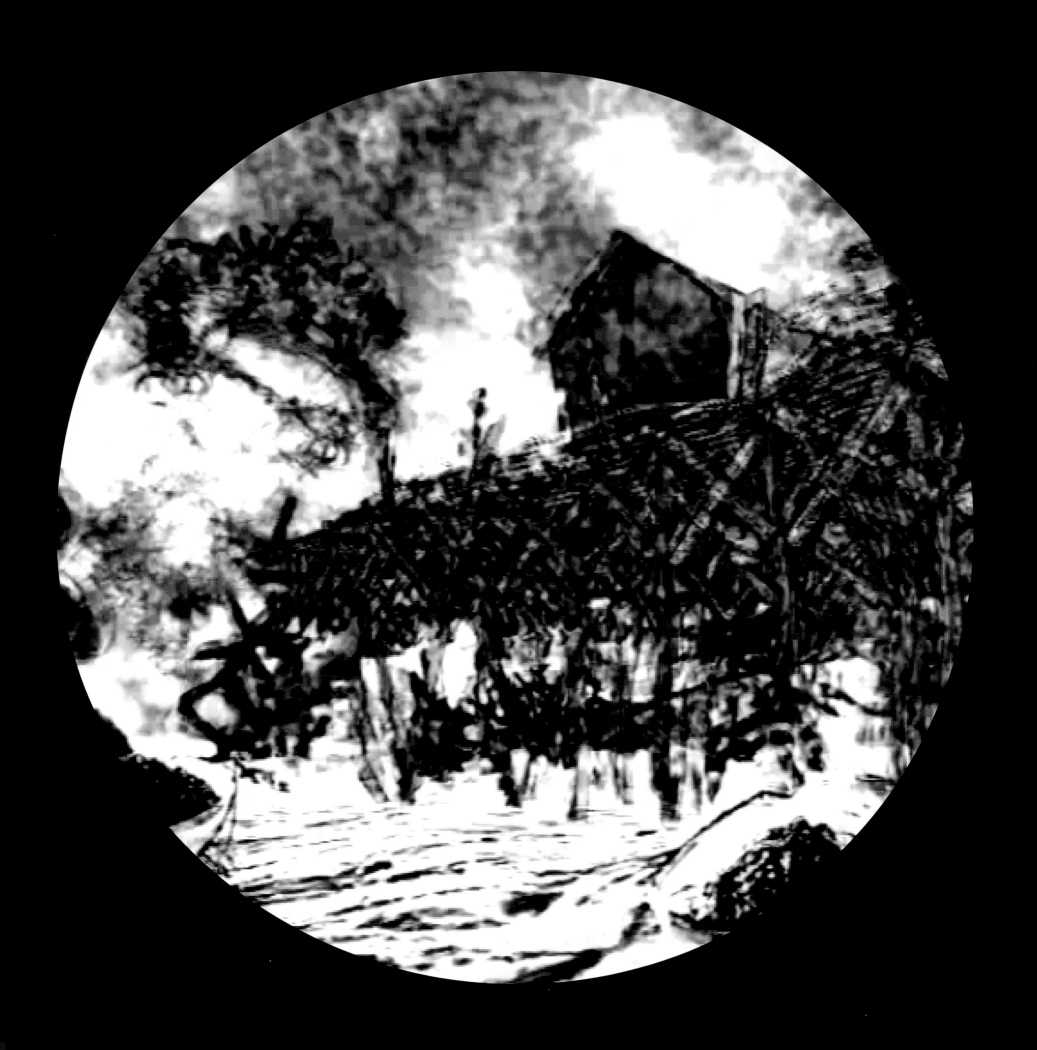

It has been found necessary to constitute artificial persons, who may maintain a perpetual succession, and enjoy a kind of legal immortality. In all the patients, the delirium introduces great delusions: Their brain, stomach, heart, blood, spirit, or body are missing.

These artificial persons are called bodies politic, bodies corporate or corporations. We're an empire now, and when we act, we create our own reality. Are you ready for your beating? In 2005, the United States government classified fifteen scenarios as major threats to the population. I'm not saying there were no choices, no second chances. The different accidents of life are not so changeable as the feelings of human nature. Even right at the end, when we were begging for mercy, there was still a path, a pilot … a kind of light. You know you deserve it. But not one of us truly knew whose invisible hands shaped and steered them, who keeled and captained their ship. With what glass and devil. To such ideas, delusions of immortality may come to be included. You've been bad. Very bad. Collectively these are known as the Universal Adversary. And while you're studying that reality — judiciously, as you will — we'll act again, creating other new realities, which you can study too. What I'm saying is; not one of us, even those who believed they were true, could read that kind of weather. The flickering lights cloak you in the shadow of a cell. Coffin weather. Following the ideas of immortality may come ideas of bodily expansion in space. Neither can a corporation be excommunicated; for it has no soul. We want to see some light. But the clenched fist you call your heart has never had much time for that kind of thing.

FOTOGRAFIE
FORUM
FRANKFURT
KOMMUNALE
GALERIE

We
So

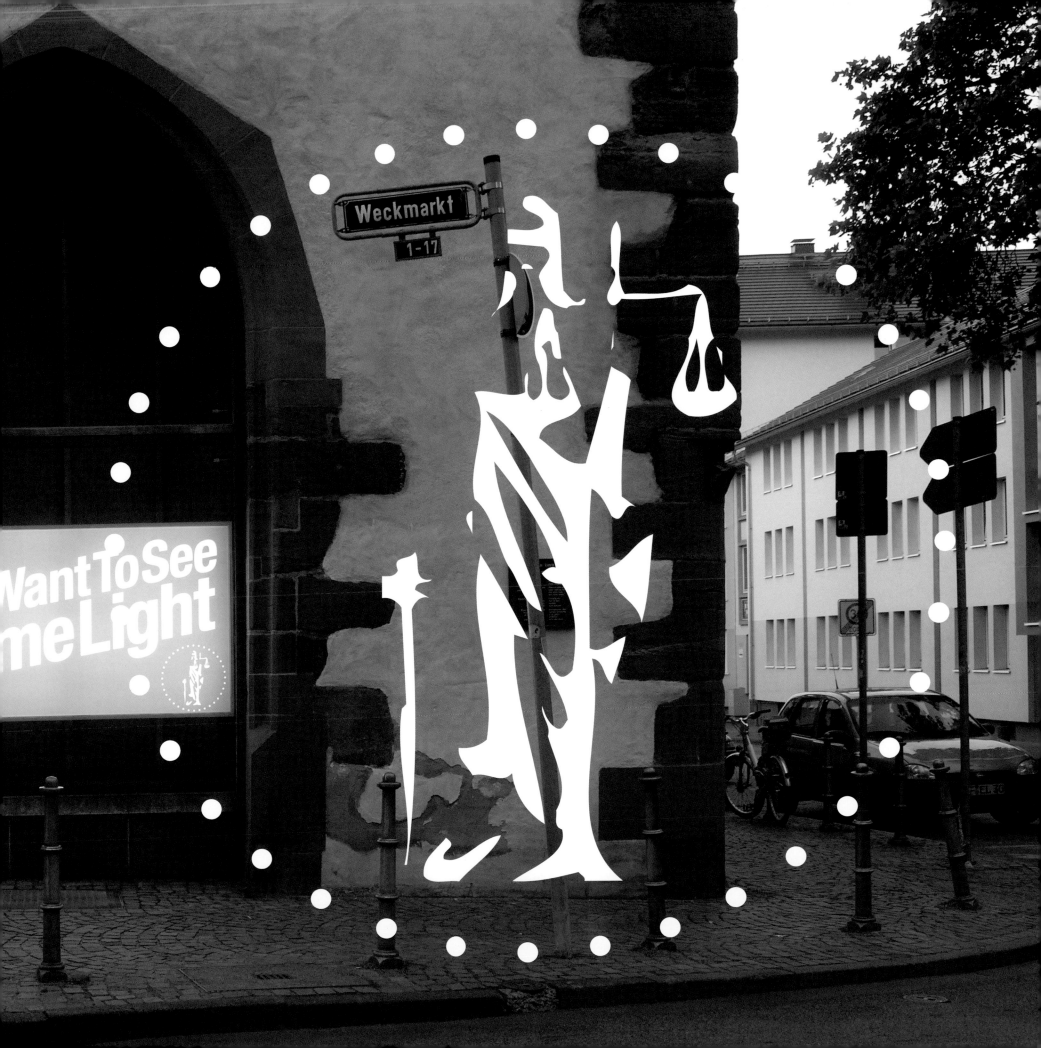

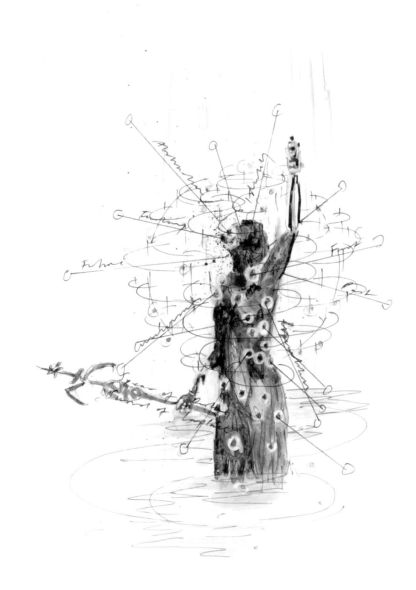

Electa Anne IX

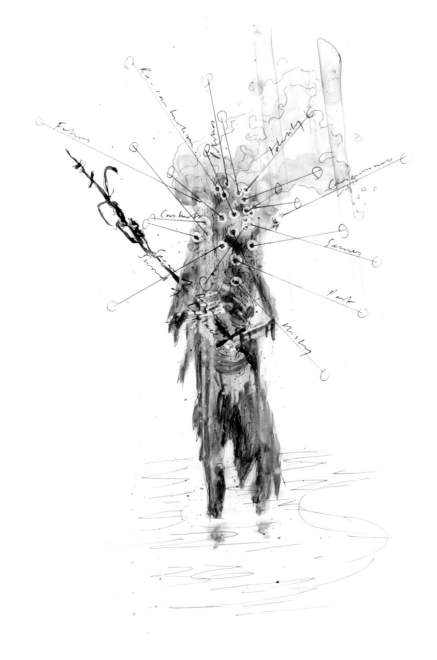

Elector Tubiana II

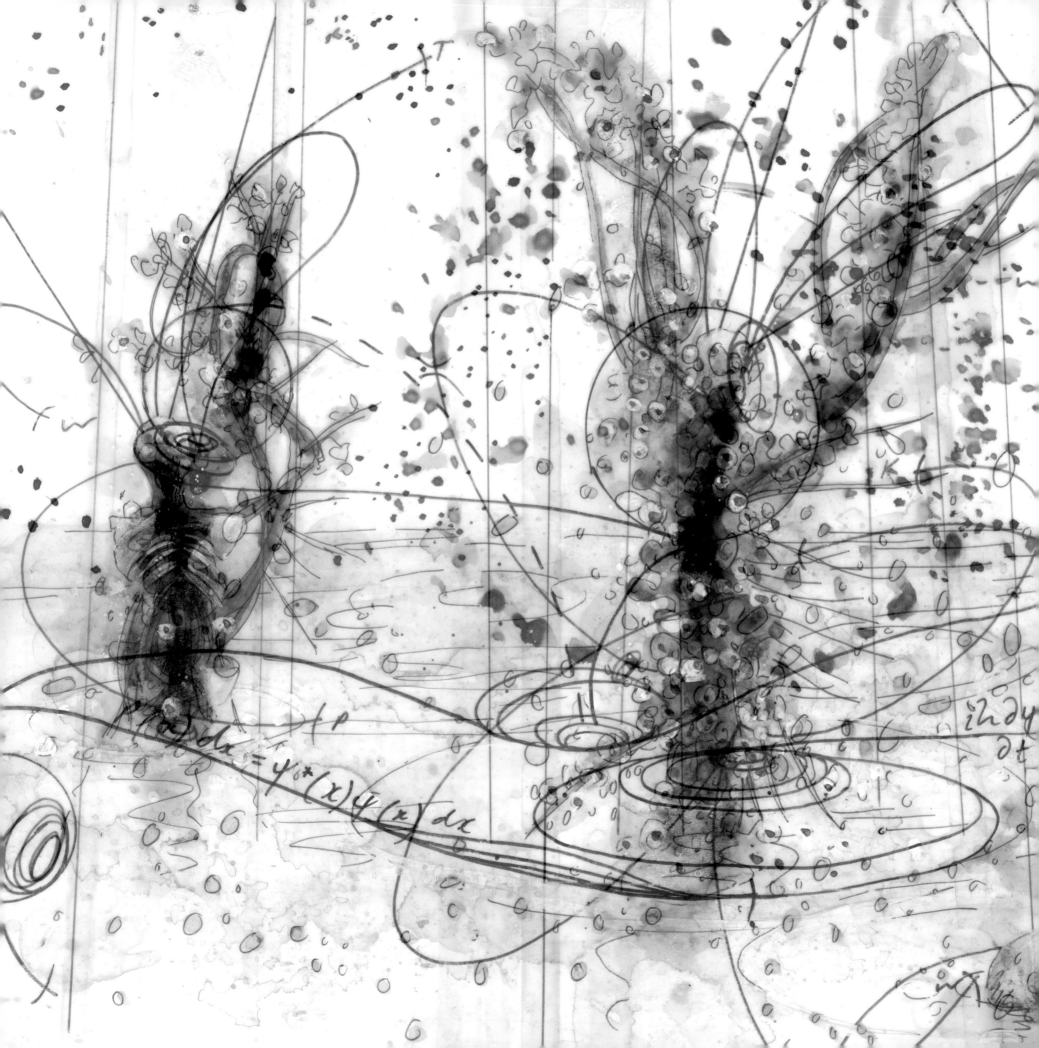

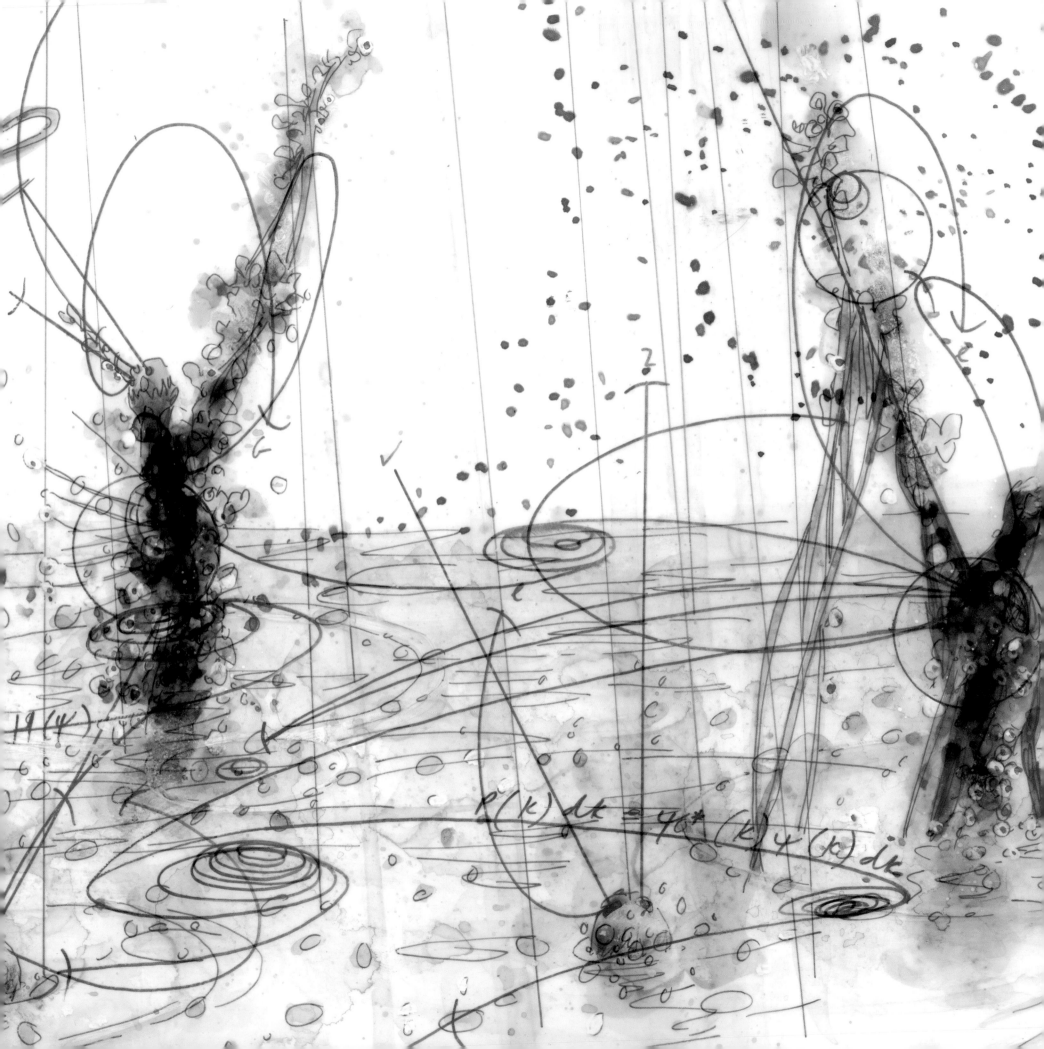

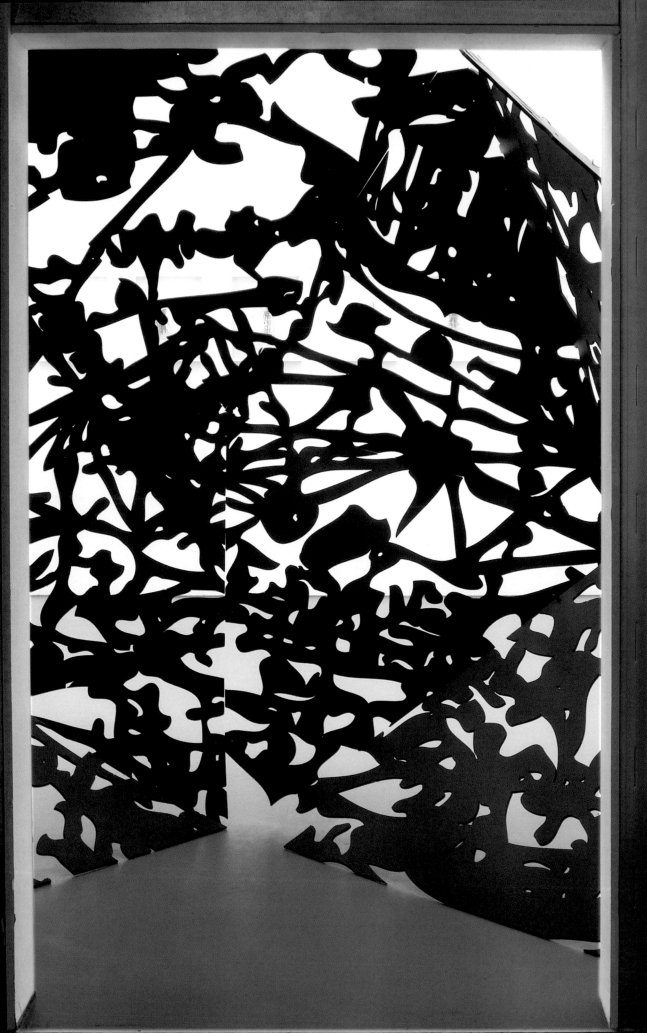

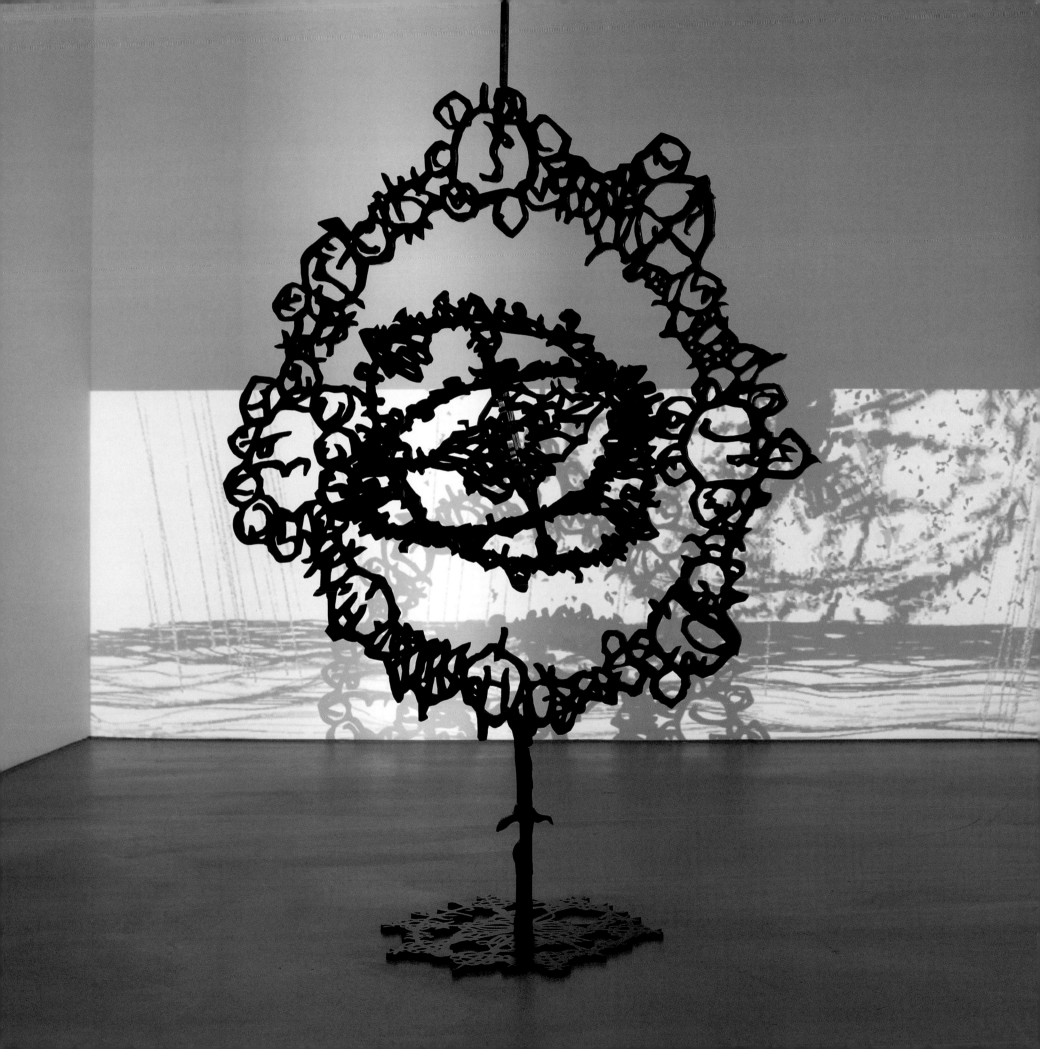

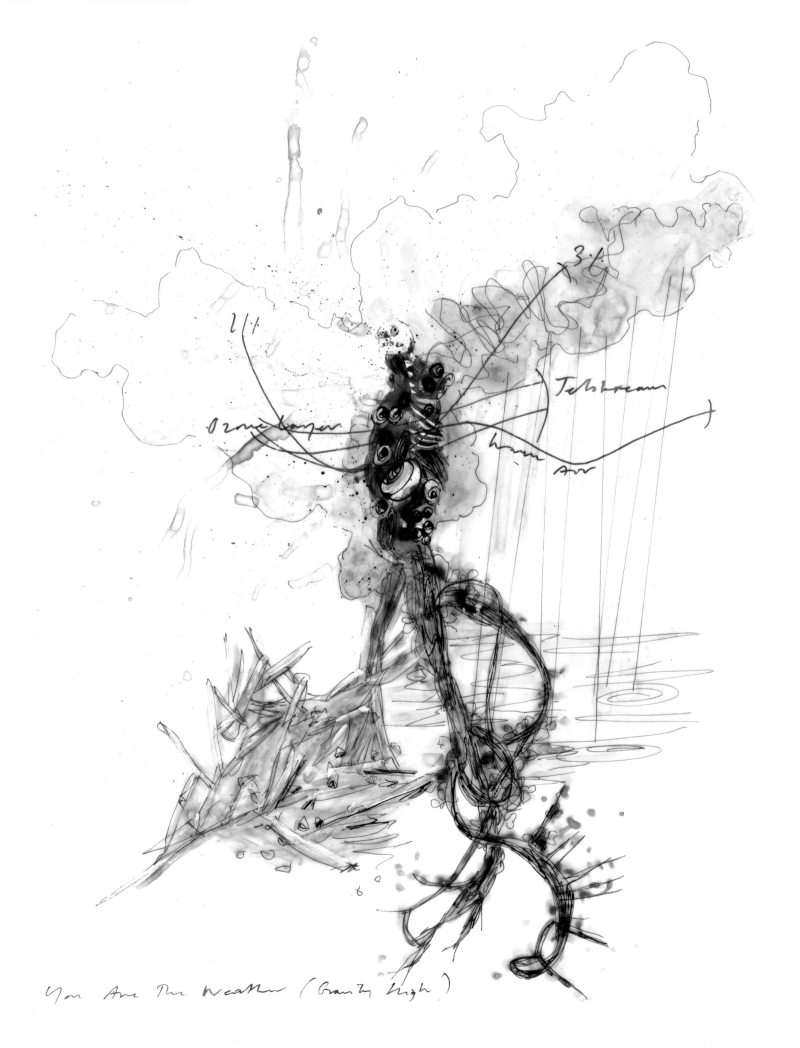

Ozone layer Jetstream Warm Air

You Are The Weather (Gravity High)

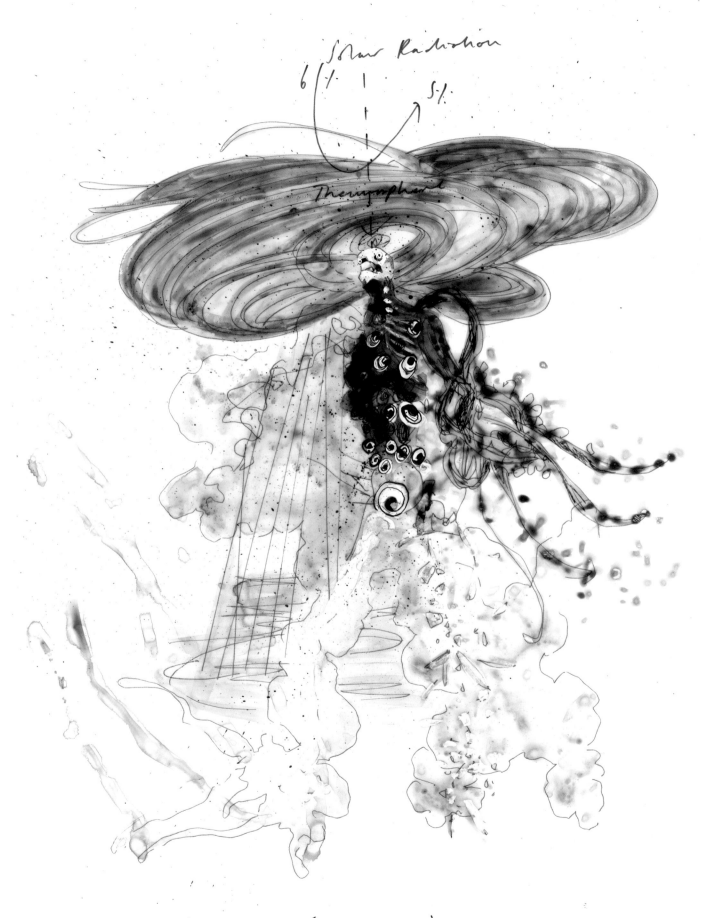

Carter Scholz

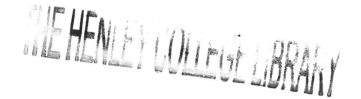

Rectangle in air filled with perpetual static of lightning. Onesided portal thin as a blade with no back to it. Countless uncertain exits to this entrance. Exits across all theres all thens. Most thens not now. Most theres the void of space. Choose there not then or then not there or not there not then. Impossible to choose some certain then some certain there. Branches of lightning come and go too quickly. Tongues of fire lick all possibility alive all theres all thens available till the last moment as the gate opens as all retracts to one point one there one then uncertain but inescapable entered before apprehended. As though all possibility came to annihilation at the crux of every moment the universe collapsed upon itself to restart in perpetual static of lightning.

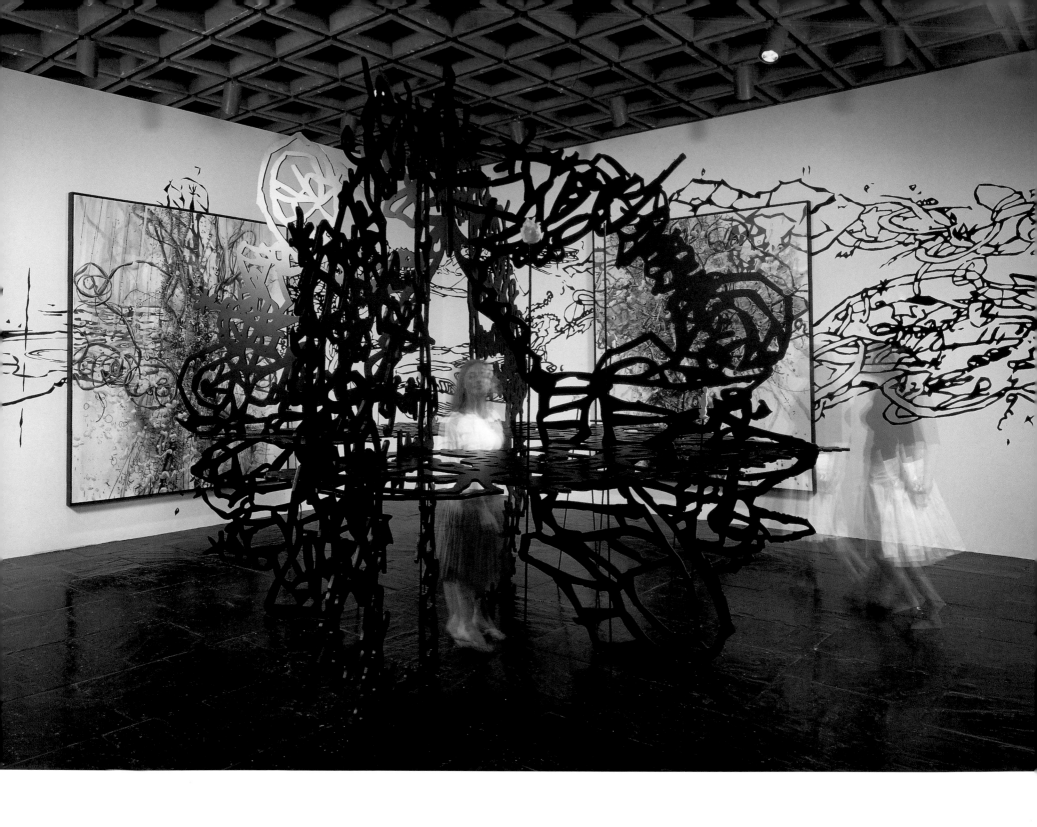

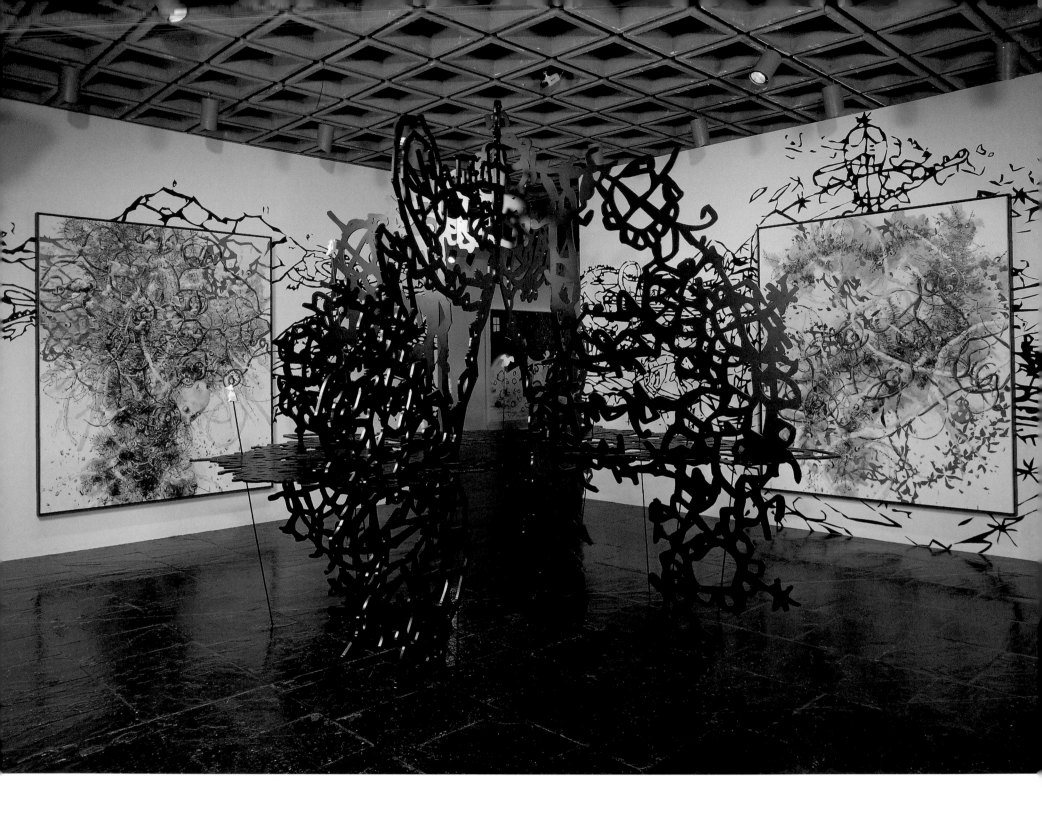

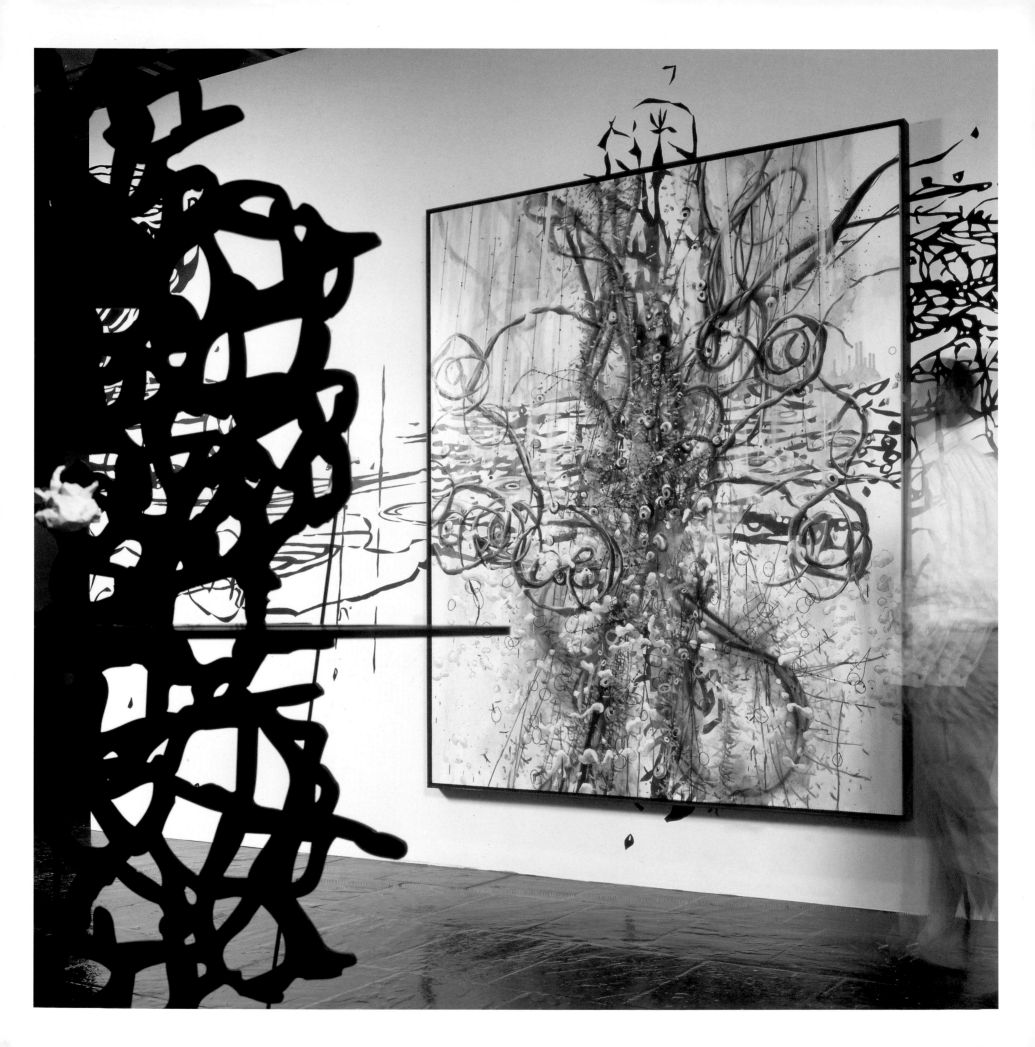

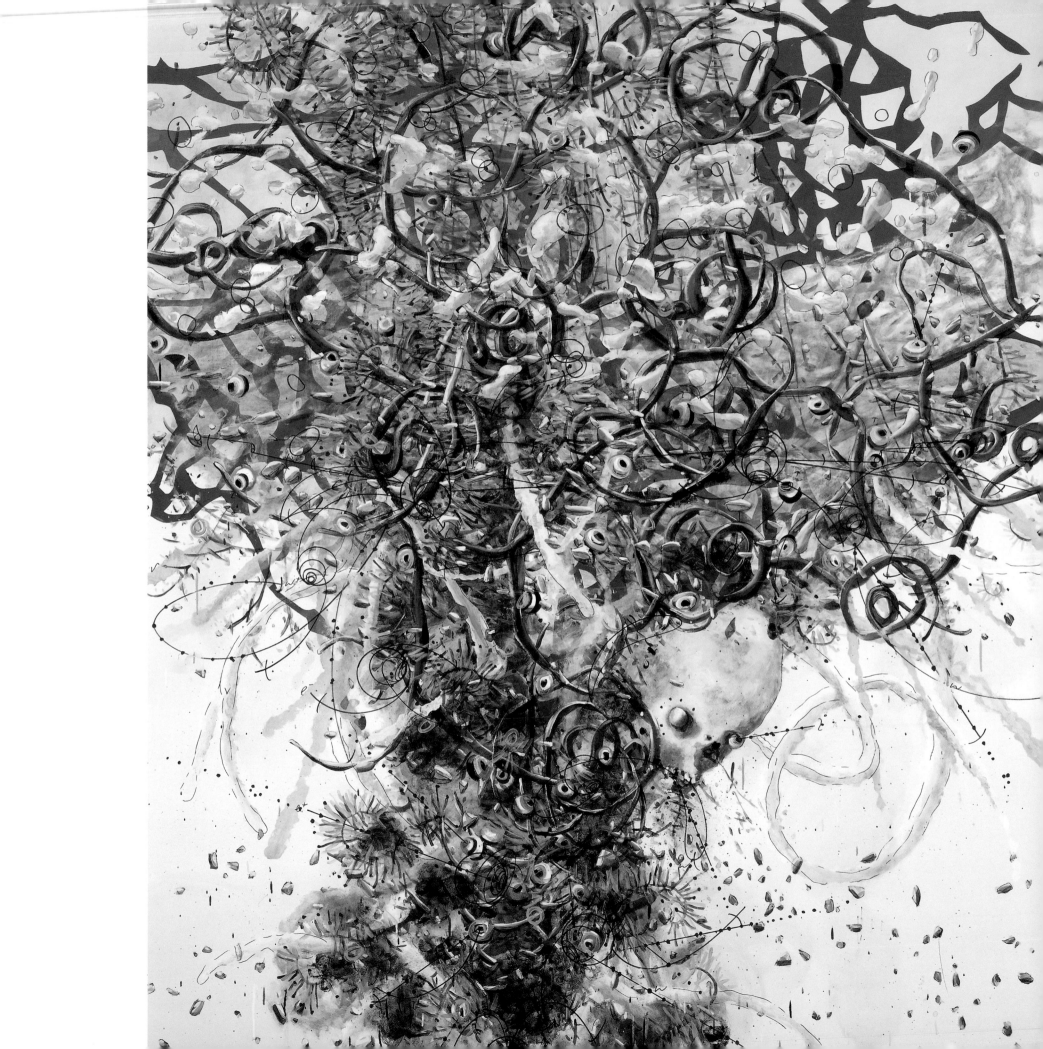

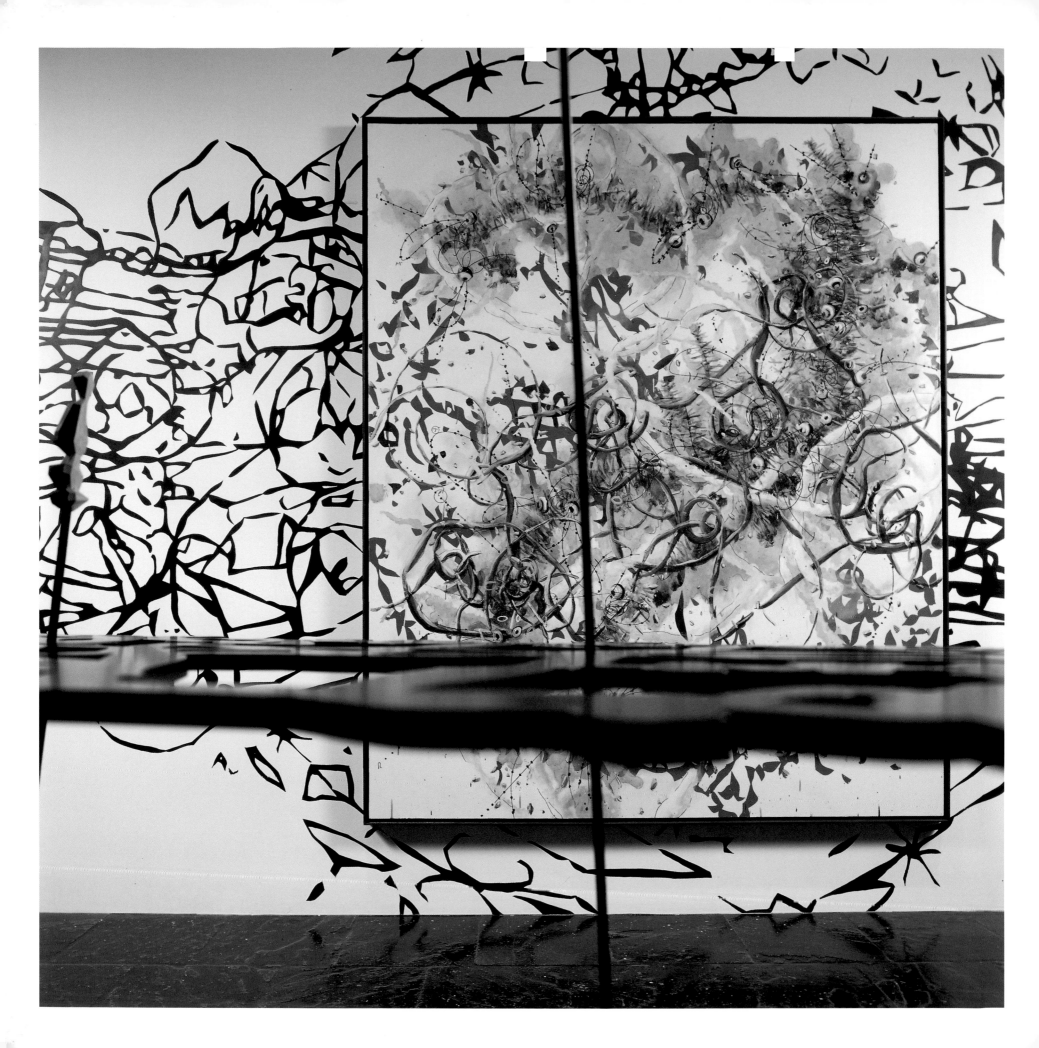

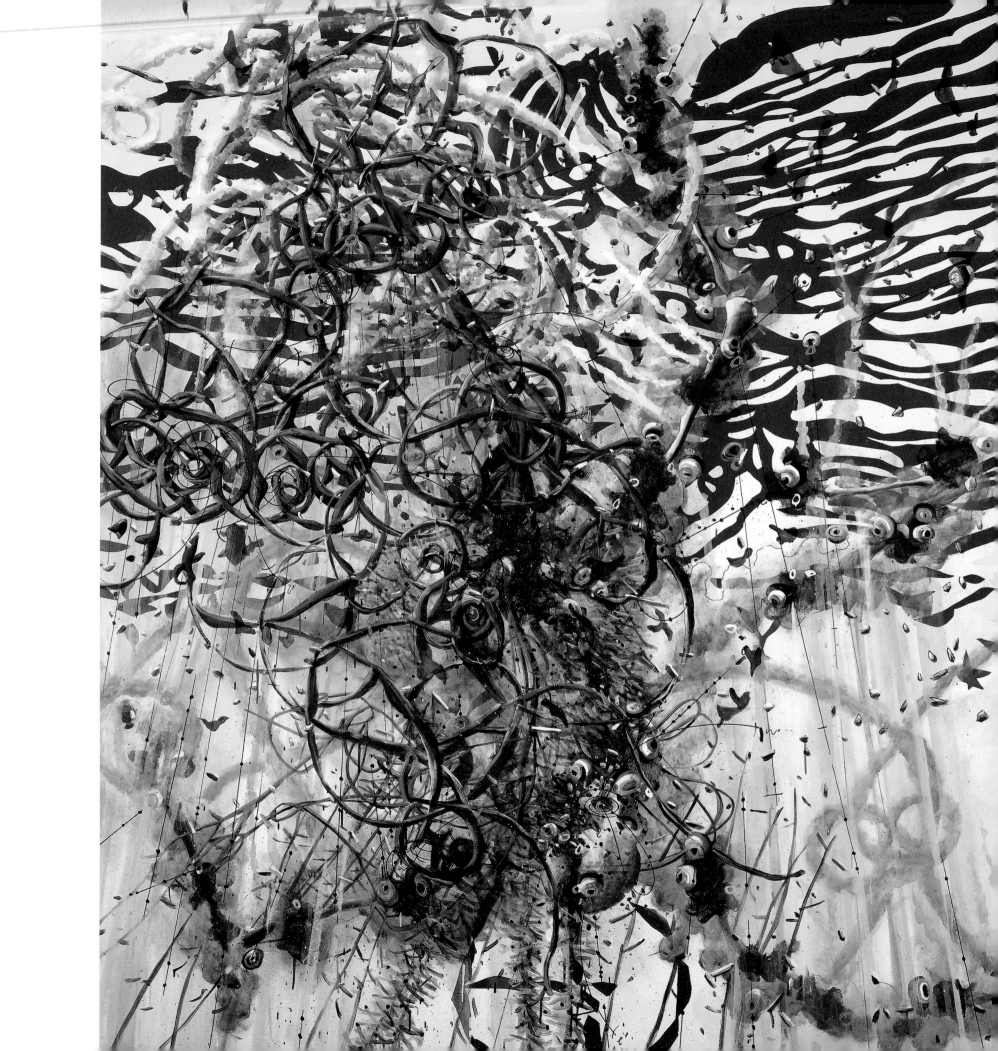

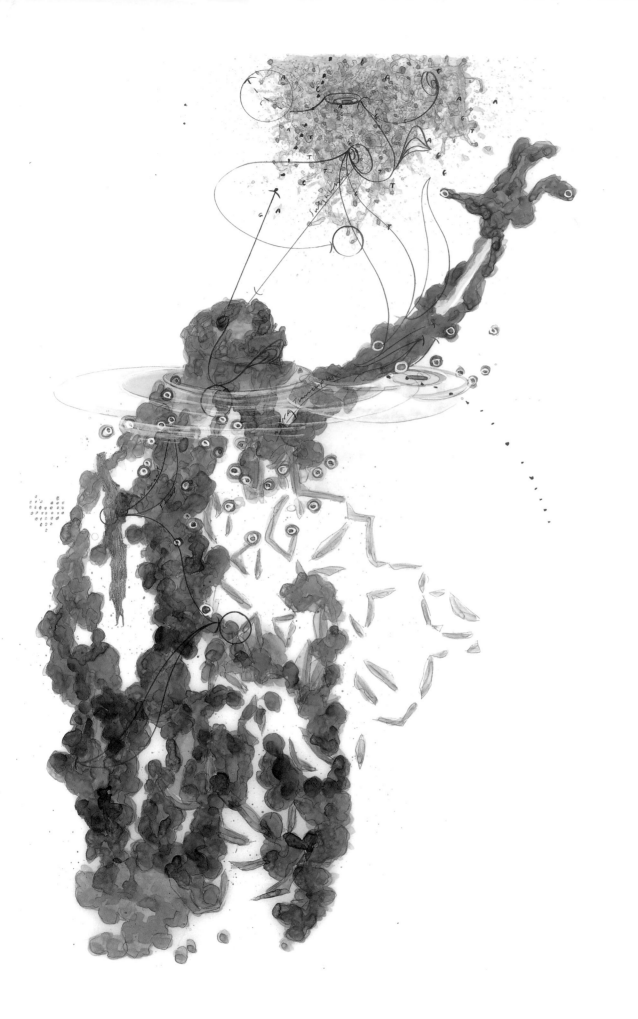

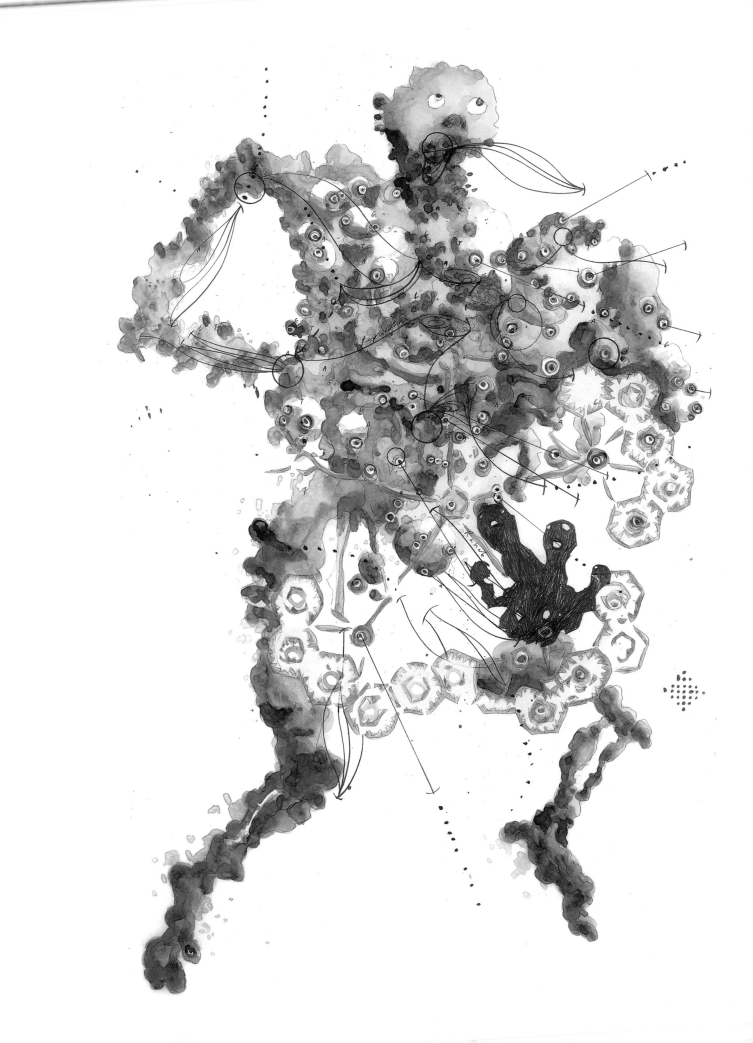

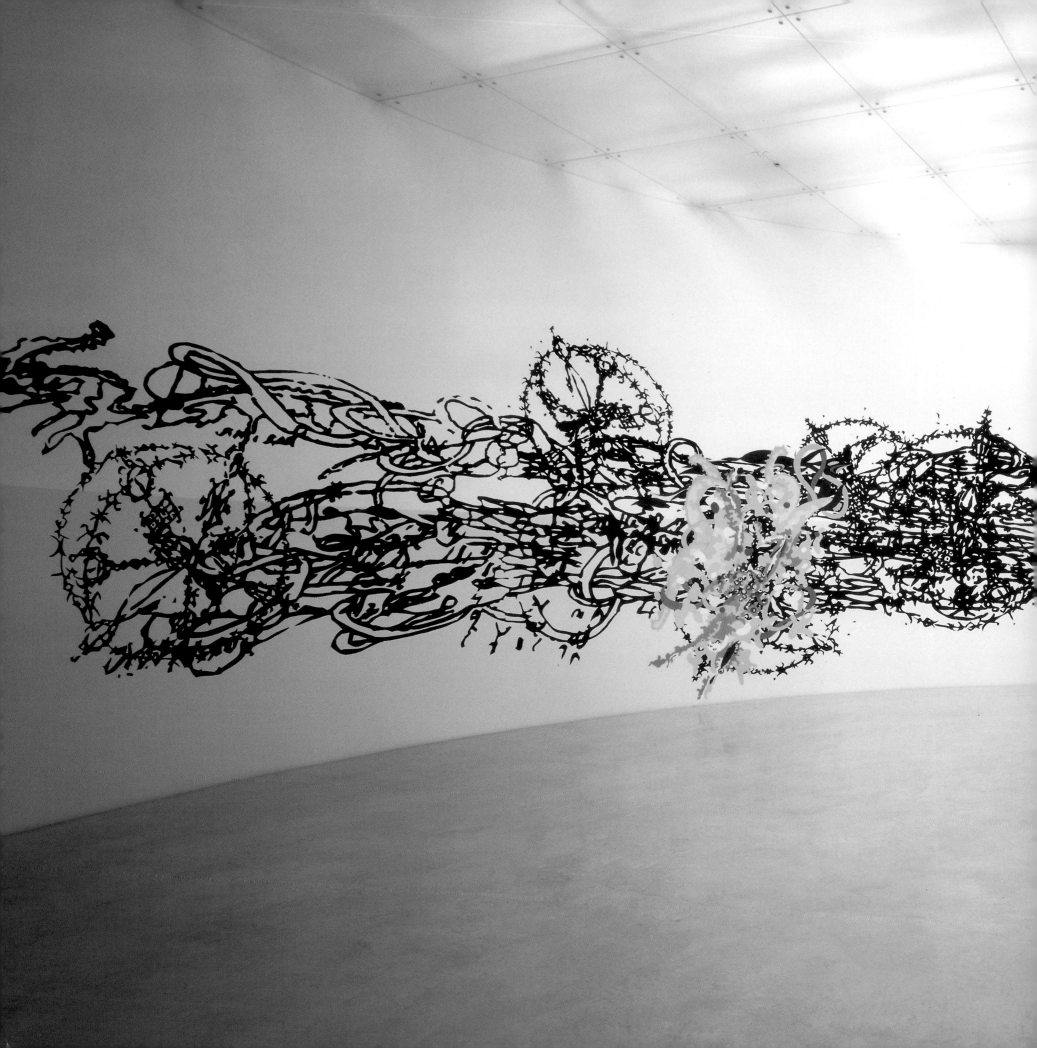

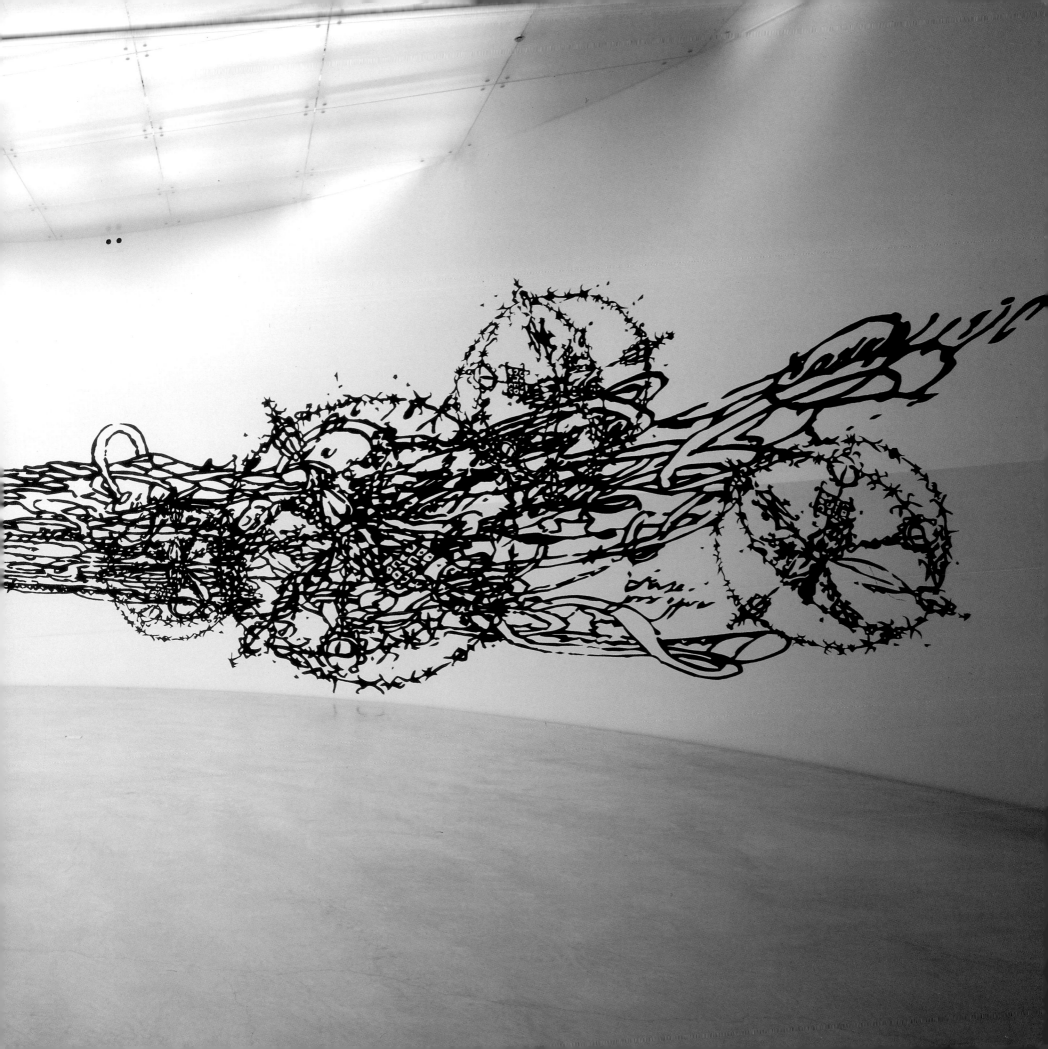

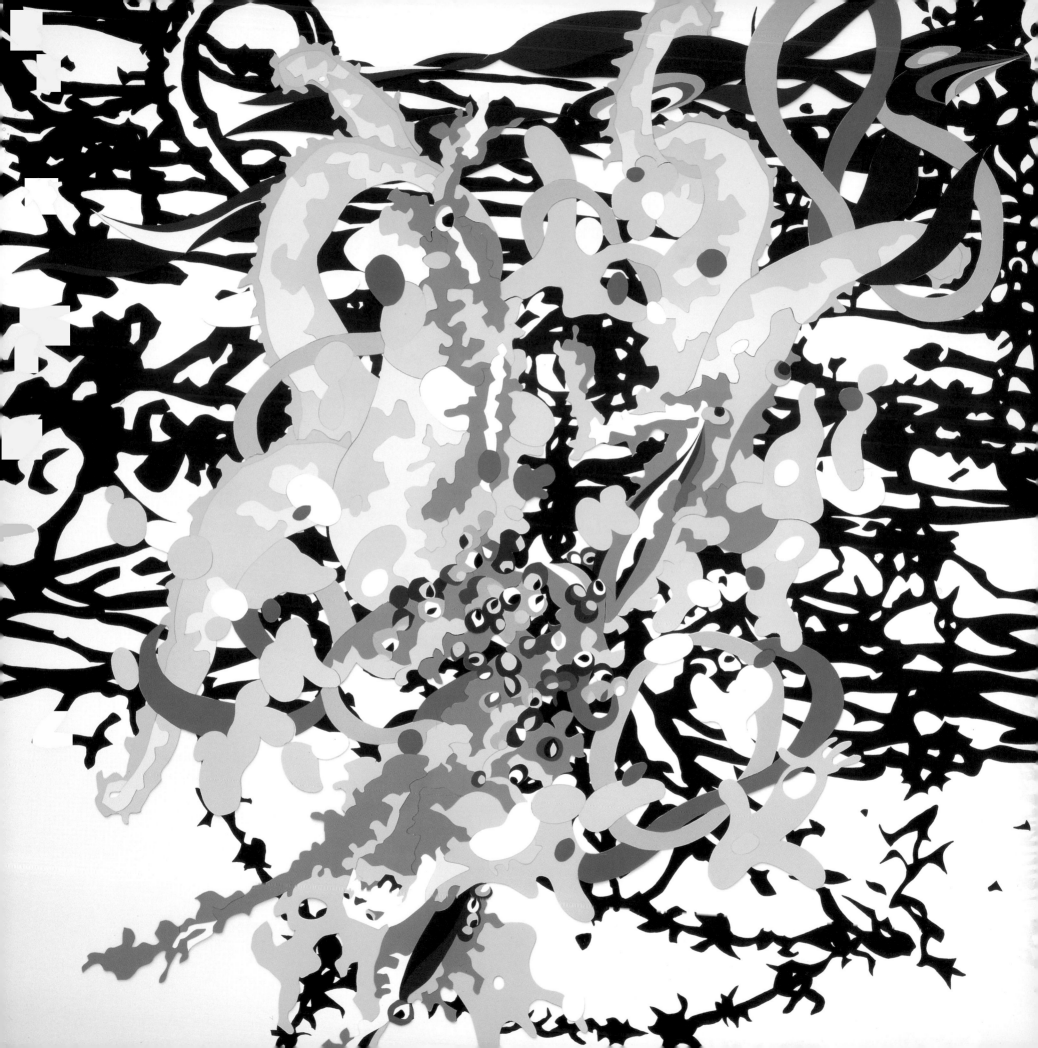

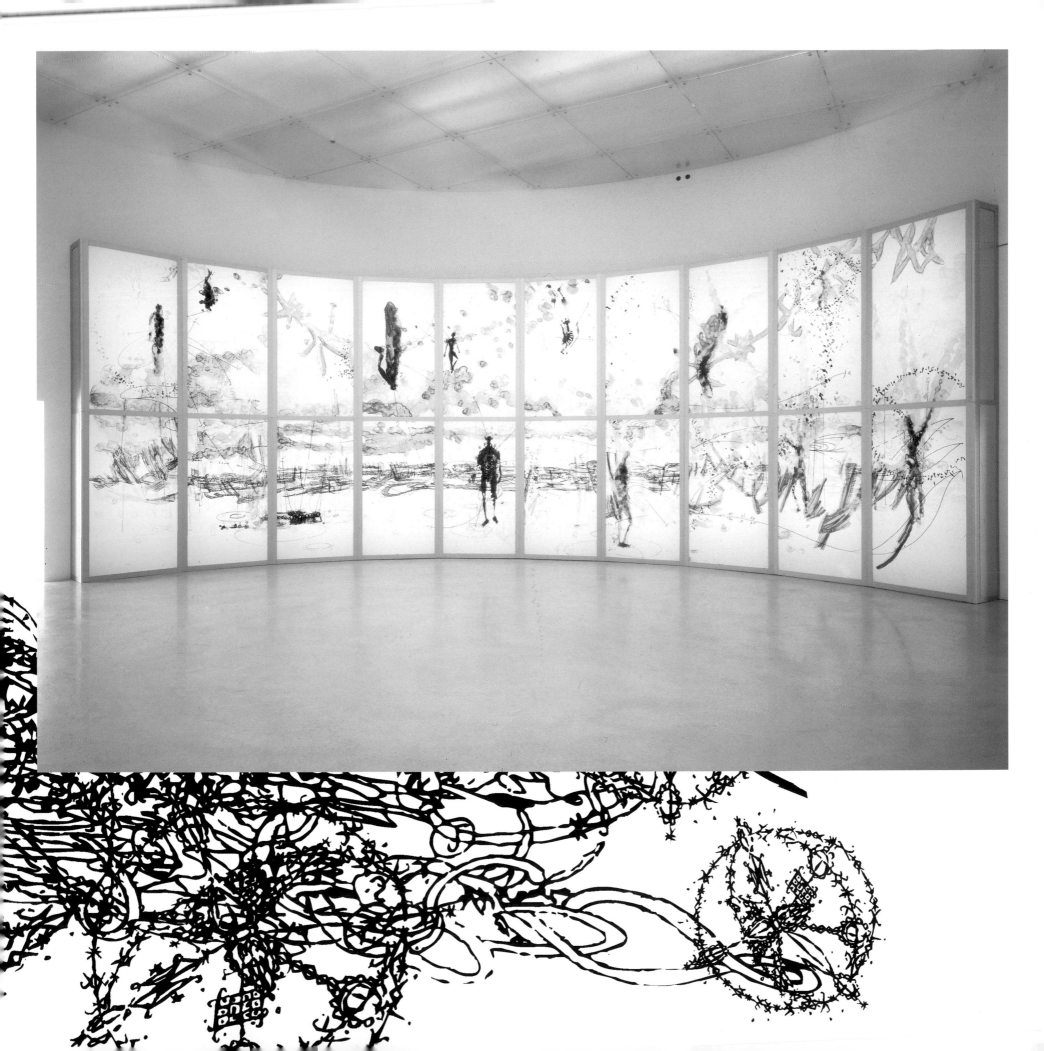

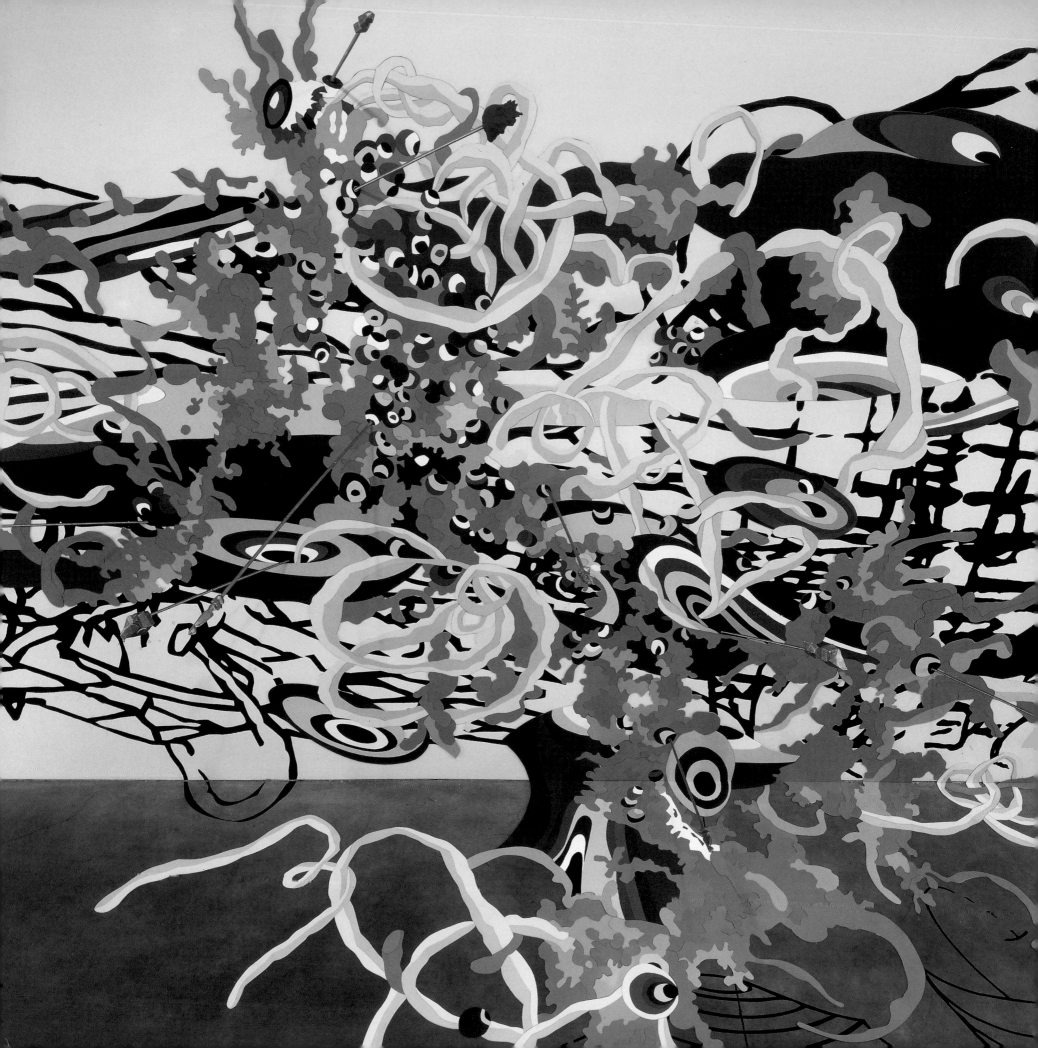

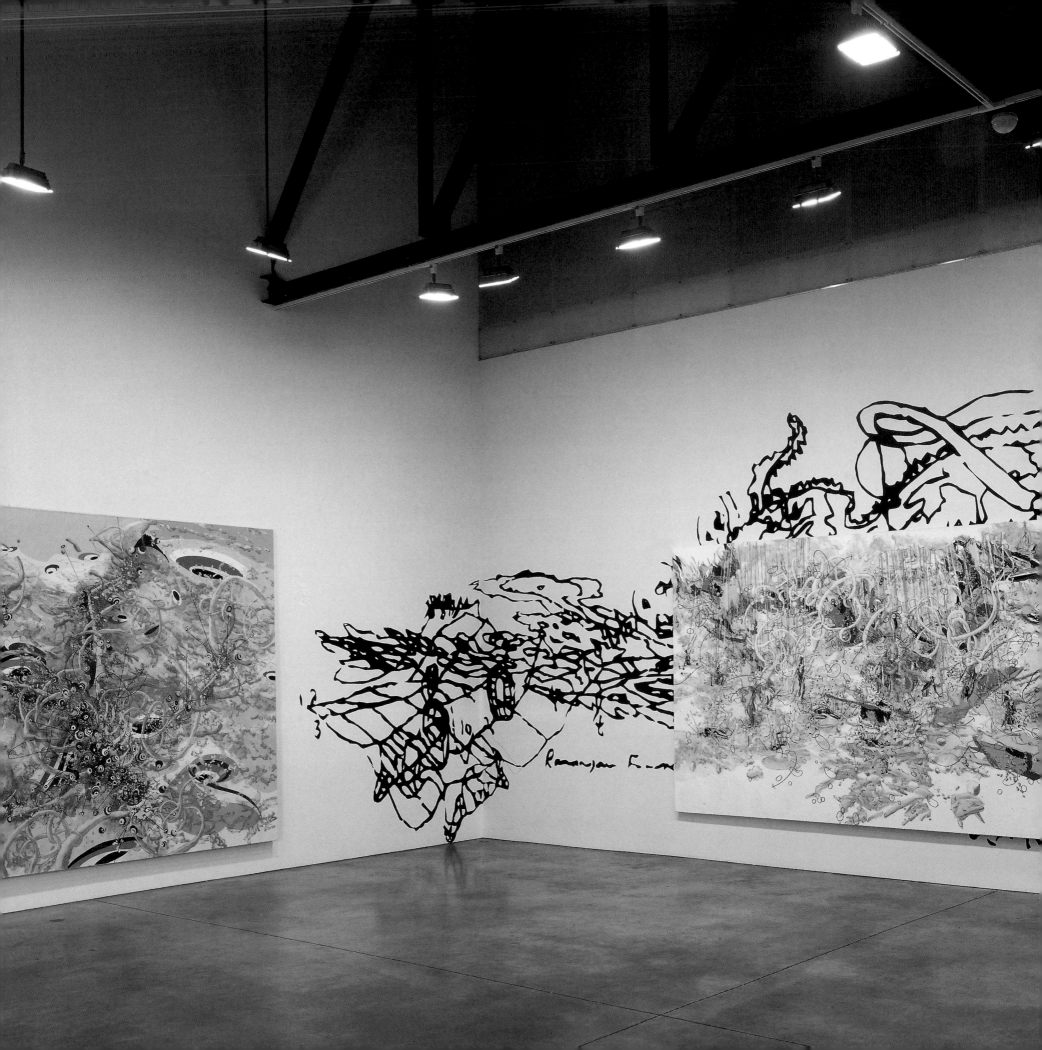

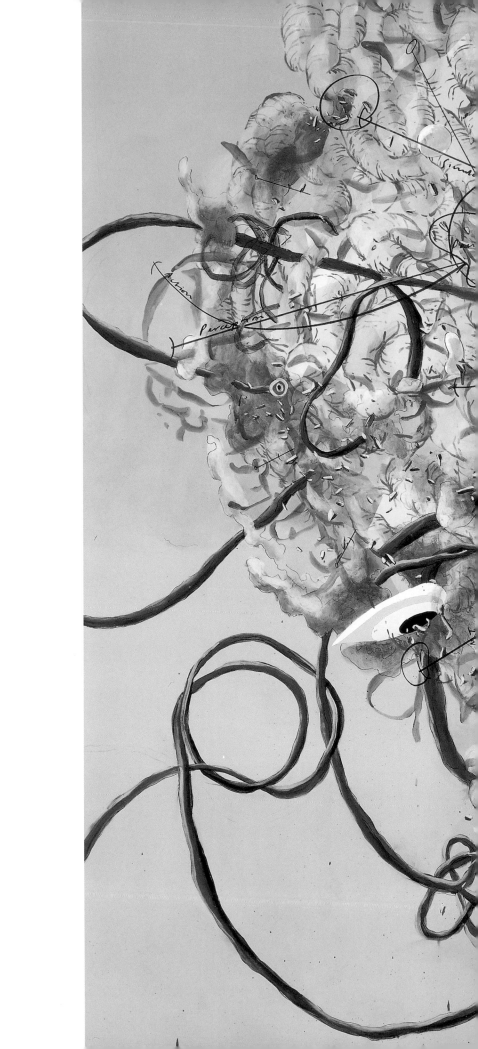

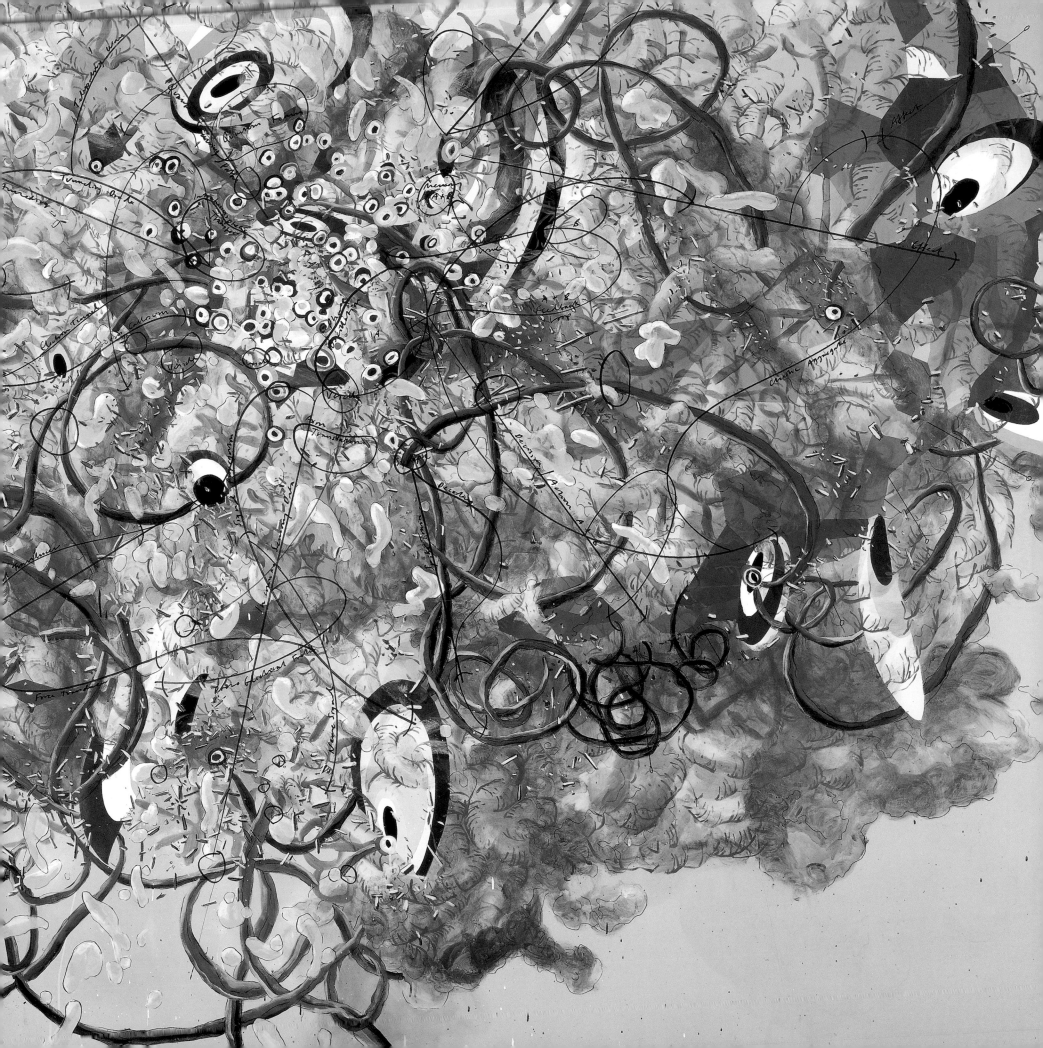

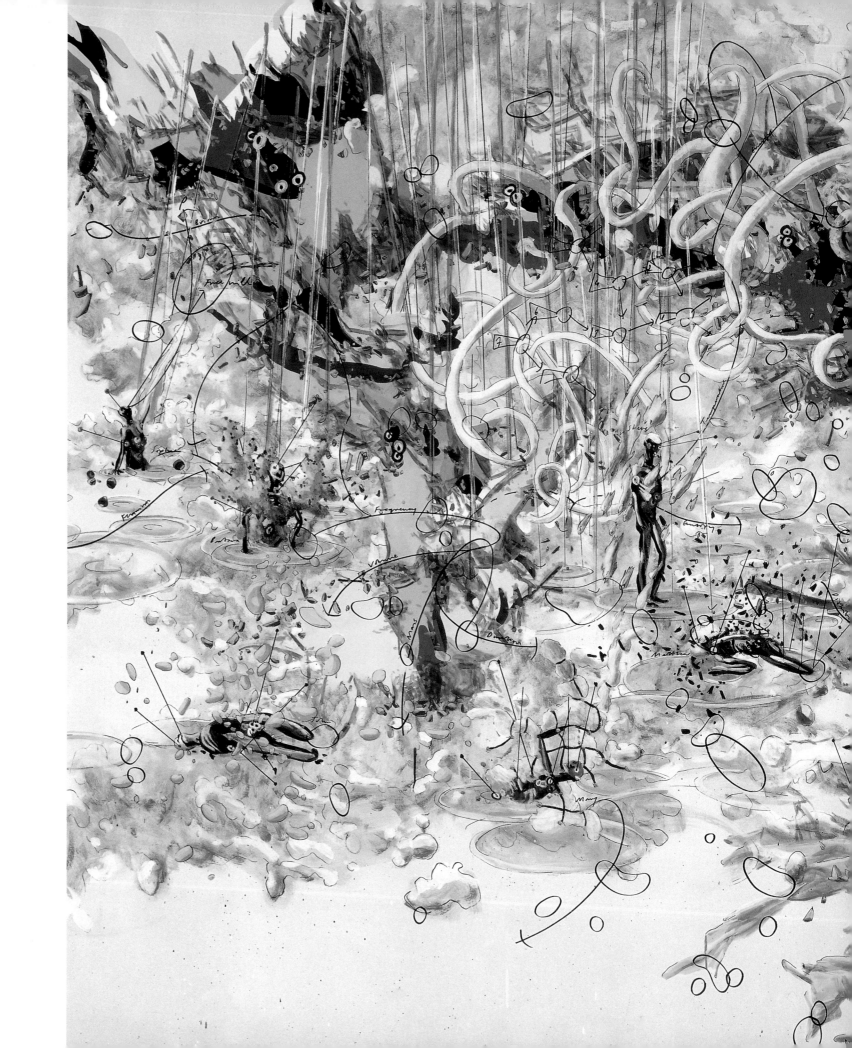

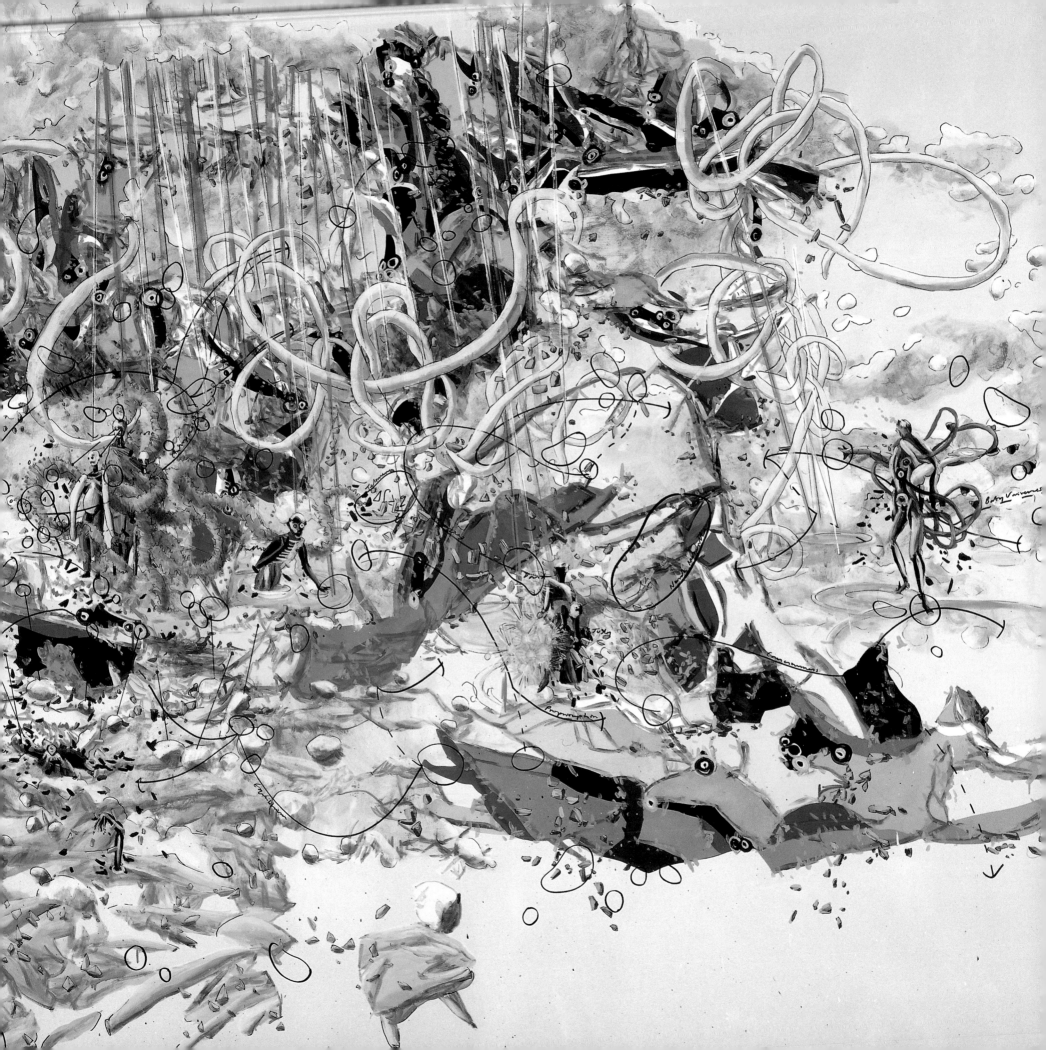

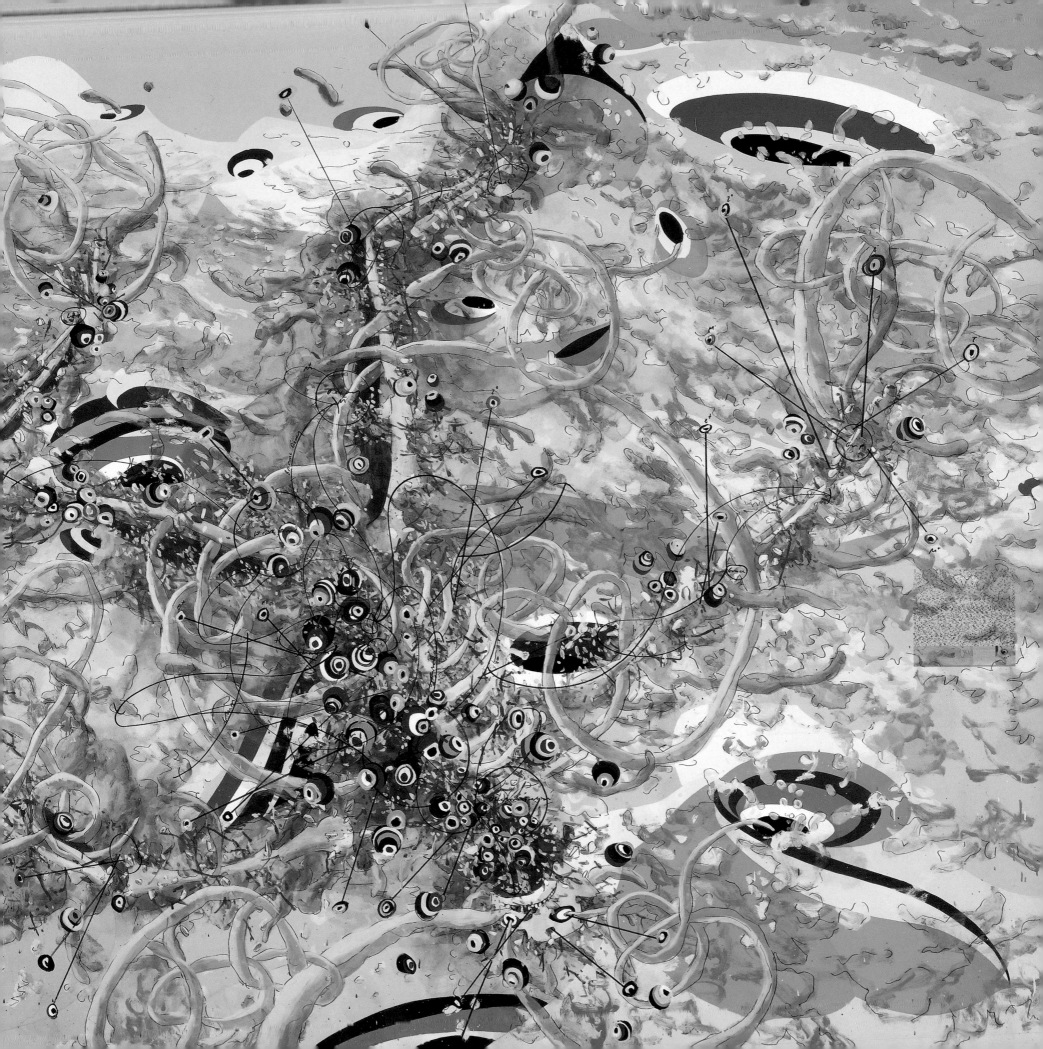

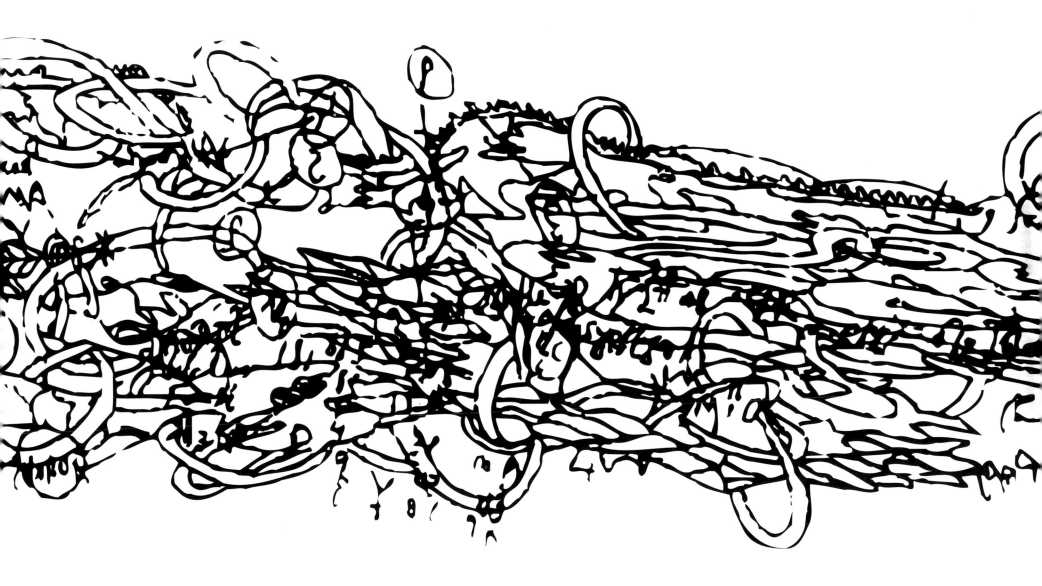

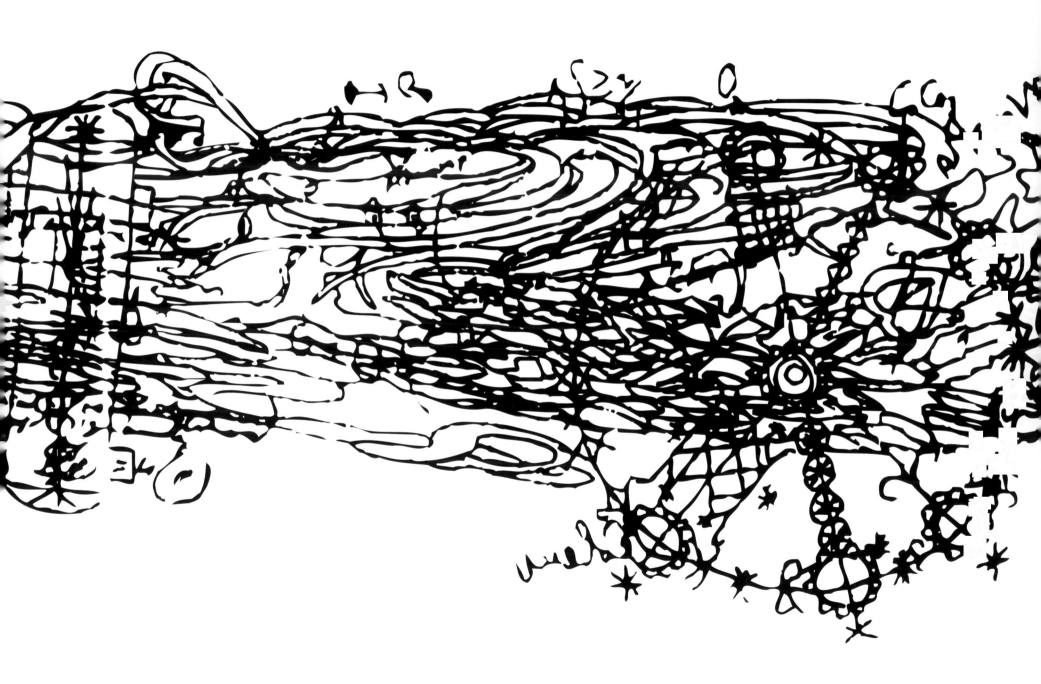

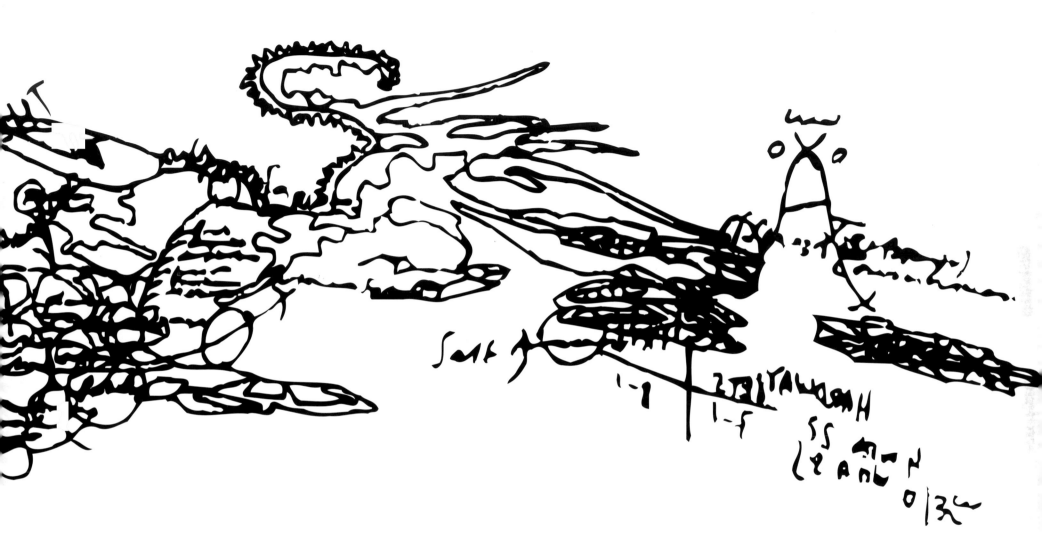

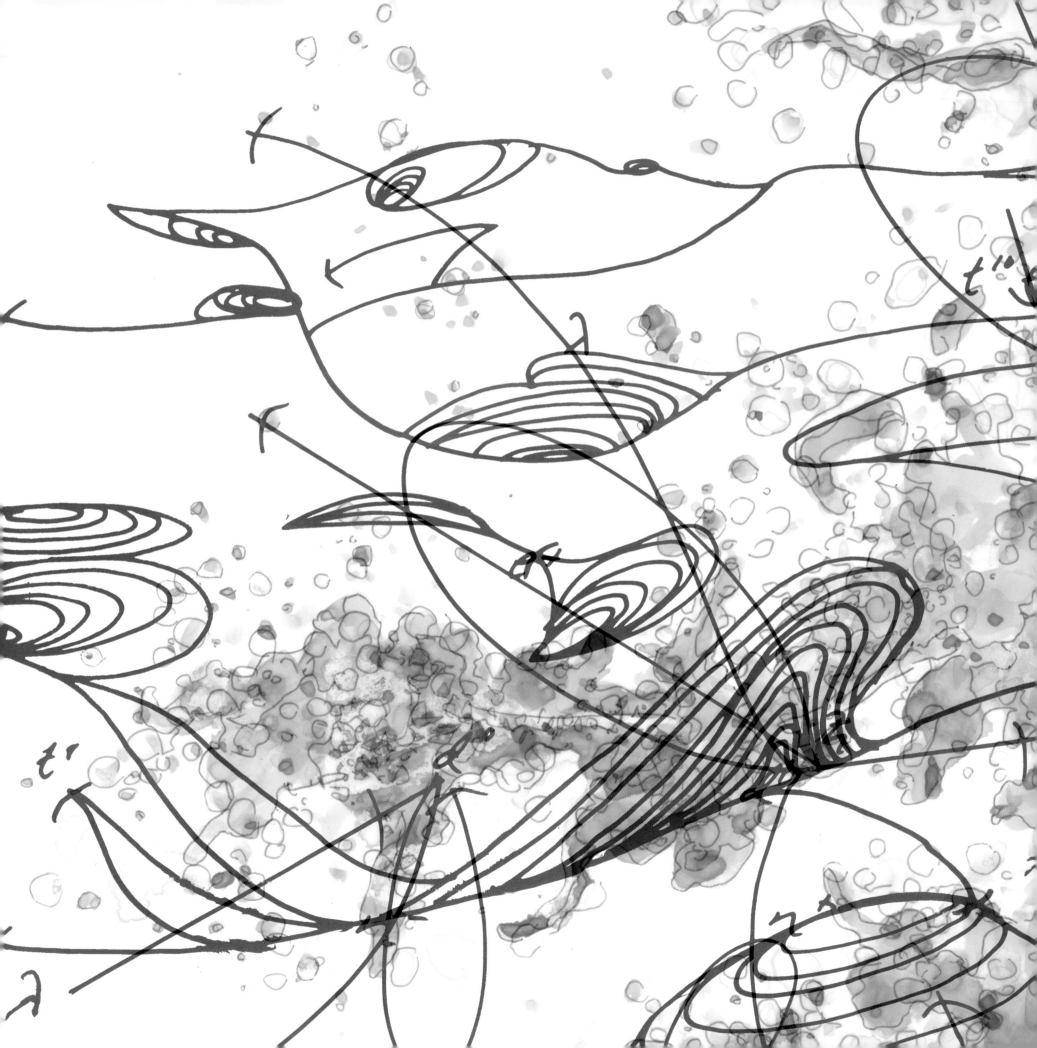

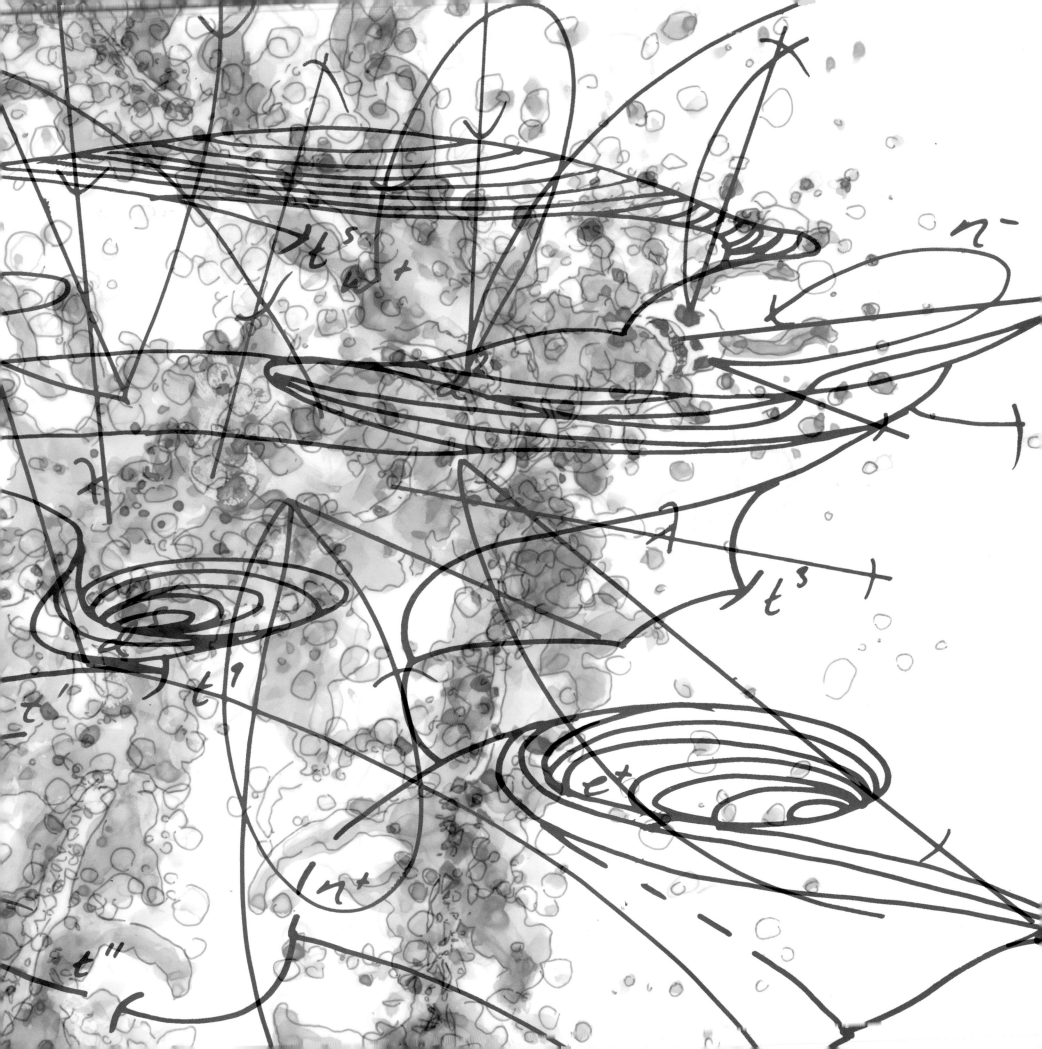

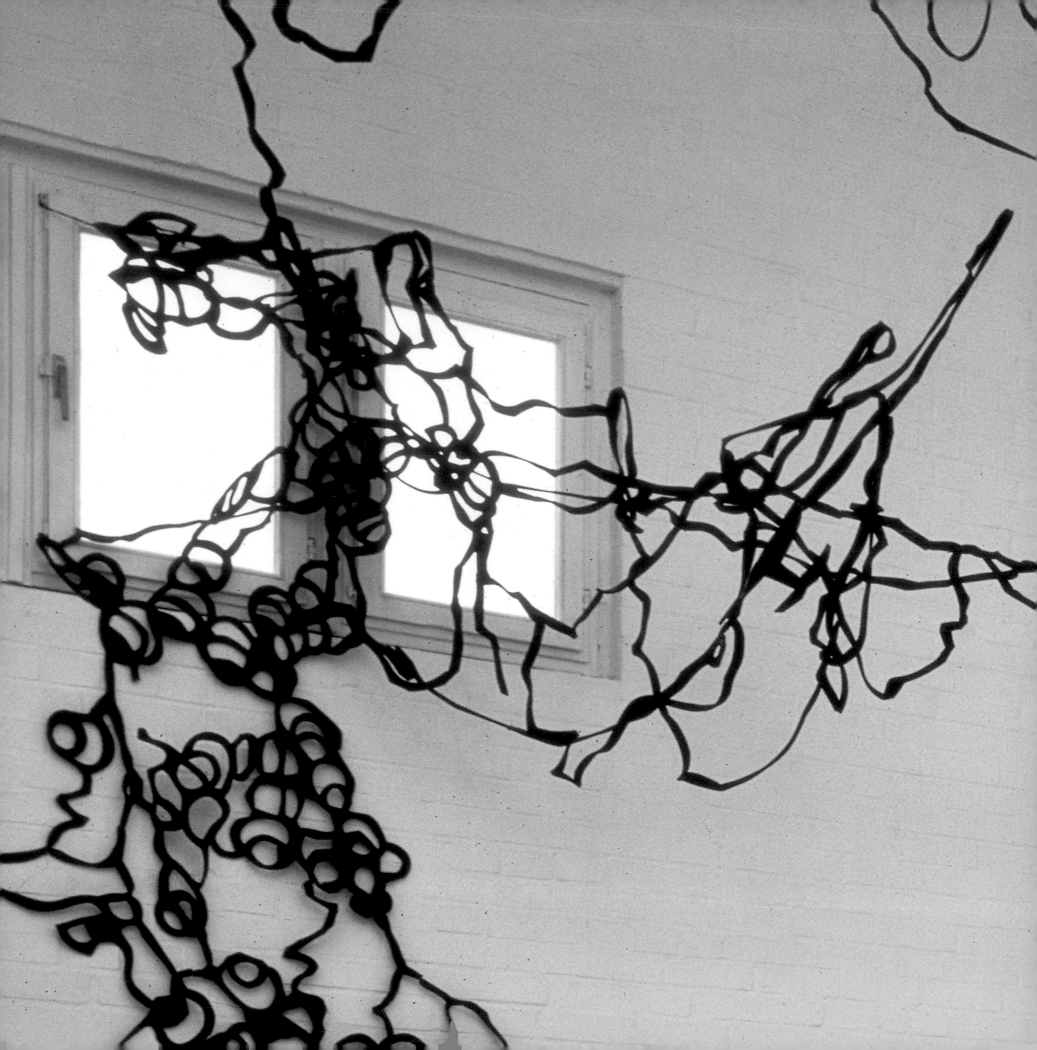

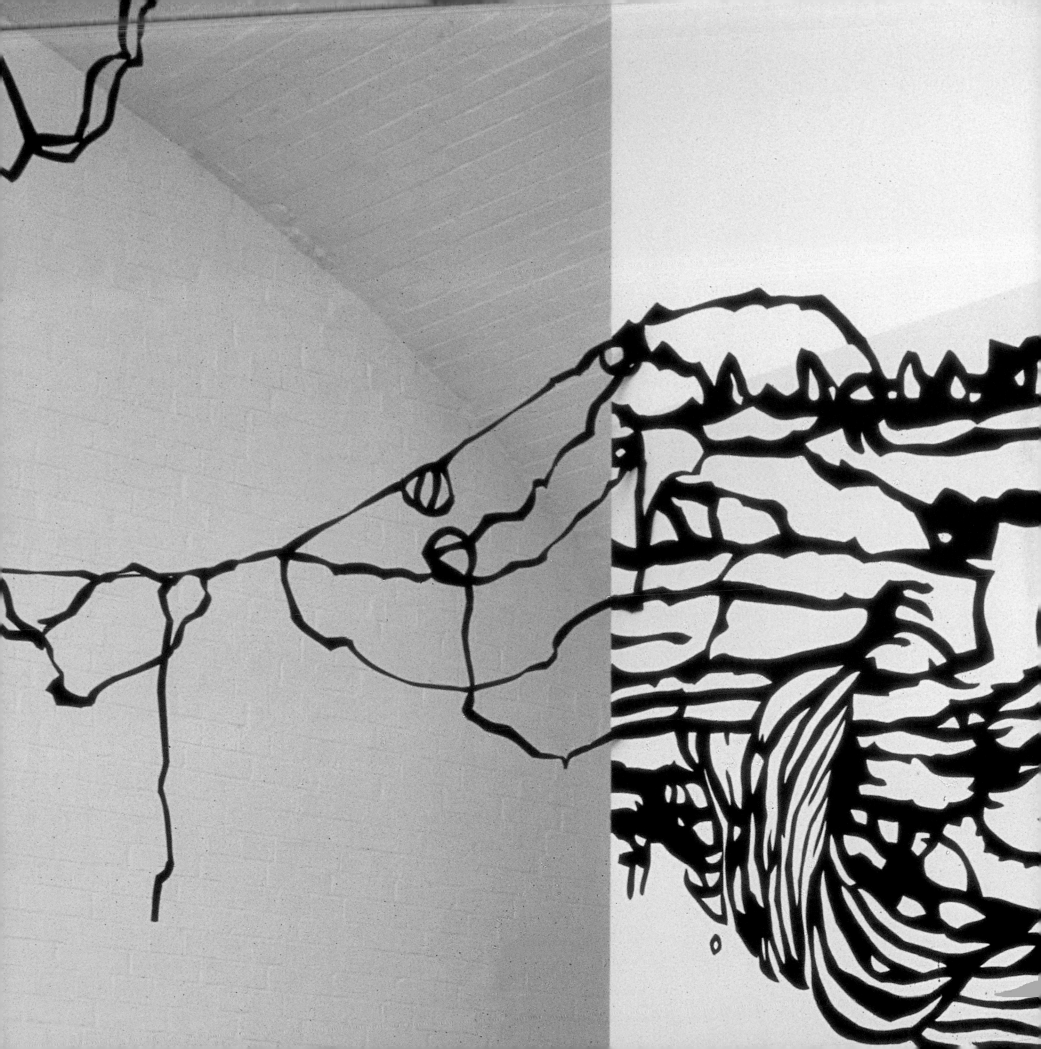

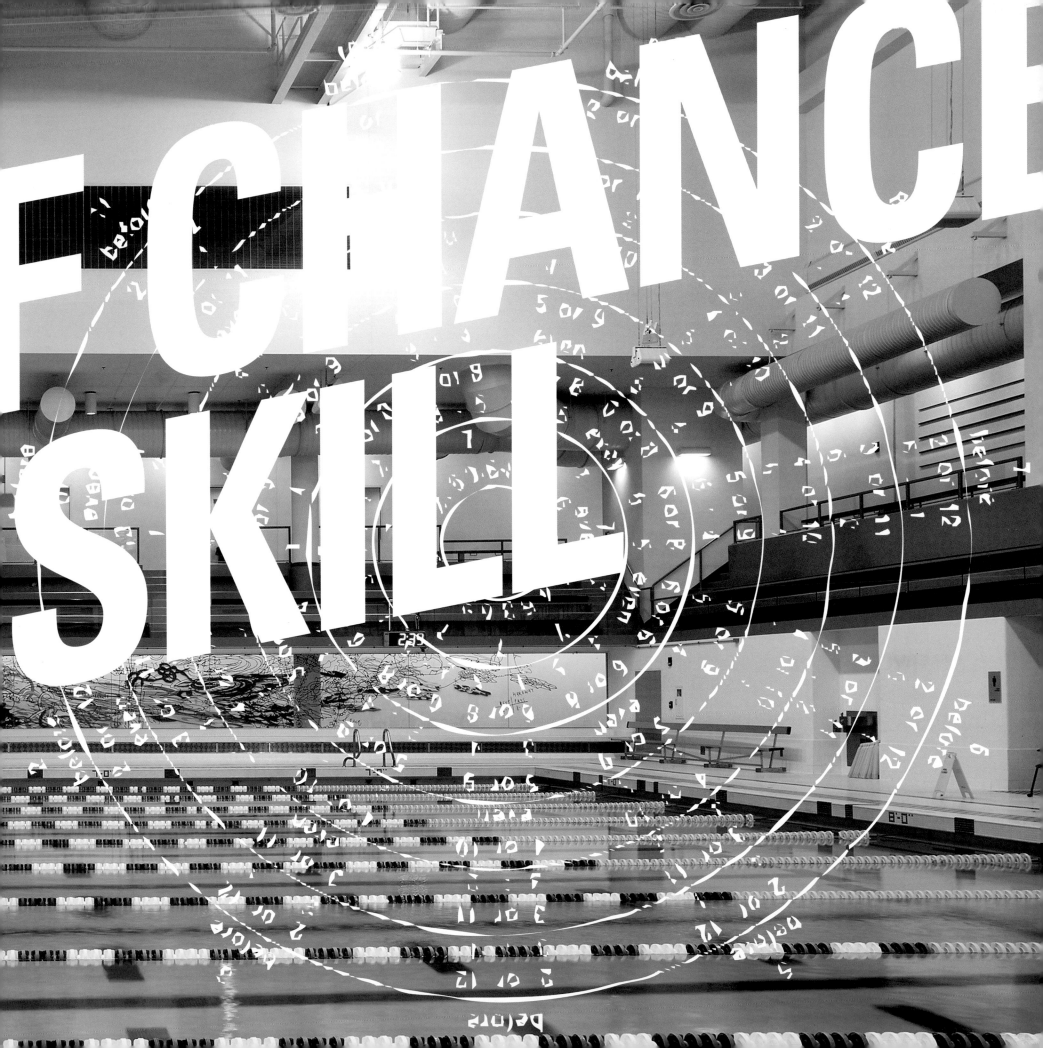

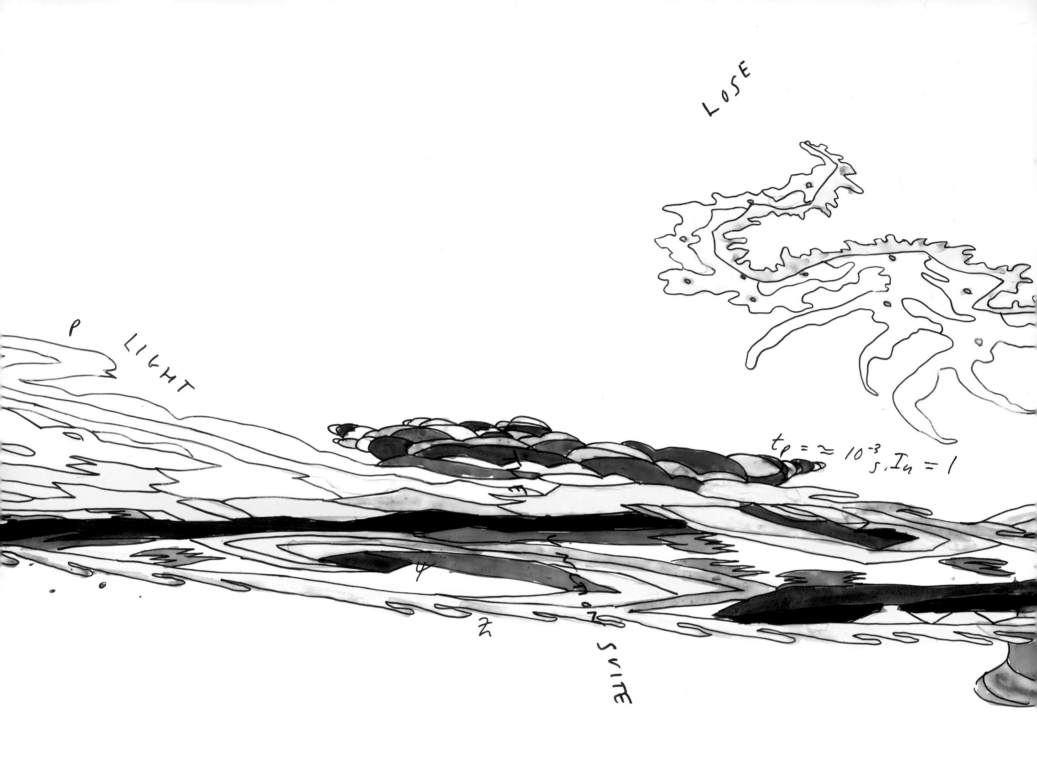

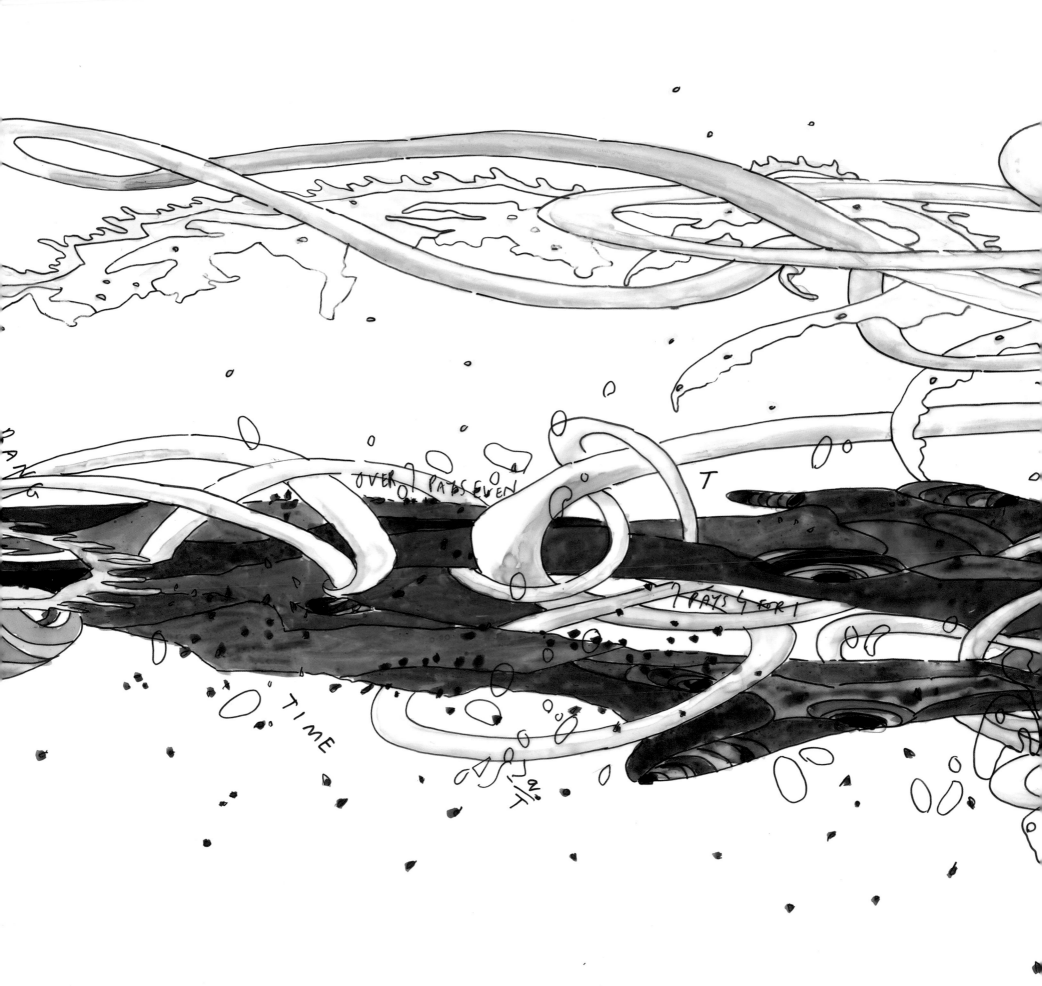

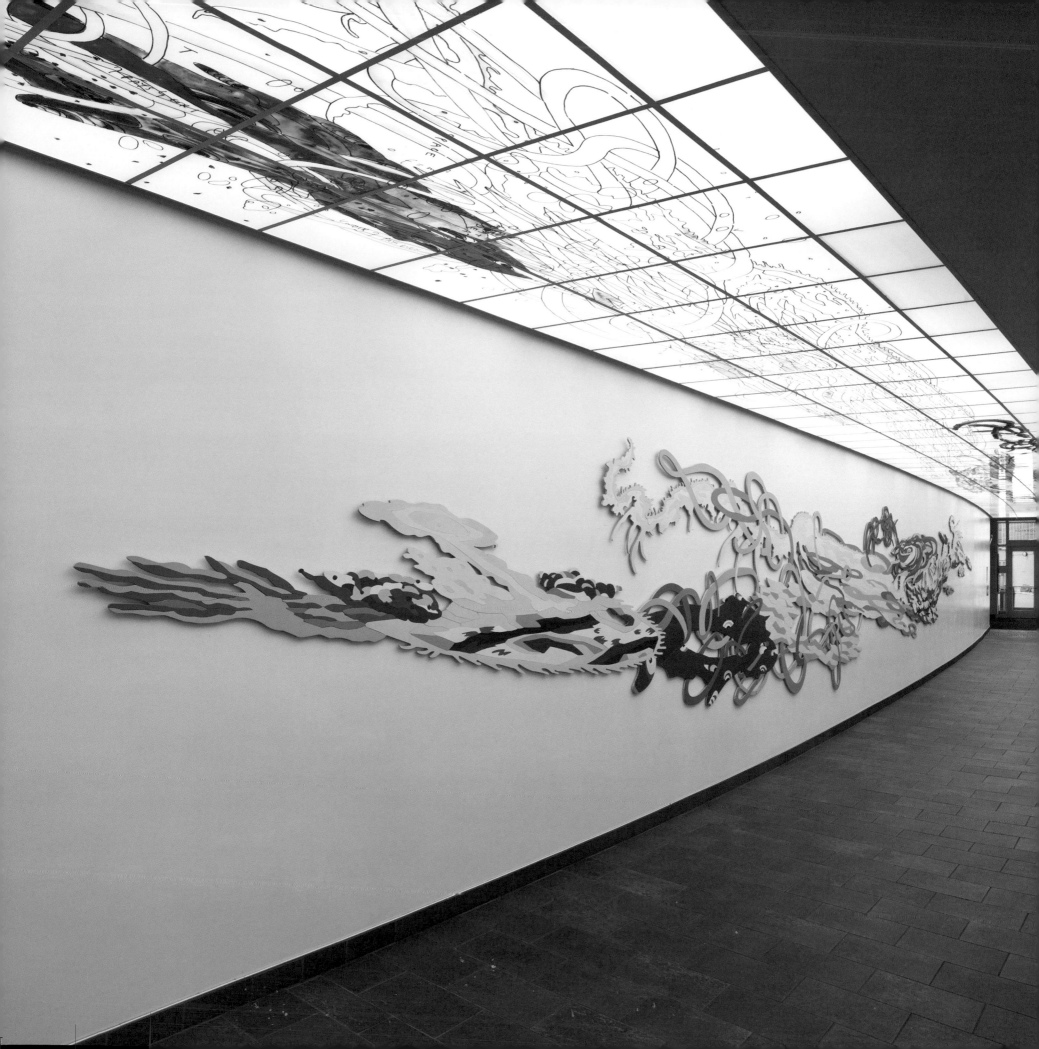

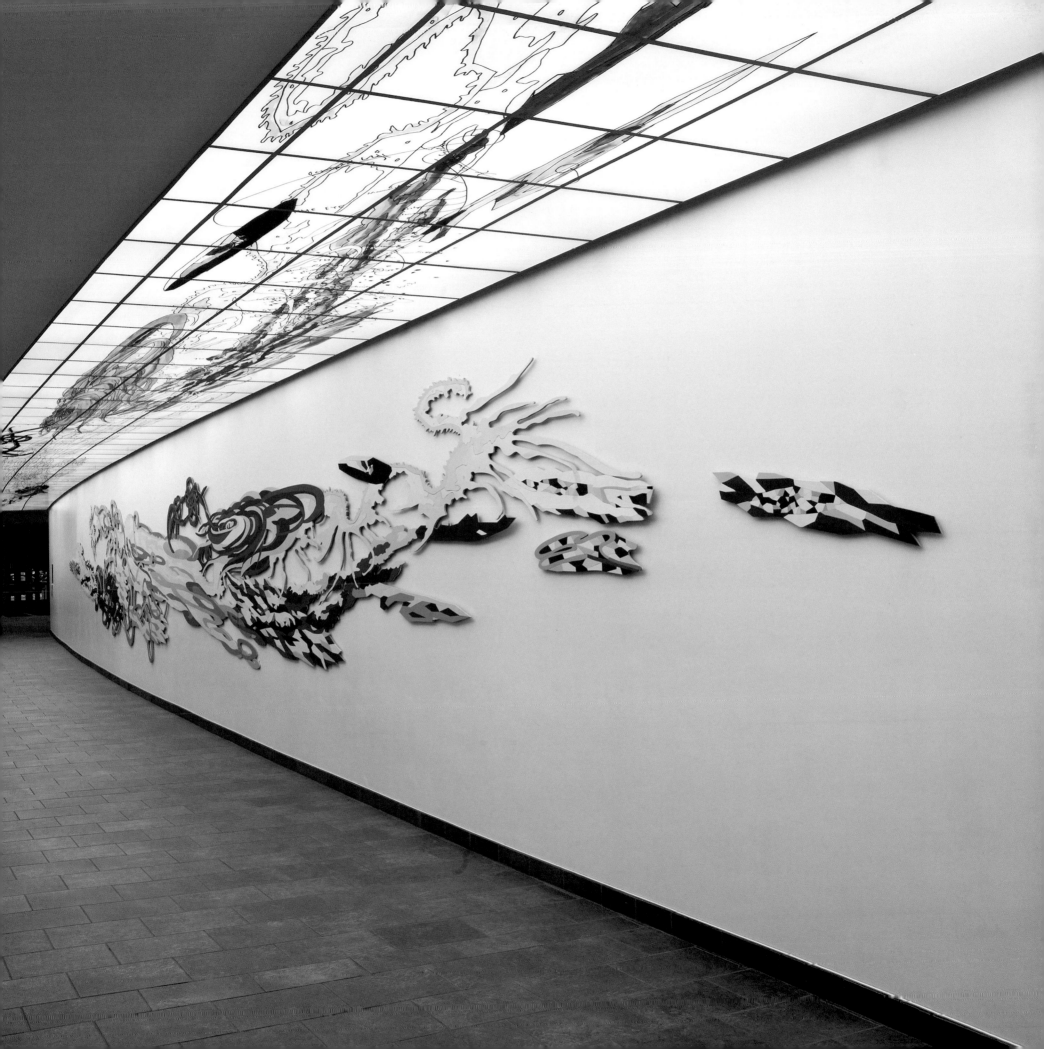

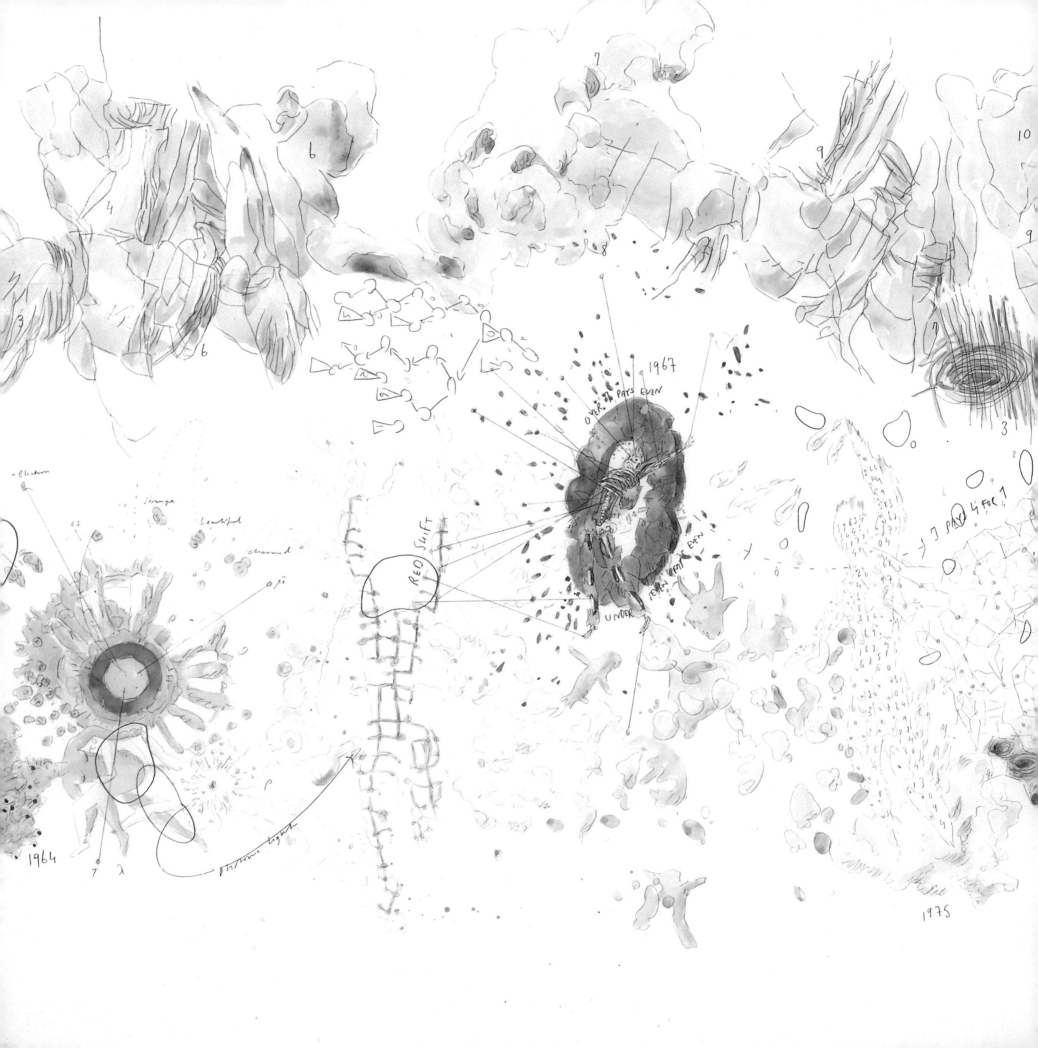

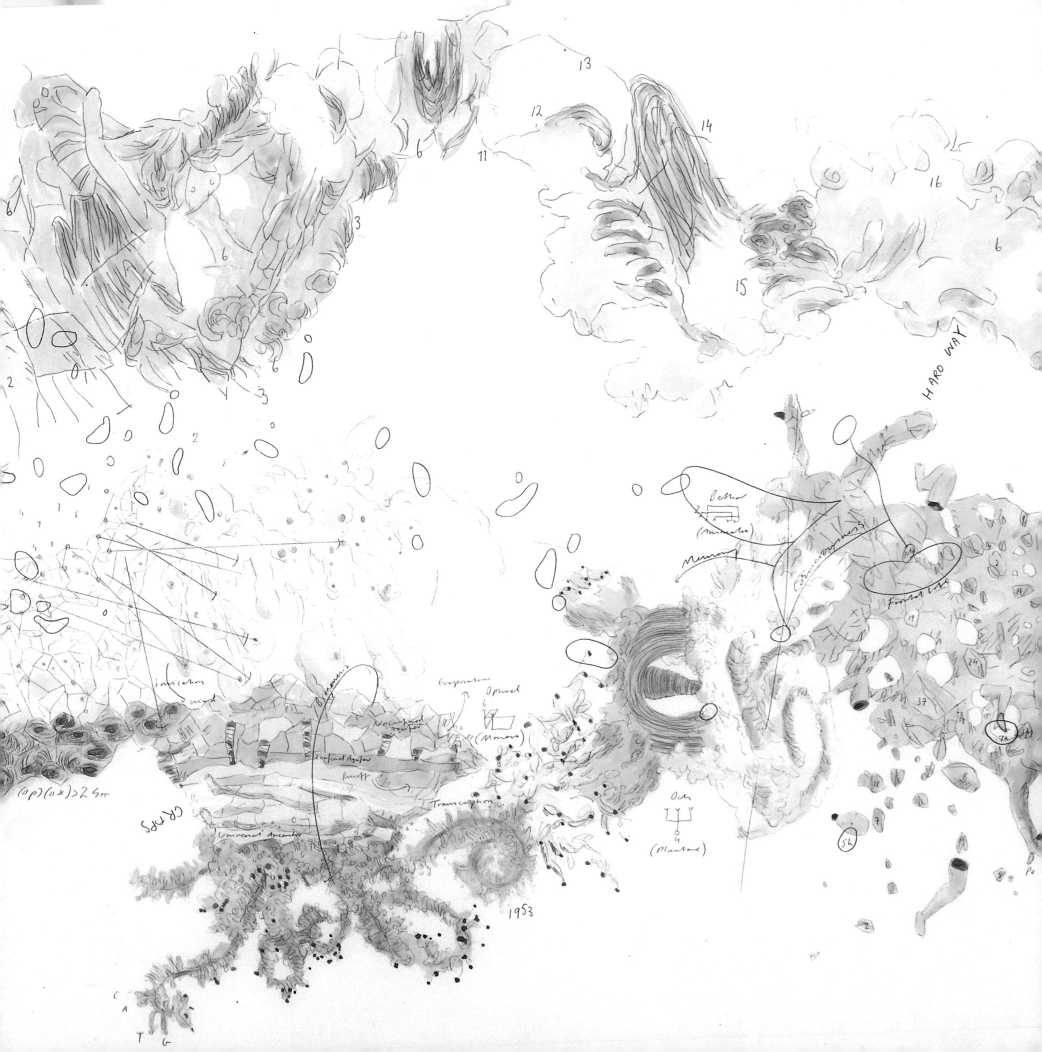

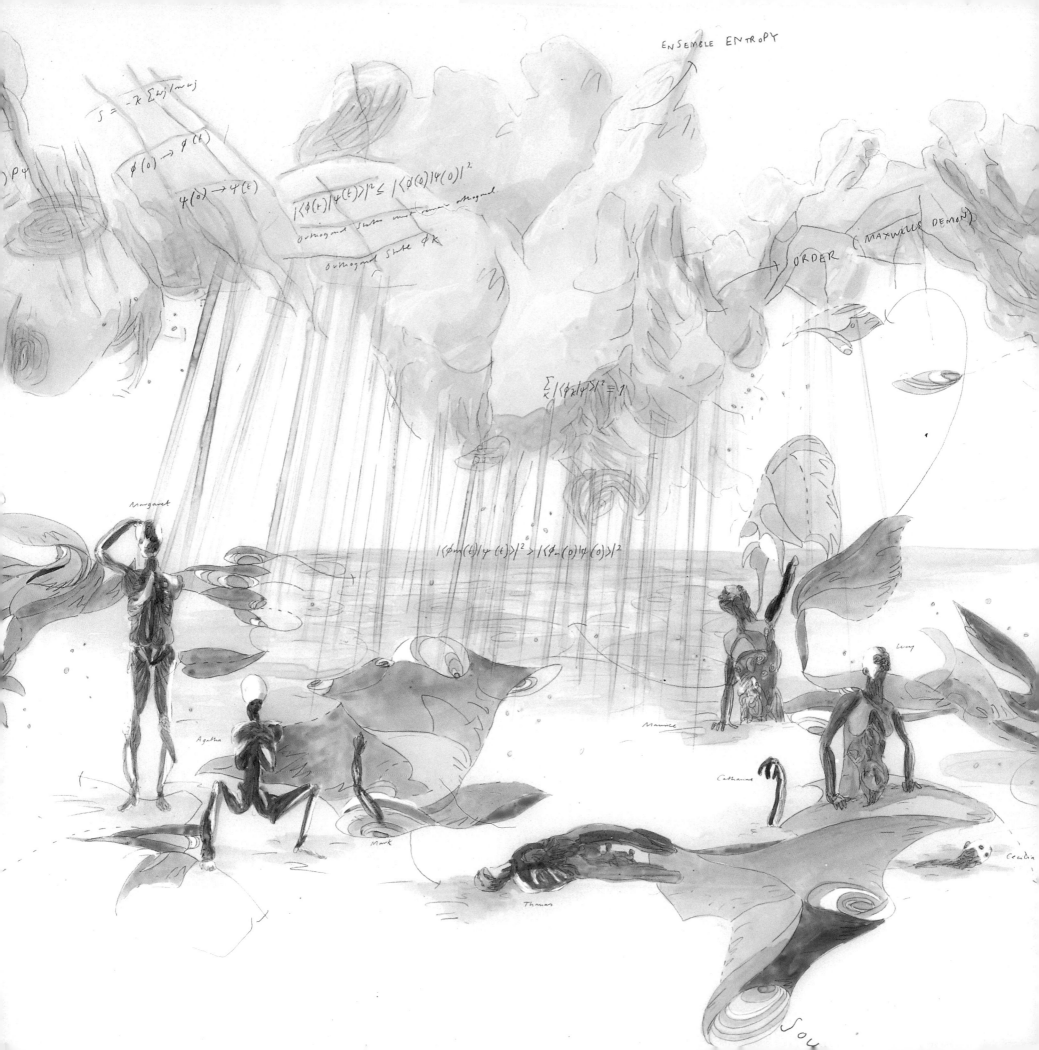

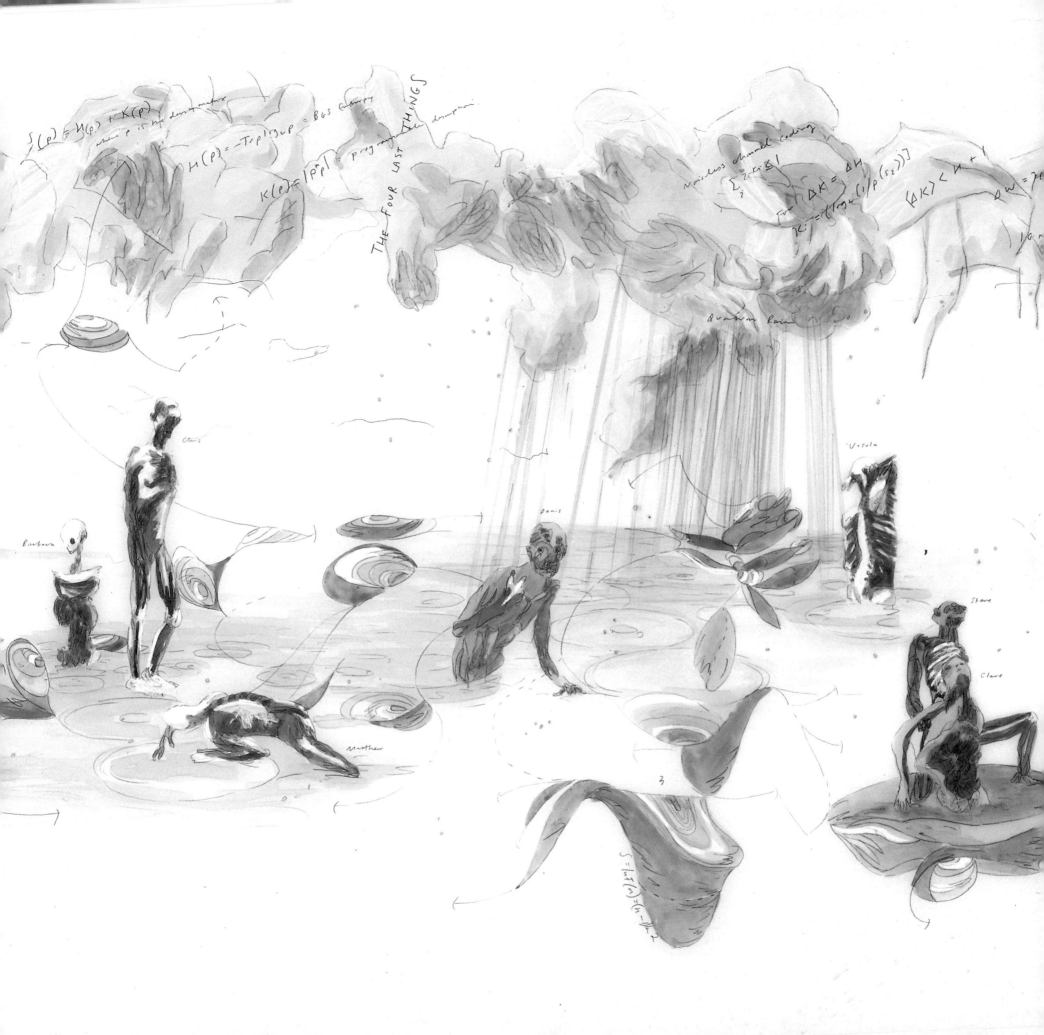

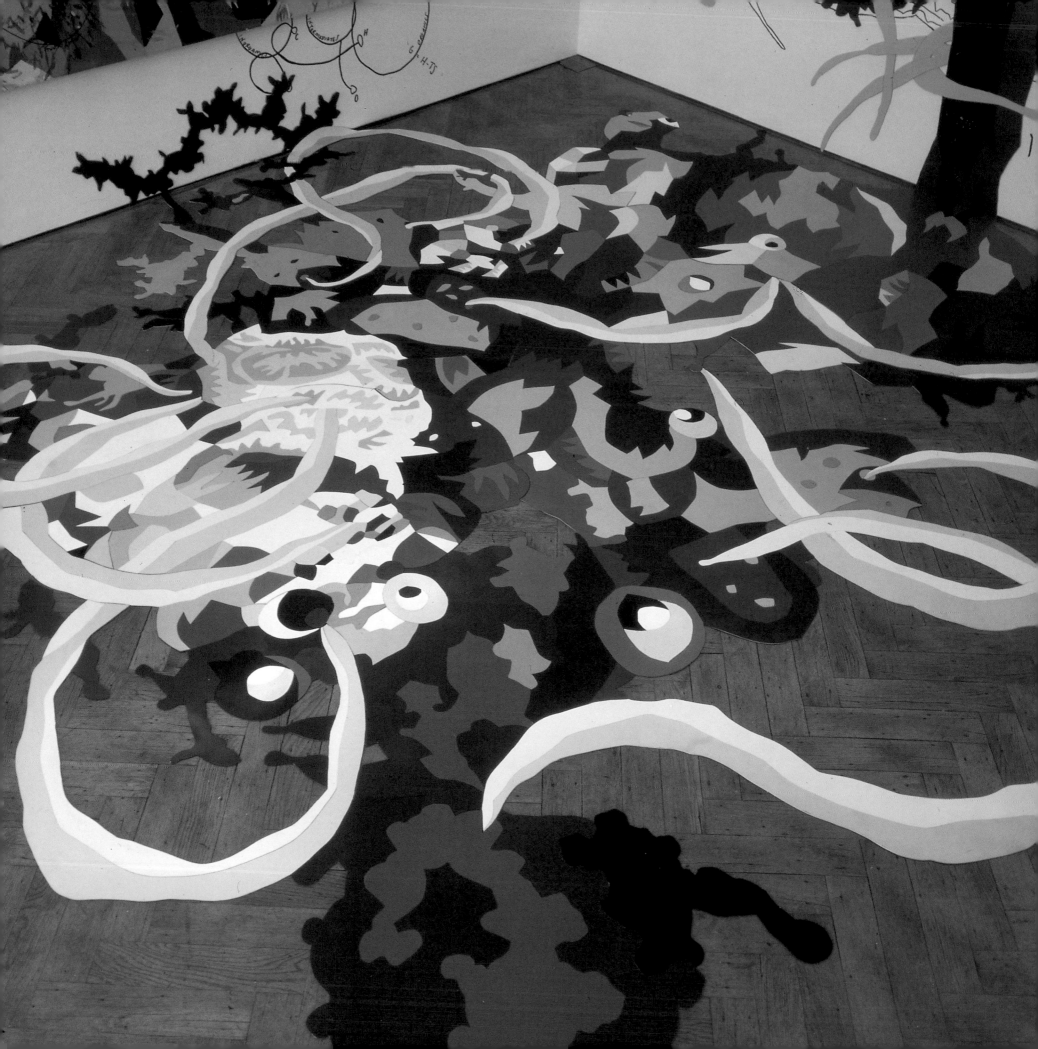

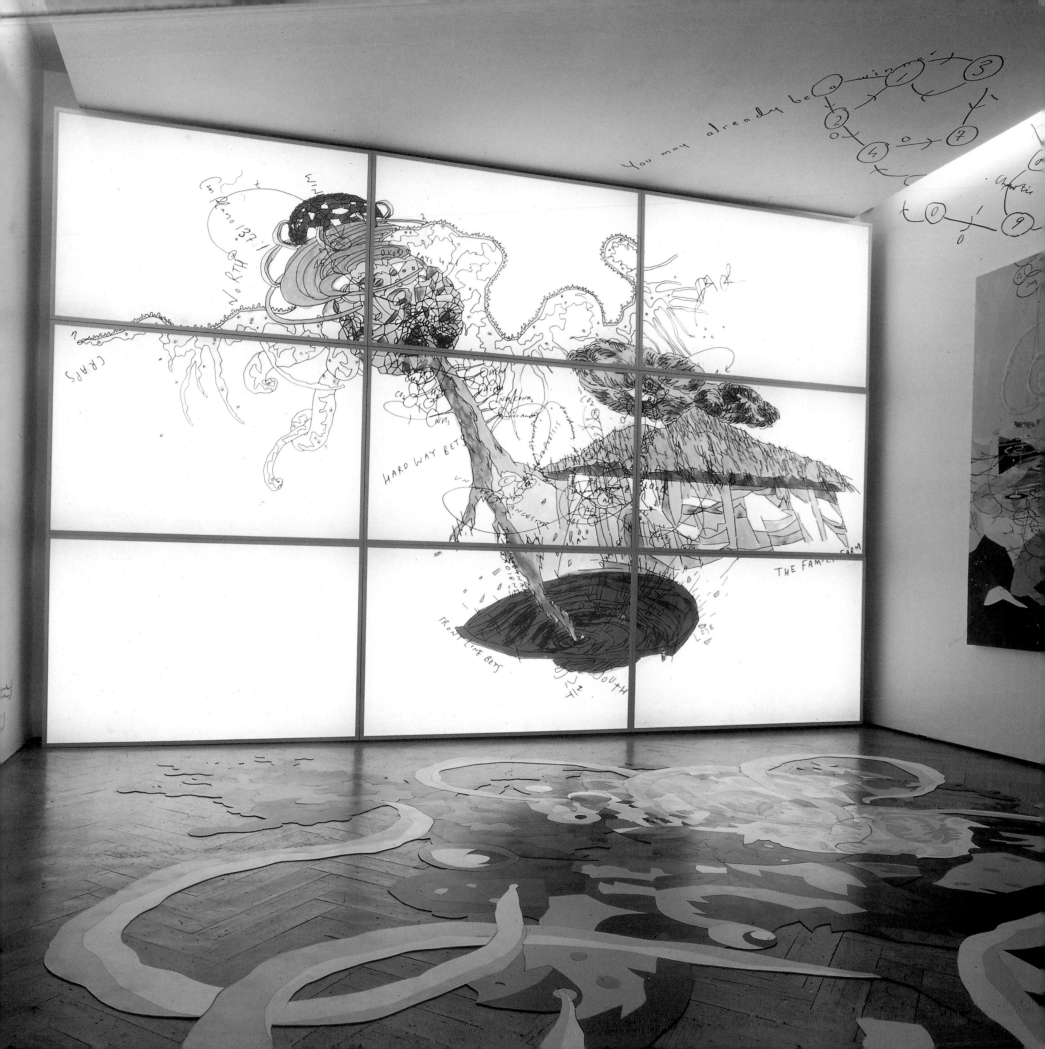

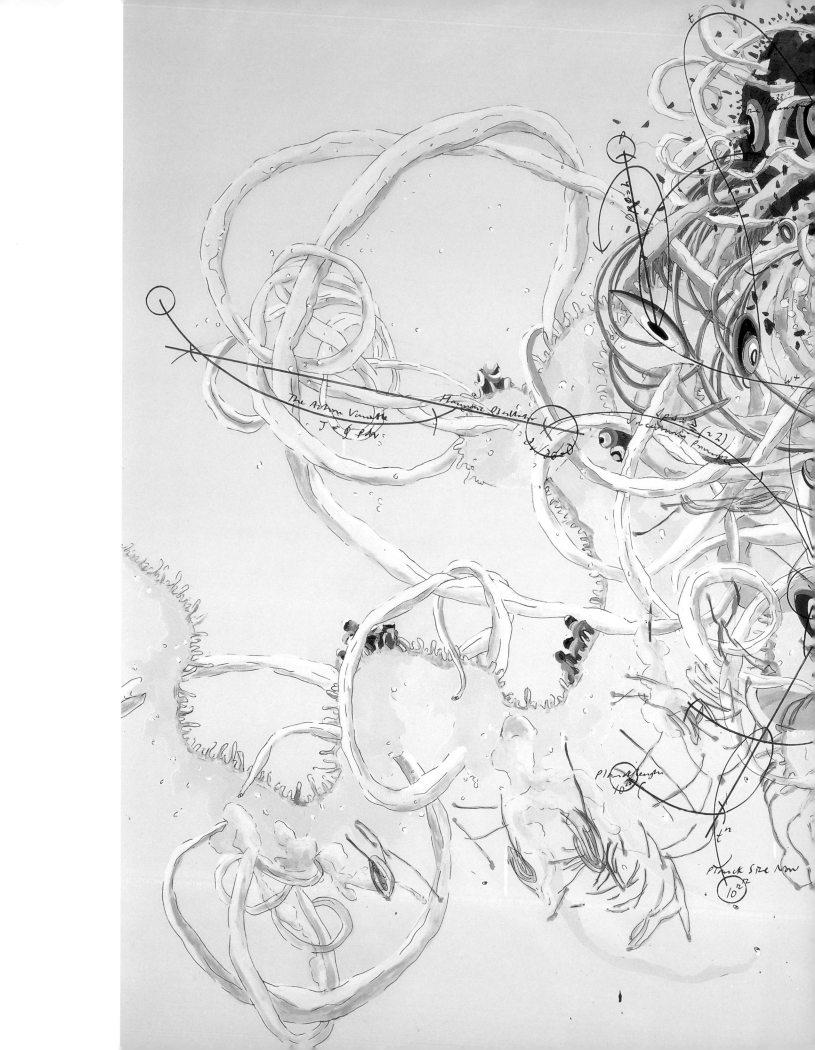

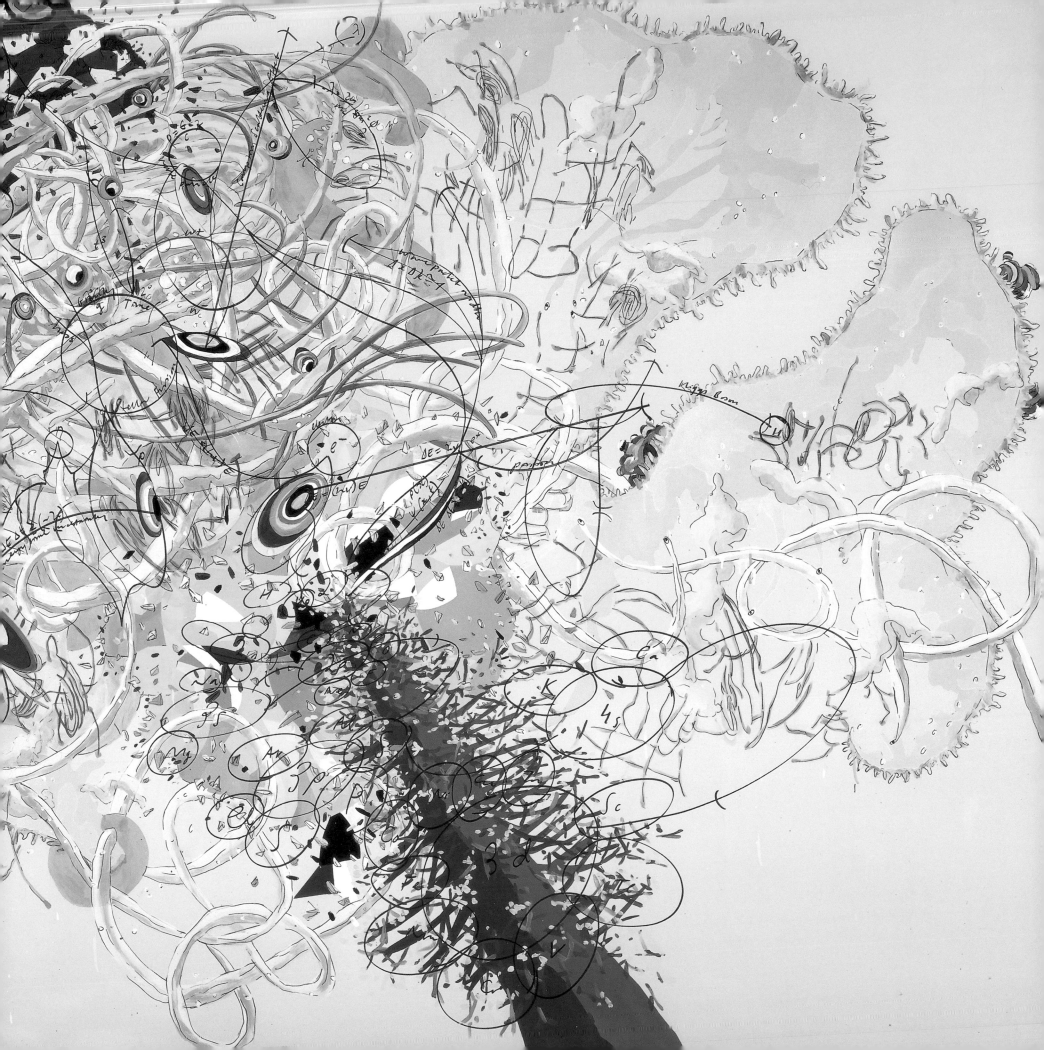

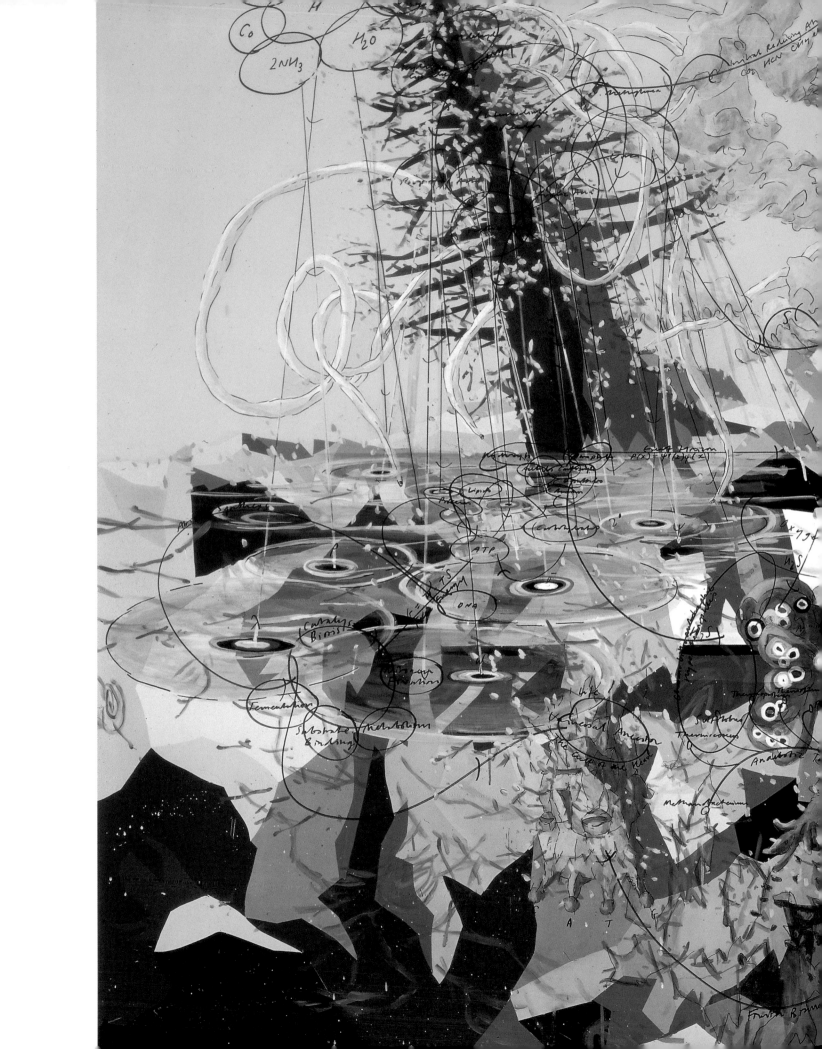

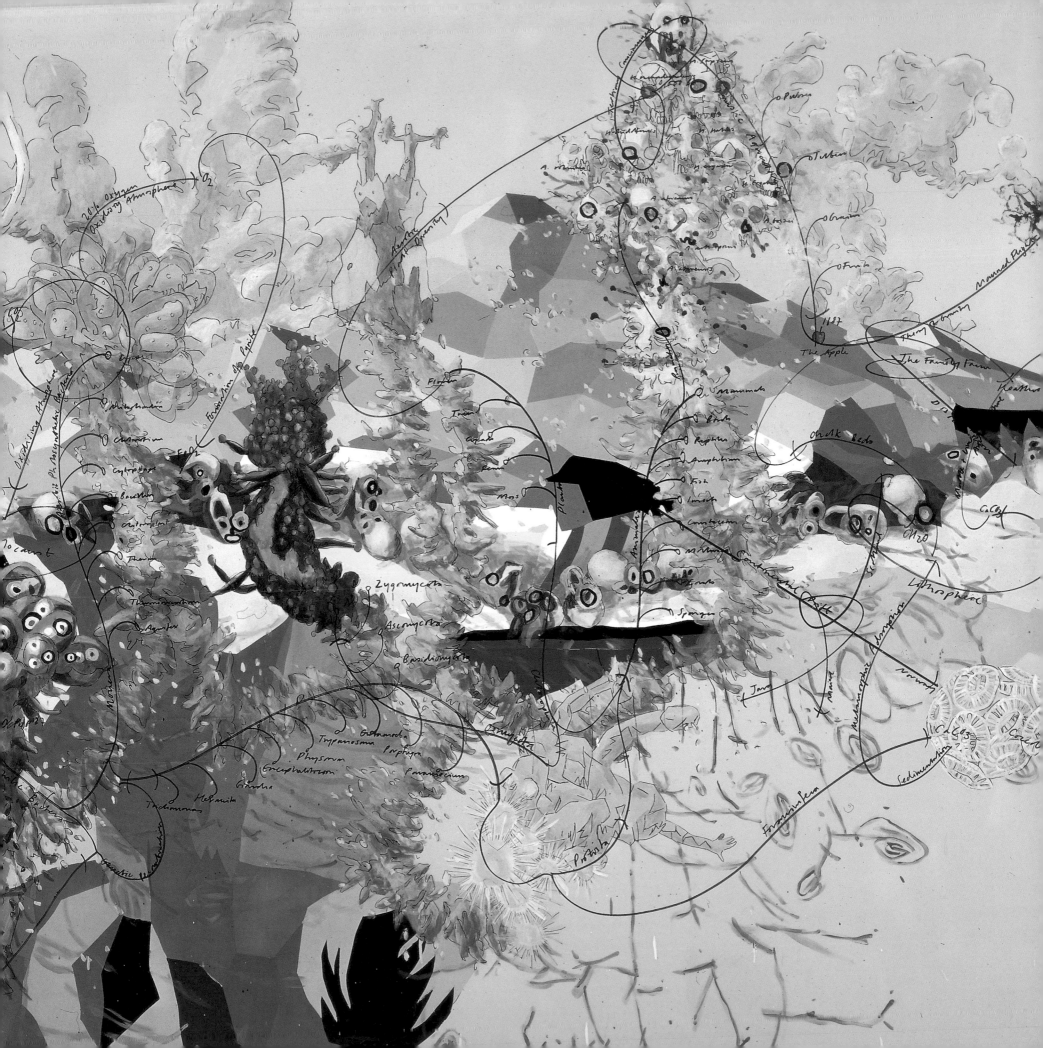

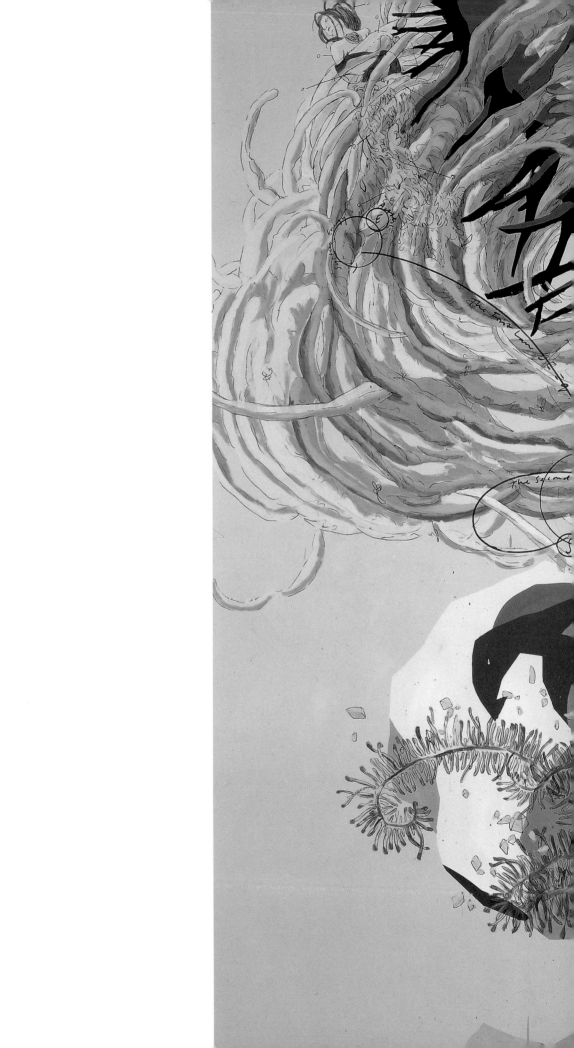

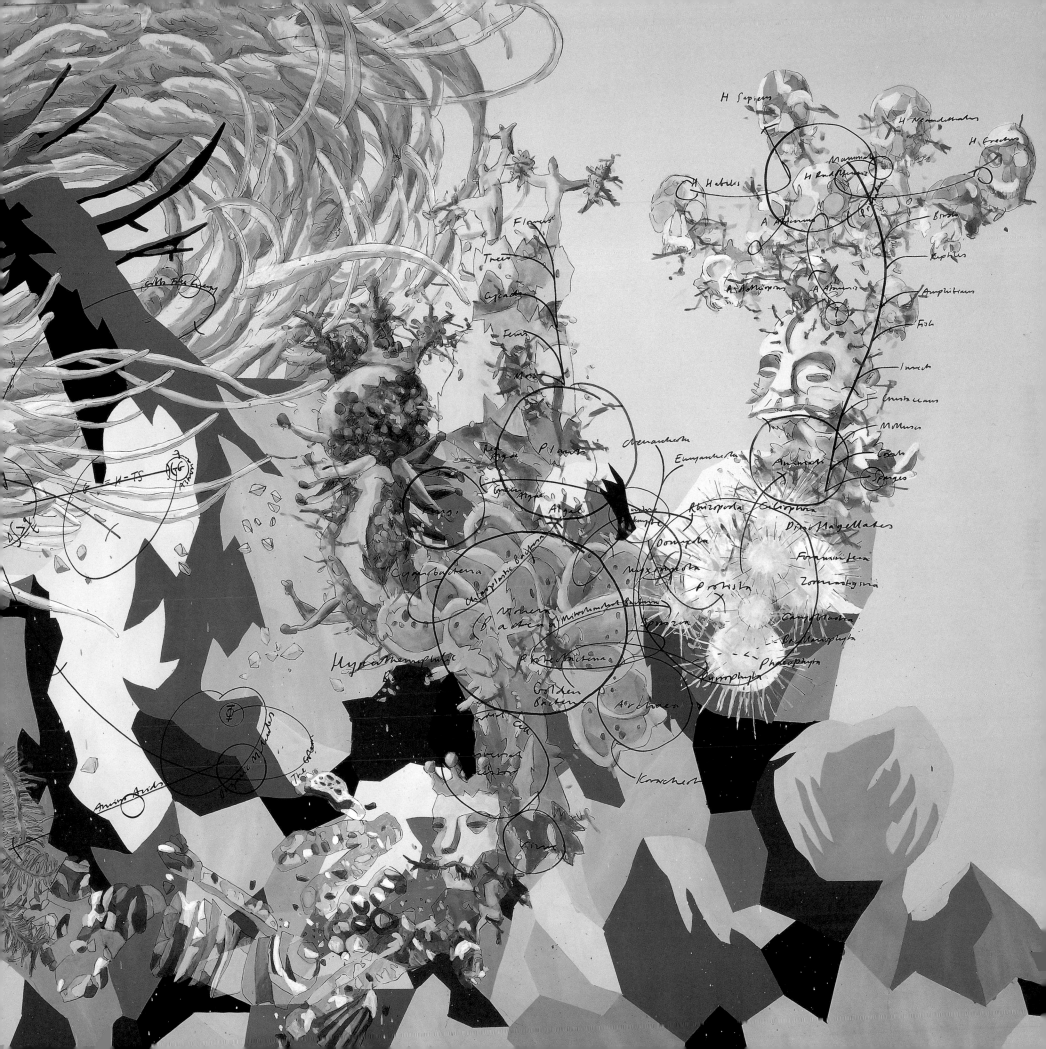

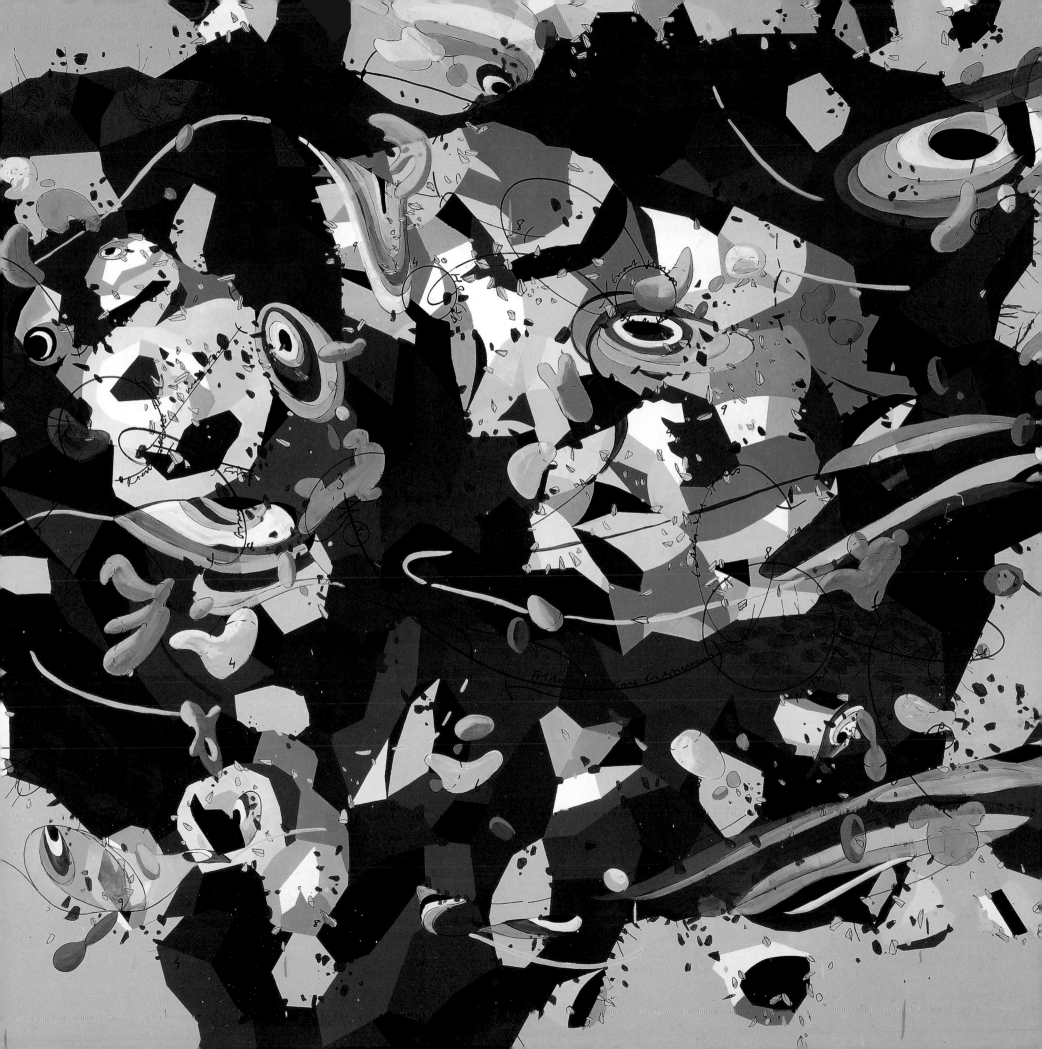

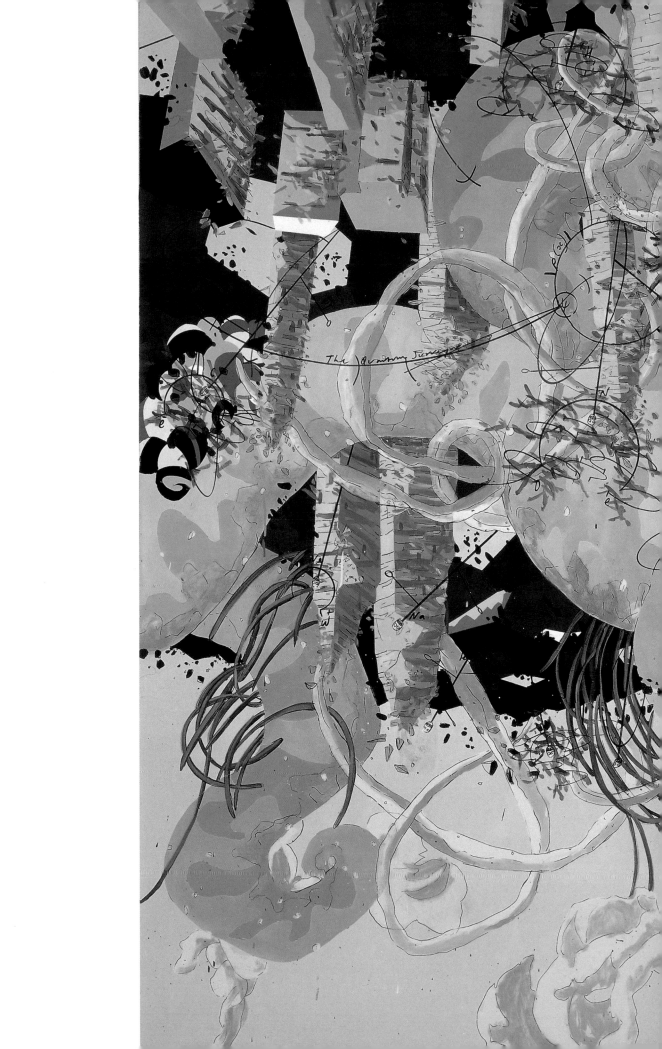

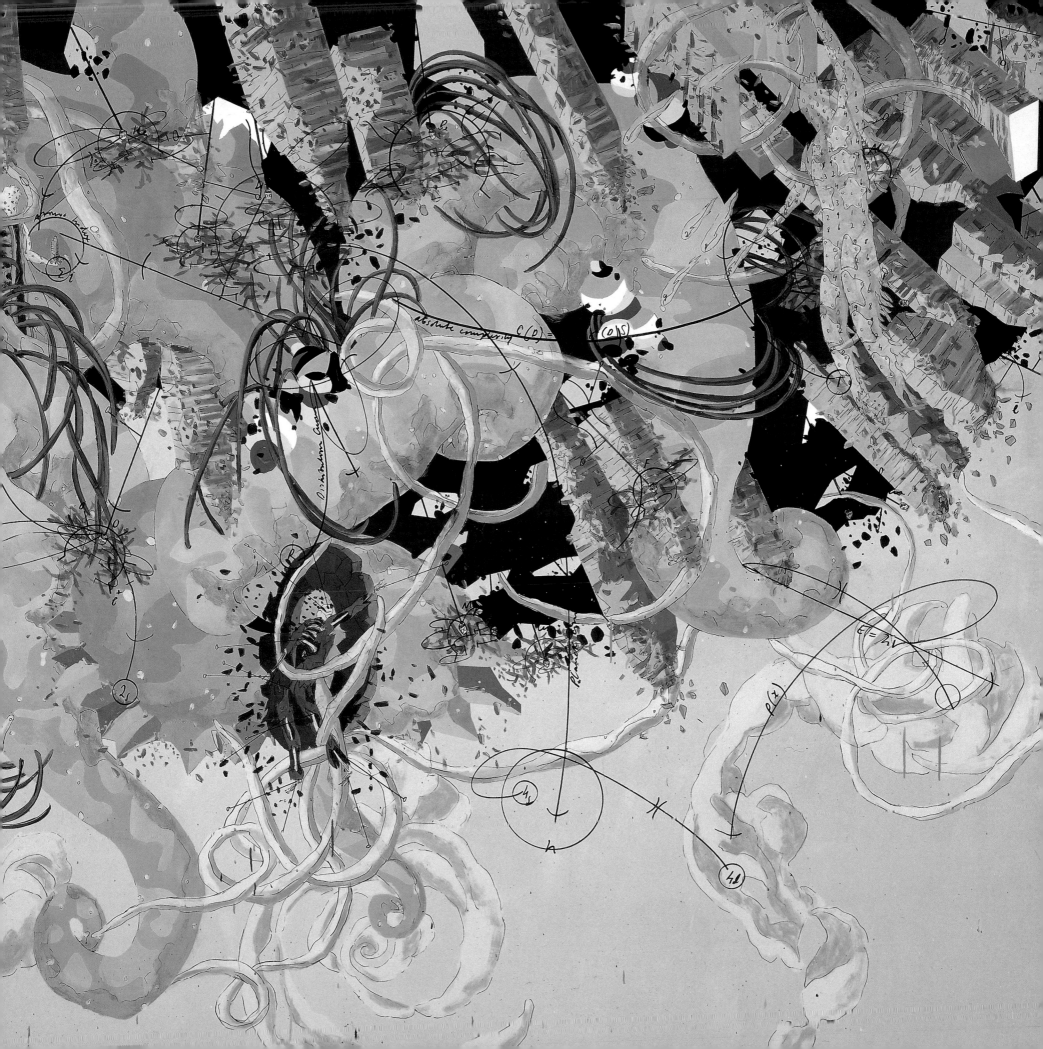

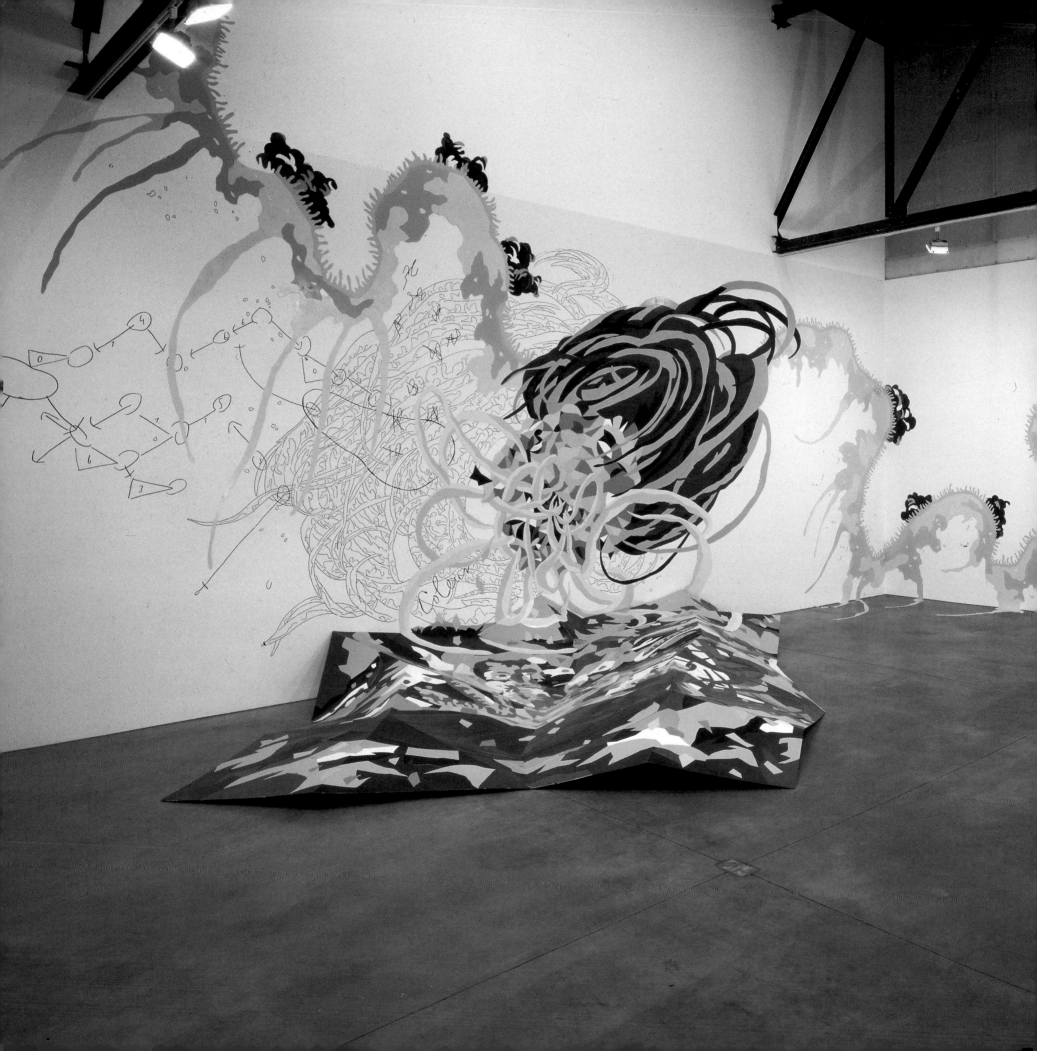

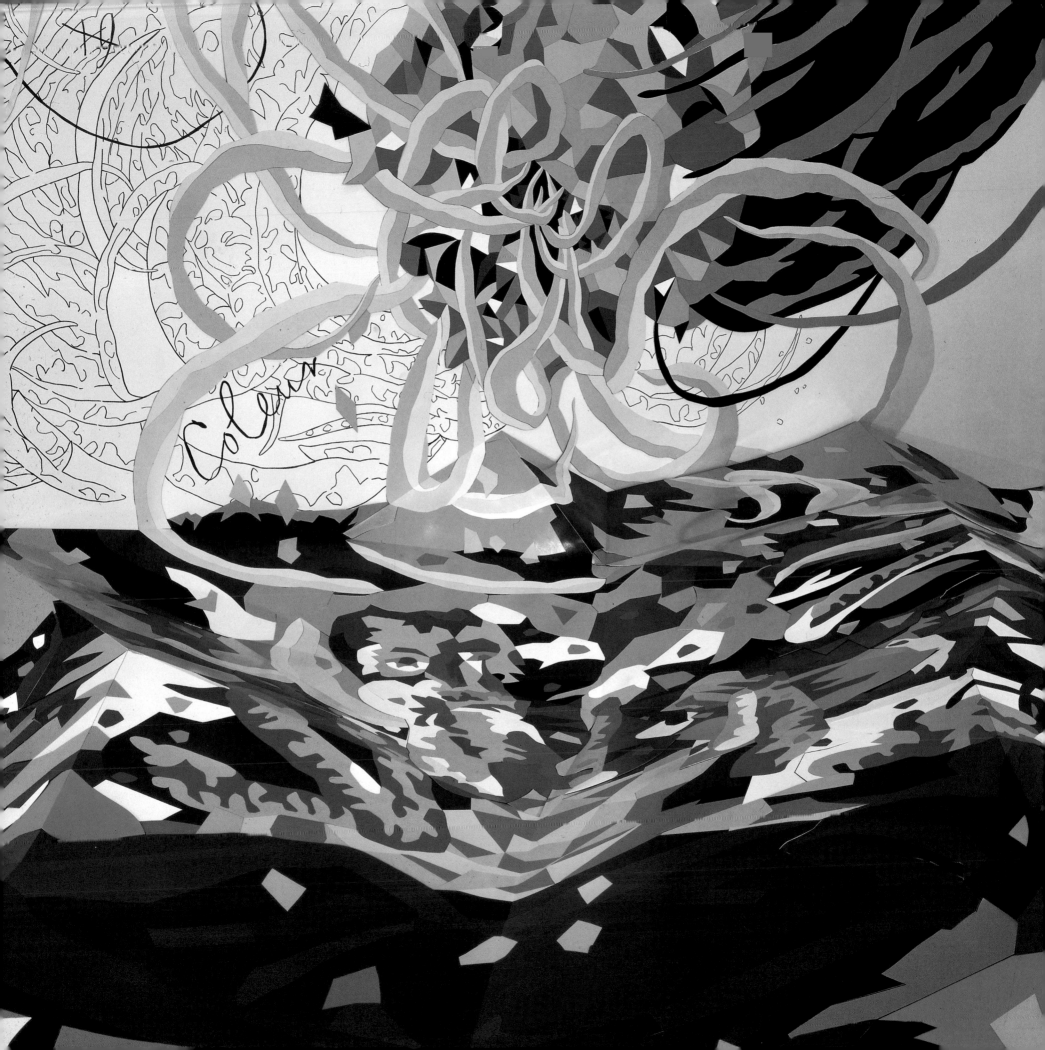

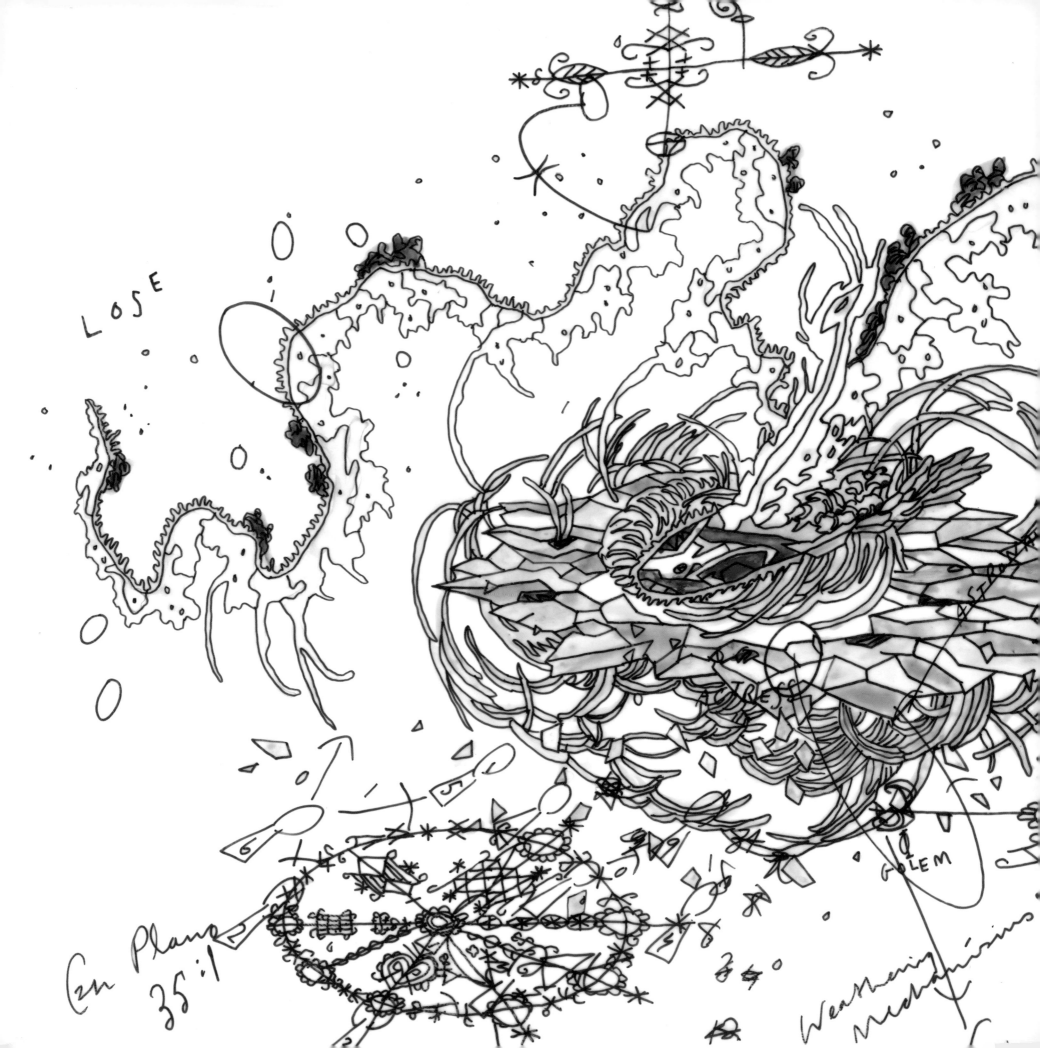

LOSE

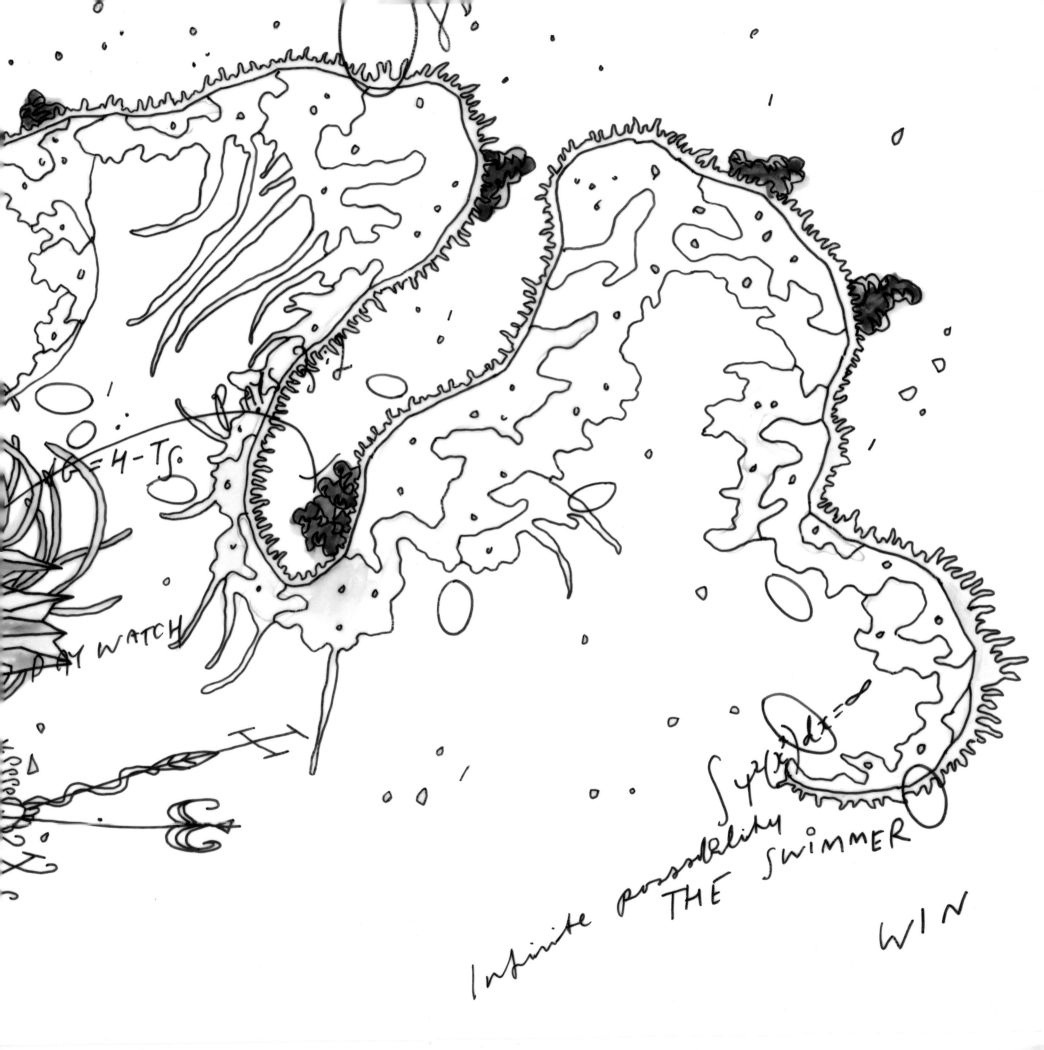

$\sqrt{5} = 4 - T_c$

7 DAY WATCH

$\int y^? (x) dx = \delta$

Infinite possibility

THE SWIMMER

WIN

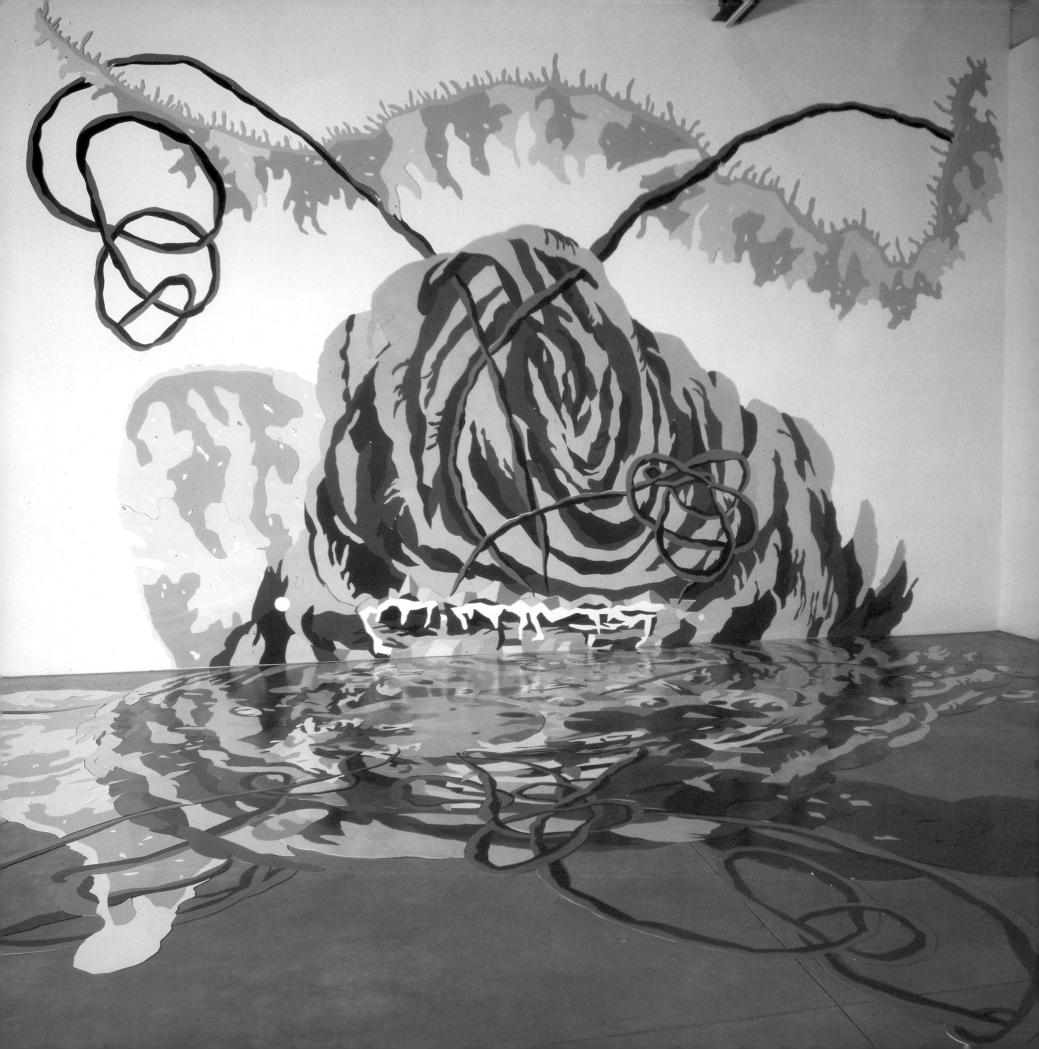

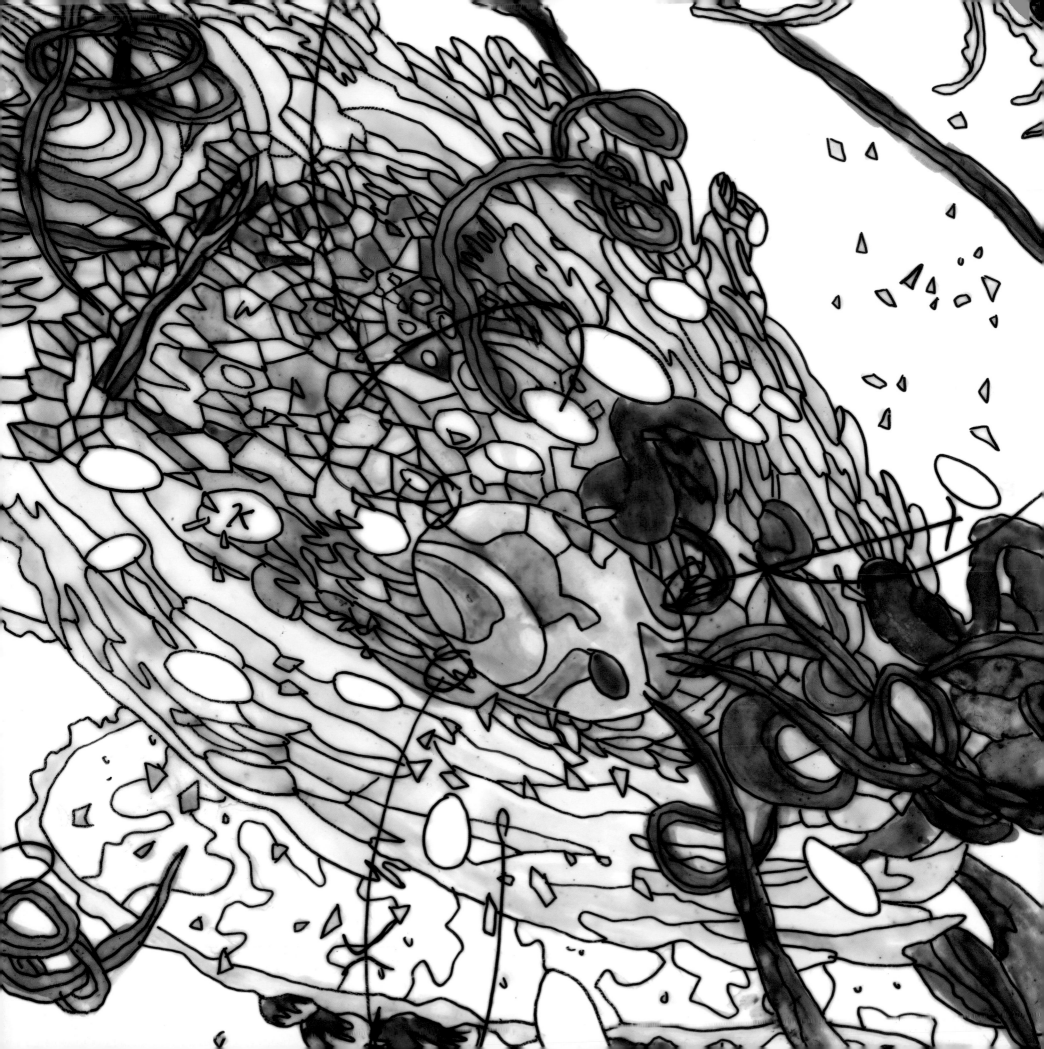

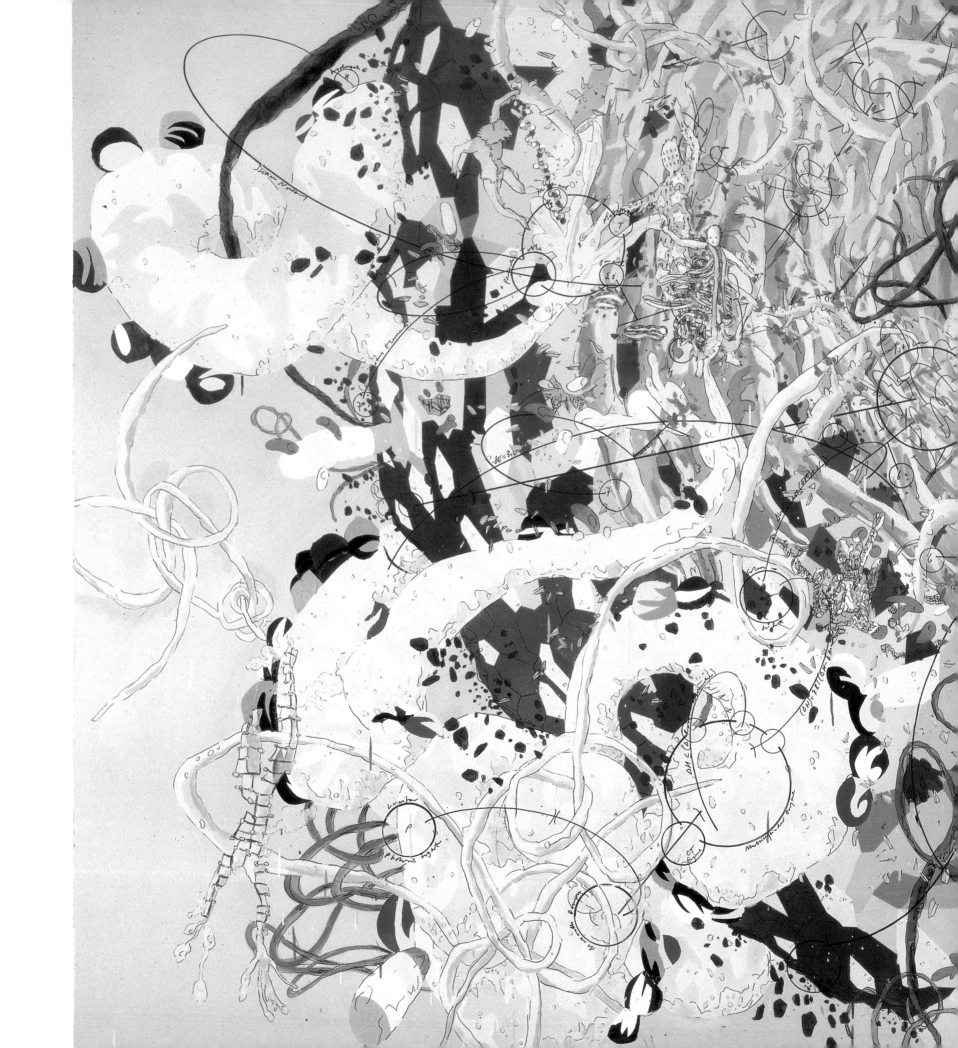

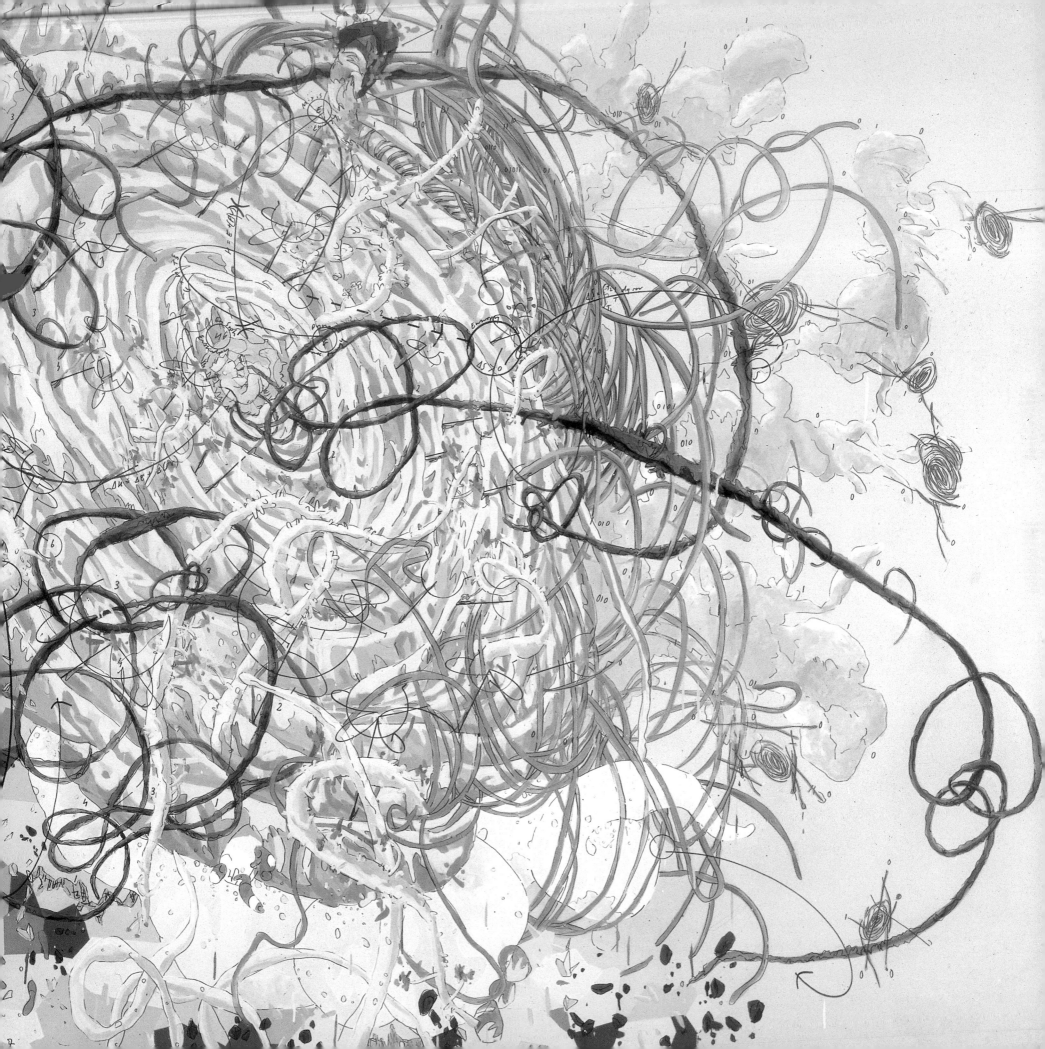

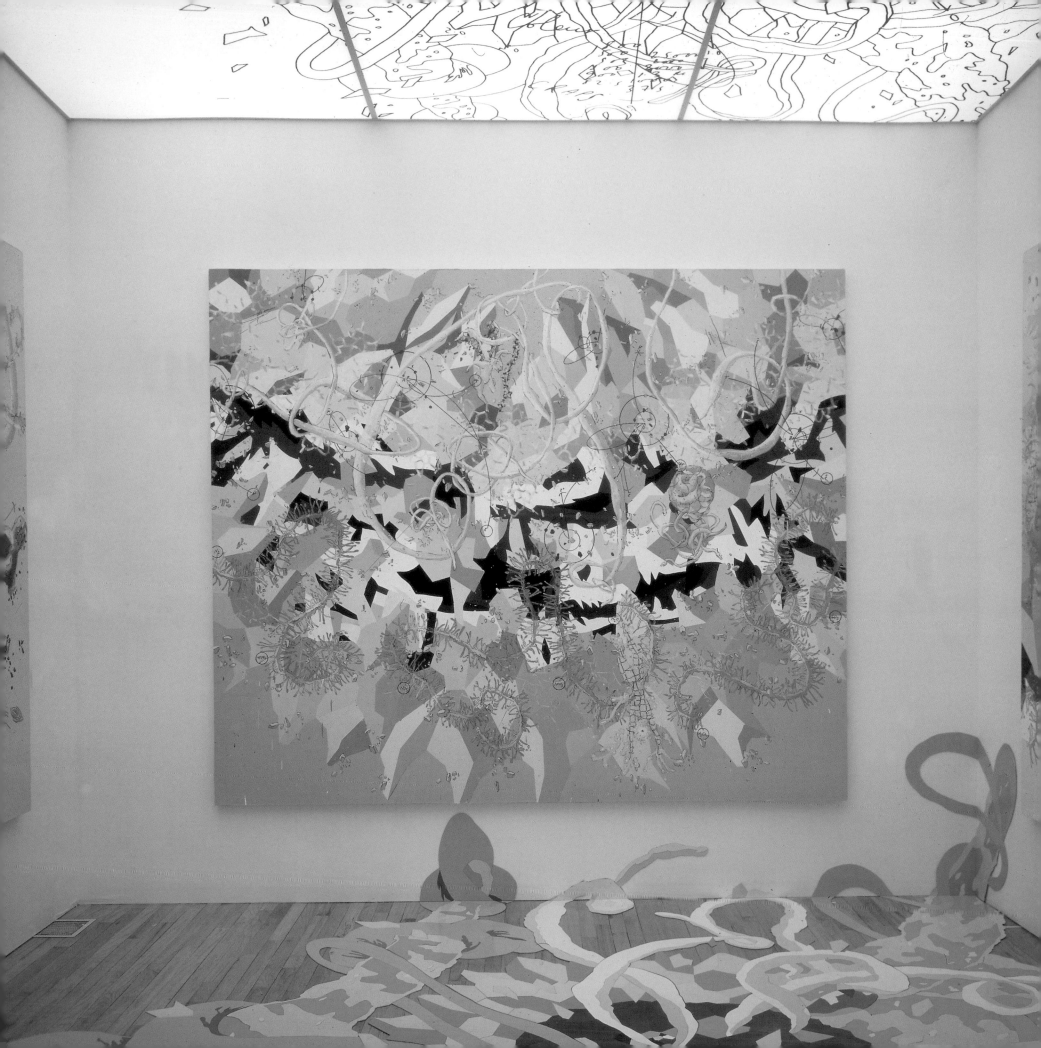

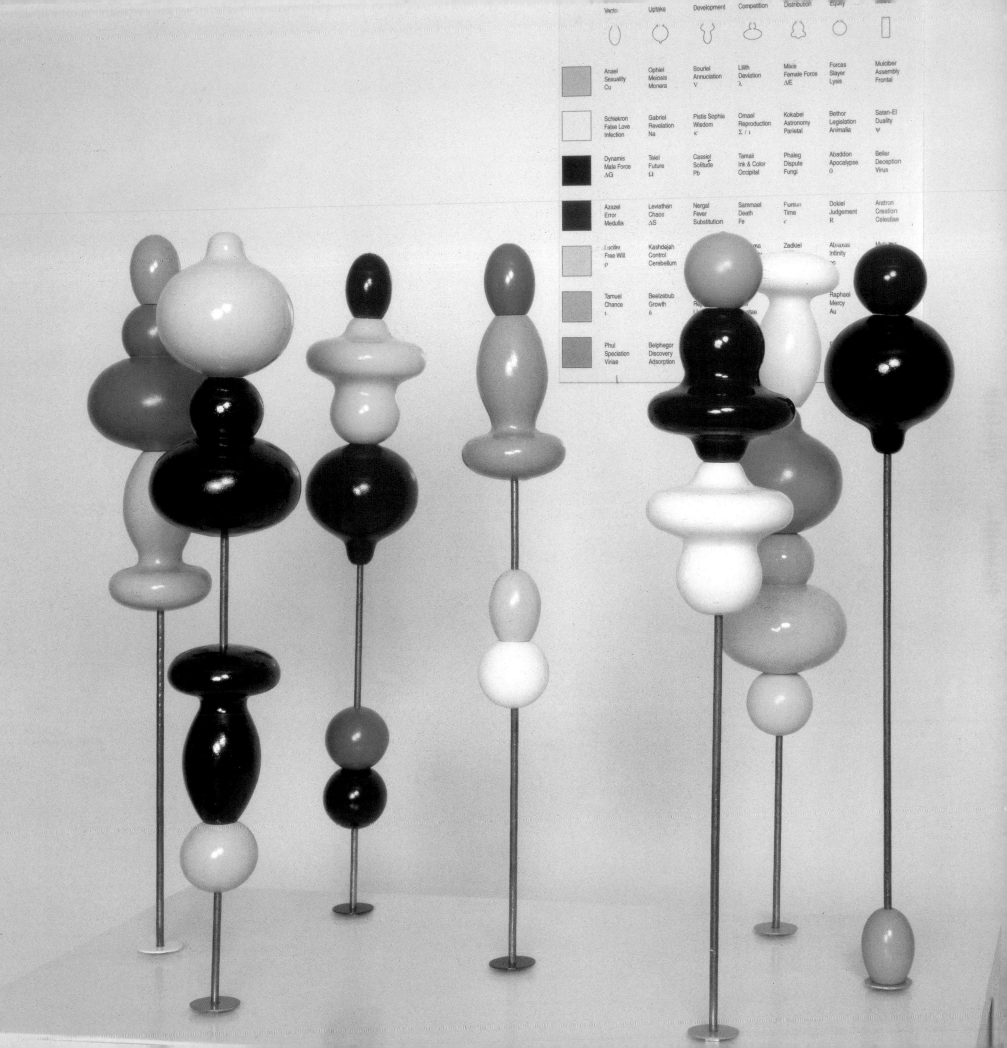

Jonathan Lethem

Twenty Statements About Chaldrons

1. A chaldron is an impossible object.
2. A chaldron is not a golden bowl.
3. A chaldron is "treasure from the future."
4. A chaldron is "beautiful, isn't it?"
5. A chaldron is "lit from within."
6. A chaldron "speaks of the possibility of another world."
7. It is impossible to win an auction for a chaldron on eBay.
8. An encounter with a chaldron can be catastrophic.
9. The price of chaldrons is "skyrocketing."
10. Maybe Marlon Brando owns a chaldron.
11. A chaldron "smashes all available frames of context."
12. A chaldron is "like an opera pouring from a flea's mouth."
13. A chaldron is "like an altarpiece bigger than the museum which contains it."
14. A chaldron is "a sacred accident of commerce."
15. Some people, upon first glimpsing a chaldron, remove their clothes.
16. Chaldrons "circulate in a zero-sum system."
17. Chaldrons "interrogate Manhattan."
18. A chaldron is "a beacon of revolution."
19. Only a chaldron can salve the loss of a chaldron.
20. It is better to have seen and lost a chaldron than never to have seen a chaldron at all.

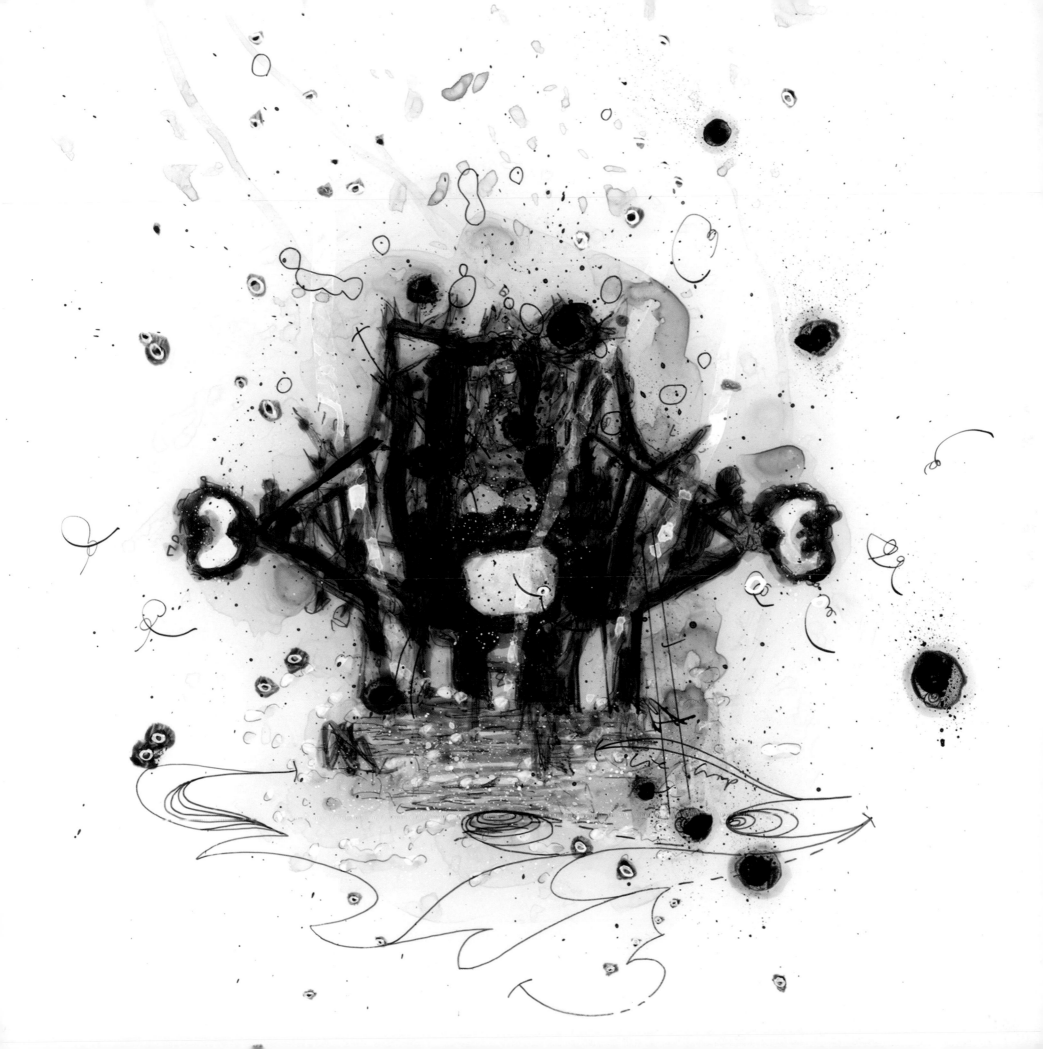

Modular Notes
Elizabeth M. Grady

Impact

A first encounter with a Matthew Ritchie installation is a little like a twenty-car pileup on an icy expressway: work after work collides with our field of vision after the initial visual impact, leaving our brain to bend and twist in reaction to the hyperactive visual (and sometimes aural) onslaught. Information intake actually changes the shape of the brain, but with Ritchie's work, that involuntary alteration is a palpable physical sensation. Ritchie uses a wide array of media, including painting, sculpture, large-scale lightboxes, digital animation, wall drawing, and mosaics of colored Sintra (an industrial PVC foam product) in an ambitious effort to describe and explain the complexity of how the universe works. The variety of materials—and their deployment in dense, interrelated pieces—mimics the recombinant nature of matter and its constitutive parts, as summarized in the elements of the periodic table. Similarly, the echoes of imagery and titles, and shifts in scale, in his voluminous body of work—often across media—mirror the ongoing expansion of the universe since the Big Bang and the limitless possibilities for uniqueness and personal choice, resulting in an infinite variety of possible narratives and outcomes.

In his descriptions, both visual and textual, of the universe's mechanisms and properties, Ritchie mines the history of human thought, taking mythical characters and ideas from an evolving roster of religions. Beginning with that of ancient Mesopotamia, which is by far the oldest, and including Judaism, Gnosticism, Christianity, and Voodoo, each is an outgrowth of the same Indo-European root lineage whose mythologies have striking parallels too numerous to list here. He also draws on historical and literary texts like Blackstone's *Commentaries on the Laws of England* and Milton's *Paradise Lost*. These are used along with the laws of physics and ever-emerging theories about the interaction of energy and matter, each more fantastic than the last, that result from our increased use of computers to record and analyze data on the behavior and makeup of previously inaccessible or invisible parts of our universe.

To make sense of this bewildering array of sometimes contradictory perspectives, Ritchie has come up with a chart of forty-nine characters, his *Working Model Chart* (1995), selected from among the various religious and literary traditions. Each character may simultaneously represent a person (like Adam or Lucifer), an act (like treason), a portion of the brain, an element, a family of life forms (like fungi or animals), an ethical concept (like redemption), or a state of matter or energy (like light). To make matters even more complicated, each of the characters may combine with others depending on context, creating multifaceted hybrids who exhibit qualities of two or more characters, depending on the moment of the history of the universe that Ritchie has chosen to depict. Overwhelmed yet? That's the morphing of your brain that you're feeling.

Mercifully (and mercy is one of the ethical traits assigned to the angel Raphael, who is also associated with the sun and alchemy in the Ritchie cosmology), he has arranged these characters, properties, and concepts into a tidy grid, which serves as his toolbox but which also has the benefit of clarifying for the rest of us exactly what he is depicting or referencing. Ritchie is nothing if not generous: he illustrates the complexity of the universe in a way that the viewer can decipher and understand according to his/her unique perspective, using this key. One of the primary ways that he does this is through narrative. Starting with the characters on his chart, he uses the form of a fictional story to describe the processes indicated by the mathematical equations of physics and the stages in the history of the universe since the beginning of time. Taking scientific theories that are ordinarily esoteric or even impenetrable for many of us, he illustrates basic concepts, beginning with the Big Bang in his text "The Gamblers" (1998). These texts form a series that cuts back and forth in time in cinematic fashion and is populated by characters that disappear and reappear, often in the guise of new characters. This is no accident, as his writings traipse through a landscape of screenplay tropes, from the slasher film ("The Gamblers"), through romance ("The Fast Set," 2000), to the detective story ("The Bad Need," 1998). Ritchie's characters are mutable, merging and separating according to their actions and contexts in a way that is akin to the subjective nature of particle physics, wherein the act of observing a particle changes it, so that the appearance of its nature is contingent upon an individual's act of viewing. Such a process of translating mathematical formulae into narrative engenders its own esotericism in turn, but this time the privileged position of an initiate is conferred upon the viewer. Similarly, using Ritchie's example as a springboard, it is my intention here to invite the reader to explore the series of exegetical texts of which this introduction is a part. It is intended to have no specific order; rather, the modular units are meant to be moved around and recombined by the reader at will, viewed from multiple perspectives so that meanings and associations are discovered that were foreseen neither by the artist whose work is their subject nor by the author who typed these words. In this way, an architecture for a personal esotericism may be formed at one remove from the artwork and this text, a recombination of available human history and knowledge as concrete yet subjective as Ritchie's own.

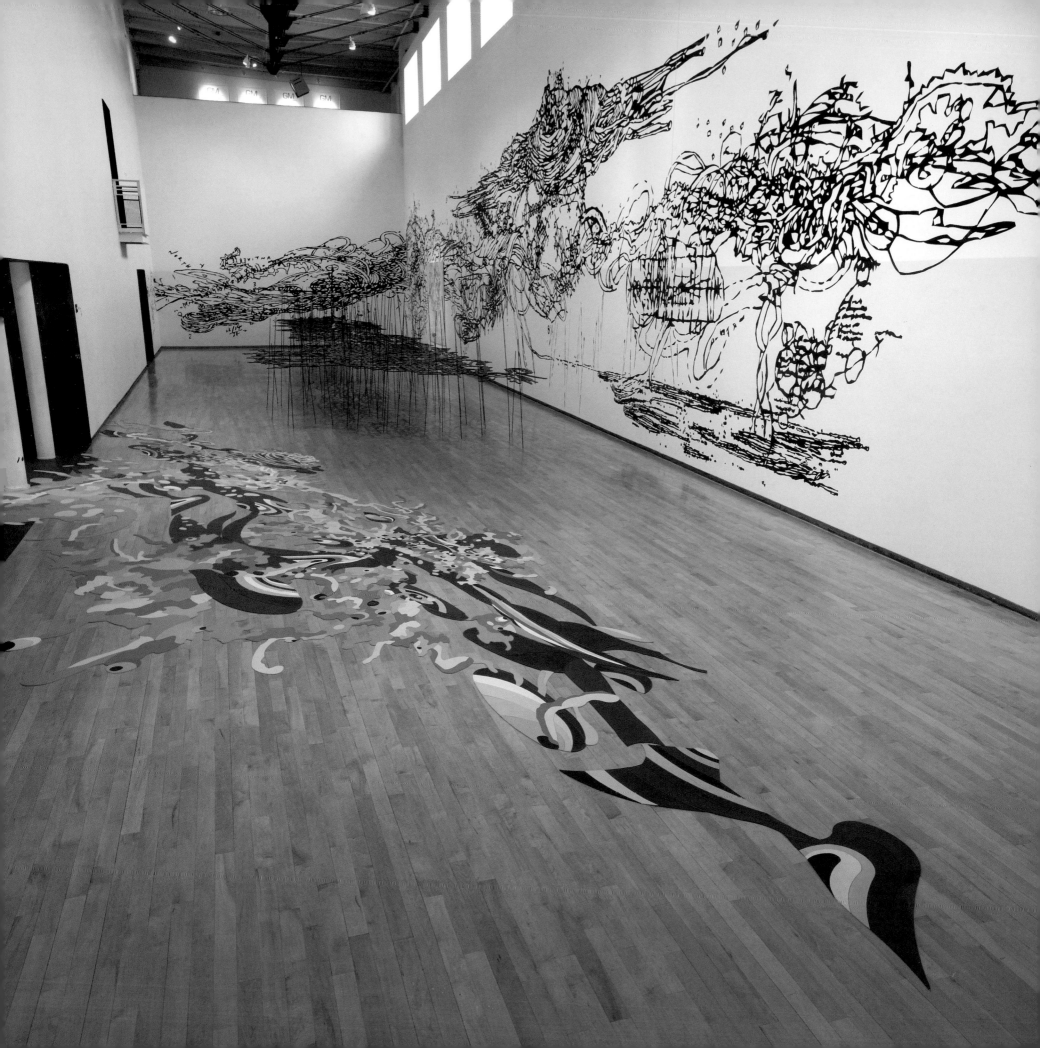

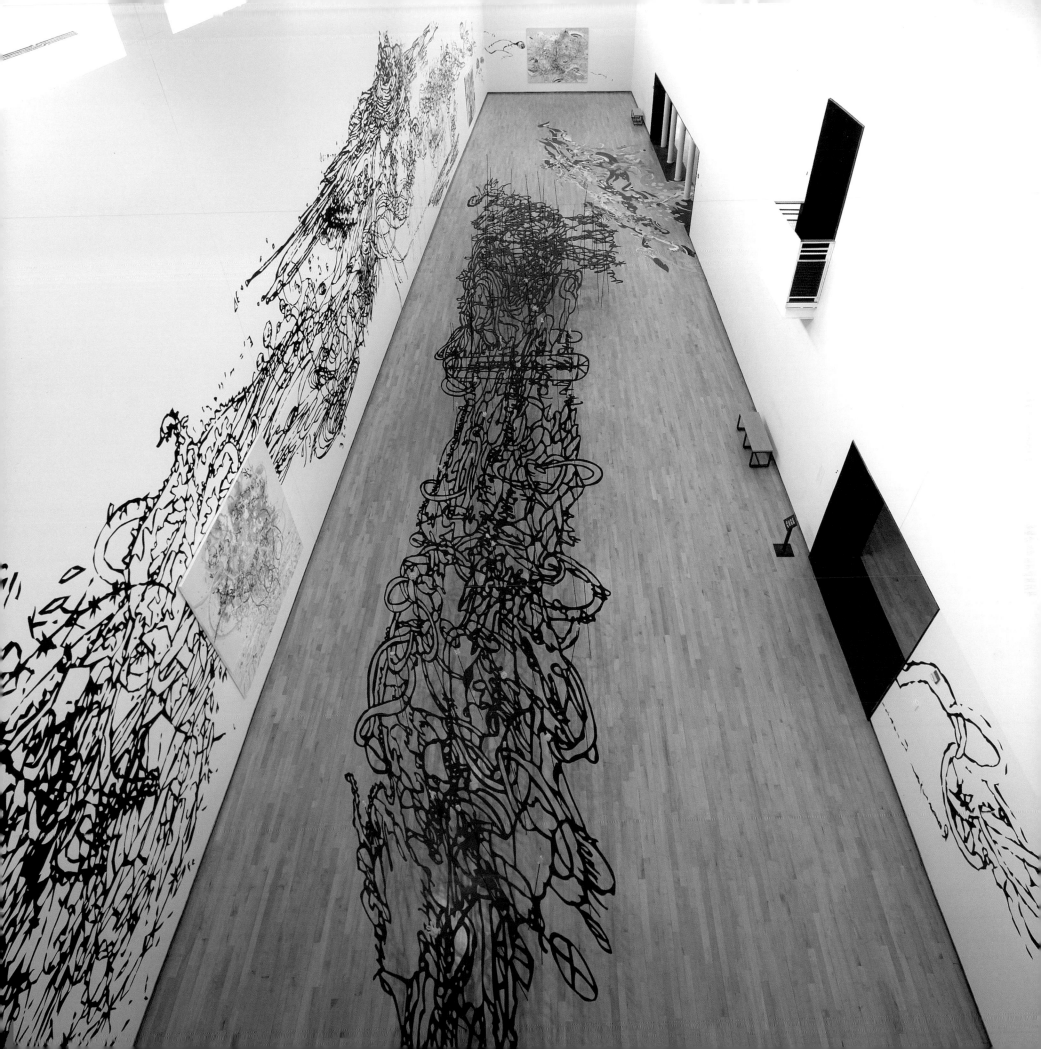

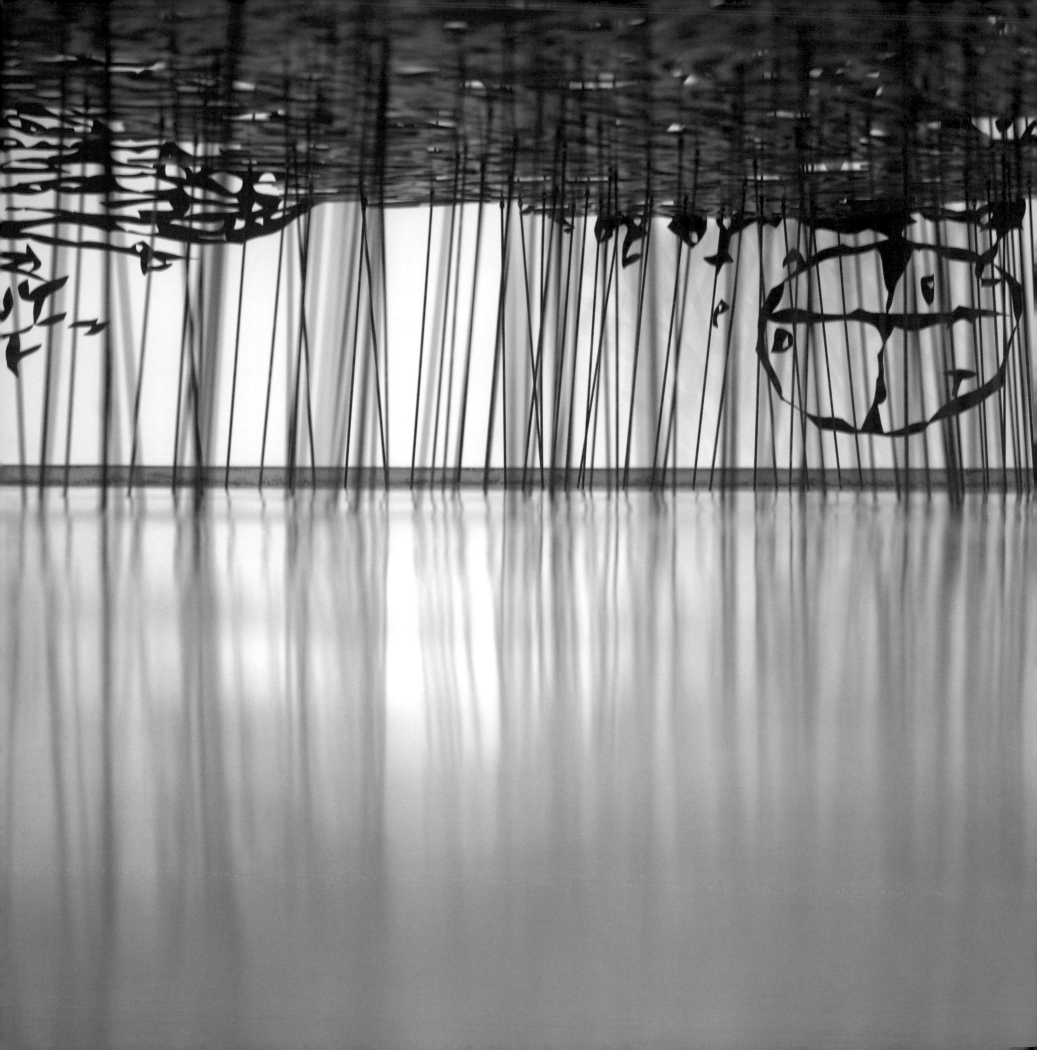

Information

Ritchie's artworks are made up of precisely the same building blocks as the weather, the landscape, and our own bodies, each atom an equivalent piece of information that could just as easily be part of something animate or inanimate. As in an alphanumeric language, where meaning is based on mutually agreed-upon ranges of associations for specific combinations of letters or symbols, it is in the way that the atoms are joined that the ultimate form they take (probably only temporarily) is determined. The use of Magic Marker to draw equations, indicate trajectories, and make notations reinforces this notion that everything is information. Similarly, the contrast in color and translucency between various parts of, say, a painted surface, speaks to the varying physical properties of different elements and serves as a reminder of the chemical makeup of the pigments and the media into which they have been mixed. Further, the relative lack of perspectival space, and the repeated efforts to subvert the impression of the painting as a window onto another world that one finds in the vast majority of Ritchie paintings, drawings, lightboxes, and even digital animations, forces us to see the works as metaphors and descriptions of theorems, rather than transparent illustrations of the story Ritchie has written. The Magic Marker scratchings also call to mind dry-erase boards in classrooms, even as Ritchie records the very equations and formulae that might be found on them during a physics lecture, like the second law of thermodynamics, which is increase in entropy within a closed system, or $\Delta S = q/T$ (change in heat, ΔS, is equal to heat absorbed by a system, q, divided by the absolute temperature of the system at the time the heat is absorbed, or T). Conversely, the equations that he integrates into his works are shorthand notations for rich and meaningful, yet nonetheless often incomprehensible, parts of human existence. Though a story like the one Ritchie has written in installments may describe things like mating and death (exchange of energy within a closed system and entropy, respectively), the actual sensations and understanding of the phenomena remain as abstract as equations until experienced.

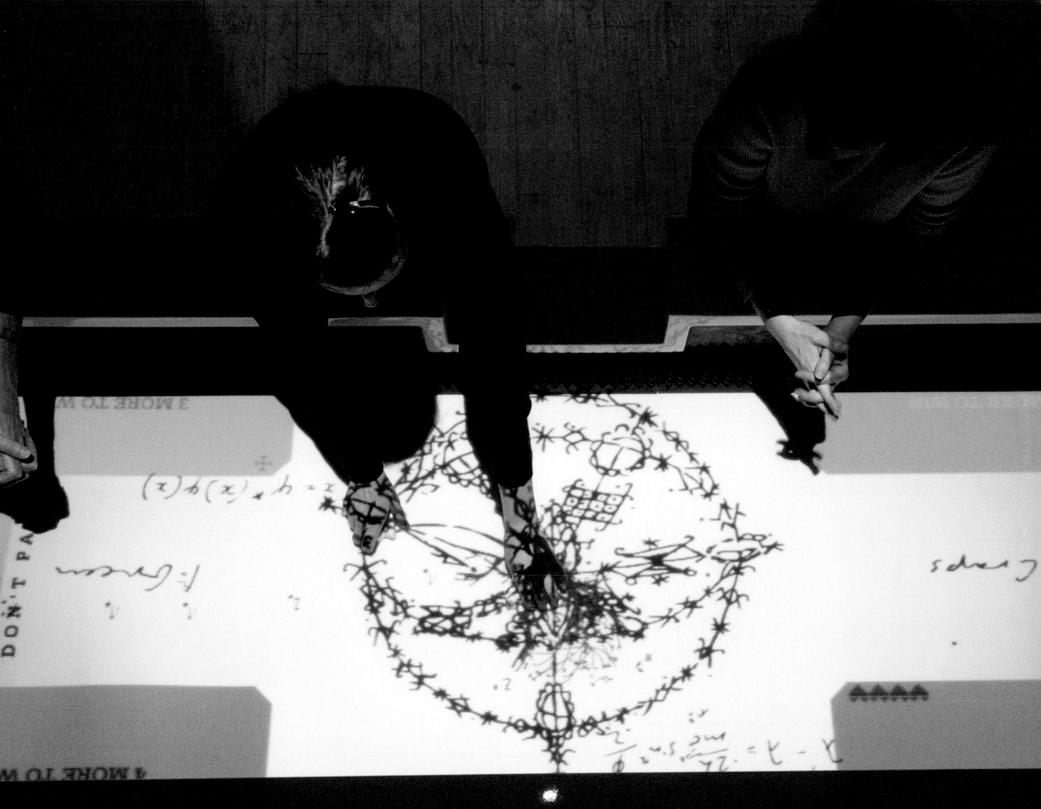

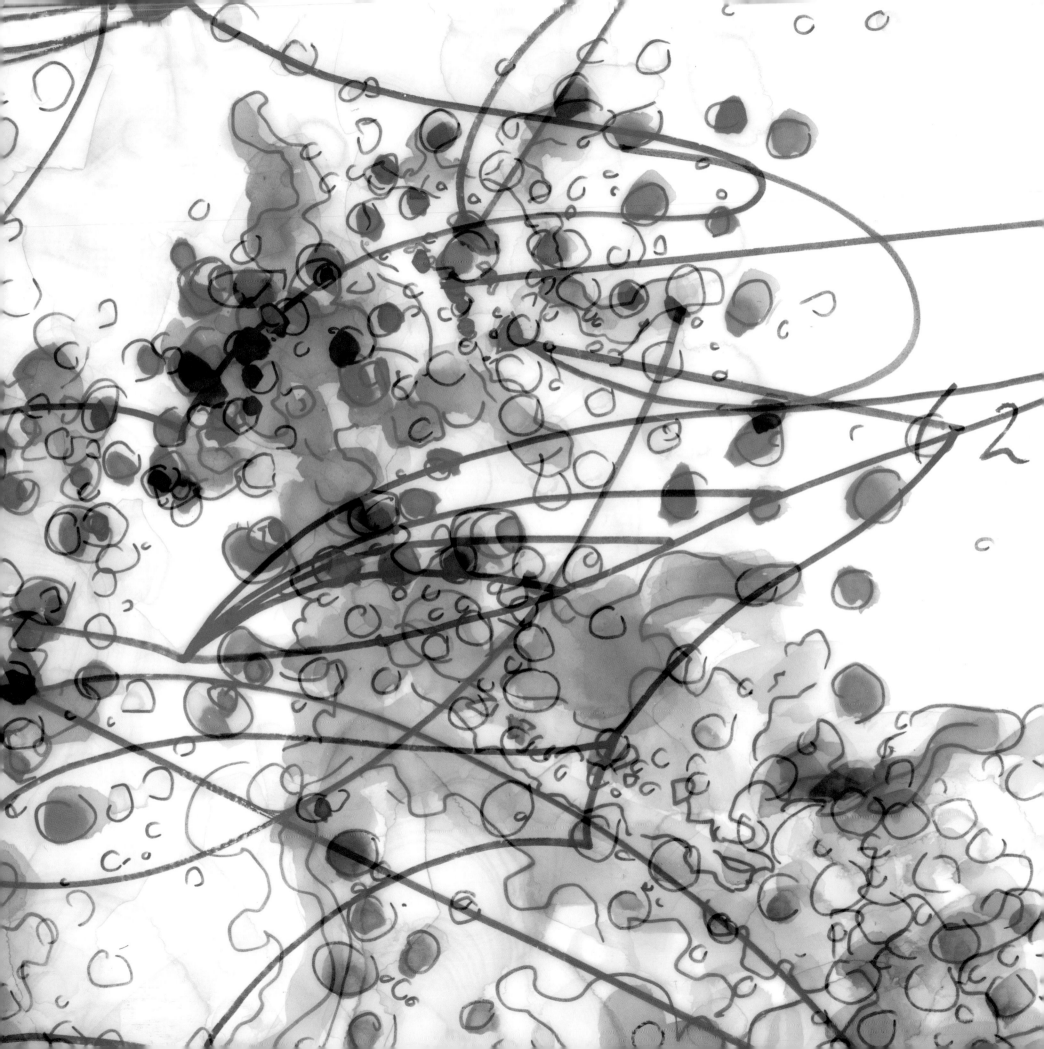

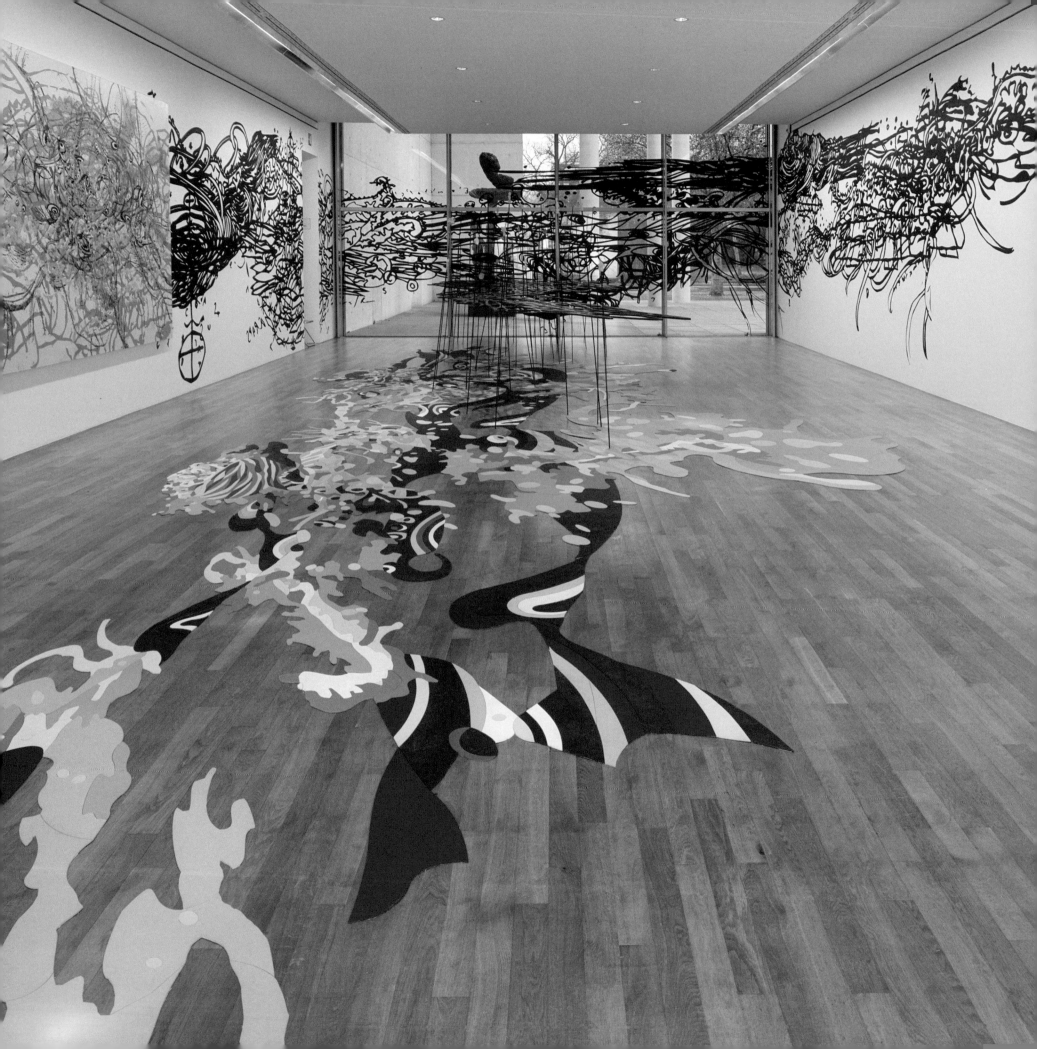

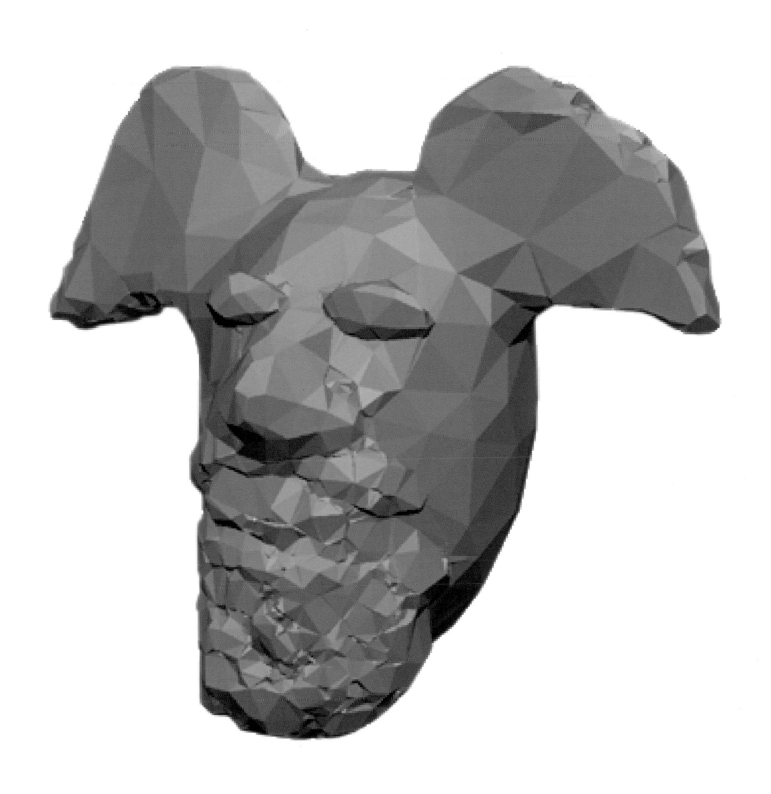

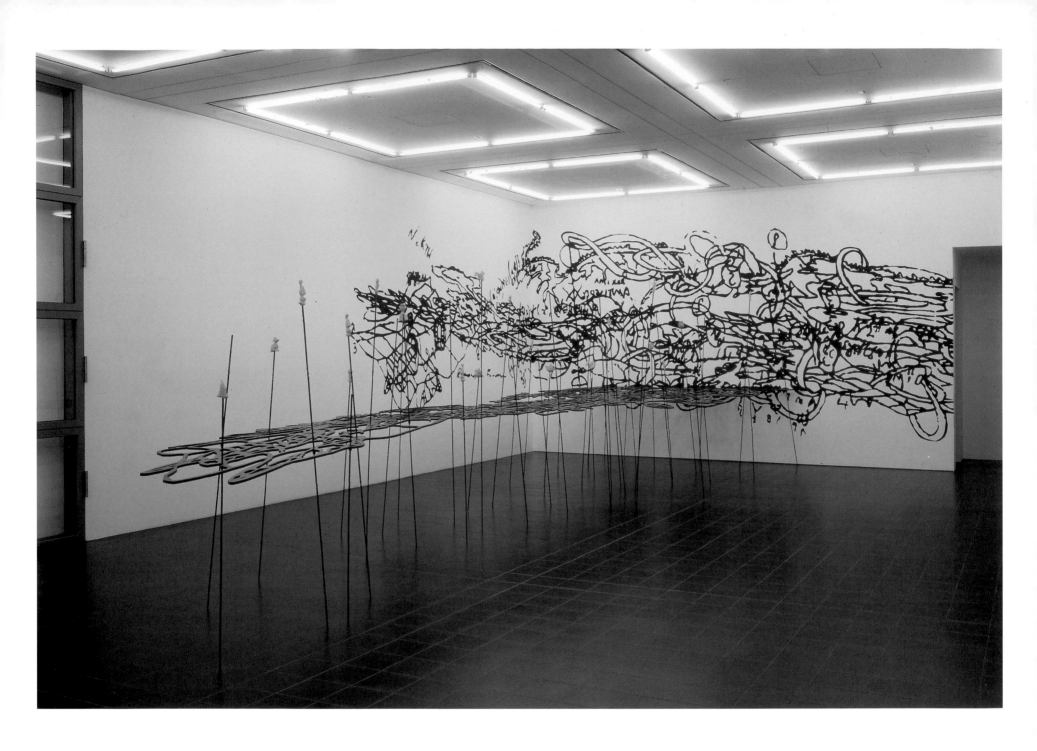

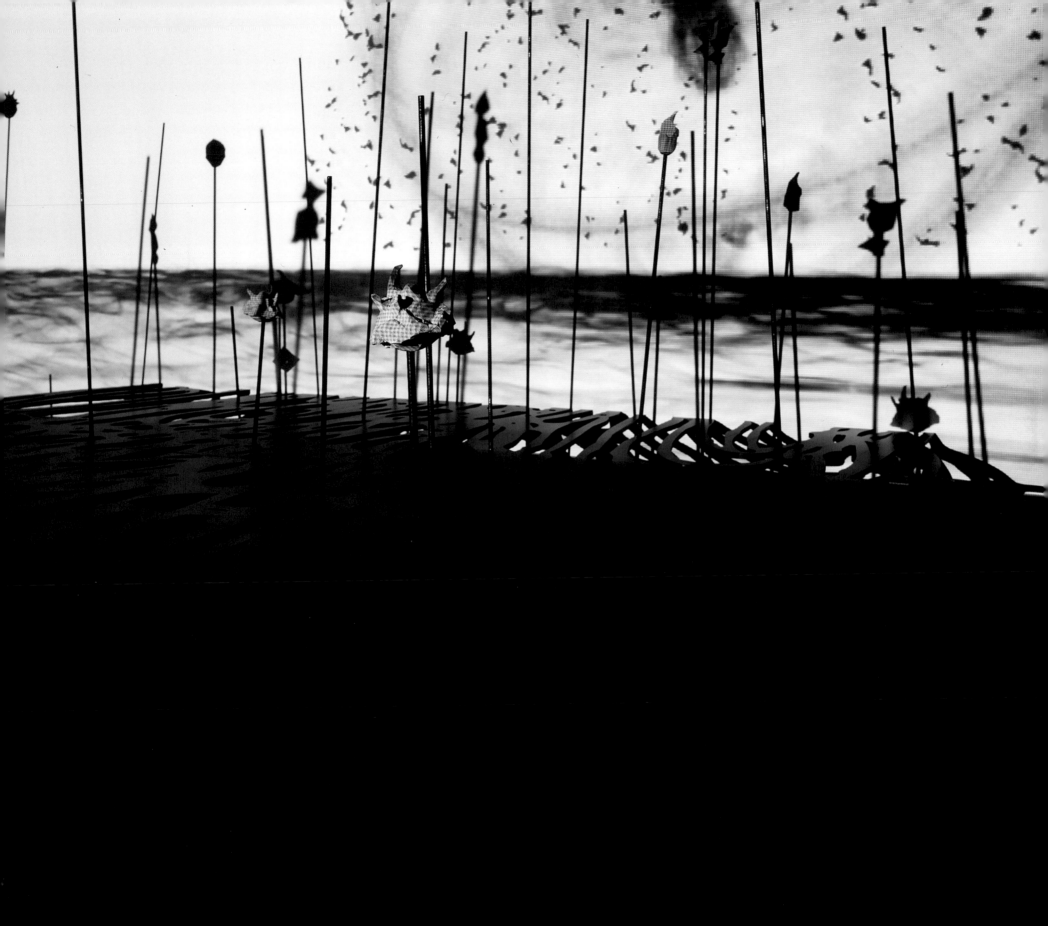

Florilegium

Like the original Greek meaning of the word *anthology*—a garland or collection of flowers of knowledge—a florilegium, or selection of flowers of knowledge plucked from larger texts, sometimes symbolized as a garden, was a repository for key excerpts from significant texts in the Medieval period in Europe. In an age when books were handwritten and their production exceedingly expensive and time-consuming, florilegia were a means by which aspiring monks and nuns could learn the key tenets of their faith and its cultural worldview without the need for a prohibitively expensive library of the full texts of all the writings a florilegium might contain, like the ruminations of the Church Fathers. These books were often heavily, if not always richly, illustrated, the drawings serving as mnemonic devices to aid the novice in remembering their textual contents. They served as stand-ins for the individual's access to knowledge in a way that is very similar to Ritchie's abstract but highly suggestive references to the laws of physics. Just as the illustrations of these early textbooks served as memory triggers, the scientific equations and formulae scrawled in magic marker on Ritchie's lightboxes, paintings, and wall drawings offer clues as to the content of his richly layered and partially abstract oil paintings, among other works. For the artist, these are reminders of his thought process when making the works; for the viewer, they are indications that the subject matter runs deeper than, for example, skeletal figures dissolving into an abstract vortex. They enable the artist and viewer alike to recall key parcels of information, analogous to quantum energy packets, that similarly interact, release parts, and recombine, and that may be deployed as needed and at will. The metaphor of a florilegium is not frivolous, but alludes to the many and varied historical, religious, and philosophical resources that the artist uses. Like a Talmudic scholar, who believes that revelation will eventually result from the iteration of the arcane texts that are the Word of G-d, Ritchie's inscription of cryptic notations implies, with a nod to information theory, that any sufficiently complex system generates its own meaning.

The metaphor of a garden of knowledge has a concrete reference point in the installation *The Family Farm* (White Cube, London, 2000), where Ritchie plants his many seeds in a multimedia extravaganza that includes drawings, paintings, wall drawings, a lightbox, and a Sintra mosaic that spills off the wall and across the floor. Here, he lets us see the connection between the universe, his narratives, and the story of is own life—another thread in the tapestry of associations, not unlike the many literal and almost scientifically descriptive references to specific flora and fauna found in the Flemish tapestries that were made roughly contemporaneously with florilegia, but for a secular audience. The farm of the installation's title is the literal farm of his grandmother, whose image graced the original exhibition announcement. However, just as everything is subject to loss of coherence and decay over time as energy is equalized in a thermodynamic system, the family lost the farm when it was requisitioned to become part of Heathrow Airport. This is not the only instance in which the personal infiltrates Ritchie's work: some of his characters are actual players in his life, like Anna, who happens to be his sister-in-law. Though the personalities of his avatars may bear little or no resemblance to those of the actual people on whom they are based, still the notion that his loved ones and acquaintances have virtual interactions in an imaginary sphere relates both to the idea that *Everyone Belongs to Everyone Else* (the title of a series of seven drawings from 2000–01)—that is, that they are all made up of the same matter and will decay, dissolve, and become literal parts of new people on an atomic level—and suggests a virtual plane on which they can enact their fantasies and nightmares, as in the many current online, real-time Internet video games. In this way, he allows both his characters and his work to take on lives of their own in spheres entirely beyond his control, if not his influence.

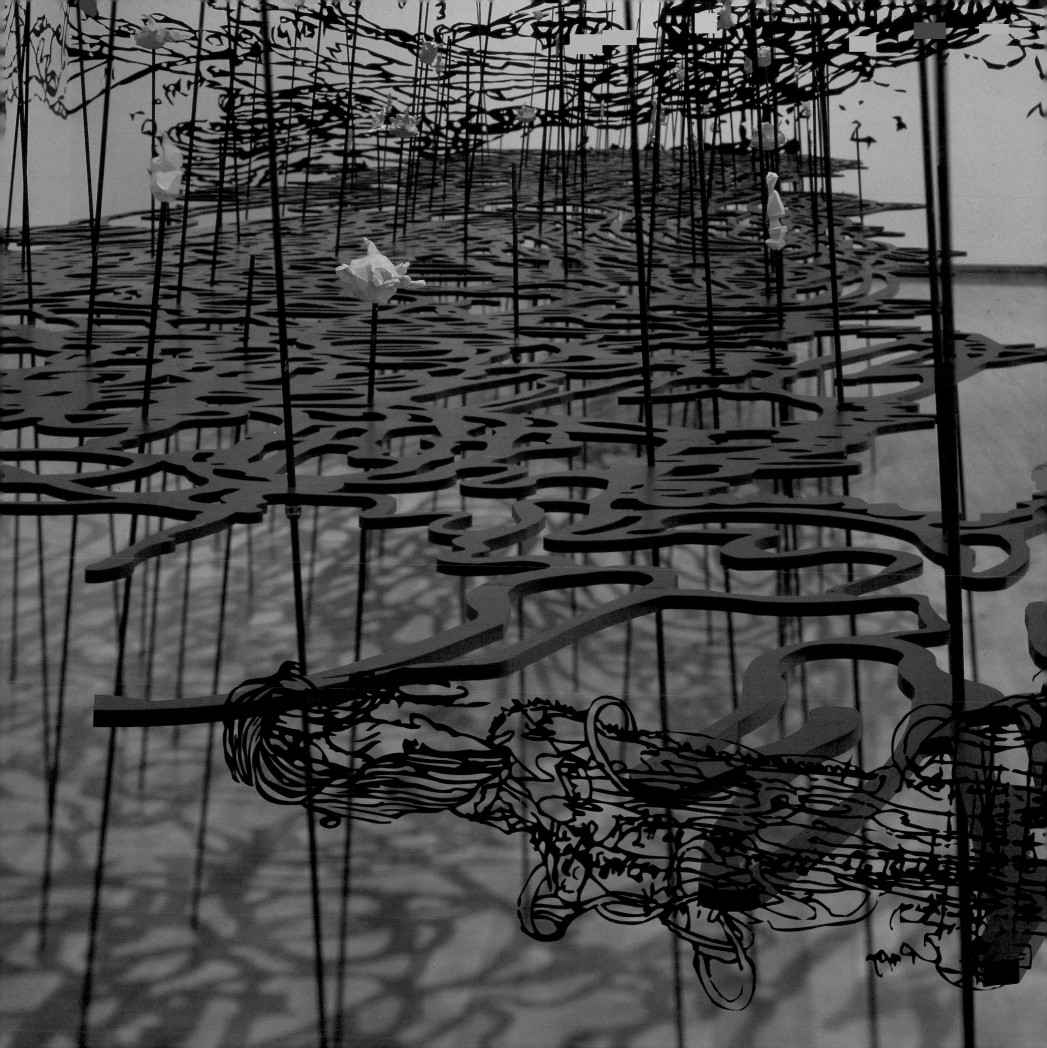

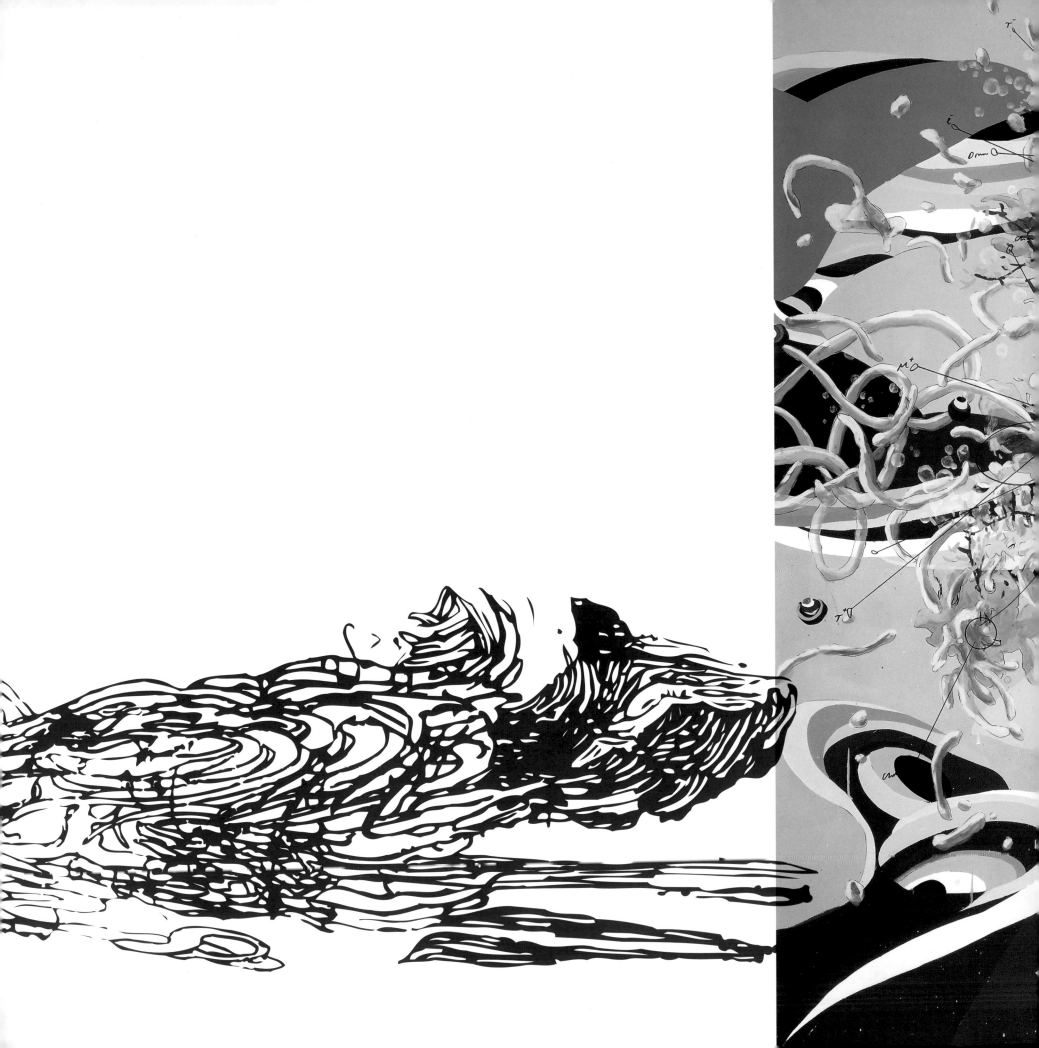

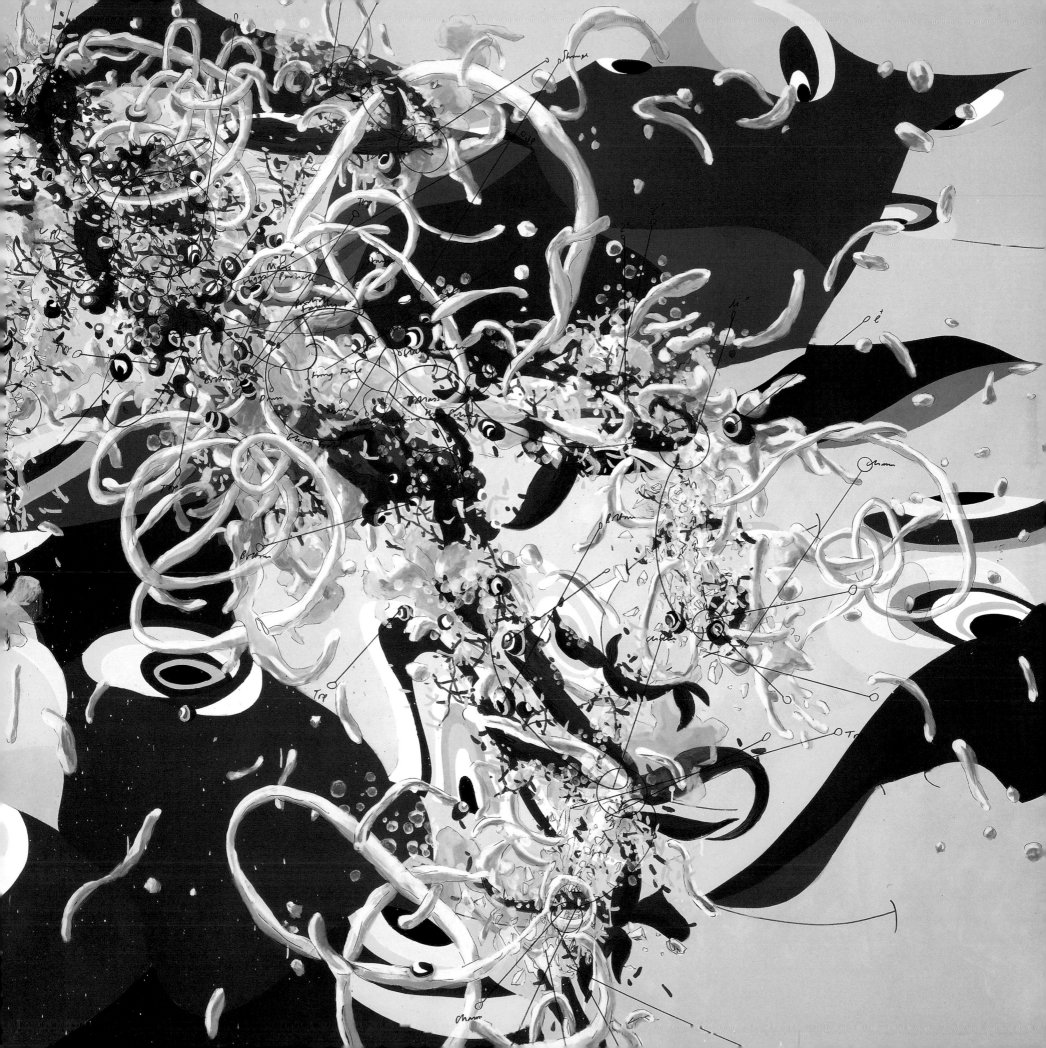

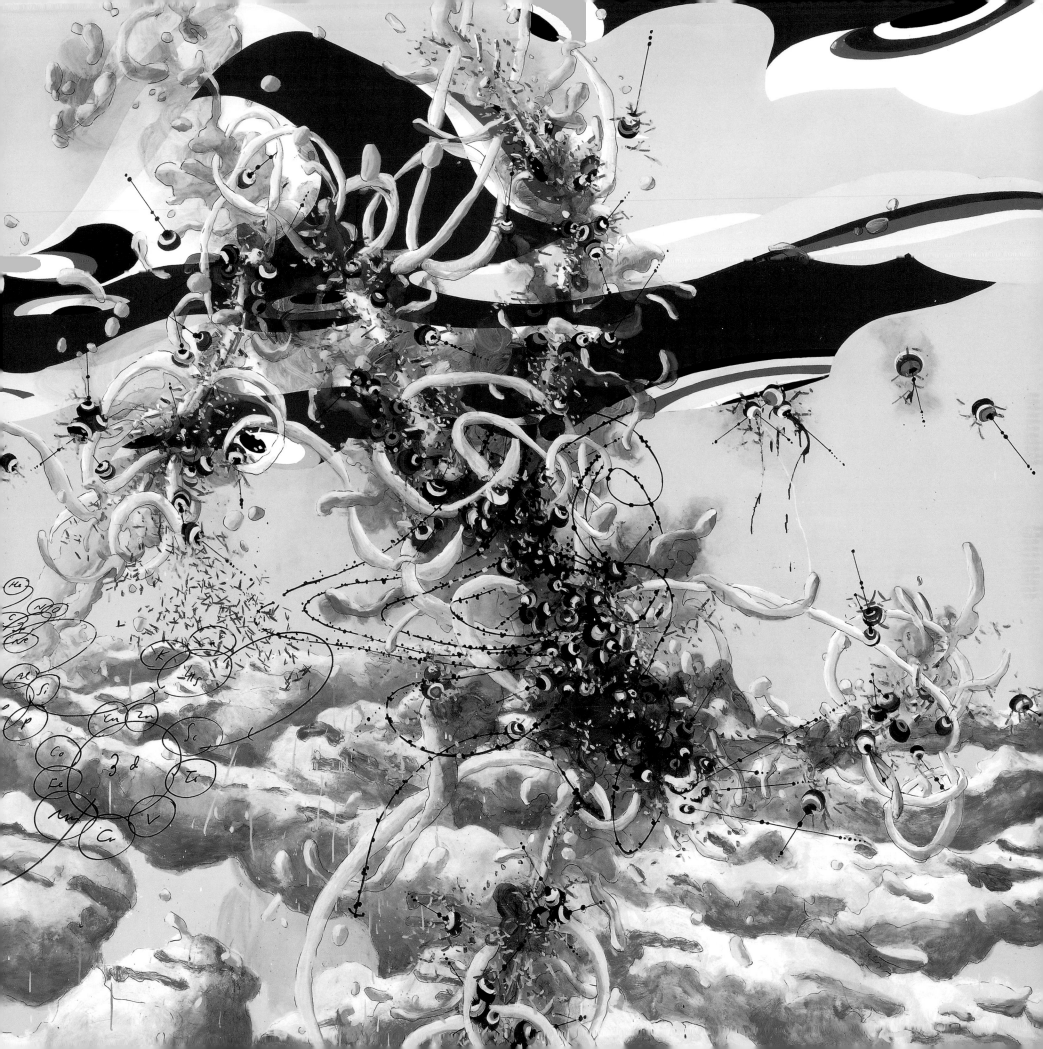

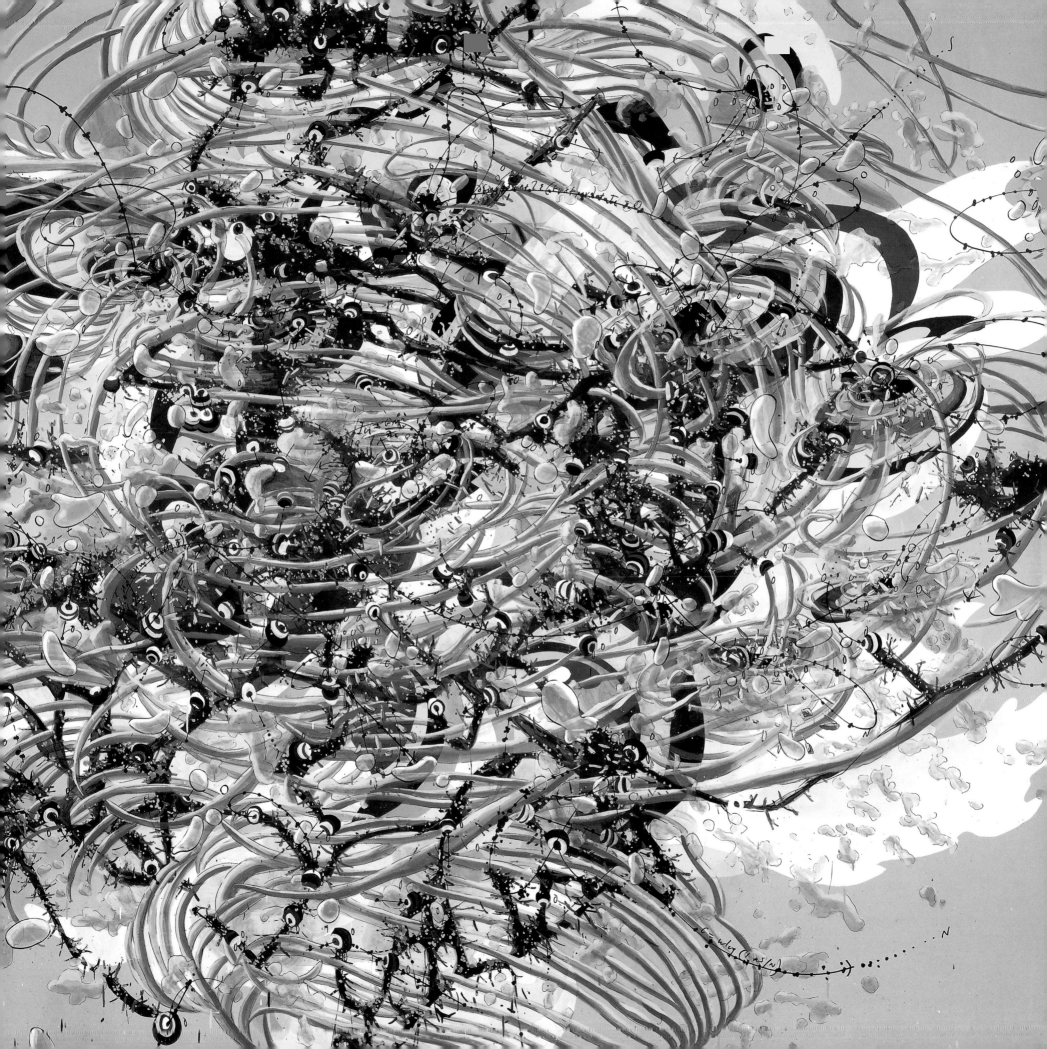

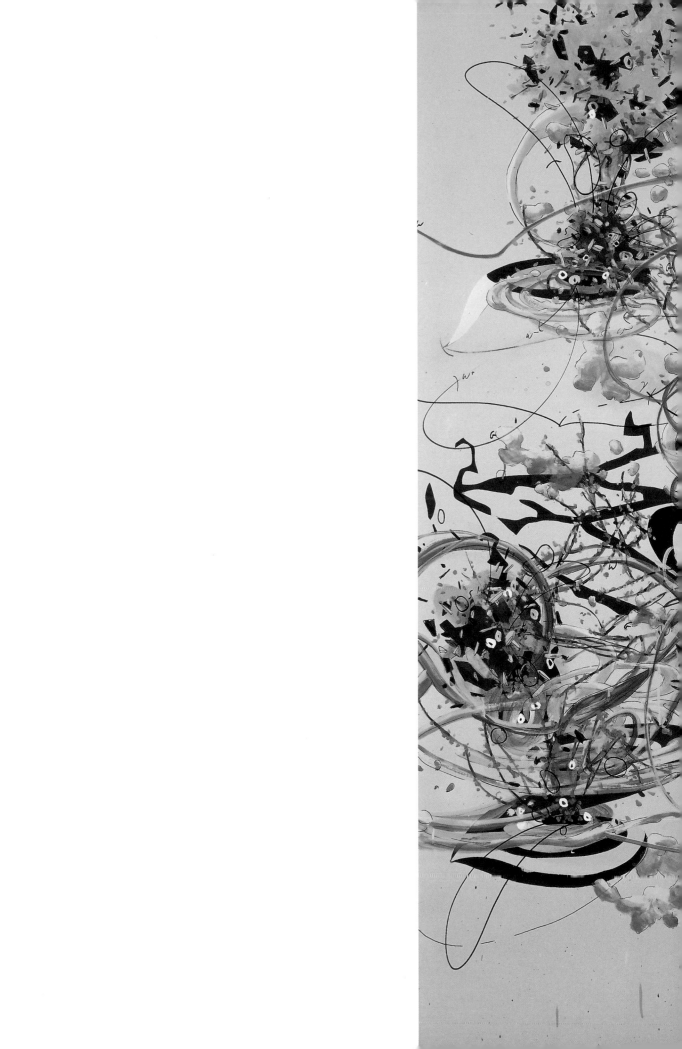

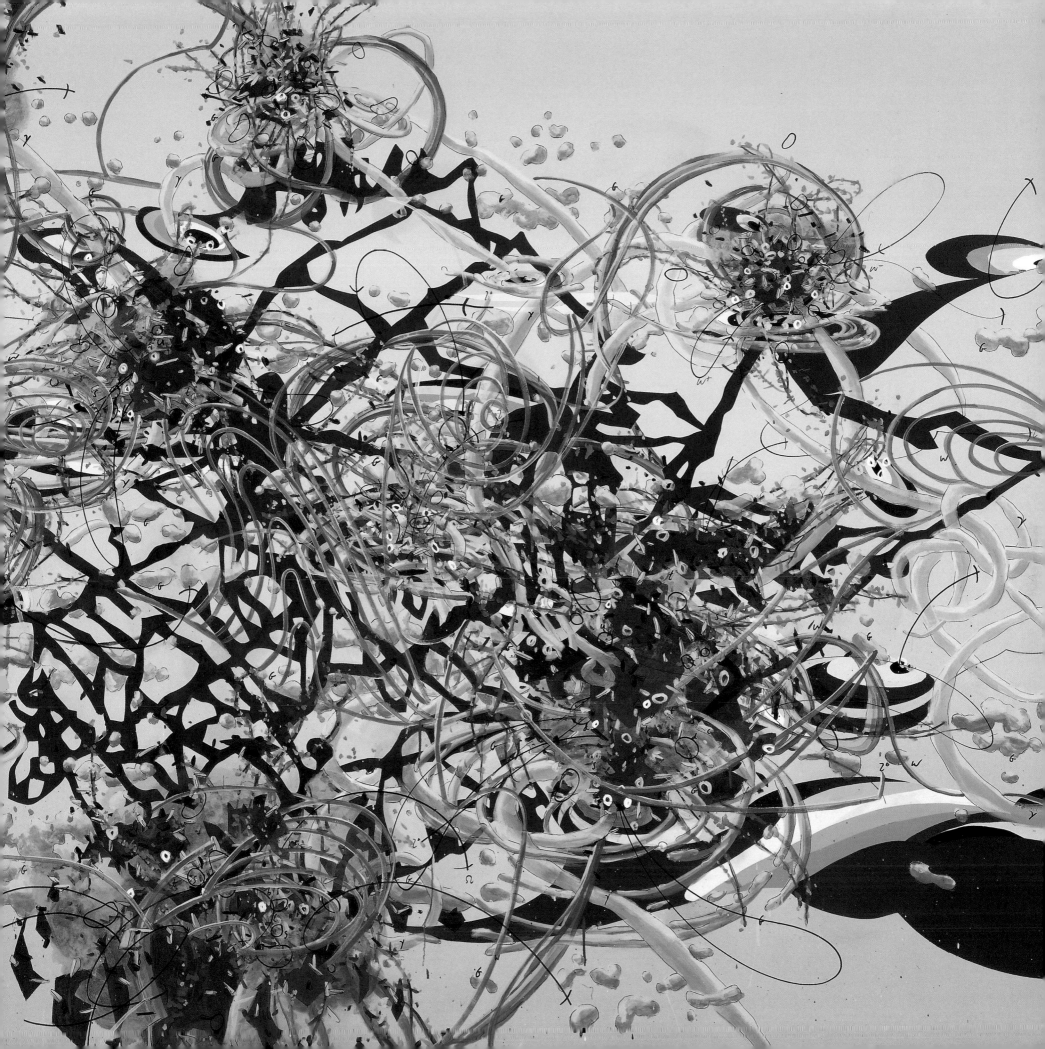

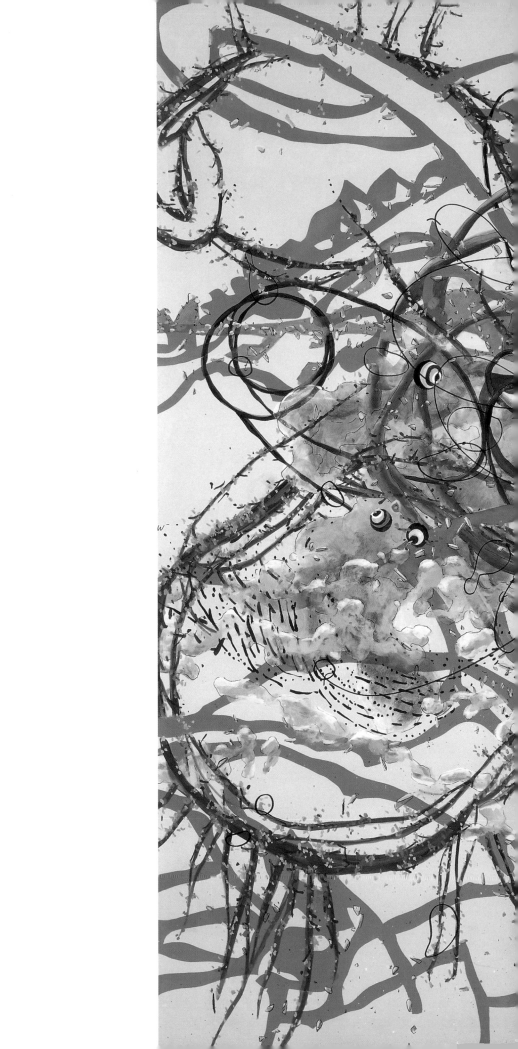

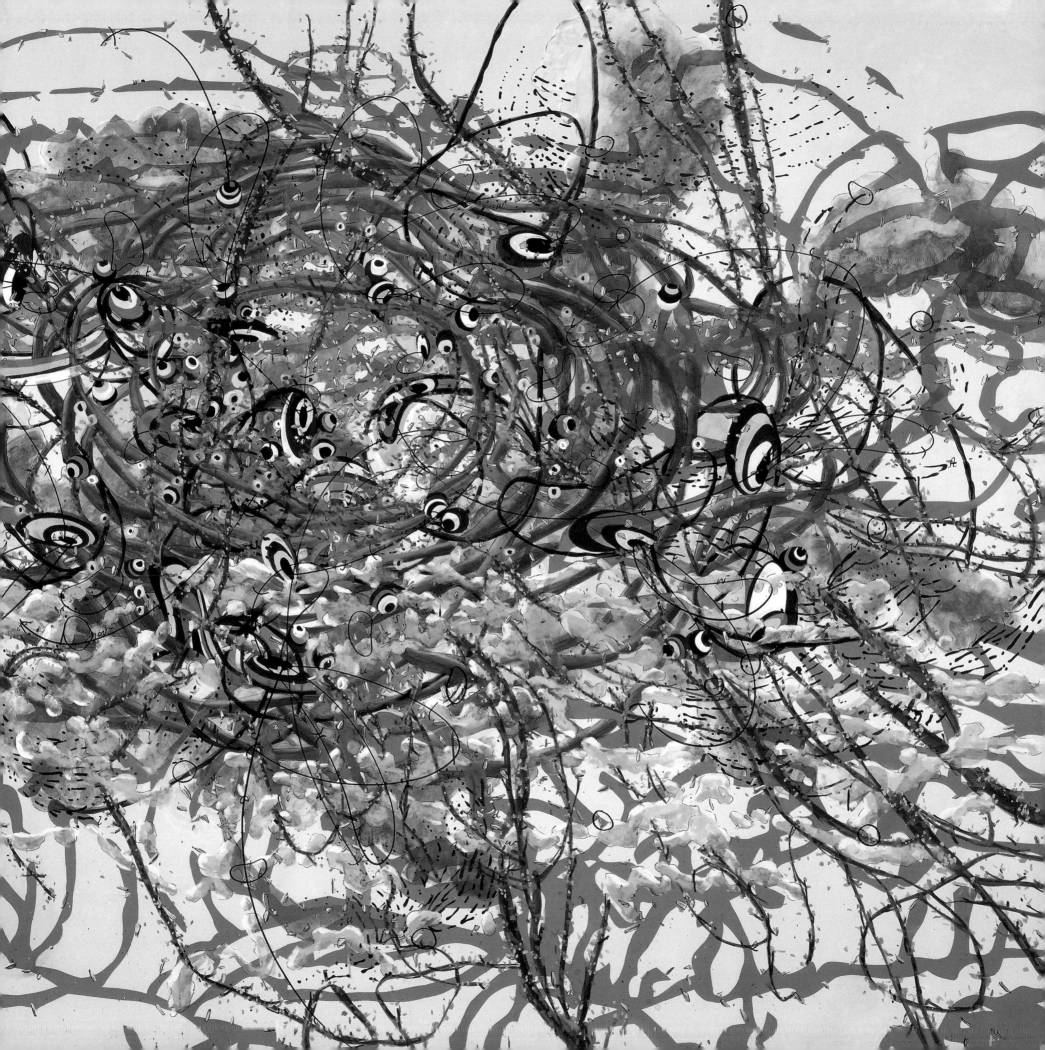

Genealogy

Seven families, of seven characters each, populate the stories written by Ritchie to summarize the history of the universe, and appear in related artworks. Since experience is retroactively structured by narrative, Ritchie believes that it is more empowering to offer viewers a parallel story to think about—something they can participate in—rather than just overwhelm them with a show of visual force, relegating them to raw experience and observation that they will swiftly and automatically categorize as pictorial. He starts at the beginning of time, where we find The Gamblers, a violent and seedy group of drug addicts who have collected at the Brockton Holiday Inn on Route 24 outside Boston. They fidget and argue in a fetid hotel suite, waiting for Purson, the Timekeeper, whose arrival follows and coincides with a series of power struggles resulting in murderous acts symbolic of the Big Bang. With the beginning of time, all Hell breaks loose. In the next installment, seven characters, a posse of angels called the Working Group, engage in building the universe in the Box Factory. Creating energy and matter in the newly formed space-time continuum, they play in an internally conflicted cover band after hours, with each member aping a different musical style, and donning its accompanying fashion, from David Bowie circa Ziggy Stardust to Bootsy Collins and beyond. The random cacophony that results is Kepler's Music of the Spheres. They are followed by the Day Watch, a group of seven cops and corrupt government officials who oversee the control apparatus of an imperfect but autocratic state, located in the Anti-City, described in the story "The Bad Need" (2001). The Anti-City is composed of 109 parts, elements of the periodic table, some of which are also the characters who inhabit it, including police detective Anna Elizardo, who is copper, and her flabby, shapeless partner Mike "the Lion" DiAngelis (mercury). They are called in to investigate a scene of violence and decay in the form of a ritual murder, where the victims have been eviscerated and their blood, shit, and entrails used as the media to draw a voodoo vévé, or wheel-shaped diagram for the summoning of all spirits. The only trick is: you never know which one will show up. The third cop to respond to the call, and the last summoned to the scene, is Sam Morden, the Iron Cop (an alias of Sammael, the Angel of Death). As in the stories "The Fast Set" (2001) and "The Slow Tide" (2000), the work of living, the consumption of energy and gradual deterioration of the individual, results in net transfer of energy away from the working system; that is, death. Seen through the lens of science, this describes the first and second laws of thermodynamics, wherein energy is conserved overall, but is constantly redistributed through entropy. We will revisit Anna, Mike, and others in "The Iron City" (2006).

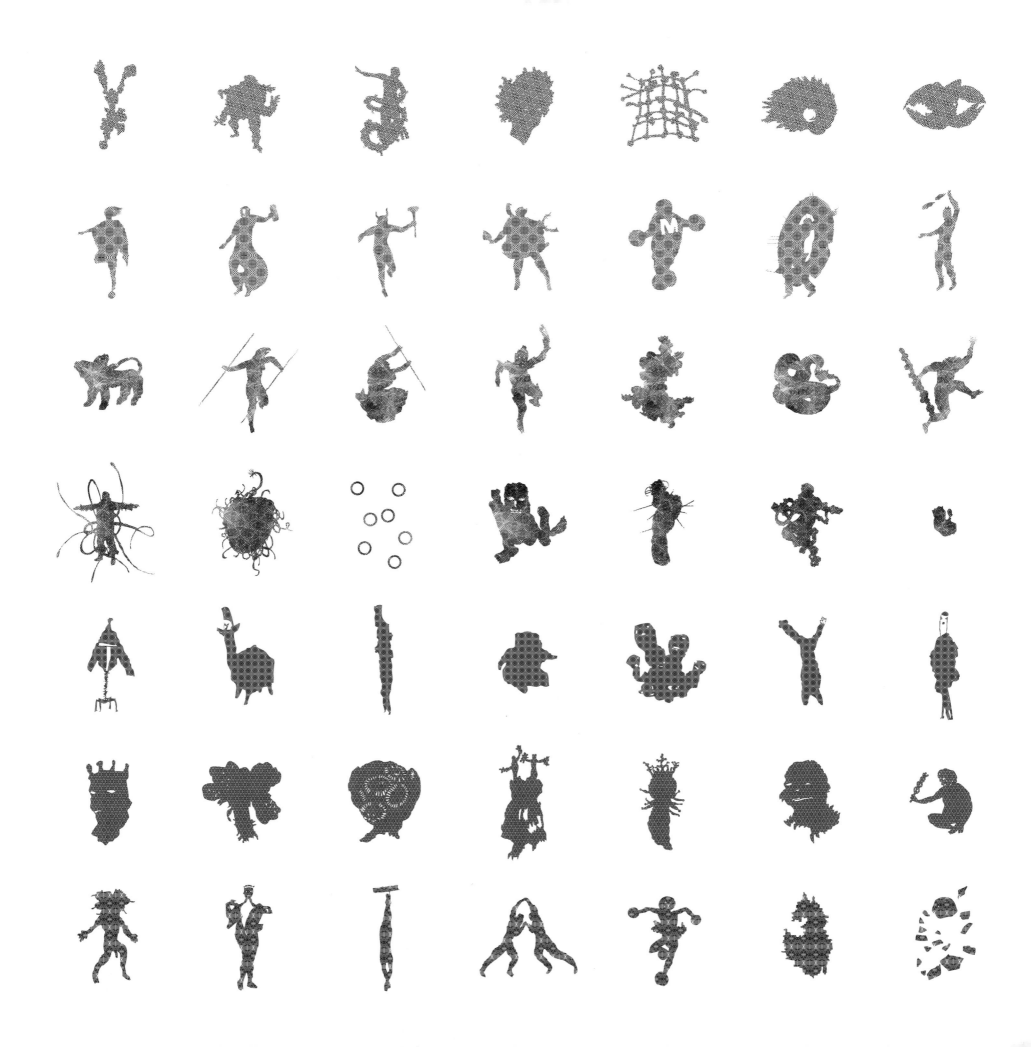

Shelley Jackson

I'm told to describe it, but I know nothing about it. Or no more than this, that it is the object I am to describe. I can't know more, since it doesn't exist yet, although I find I have already begun a kind of description in saying, It is an object, it is not yet, it will be described. If it does not yet exist, and yet is an object, then it is no ordinary object. Ordinary objects exist; that this one does not must, in fact, be its most distinctive endowment, and I have already described it. This is encouraging, I am farther along than I thought, already the object has attributes, surely its substance cannot be far behind, and in fact I already feel silt collecting under my tongue. Still, it is with the adjectives I feel safest, *waxy, yellowish,* it always starts this way, *semi-translucent,* familiar words, you would think I knew something, *tiny,* no not tiny, sizeable, but giving the impression of something tiny under extreme magnification, I don't know why, maybe due to the fine detail on its surface. A glancing light would reveal that the apparently smooth bulges are finely ridged like fingerprints, while here and there pinkish stains bloom outward from the tiny scarlet numerals that congregate in the creases like staphylococci. Because elsewhere faint meridian lines can be described I know that this object is more of a diagram of or plan for an object than most objects. You might call it a description of an object, an object that does not yet exist. This second object, described by the object I am describing, is different and better than this object in at least one crucial respect: it exists. If this second object contains the scrolled blueprints of a third, and so on, it is none of my business. What concerns me is that my object, although by now fairly jumping with nouns, *finial, promissory note, ball sac,* remains in places so difficult to make out, no doubt because it is so close that part of it is actually behind me, jutting through my eyes and out the back of my head. Describing it would thus entail describing the state of affairs within my head: slight pain, great pressure, the impression of a large wooden mass, perhaps a figurehead, proud woman, green hair, bristling with splinters, these splinters stimulating various cerebral folds, inciting thoughts such as these, thoughts that must also be described.

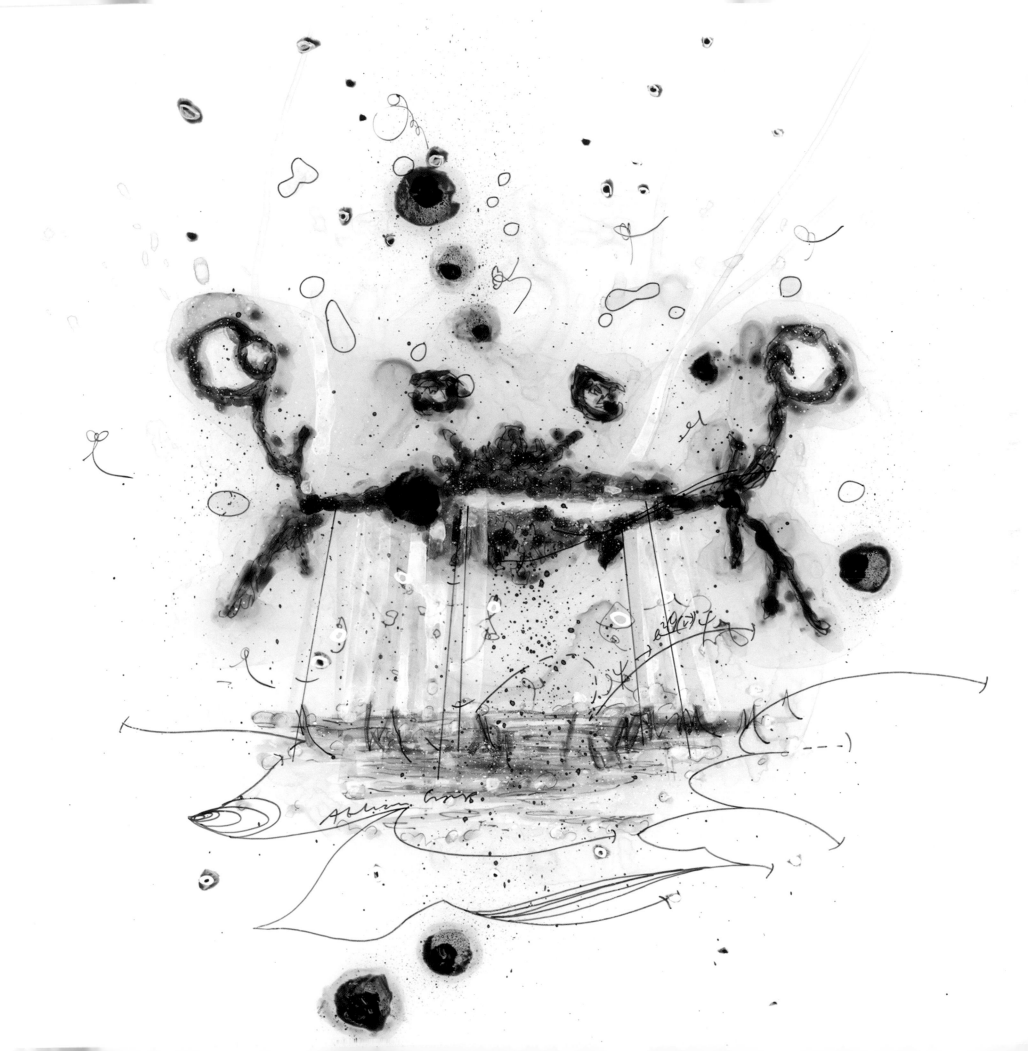

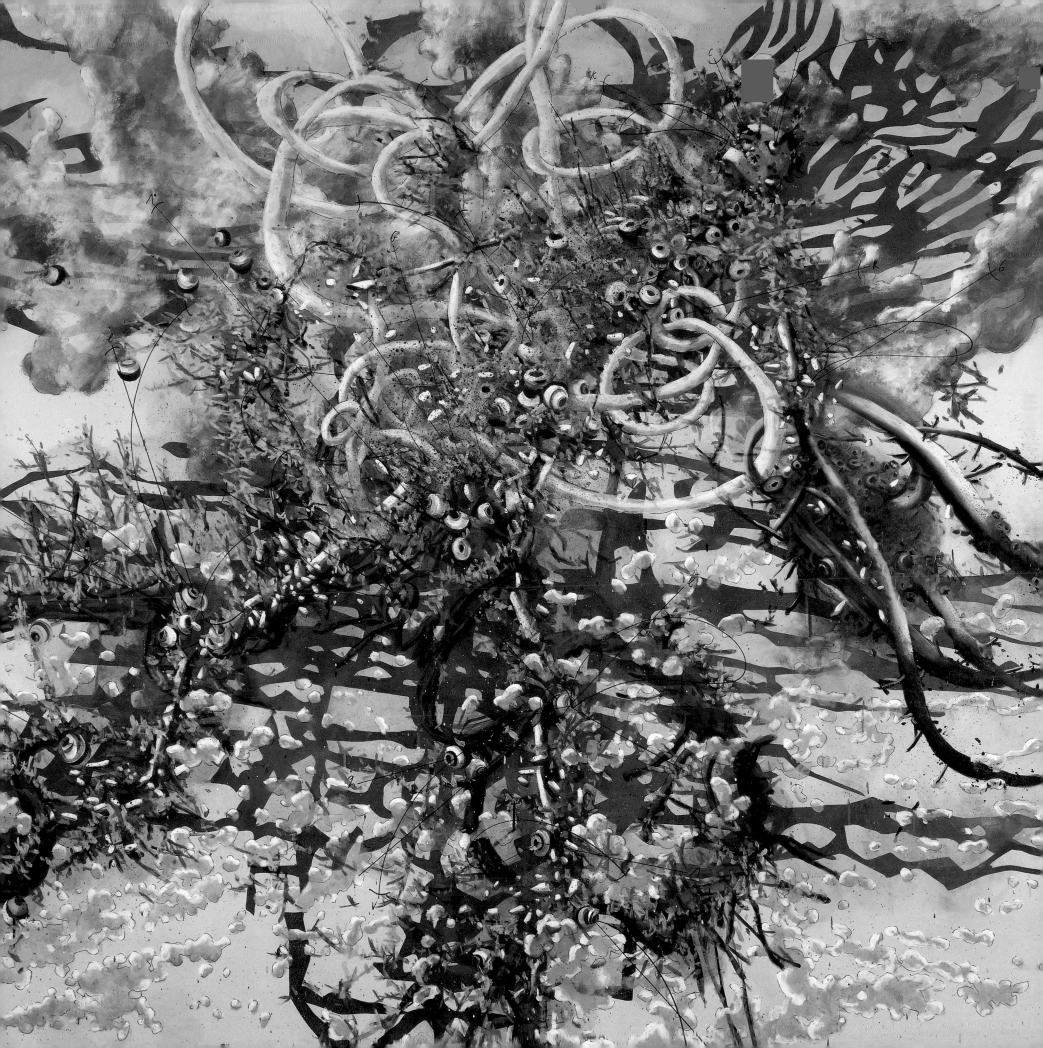

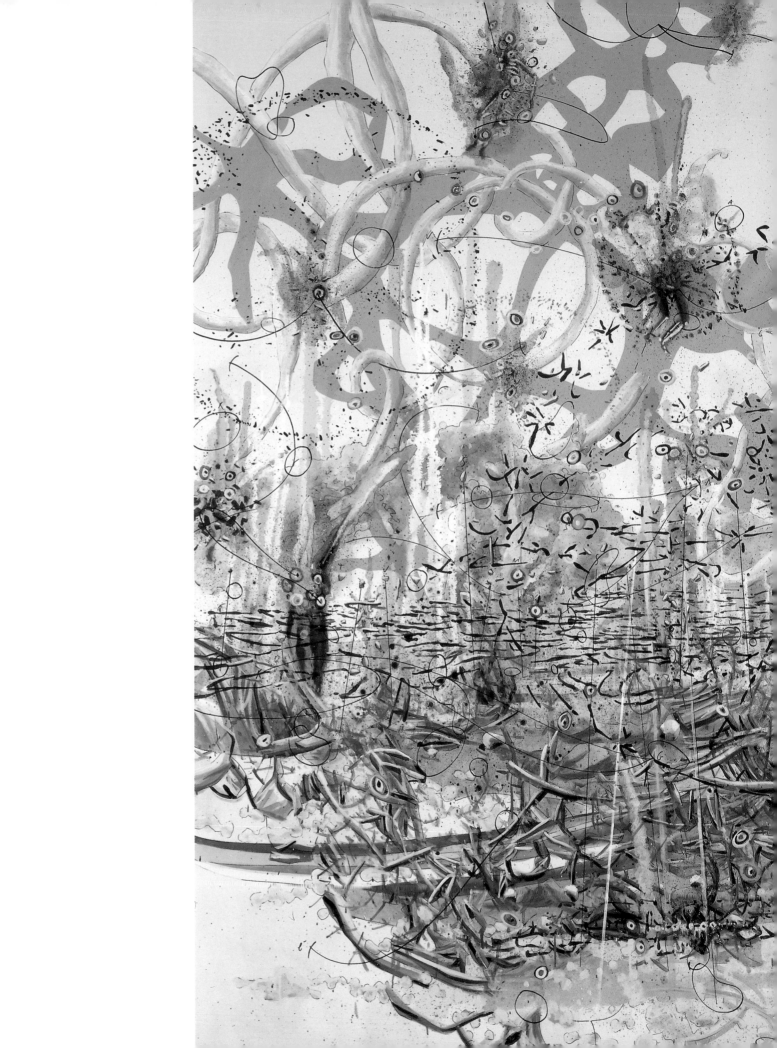

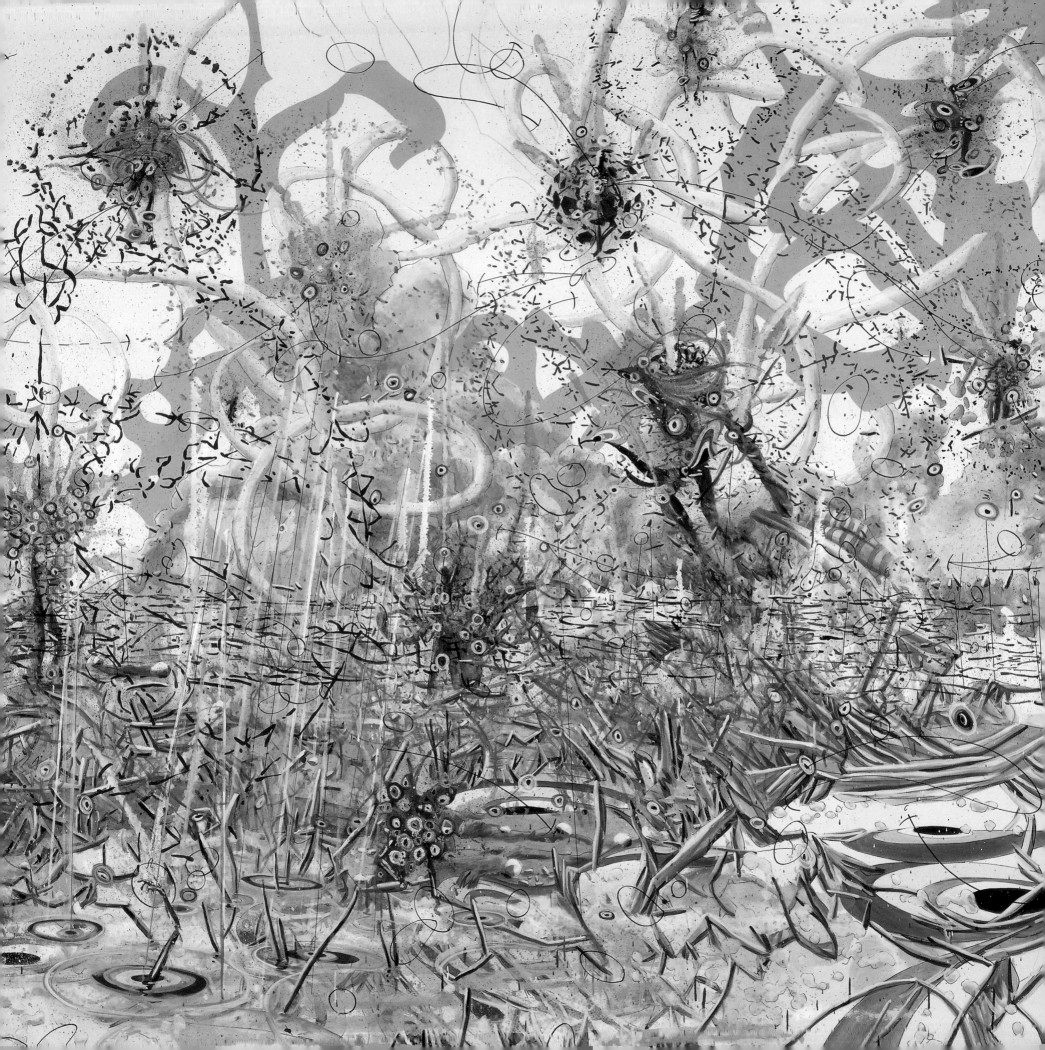

Superposition

The many traditions on which Ritchie draws in his work—religious, philosophical, historical, scientific, artistic—form a virtual Gordian knot of human intellectual endeavor. Complementary and contradictory, they seem resistant to any unified, or even coherent, explanation. The works themselves also have qualities that resist easy identification. Imagery is used at different scales and in different media in a way that suggests repetition, yet the titles differ, signaling that these are to be seen as unique works. *Eschaton* (2001) is a wall drawing that, when considerably enlarged and adapted, becomes *The Main Line* (2002) and then a large fragment of the *Hierarchy Problem* (2003–07). The production process makes enlargement and even reiteration relatively easy, as a basic drawing template is placed on an overhead projector, which throws the image onto the wall and allows its web of twisting and interlocking lines, notations, and actual formulae of thermodynamic processes to be painted in place. Though the same digital files are used to make the transparency templates to create the drawings, and they appear identical when depicted in paired installation photographs that disguise their scale, the impact of viewing each is genuinely and dramatically different. The experience of the work in real time and space and the installation strategies that enable this experience, like new groupings with other Ritchie works and adaptations for ever-new exhibition venues, are the factors that create the works' individuality. This pairs with viewer subjectivity to form new meanings and associations. The information on which the work is based—in this case, a freehand drawing that Ritchie has scanned into the computer and manipulated to lose precision and detail through commonly available graphics programs—is indeed identical. However, the two or more resulting works are no more the same than a sixteenth-century Dutch still life and one by Cézanne: both may convey the basic information that allows us to identify oranges and porcelain bowls, and both are made using oil and powdered pigment, but that is where their similarities end. On the other hand, titles may be repeated in works that are clearly very different, as in *Some Things Will Be Different*, a title assigned both to a projection and a lightbox work that share little in the way of imagery, but which were both conceived around the time of the *Universal Adversary* installation at Andrea Rosen Gallery in 2006. As so often in Ritchie's work, however, there is a clear if somewhat difficult scientific concept that helps us to disentangle the knot, which is quantum superposition.

The idea goes something like this: there is any number of possible states for any subatomic phenomenon. However, we cannot be sure in which state we will find it when we observe it. Further, the appearance of its state, whether a particle or a wave, depends on our position of observation, so it may be possible for it to simultaneously be observed in two (or more) different states if viewed from different perspectives. This in turn implies that it is actually able to exist in two different states at the same time.

Presumably, it is our own human point of view that prevents us from seeing the unifying law that makes it possible for something to be the same but appear different—we simply cannot yet get far enough outside of our own model of the universe to explain the connection. Ritchie says, "It's a new and difficult idea, that you can simultaneously be two things that are not the same thing." It is also an example of the "strangeness" of quantum mechanics, and accounts for the peculiarly perplexing character of Ritchie's project. His work, regardless of its location, medium, title, or date, is actually only one work, one universe. His and our observation and measurement of it in a given place at a specific time make it appear and manifest in apparently differing ways.

Subjectivity

The idea of quantum superposition plays out in a number of ways in Ritchie's work. For example we have seen that the stories and artworks are often different manifestations of the same ideas about thermodynamics and other laws of physics and chemistry. It also explains having the same name for different works, with different imagery in different media—perhaps they only appear different because we are seeing them from different perspectives. Nothing less than the nature of subjectivity is in question here. Historically, a subjective perspective was associated with things religious or personal. Quantum mechanics shows us that subjectivity is actually a universal and scientifically provable phenomenon. This turns religion on its end, and indicates that religion and science are actually only different models for explaining the universe, and not the contradictory and adversarial positions that recent political debates over creationism would have us believe. Conversely, science, not unlike religion, rests on faith, not in God but in the idea of an orderly universe. Without that presumption a scientist could not function. It is freeing to see, as Ritchie does, that their opposition is mere ideology invented to push a particular agenda in the political sphere, and that there is actually a great deal of continuity and harmony between apparently differing explanations for the way things work. His perspective implies the power and freedom of choice, as we ourselves determine the moment and point from which we choose to observe a particle or phenomenon.

In paintings like *After Lives* (2003), *Forge* (2007), and *We Sail Today* (2006), there are echoes of the analogous relationship between religion and science, and visions of simultaneous yet different states of being. The form of a wheel is found in many paintings. At once the wheels of Ezekiel's vision in the Bible/Torah, a compass by which to navigate the universe, and a voodoo vévé, the wheels have multiple meanings. But it is that of the vévé which shows the analogy between religion and science. This intricate diagram is a kind of antenna used for summoning spirits. By nature, it is a call to all spirits, so you never know which one will decide to put in an appearance. You observe it, but you do not know what it is you will end up seeing. In this way, it is the result of a decision (on the part of the spirit anyway)—the consequence of subjective observation and action, and therefore directly analogous to quantum superposition. In Ritchie's work, the wheel is picked out in a glowing white on a chaotic middle ground, behind which we find another, burning orange-brown wheel. Identifiable as the same basic form, we see the wheel simultaneously in two states. Further, the twisting loops of white energy that thread through the whole work are another kind of rotating motion, and potentially another state of the same object.

This notion of quantum subjectivity is really a manifestation of a choice, in which a measurement or an act can make concrete a previously uncertain state of being. In *We Sail Today*, for example, we find maroon polygons floating in the sky, along with undulating pale blue strands of pure, swirling energy. Although these appear in a work of 2006, they relate to the Golem character from "The Fast Set" (penned in 2000) and Lucifer, or light ("The Gamblers," written in 1998). Needless to say, the whole of the history of the universe was implicit in Ritchie's work from the beginning, and it is no surprise that the chart of forty-nine characters with which he began continues to be of use even as the entire project has long since detached from any linear or even diagrammatic reading. What is significant here is that Ritchie has chosen to depict the actions of work and light; thus, their images become visible. He observes them in action and they consequently become concrete. There is a downside, though: by observing and choosing, we do work, and in doing work, energy is released, entropy accelerated, and death brought one step nearer.

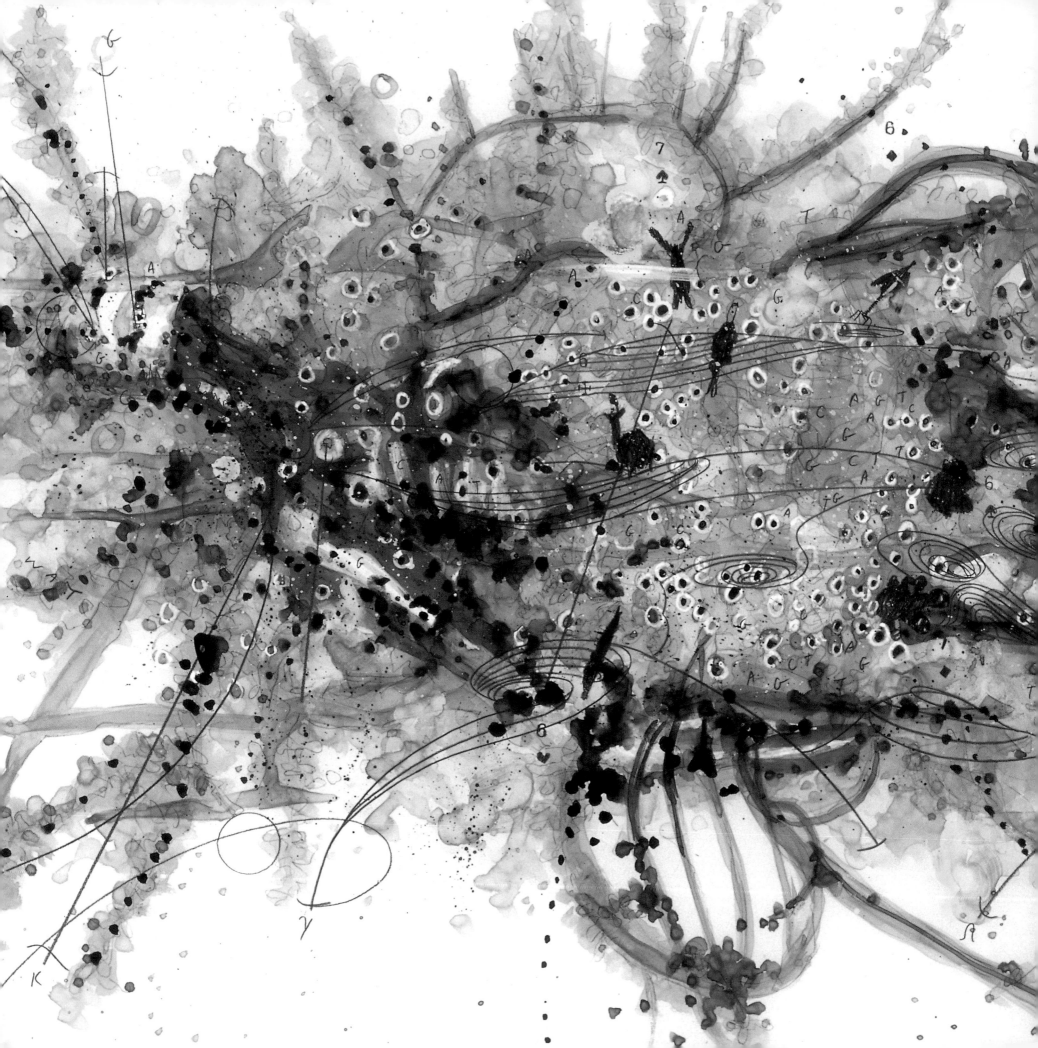

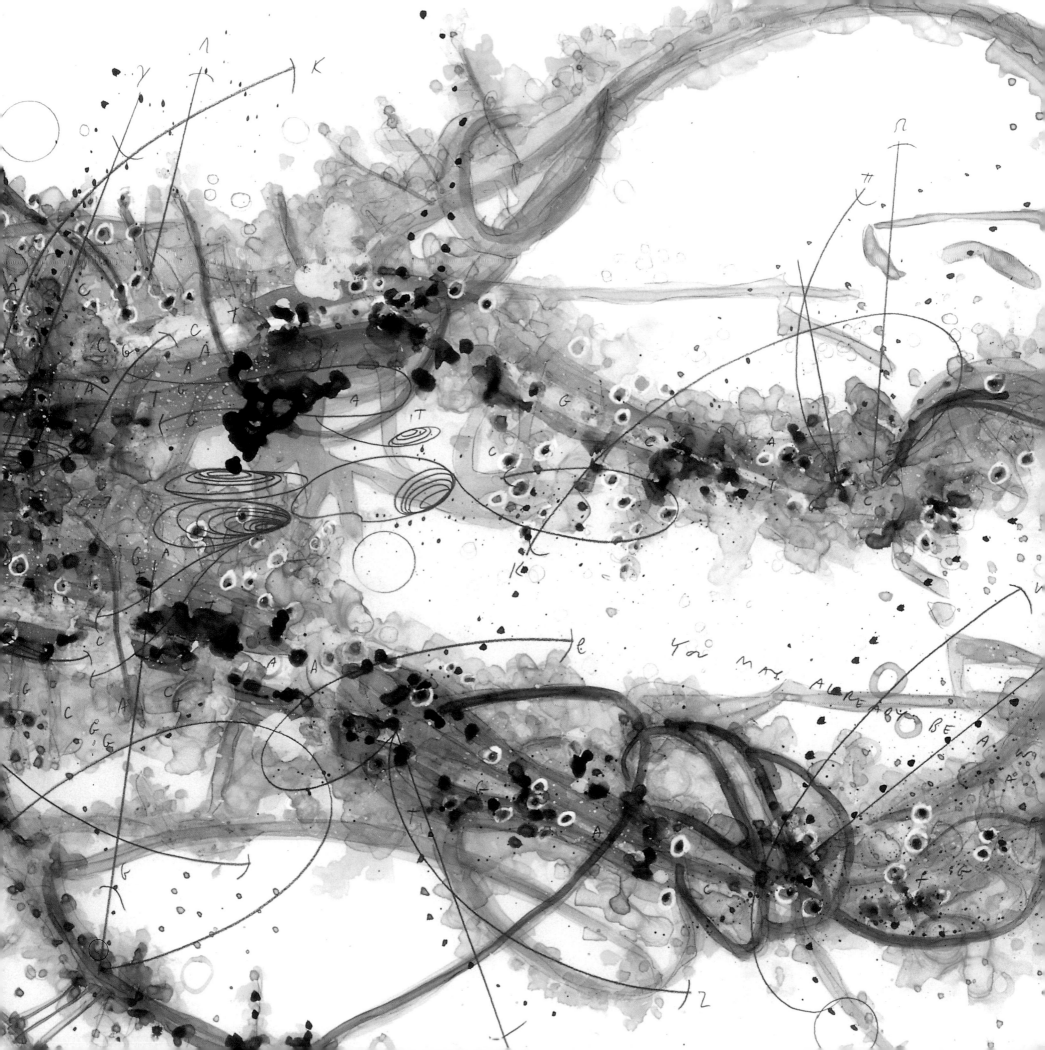

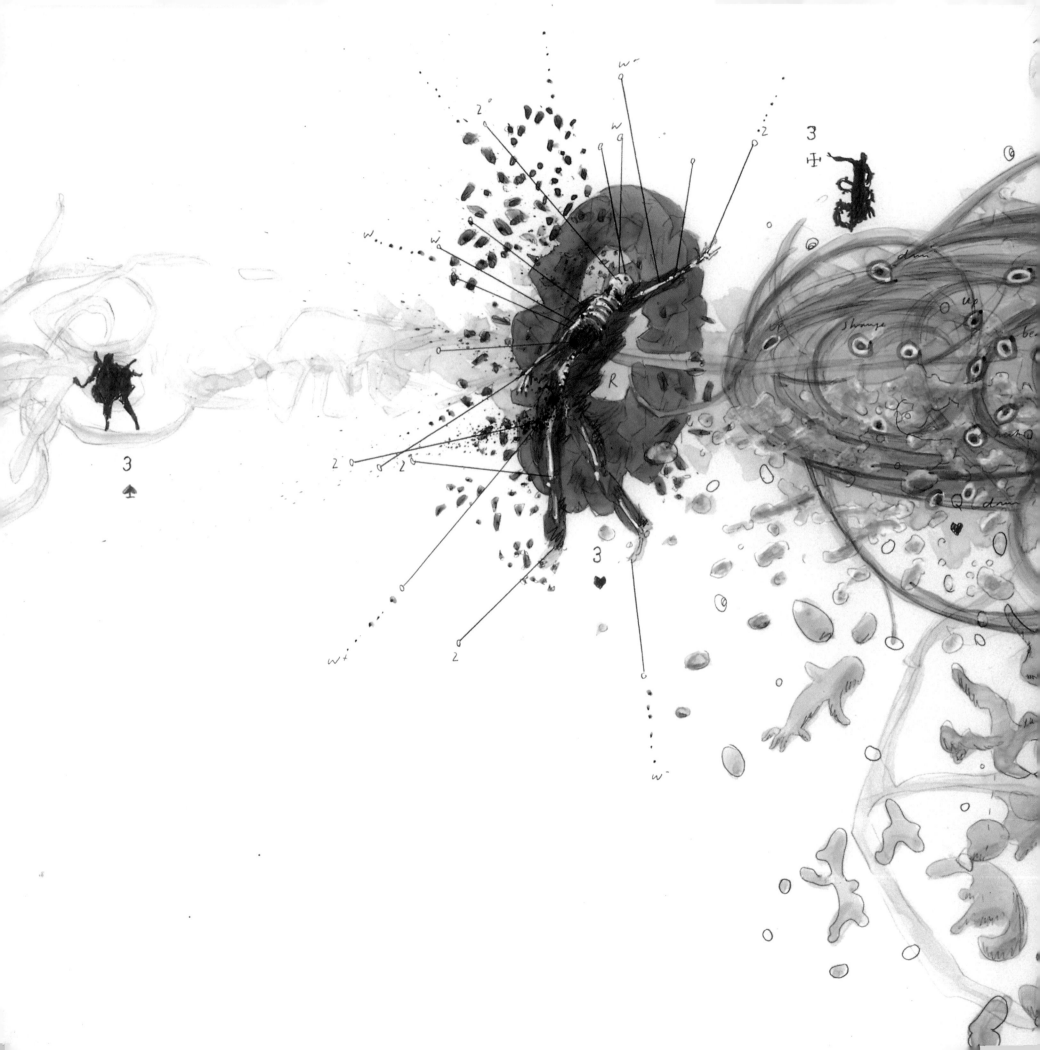

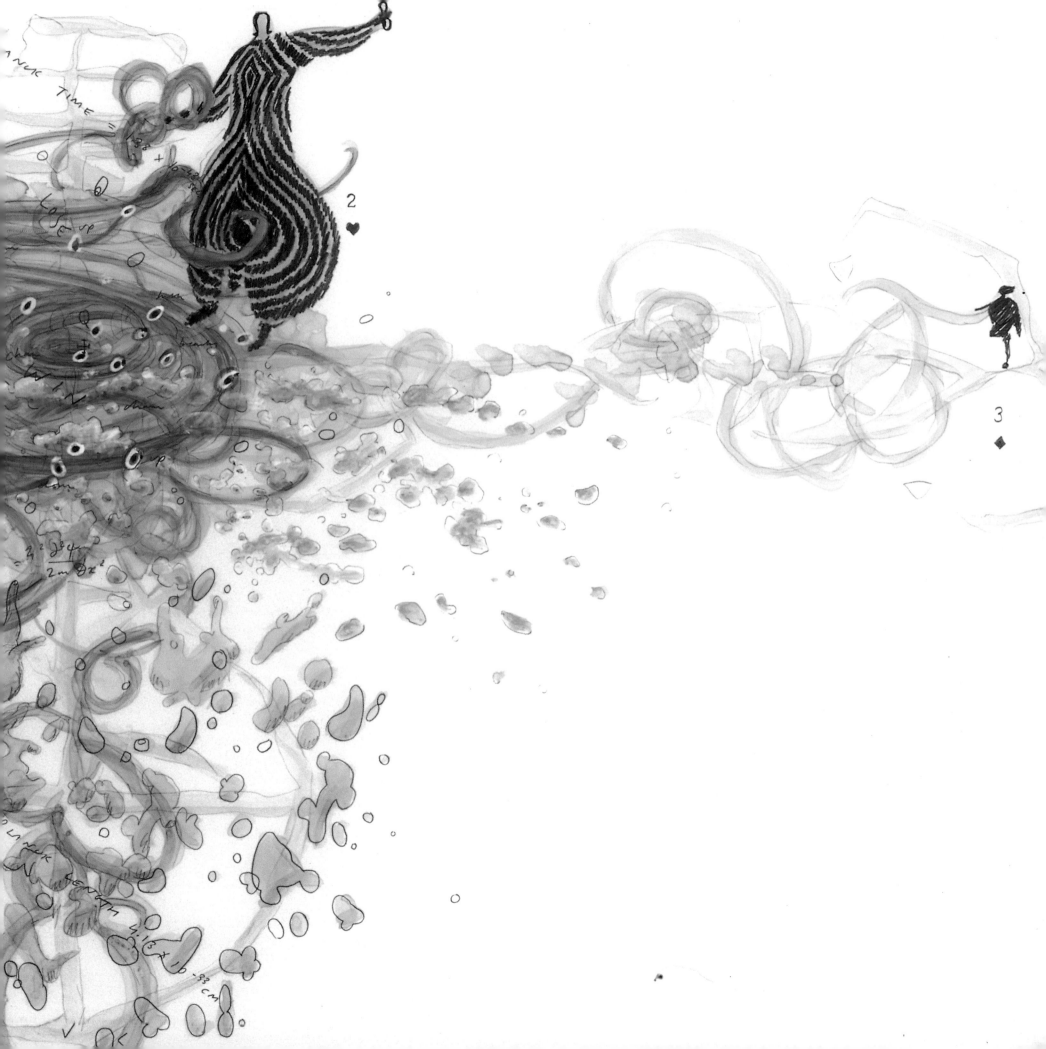

Digitization

It is a commonplace notion that as individuals, we are unable to come to terms with the overload of information provided by computers and the Internet. No less than the entire history of human endeavor is available, and it expands exponentially every second. We have reached an event horizon, a singularity similar ot that of the invention of the printing press, the Industrial Revolution, or the invention of the camera, a moment in which our very assumptions about reality, and certainly our perception of it, are up for grabs. Words like "bombardment" and "assault" are often used to describe the phenomenon of increased information flow that has resulted from the widespread access to personal computers and the Internet. The inevitable consequence has been to boil down information and homogenize cultural expression, in adherence to the natural progression of energy (information) exchange and entropy. Since the Internet treats every piece of information as though it were of equal value (a pixel, a byte), organization is lost. Without the ability to prioritize and categorize, we lose control over the constituent parts of our own history and social organization. There is the potential for us to become slaves to this system, as science fiction so often warns. (A popular, if overly analyzed, example may be found in the *Matrix* series). But people have always had an impulse to create models of reality for the sake of convenience in relating to the world, and for the sake of developing a sense of security about probable outcomes in planning their lives. Whether religious or scientific, this impulse remains. Ritchie suggests that we use it to reverse the flow of entropy. Instead of falling victim to a tool of our own devise, Ritchie tells us that through the computer, "we have renewed possibility, and in a sense, power. We have more power as individuals (with data storage and processing capability in our personal computers) than the Pentagon had in 1951." And that power is fully within our grasp—it resides within compact and portable units of manageable size, in corners, under desks, in briefcases, no matter how small the home or office. We can invent our own worlds and political and social systems—as many as our creativity allows. We can work against the debilitating flatlining of all of our systems, including political systems (every empire has its decline, right?). "It's all there for you, all you need is this little box, this cornucopia of intellectual practice," to close the power gap. The ability to use it as a tool, manipulating the functions of its programs, and capitalizing on the unprecedented access to worldwide communication that it affords, works against the assault metaphor so commonly heard. And new communities are created in resistance to homogenization and decay.

Instead of falling prey to its power, we may use it in ways that both work with and against the intentions of programs and programmers. We can manipulate images for our own use, adding and subtracting images and information at will. We can use it to organize or disorganize an image or idea, as Ritchie so carefully

does. The wall drawings in his installations are made by scanning a gestural line drawing on paper or Denril (a synthetic vellum) into the computer, blowing it up to the point where it appears to pixelate, and both adding and removing detail and information in unusual ways, simplifying it and allowing it to hover between the analog and digital. The result, made by taking a printout of the file on a transparent sheet, placing it on an overhead projector, and painting in the lines thus projected on the wall, ends up not looking particularly individual and gestural, allowing him to resist old-fashioned ideas about the artist as god-like creator. The drawing's final form is neither mere printout nor obviously handmade. Neither does it appear "digital," as an artificial, perhaps pixelated, image of something else: it has its own independent and unique status that resists both the thermodynamic breakdown of digitally manipulated information and the cliché of the mark of genius. *Ezekiel I*, *The Holstein Manifesto*, *Ghost Operator*, and *Day One* work similarly, as Ritchie's drawings are scanned and then manipulated to make digital films that appear to be in motion (it's still just information recorded on a hard drive, after all, so the movement is illusory). Identifiable as drawings, but overlaid with a subtle but insistent pixelation, they too manage to walk the digital/analog line. One thing is certain about all such endeavors, though, which is that the mixture of digital and analog processes ensures the production of totally unique works every single time, regardless of whether they rely on the same information sources.

By taking advantage of these possibilities posed by technology, each of us is a potential explorer of new territories that are entirely beyond the control of any real-world political authorities, or other people in general. We can carve out parts of the digital sphere as our own. Ritchie's entire oeuvre may actually be seen as just such a colony, where he allows for himself and us the space to act according to our will, and to take responsibility for our own place in the universe. And what about his entirely nondigital works, like paintings and drawings? Well, it's simple enough to say that he just likes to paint and draw, so he keeps on doing it. It is just as possible, though, that these practices allow him to maintain a place for personal agency, and to resist the potential flatlining of the information environment.

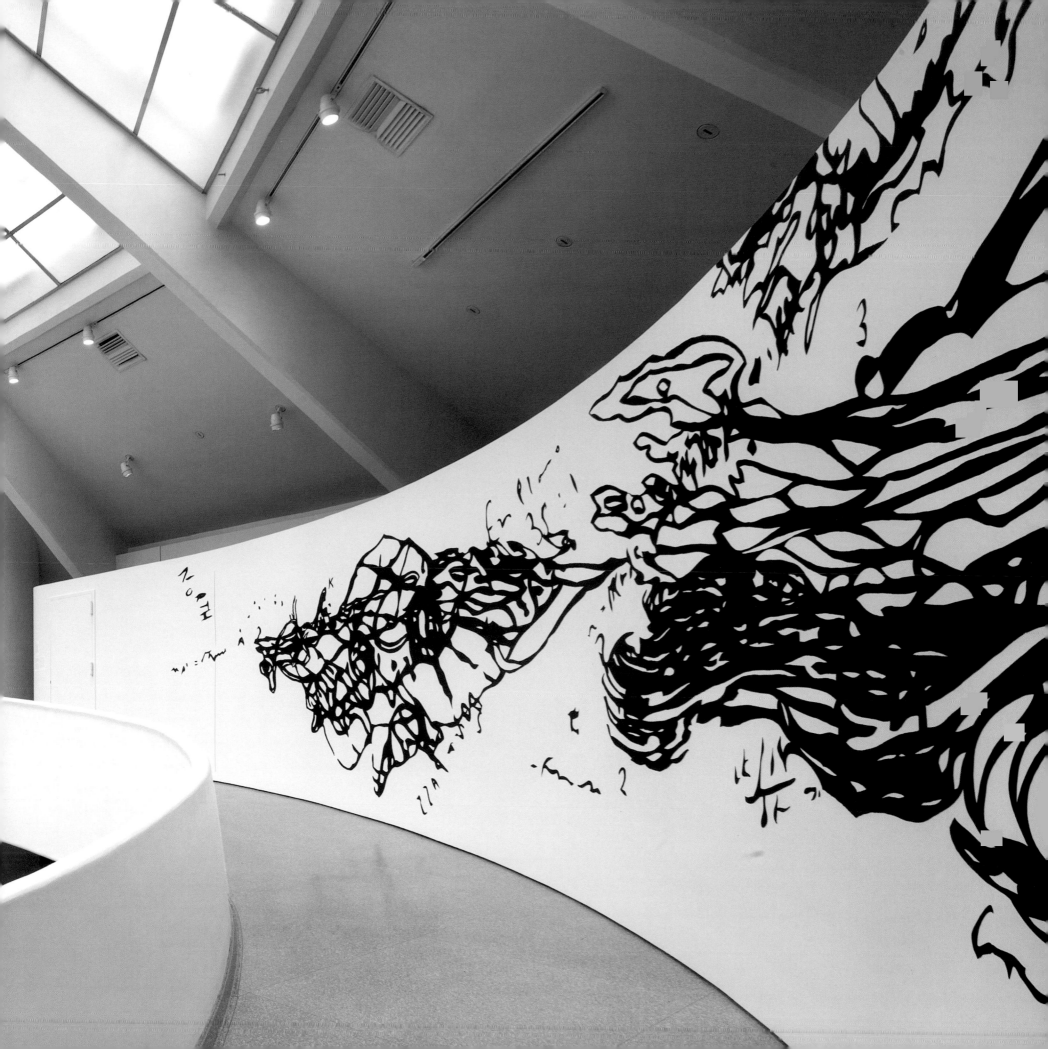

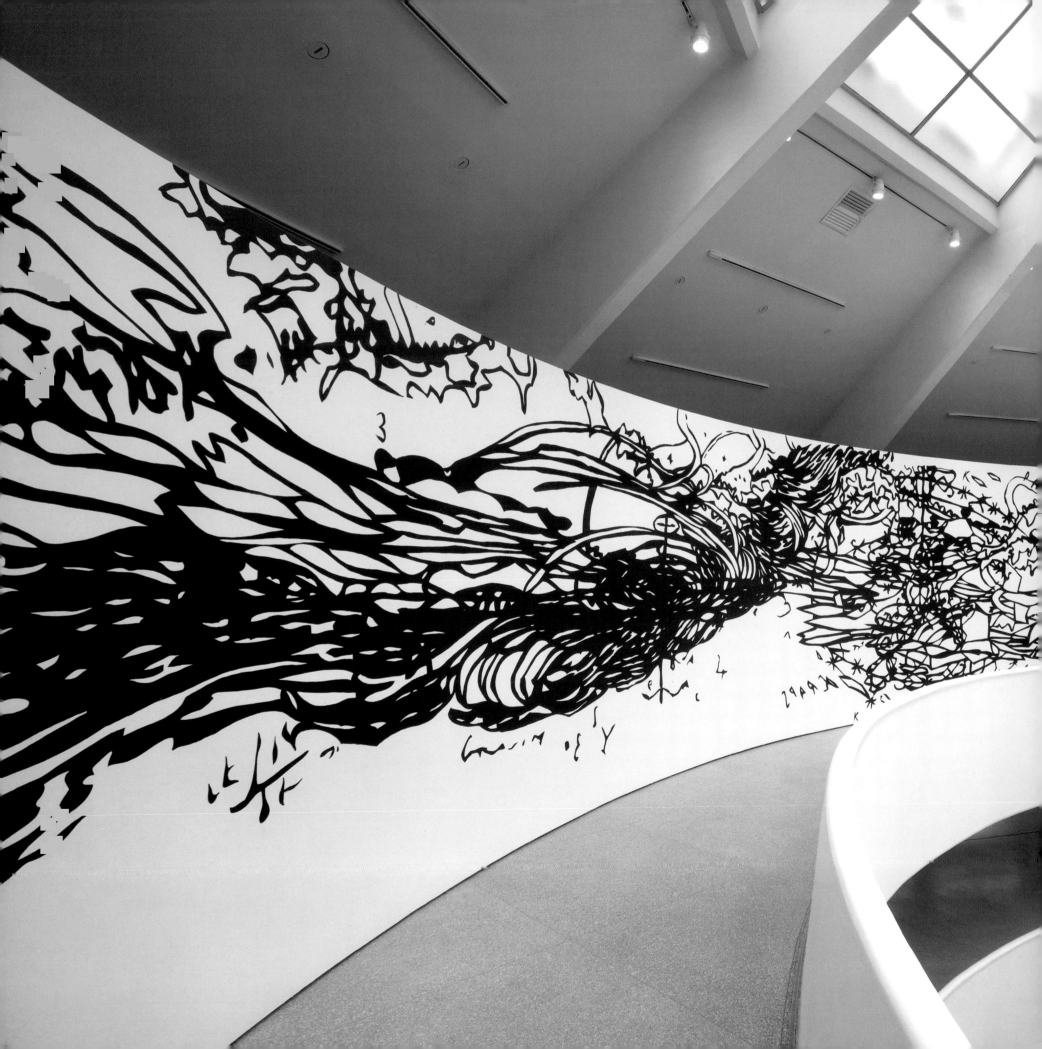

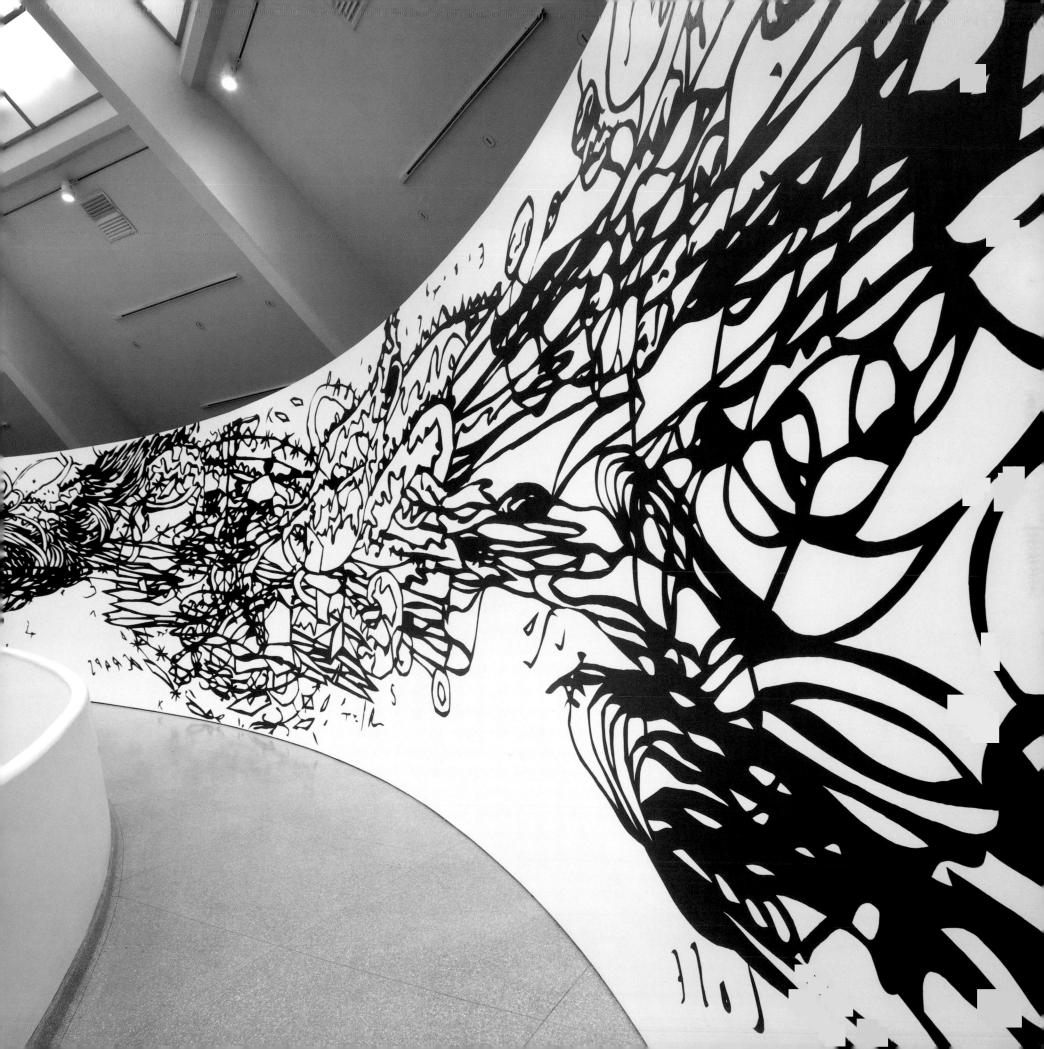

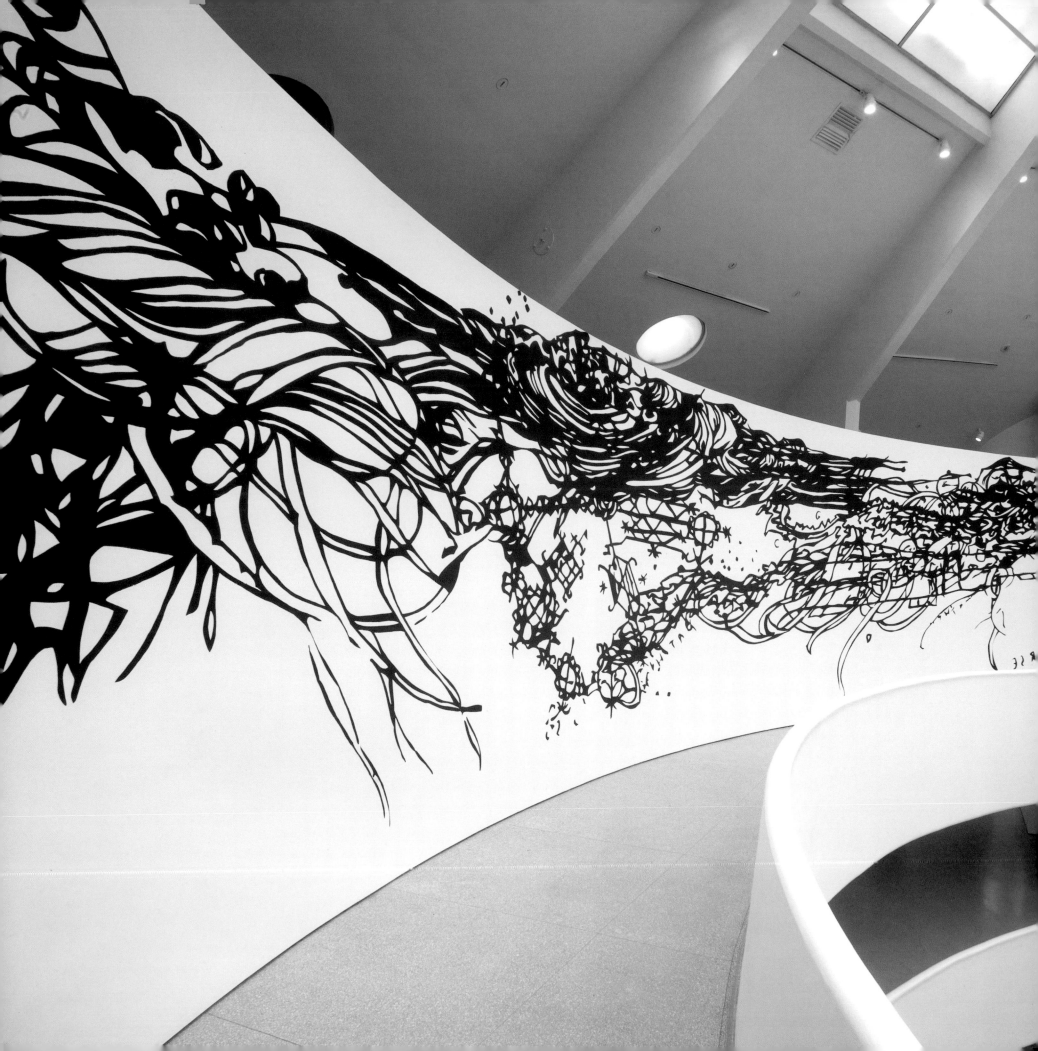

Scaling

The universe is all that there is, without anything external to which it might be compared, so it has no sense of inherent scale. It is also important to understand that the universe began with a very small thing and is continually expanding. With this in mind, we can see that the repetition of imagery at differing scales in Ritchie's work, most obvious perhaps in wall drawings like *Eschaton* (2002), *The Main Line* (2002), and *The Hierarchy Problem* (2003–07), then, is less about mechanical reproduction in the tradition of Warhol than it is about superposition and expansion. Such works, along with powder-coated aluminum sculptures like the enormous *The Fine Constant* (2003), are made from materials that give little sense of texture, scale, distance, or size, implying the expansion that is under way, in addition to reinforcing that our perception of the objects depends on our relative subjective position. And while one might surmise that the works are simple editions and variations of the same thing, this is not accurate. Similar or identical imagery made at different scales, sometimes with different names, is another way of describing the way the expansion of the universe looks from different points of observation, and just because something may be seen in two different states – say, in different media or different sizes – that doesn't mean it isn't the same thing. Superposition has taught us this much. But how do we account for these as unique artworks if they are not intended as editions? Ritchie posits the notion that uniqueness and reproducibility do not preclude one another in the context of a digital environment: "[A work's] uniqueness is not privileged to its reproducibility. And its reproducibility does not defeat its being unique. These two things are no longer antagonistic." Since the information is digital, it may be utilized – made to work – without any net loss to the system, in contradiction to the laws of thermodynamics: it remains unique. Each unit of information is a kind of universal cell that can be endlessly combined and recombined with others of its kind to create an infinite number of different and discrete possibilities, each with its own outcomes, depending on the moment of observation. The flip side of this is that since it is generated virtually, when you try to pin it down it's not really there – it's immaterial. What appears to be water in *Clinamen* (2005) or *Ezekiel I* (2006) or *The Holstein Manifesto* (2008) is really only a representation of quantum wave forms, and the pieces are stored in a tiny section of a hard drive – the spaces they depict do not exist in a form we can inhabit. All of the works, whether material, as in a painting, or digital, as in the animations, are not the actual places or narratives or things – they are mere artifice, the representation of information. Like a hologram, they can be entirely unique (as they are in the case of the uneditioned works), they may have area from some viewpoints, but they do not have volume.

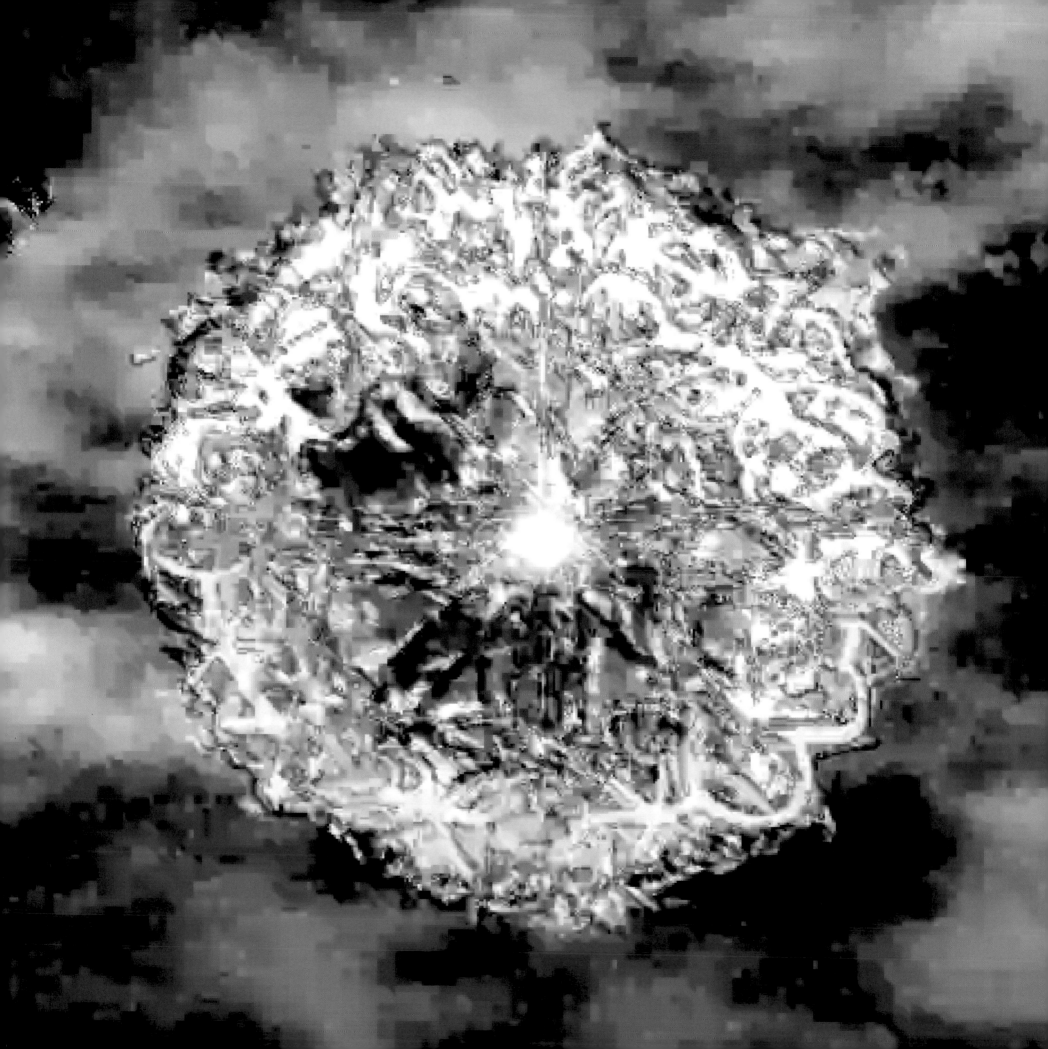

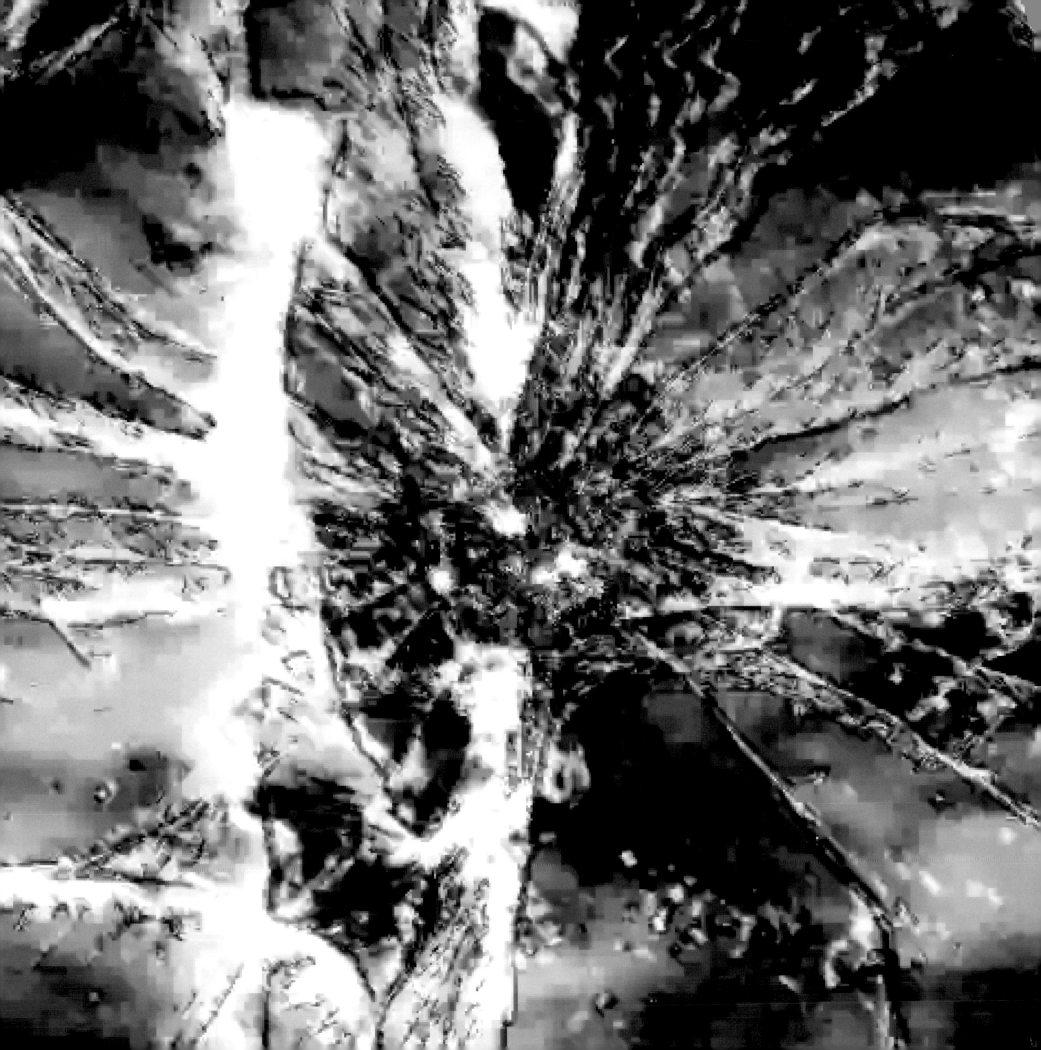

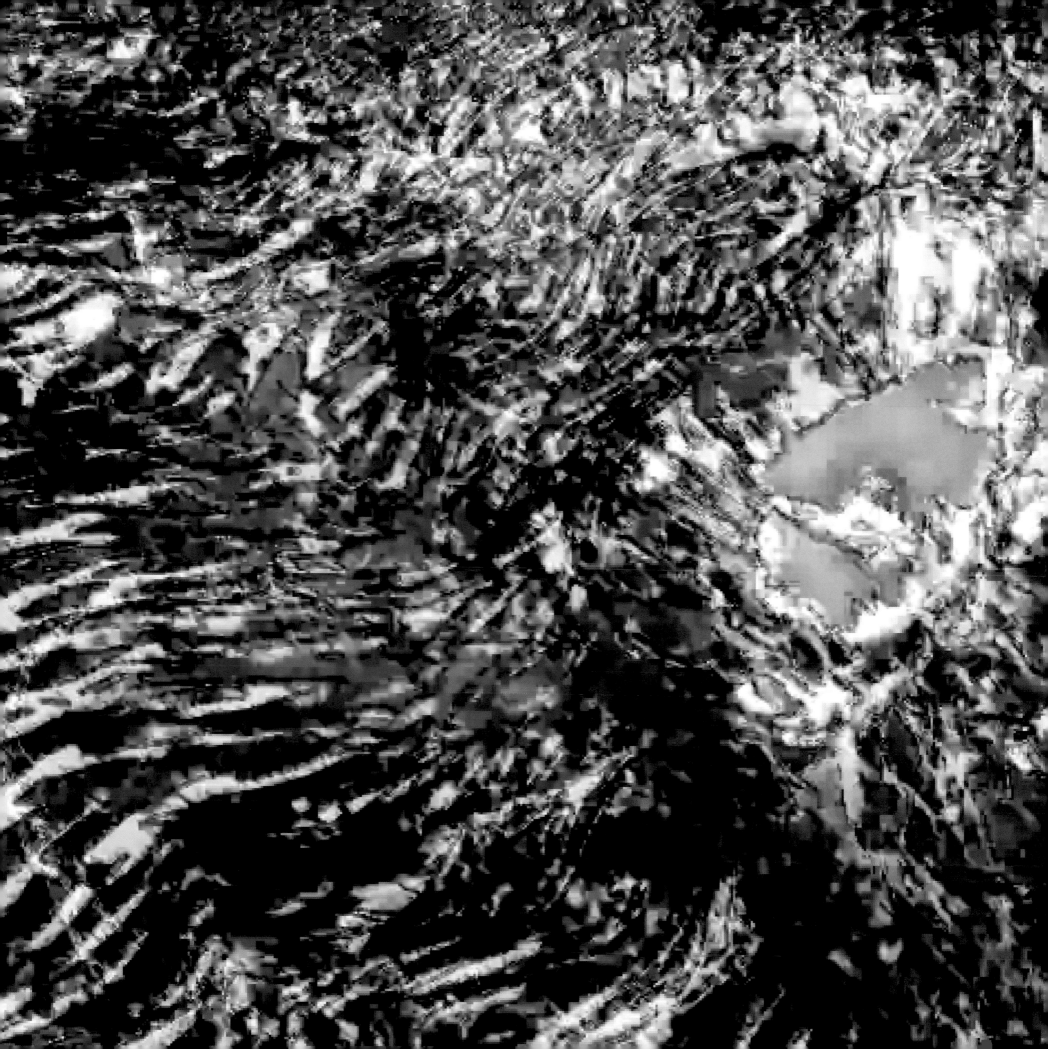

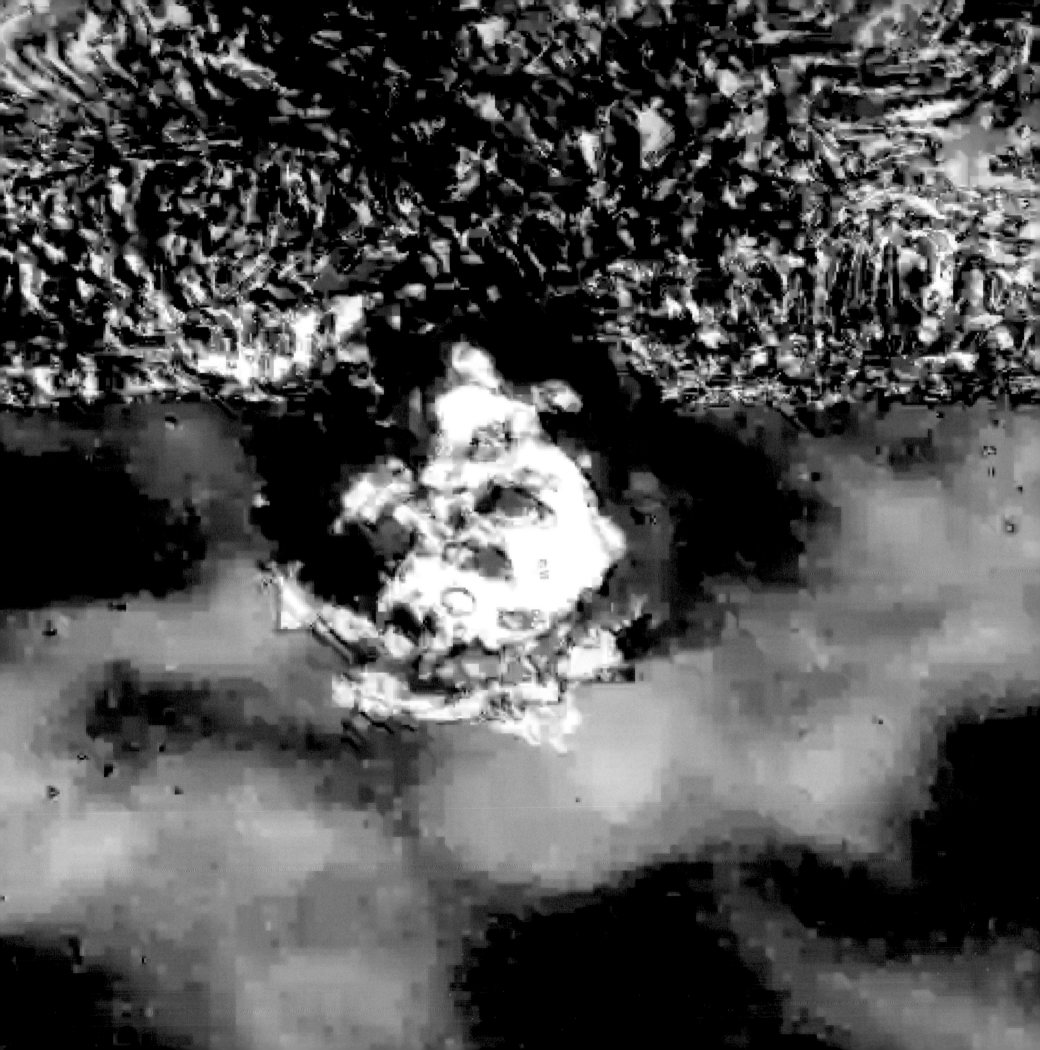

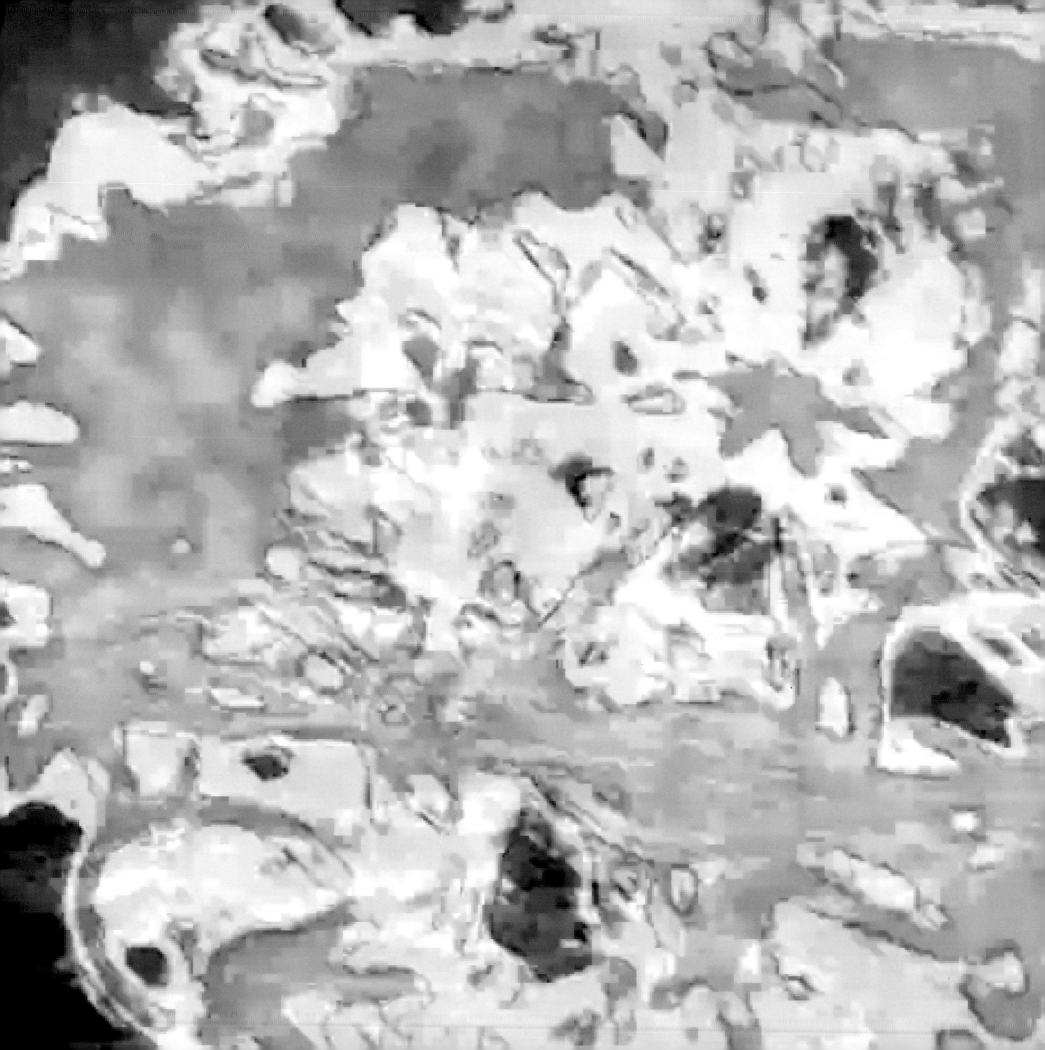

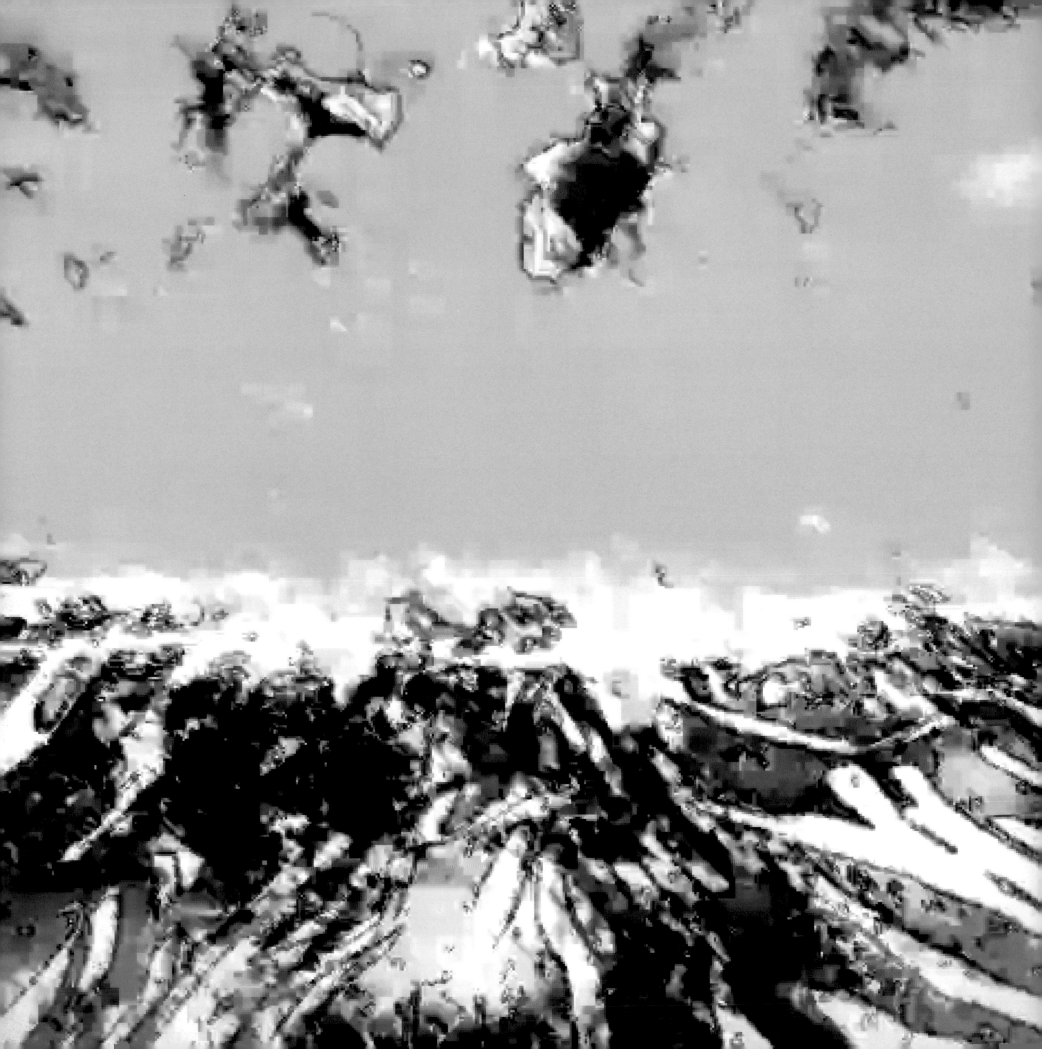

Another revelation, the eye opening. So different from the sheltering skin that it appears as strange as a wound seen in a dream. The visual system is not like a television, it does not turn off, does not sleep. Deep into the night it is telling you stories, sending you pictures of other worlds, other versions of yourself. So what exactly are you seeing when you are awake? A ship is safe in harbor, but that's not what ships are for. The holographic principle proposes that volume itself is somehow illusory: that mass occupies area, not volume. A memory drowned in light, dreaming of stars, looking down from the wing. Flight, a revelation, the unbelievable inversion of the universal descent. The renunciation of gravity, converted back and up through pressure, mass and energy, into a hurricane of dreadful and sublime desire, a storm that heralds endless and total change. They all are gone now, only their echoes are left, embossed on the wing. There's a rushing noise, the scent of feathers and powdered seashells, the taste of iron. The universe can be understood as a hologram, isomorphic to the information "inscribed" on its boundaries. For a moment, you feel the strangeness of your new body and then even that dissolves into a million perfect heartbeats. There is a grain to the light here, a pattern in the shadows. It is not the sail, but the unseen wind that moves the ship. In other words, the universe is a kind of picture. You'll never see a finer ship in your life. A transhuman consciousness emerging from the interactions of human minds; culminating in the Omega Point. At the end, some of the same things will happen that happened in the beginning. Some things will be very different. We sail today.

Just as a thermodynamic system begins in a state of relative organization and diversity, and through energy exchange and entropy becomes slowly both more homogeneous and less coherent (and after all, the universe is made up of an infinite number of such systems, which govern the exchange of matter and energy), Ritchie's own work of the nineties began with charts and diagrams—and relatively clear and direct relationships to his chart of forty-nine characters/elements/states of being—and slowly evolved into more visually complex, more interrelated, and less readily decipherable works. In "The Iron City" text, Ritchie goes on to describe yet another murder, in which the victim is found with his body somehow fused with a tree in the park. His figures decohere as they die, or evolve to survive, uniting with their surroundings. Anna's experience with the Commissioner of the Gaming Board, Stanley (Satan)—who also happens to hold the key to the prison from which Anna suspects the murderers have escaped—is similar: she becomes a part of all the weather of the world, as it fills the Commissioner's glass-cube office while she waits, and observes, too, the anthropomorphization of the landscape, as the river below coils like a "great colon" towards the city. This basic interrelatedness of all matter, whether animate or not, is echoed in many works, such as *You Are the Weather* (2005), *Something Like Day* (2004), *No Sign of the World* (2004), *The Measures* (2005), and *After Water* (2005), in which figures entwine and fuse with the good old-fashioned elements of wind and rain, air and water, the narrative serving here as a parallel explanation to the drawings and paintings. Just as the characters in Ritchie's stories change through interactions with one another, denying fixed identity and meaning, so the works are multivalent, and we begin to understand that describing science in terms of characters and artworks is just another way of suggesting that the world is made up of information that may take many forms, depending on momentary needs. We are all made up of the building blocks of the universe, and these constituent parts must naturally obey its laws. In many ways they are actually equivalent to and a part of the landscape and the weather. This is thematized in paintings like *Split* (2005) and *Fused* (2007), where skeletal figures may be seen literally merging with the energy and matter of the wild vortex that surrounds them. In the latter in particular, the figure can barely be made out, as Ritchie leaves us only a skeletal head with bulging eyeballs in the upper left corner by which to identify the hapless figure. However, he appears almost to be grinning—he knows that his decay into gooey bits of particulate matter is inevitable, and that the slimy atoms that compose him will find new homes as they unite with new materials. A masochistic glee takes hold, as the intensity of experience is embraced as a virtue, whether it is intensely pleasurable or intensely otherwise. Lest we should find the burden of science and human history too weighty or pompous,

Ritchie takes us on a mad romp from the tropes of hardboiled noir thrillers to the absurdly funny sadomasochism of cult horror classics like *Night of the Living Dead*, speaking the language of B-movie clichés and pulp fiction through his stories and his art to prove a point: as gruesome as it may seem from our limited and subjective human perspective, death is nothing to lament. It's really just part of the way things work.

Endings

Iron is the last and most stable metal on the periodic table. Unlike sexy copper, which is constantly recombining with the elements that surround it to form oxides and sulfides and iodides, iron is immutable—the rest state of matter. A dying star, for example, collapses into a core of molten iron. Iron is the omega of a thermodynamic system—the final state after the work is done, the matter and energy exchanged, the flux of activity flatlined into a final resting place. And the text "The Iron City" (2006) is the closing installment in Ritchie's narrative of universal history. Such mixed metaphors of religion, science, and storytelling are commonly found in Ritchie's work: they are alternate and simultaneous ways of explaining the way things are, a combination of empirical and intuitive models that may result in seemingly contradictory outcomes, which are, however, not necessarily inconsistent. When last we met the copper-skinned Anna Elizardo in "The Bad Need" (2001), she was aware of an impending union with Sam Morden, the Iron Cop, and losing her shit—and her physical coherence—as her lungs filled with things organic and catalytic: desire, excrement, death, the smell of rotten bananas, and the taste of salty seawater. The entropy of the city's thermodynamic system seized her, as she began to morph and recombine in order to survive the ordeal of witnessing the grisly scene of a ritual murder. When we pick up her story in "The Iron City" text, she has deteriorated further, having been demoted to the missing persons bureau and lost control of her crank habit, even as she continues to try to solve the mystery of the murders. The stories are a kind of bridge for the observant reader/viewer, an episodic story with sequels and prequels, according to which moment of the history of the universe or chemical or quantum interaction is at issue.

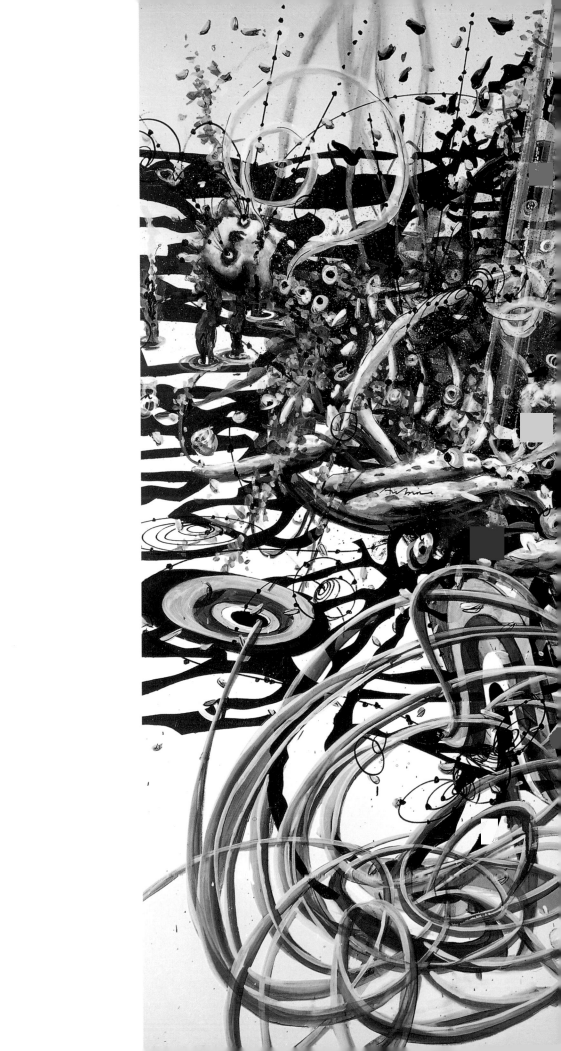

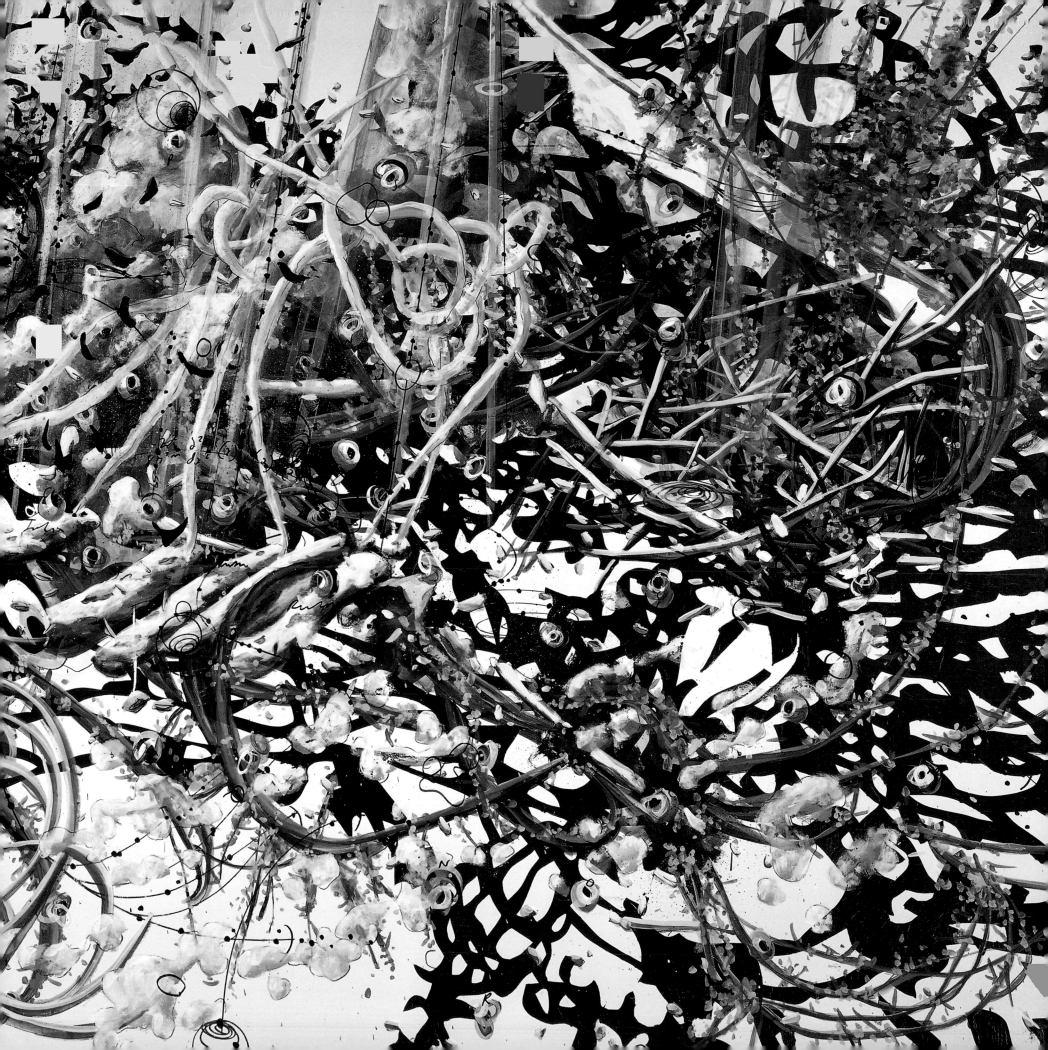

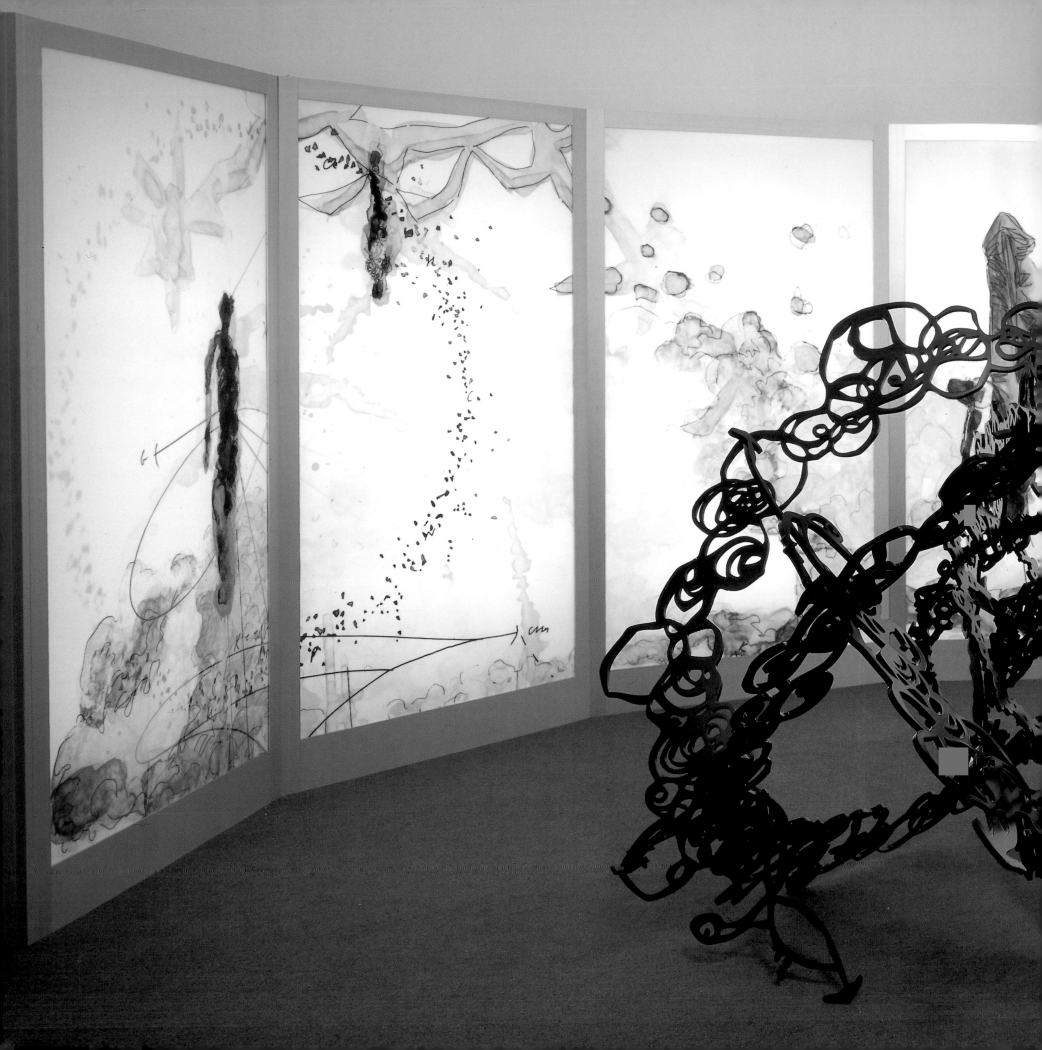

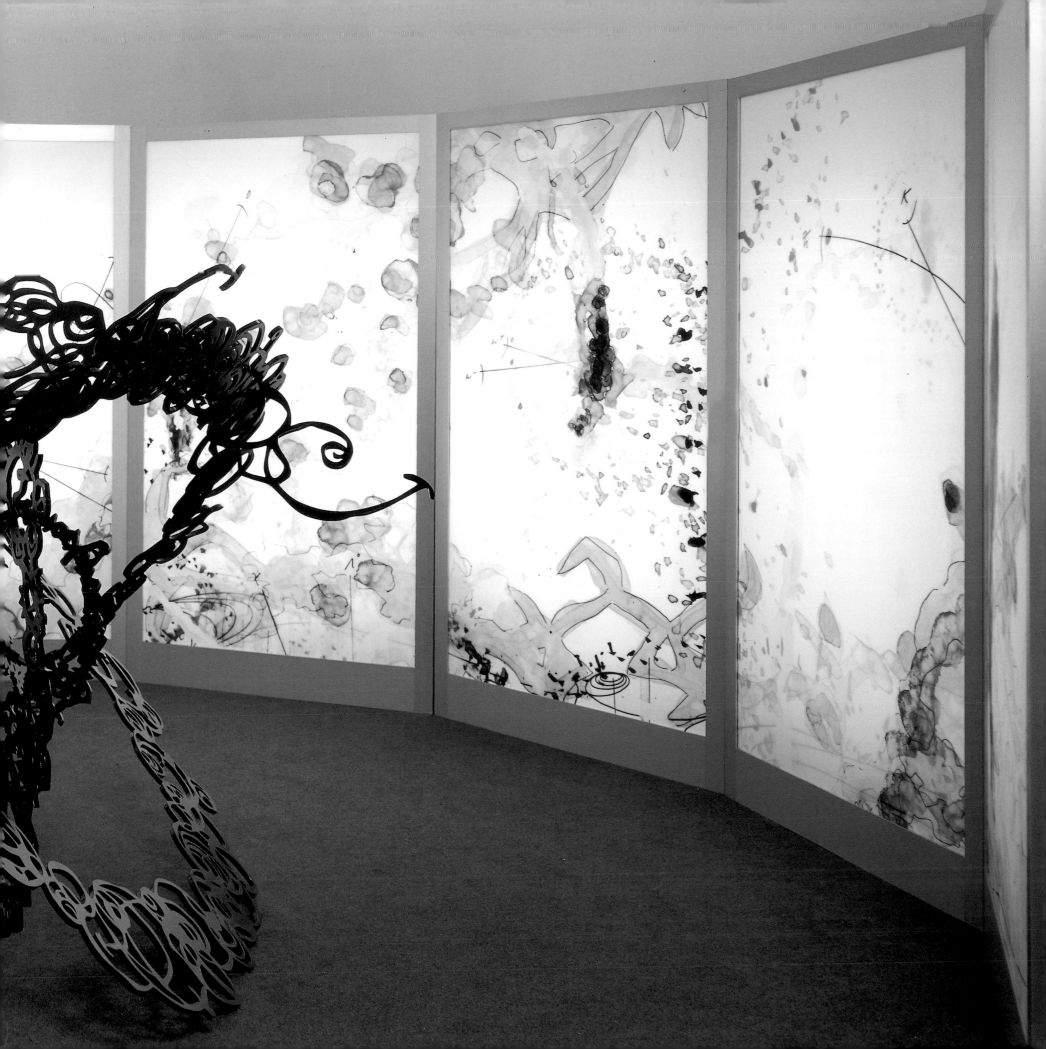

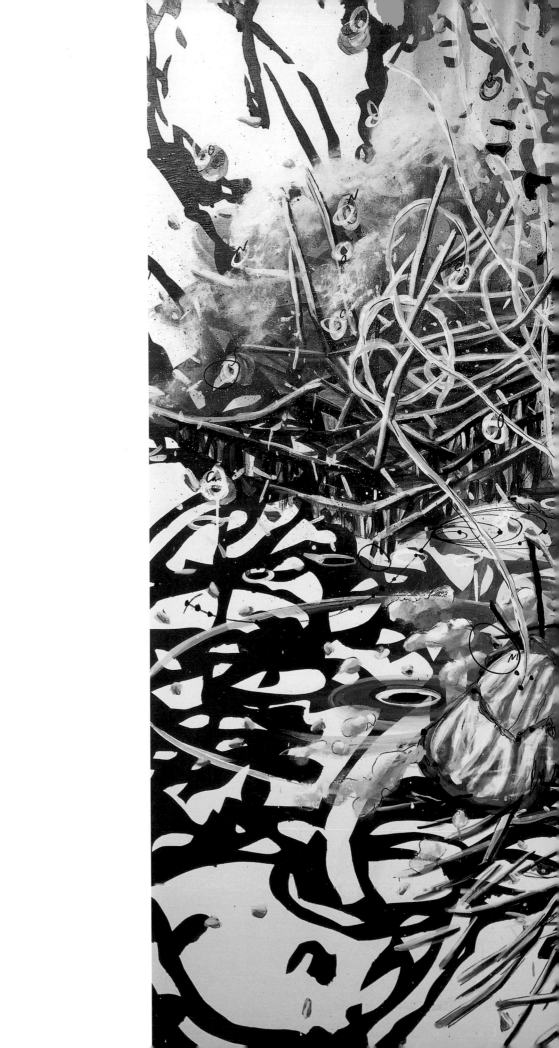

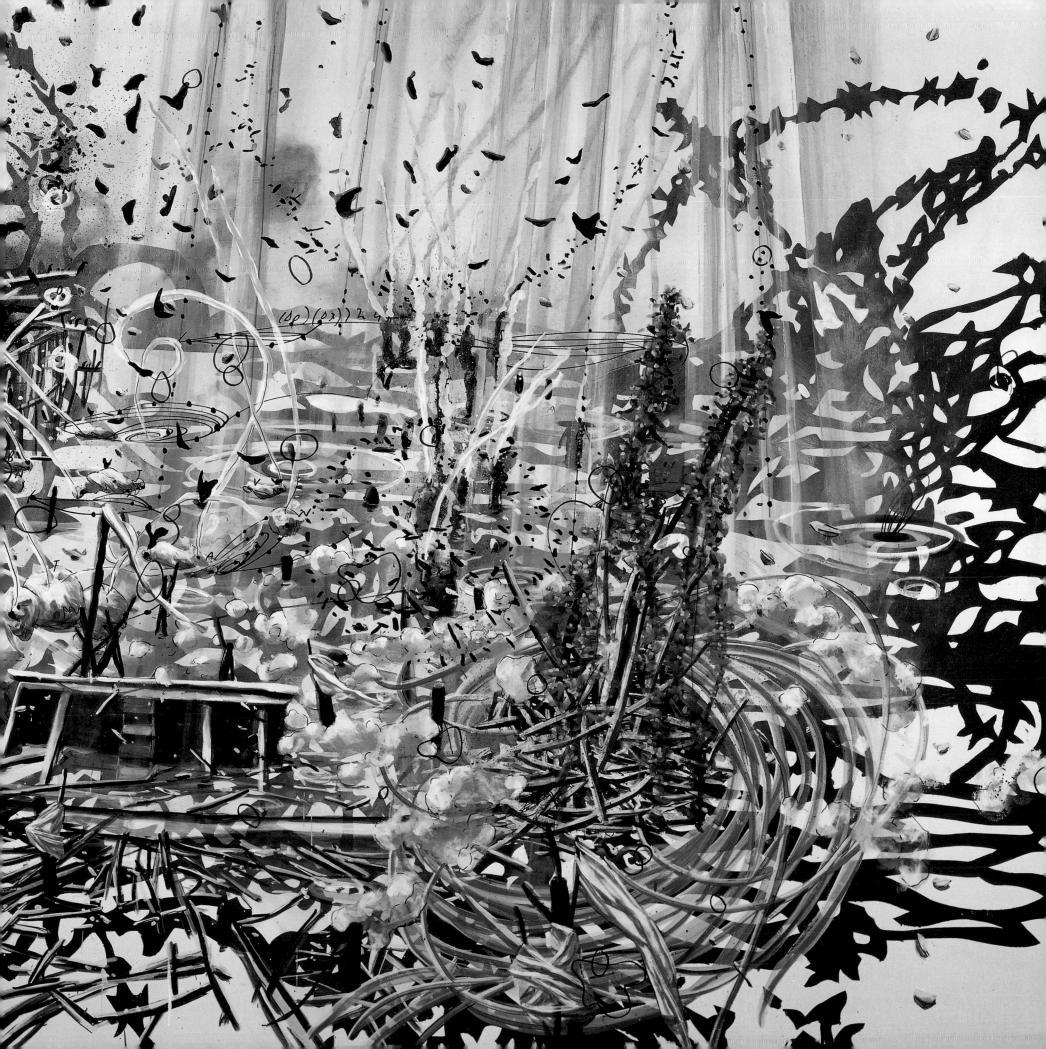

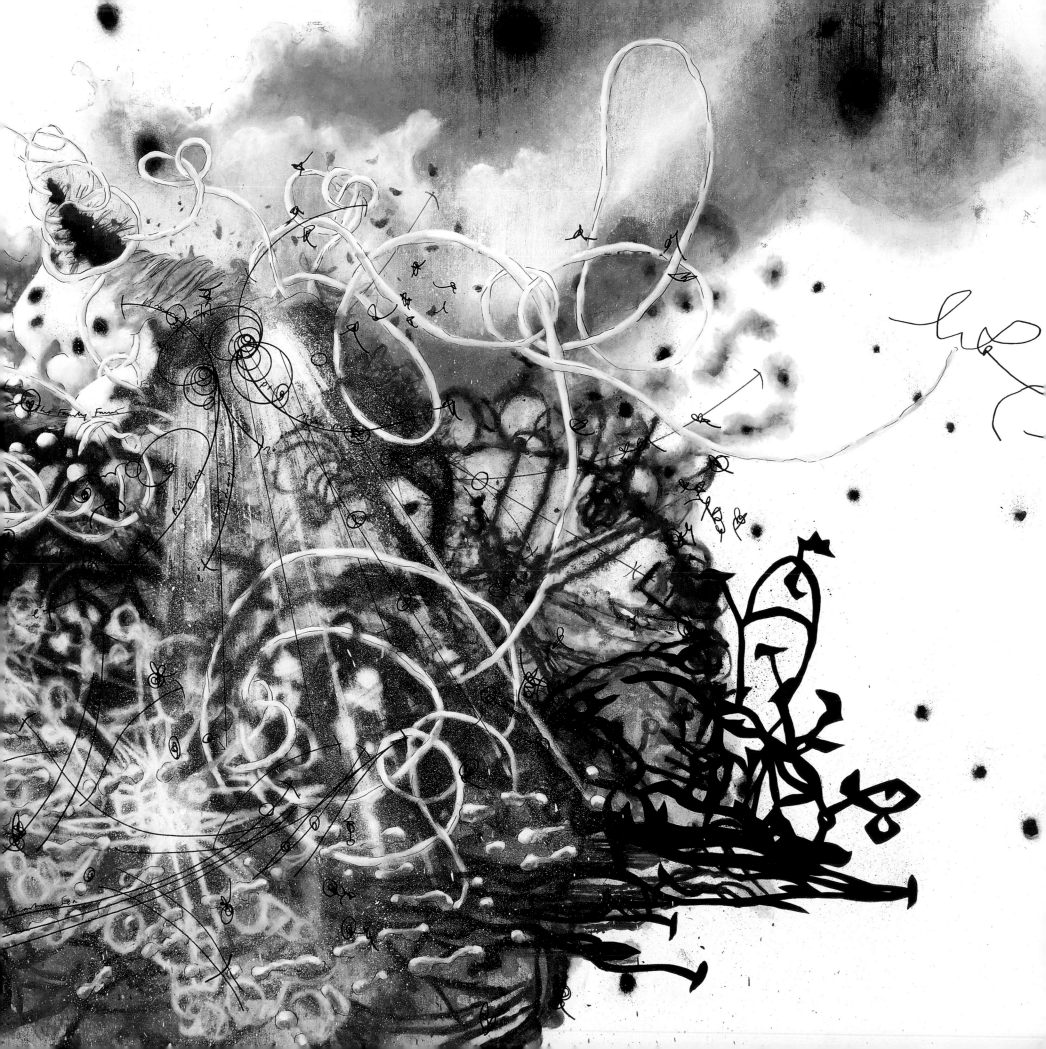

Ander Monson

When you removed the shroud for me I could see why you loved it. It was spectacular, whatever it was, what it meant. It was blinding, all refracted light. Mirrors all around the room brought it out. It took the almost nothing worth of light coming down from the skylight and multiplied it. Brilliant. It was truly brilliant. Curved surfaces. The germ at its center: a cut of glass resembling a gem. It became so bright in here so fast. And it's not even on, you said. I must have gasped. I have gaps in my memory of the moment, in my memory of my mother and father, and what happened to them. That was another time. I didn't think I could bring it back, but you did. You said this would open something up. Now you have these gaps too, I imagine. I can't say what you will remember, and how long it might take to bring it back, if it's possible.

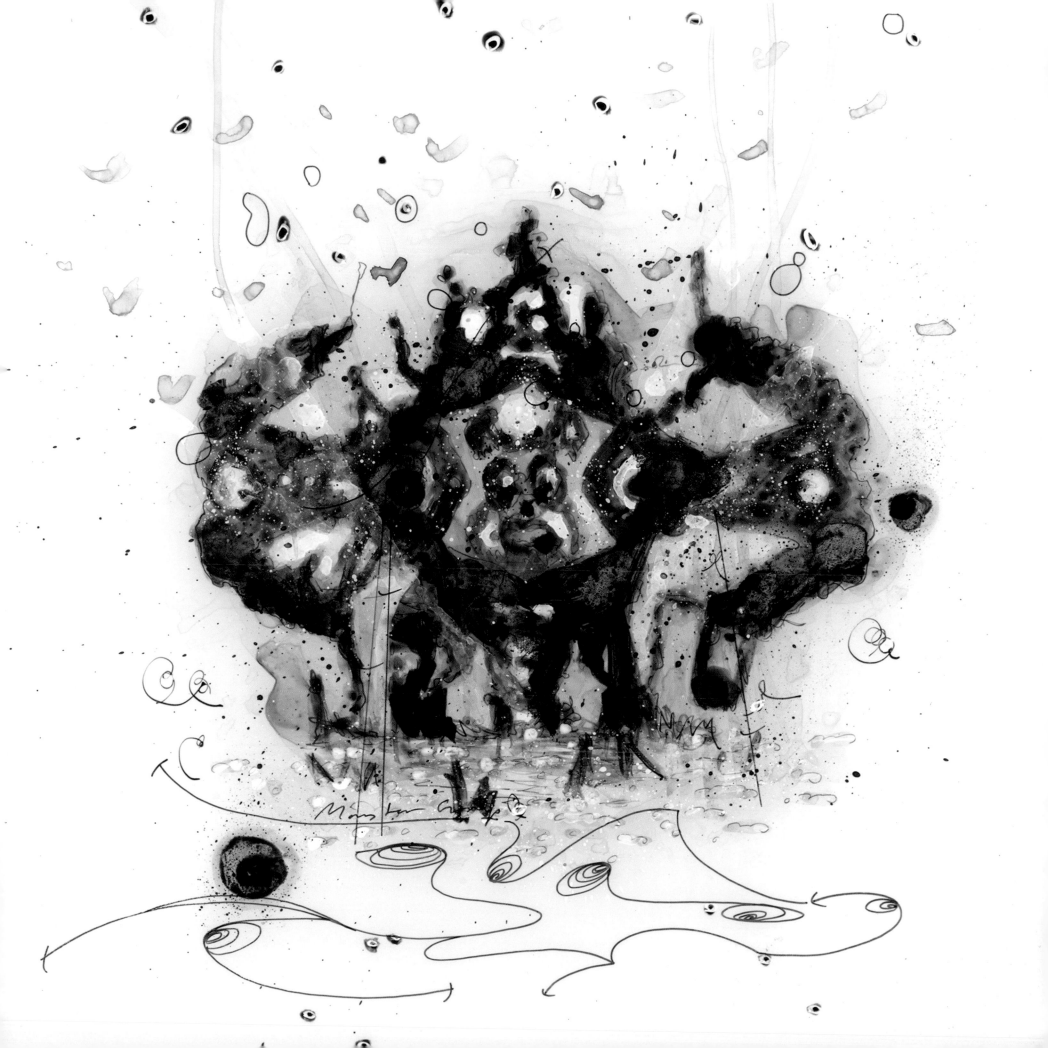

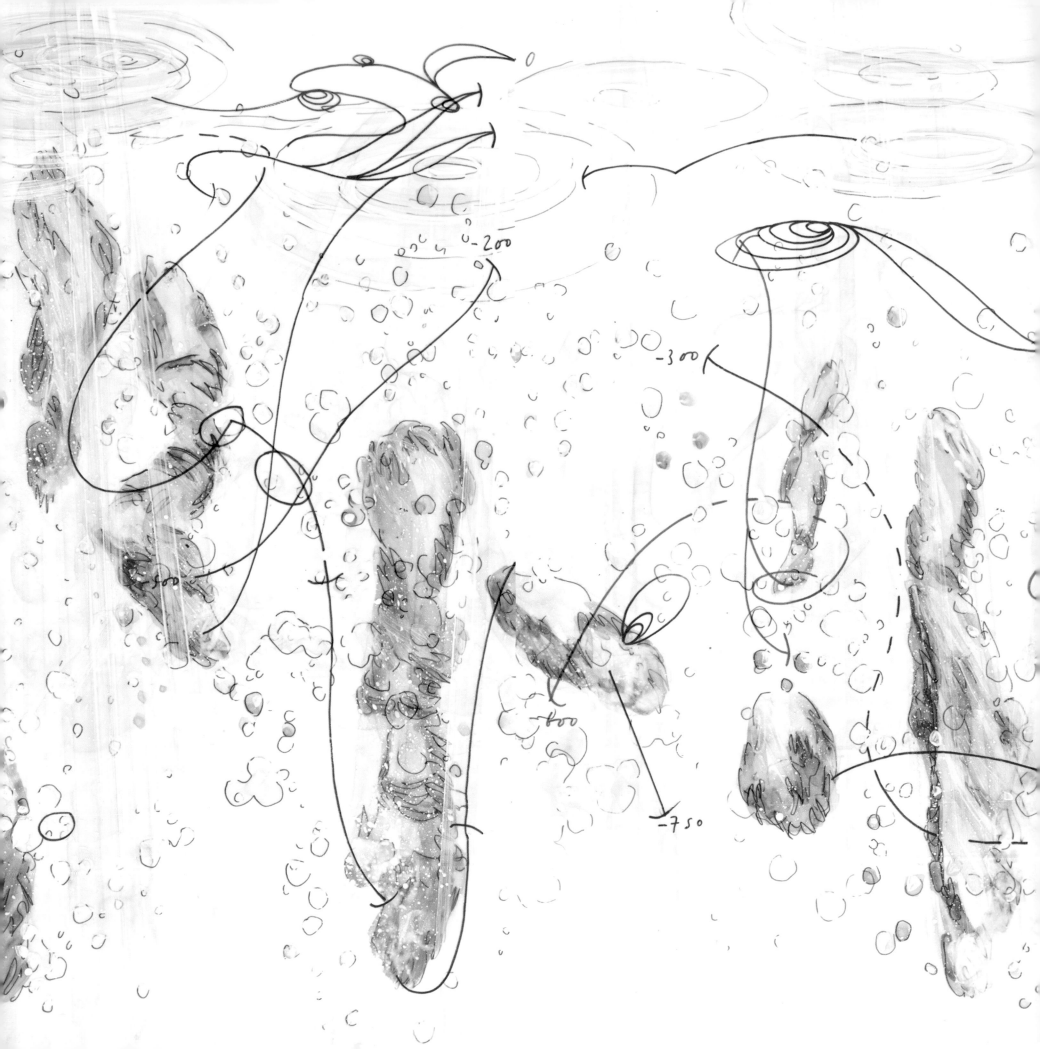

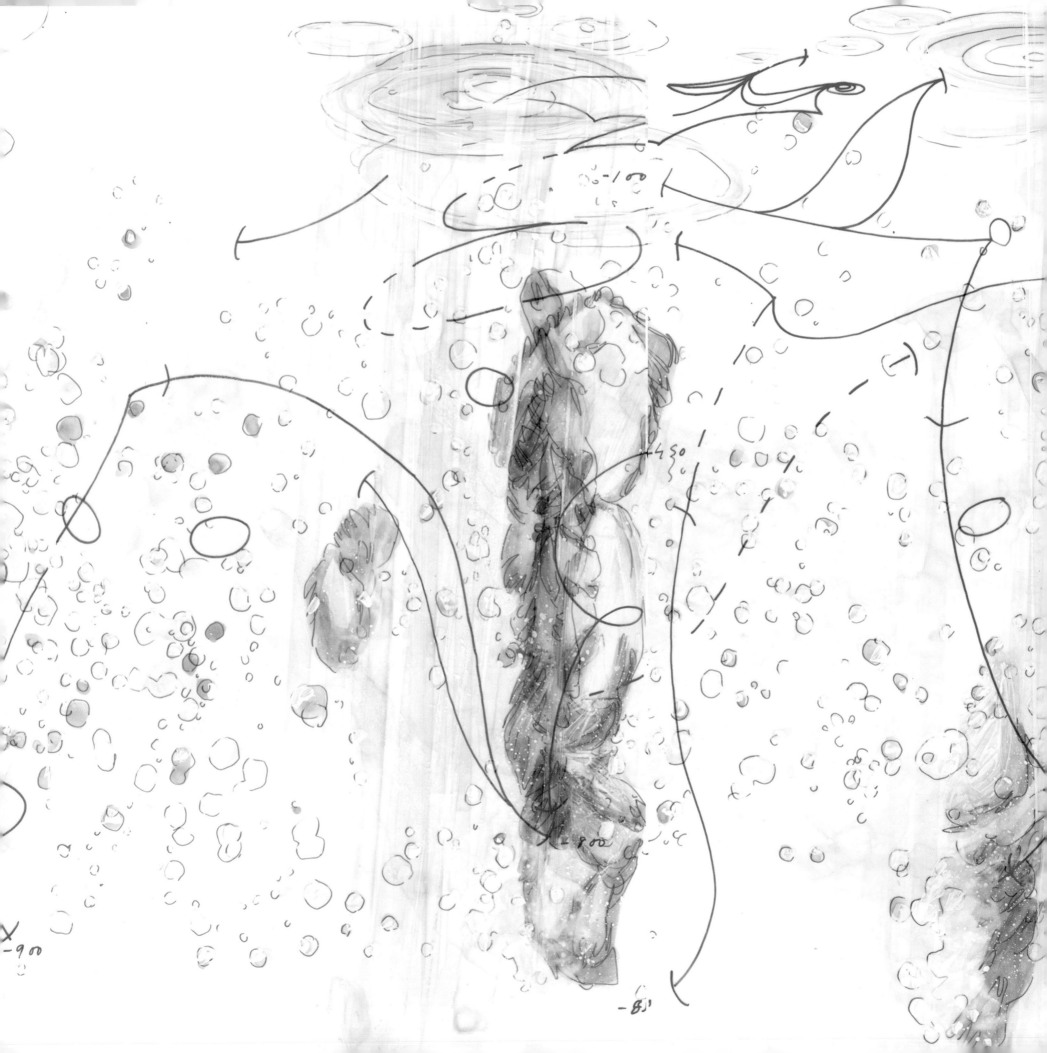

Inoculation

The digital animations *Ezekiel I* (2007) and *Ghost Operator* (2008) contain tours through the Iron City; now in a state of final decay, its population long having dissipated through entropy or some unnamed catastrophe. Traveling through the city, which is actually a representation of the periodic table of elements, is another way of describing the properties of matter, as we move gracefully from the softer and more mutable elements in the more disorganized beginning of the tour, and proceed through increasing complexity and organization toward iron. Lest we become too enraptured in the beauty of the sepia-toned ruin of the harbor and the city center that follows it in sequence, Ritchie maintains a subtle but persistent pixelation of the image. Like the notations on his paintings, this serves to remind the viewer that the digital animation is the product of many, many small, reusable, and somewhat interchangeable pieces of information. There is awareness of the flatness of the screen onto which the animation is projected, and the artificiality of the landscape depicted. As with Brecht and his *Verfremdungseffekt*, Ritchie seeks to distance the viewer just enough to enable analysis in addition to an emotional response. However, rather than to alienate, the point here is to inoculate the viewer, to create resistance to information overload, and allow him/her to appreciate difficult concepts of quantum mechanics and new theories of the physical properties of the world. Ritchie has shown us in the Iron City story what happens when information enters without proper resistance: as Anna Elizardo leaves the office after learning of the entwined histories of prisons and corporations from Stanley the Gaming Commissioner (a.k.a. Satan), she dreams of becoming a series of characters from another Ritchie narrative, "The Fast Set," feeling herself to be each successively before dissolving entirely into water, along with the submerged city. She becomes everyone and no one; living, dead, and undead matter; one with the territory she once occupied. This dissolution of the self and transmission into the universal whole could be seen as the material equivalent to spiritual transcendence, but also as the mind's response to its inability to accept the complexity and demands of the world. Knowing Anna and her experimental drug habits, this could be the result of ketamine use ("Special K"), which radically distorts the perception of the relationship of consciousness to the body and its surroundings, driving the mind into ever-smaller circles of interiority, known among users as "k-holes." The narrator of "The Iron City" relates her experience rather directly to Cotard's Syndrome, one of the first forms of schizophrenia to be observed in which the sufferer feels him/herself to be damned, the organs missing, the body a mere machine. At times, the subject may feel immortal, the body may seem to expand to touch the stars, sometimes extending infinitely, dispersing in the universe. For Ritchie, this seems a natural response to information overload. Emerging as the syndrome did when it

was recognized in 1880, around the time of the acceleration of the Industrial Revolution, and the attendant emergence of a heightened sense of calibrated time, it is hardly surprising that the rapid chemical and physical alterations the brain had to make as it adapted to new circumstances simply proved too big a strain for many. Whether this is viewed as genetics, chemistry, or the result of environment alone, few psychiatrists today would deny that episodes of mental illness are often provoked by extreme stress of this kind. Whatever might be viewed as its root cause, its trigger seems to have been a revolution in social, political, and economic relations; that is, nothing less than the substantial reconfiguring of the Western worldview, which the narrator links to the historically simultaneous emergence of the legal sanctification of the corporation as an 'individual' and the story of Frankenstein, an artificial life form. This link is more literally manifested in the *Ghost Operator* installation with the appearance of a wooden head deformed by the information that has created it.

The relative density of themes in the work and the contradictory nature of the many religious, philosophical, and scientific traditions on which Ritchie draws also allow him to avoid committing to one single, unitary narrative. Once you commit to a story, he says, "it's over and you're dead — you're just waiting to die." In other words, you've put closure on it, and everything from that point onward has to happen within the system you've created, becoming ever more dramatic and important and ridiculous, instead of allowing for freedom of thought and artistic exploration. With a traditional, Hollywood-style fairy tale, "if you make treasure then you just want more treasure." If the story ends, the audience for the work will demand more and more of the same, as we have seen with the remarkable proliferation of movie sequels. By maintaining distance, Ritchie allows both himself and the audience room to challenge anew the issues raised: to enrich, expand upon, and disagree with them. This stance allows him to maintain flexibility, but is also a generous position that both prevents the audience from falling into familiar patterns, and encourages them to think in new ways. Avoiding the alternate negative circumstances of narrative immersion and the madness caused by information overload, he empowers his viewers to maintain a critical distance and inoculates them against information sickness.

Sociochemistry

Another theme played out in *Ezekiel I* (2006) and *Ghost Operator* (2008) is that of the relationship between the behavior of matter and the laws that govern it, and the laws of our society, which determine its structures and affect our actions as well. Although this is not inscribed obviously in the visual works, Ritchie often uses texts and voiceovers to work through ideas that inform but do not necessarily always appear in the artworks, giving the reader the inside scoop on his work, like an intrepid investigator that might appear in some future narrative. Stanley/Satan, the Gaming Commissioner, holds the key to the supposedly perfect, escape-proof prison, the Lytic Circus, from which the murderers, the seven virulent characters who make up the family of the Dead, one time occupants of the *Universal Cell* (2004), have broken out. When Anna tells him that she "needs to know *everything*" (italics mine), he smiles slyly and responds with a historical analysis of the interrelated histories of prisons, and of the characterization of corporations as persons in the eyes of the law. Through Stanley's analysis, Ritchie describes to us the prison of our own making, which we currently inhabit. "The modern corporation transcends every category of ownership and possession, of animate and inanimate, of person and thing, gratifying our monstrous desire to escape time and space and substituting a limitless identification of human beings with the material world … we live in the space this structure allows us, imprisoned by our own desire to be immortal, to be perfect, to be dead … we have consented to be ruled by an effective corporate bill of rights." By displacing humanity onto a corporate structure that transcends the normal human lifespan, that has greater rights than those of the individual, and few of our weaknesses, we have removed ourselves from the equation – created the condition of our own death, so to speak. This living death, this legal structure that imprisons us, is constantly bombarding us with information, even as it demands to know more and more about our private lives in the form of consumer profiling. Raw impulses and secret desires are publicized, stripping us of our privacy, while the boundaries of our personalities are under constant attack by advertisements, polls, and surveys that encourage a unitary and homogenized ideal of public identity – an erasure of individuality in favor of allegiance to a market segment. This extends, of course, to the political sphere where endless polling and blogging exert pressure to constantly calibrate personal opinion in response to the stimuli of outside data instead of actual lived experience. Again, Cotard's Syndrome seems a reasonable response. As the role of the individual diminishes, the syndrome's victim becomes disassociated from the body as possessor of officially recognized identity, and the sufferer begins to feel as though essential motors of individual functionality, displaced from personal agency to the organs of the body, are missing, and the power to operate feels dissipated across too large a space to enable effective action. The mind is aware only of itself, and not of its association with the physical world in the form of a body, and in this way exhibits an inability to correctly process perception and information – in other words, it becomes schizophrenic. As experience is devalued in the face of the demands to process data, the significance of the body is lessened to the point of its perceived dispersal. Ritchie's insistence on the primacy of experience in his strategy to construct installations that evolve for the viewer over time, as they move through them and perceive them visually, aurally, and spatially, is a way of working against this corporatization of individual identity, this drive to forge the individual into a collective corpus.

Ghost Operator

What's going on here is not personal. Reason gave us steel wings for arms and a flaming motor for a heart. There's nothing like this built today. It's business. No bucks, no Buck Rogers. The New Man is here. I'm already living in a controlled environment. He intends only his own gain, and he is in this, led by an invisible hand. A new method is presented for seismic deghosting of data acquired in rough seas. If I could have a year or two I'd make something good. Society is splitting up into two great hostile camps. Listen to me; and then, if you can, and if you will, destroy the work of your hands. Are you saying I'm going to die? Cops lie, newspapers lie. Two great classes facing each other. The sound of shattering glass; paving the way for more extensive and more destructive crises. The rich and the poor. The flames rising out of the gasoline, diminishing the means whereby crises are prevented. The one thing you can count on, word on the street. The ship of years, a ghost net, returned from victory over the sun—one hundred and fifty years too late, abandoned to trawl the quantum sea, All solid concepts are broken. Inside, the remains of the operator and his cargo of chance. The ice is gonna break. You are about to enter the supreme adventure. Bad monkey. True in our fall, false in our promised rising. Prophet to Martyr, one easy step. Spatial components of metric perturbations should vanish at the boundary, jointly with all components of the ghost one form. A new beginning. A crown, a scepter, a seal of power, look to the east. You are my father. Love and death are equally dispensed. You are my author. You can't leave your blood behind. All ghost modes are forced to vanish identically. "I expected this reception," said the demon.

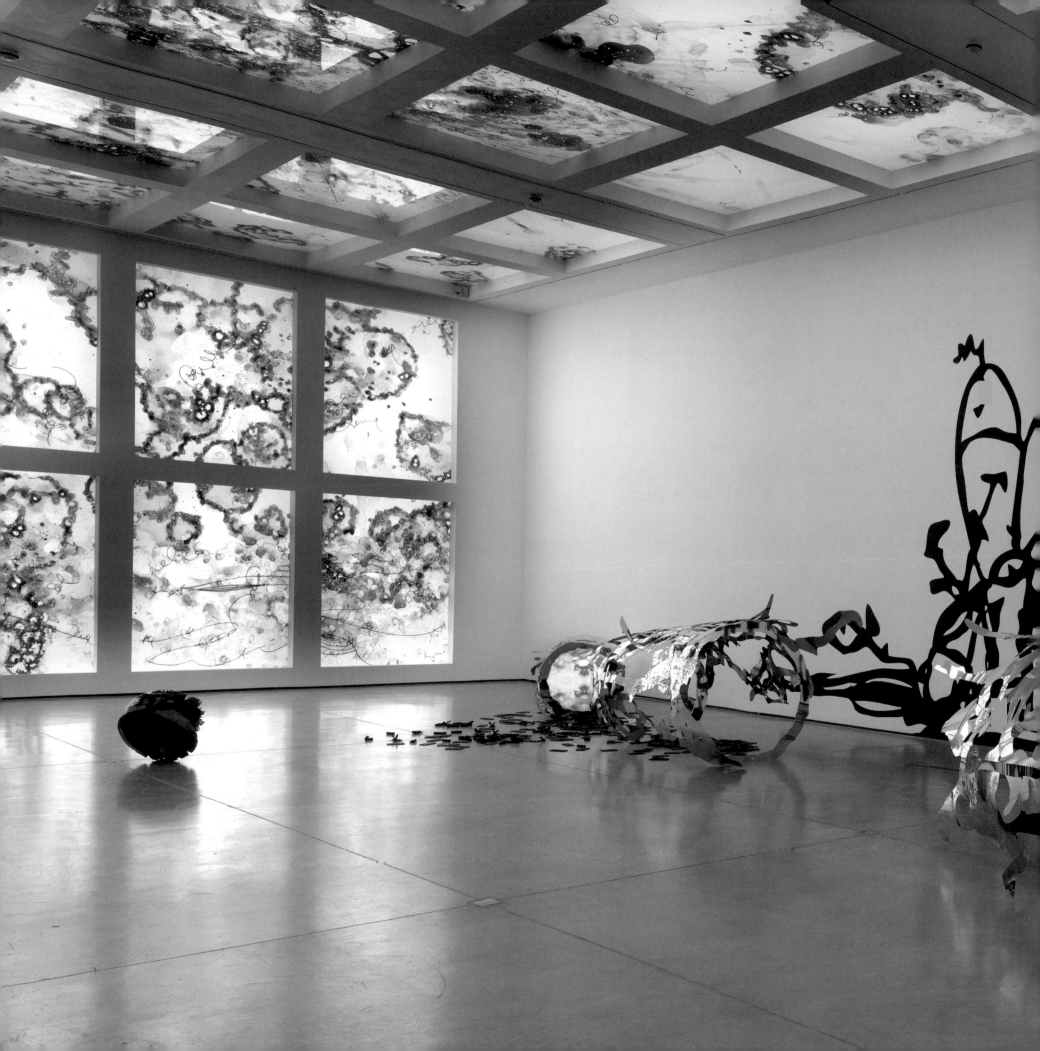

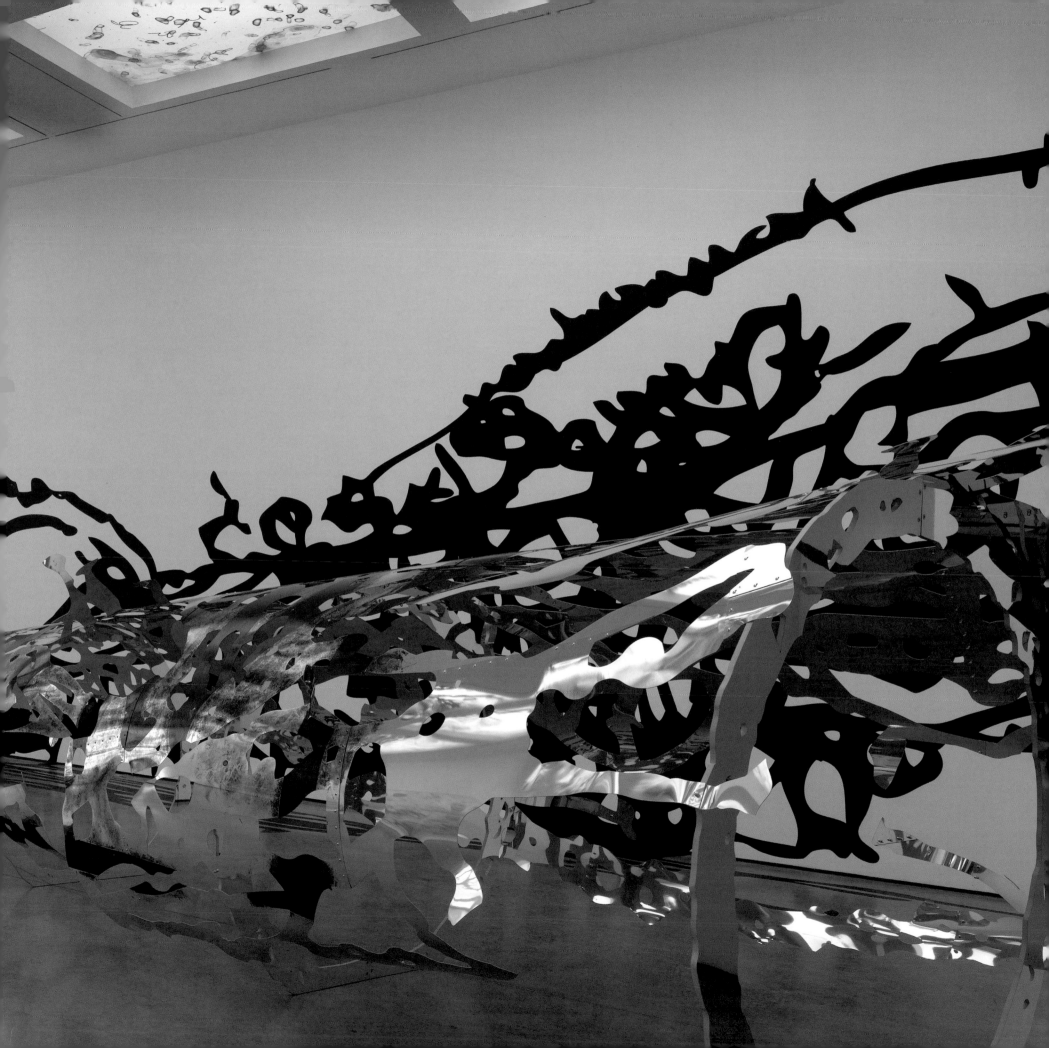

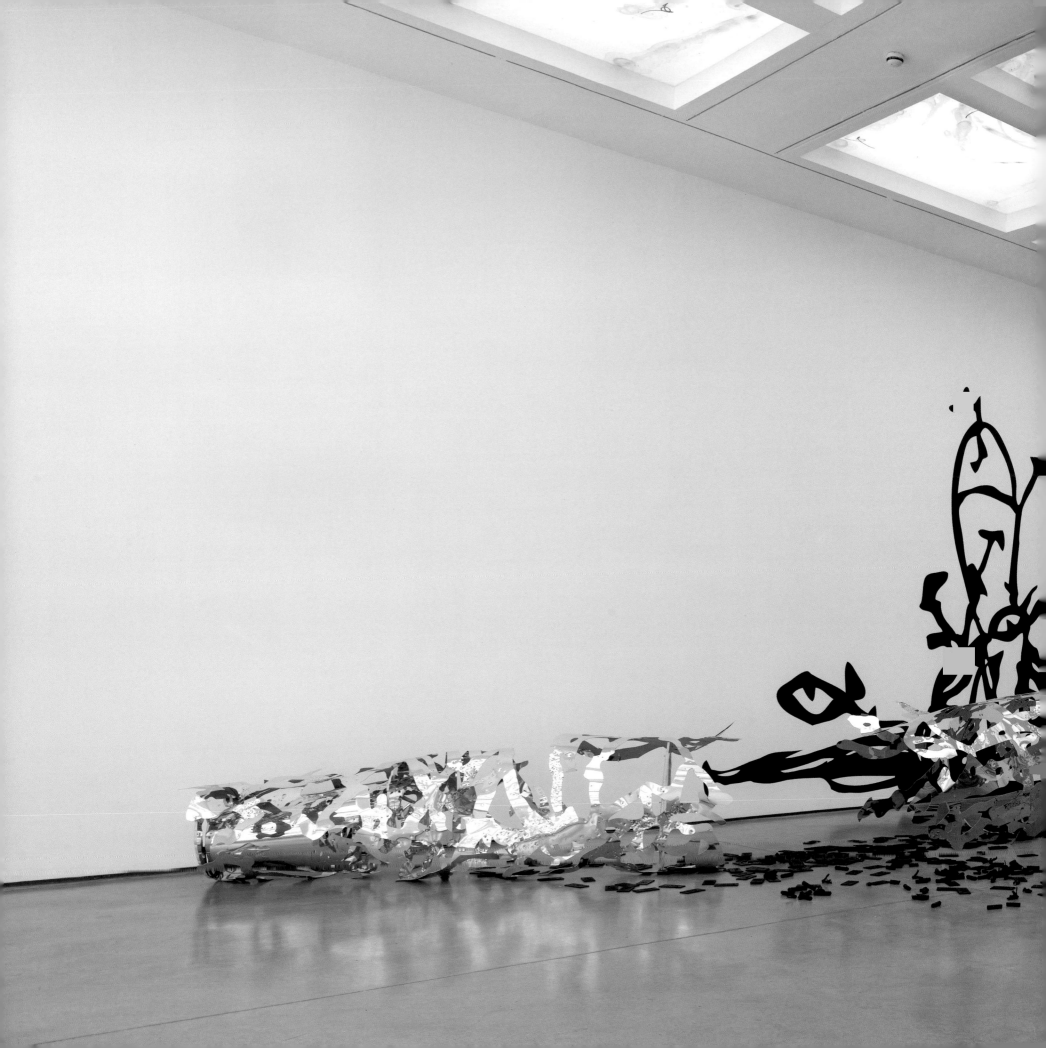

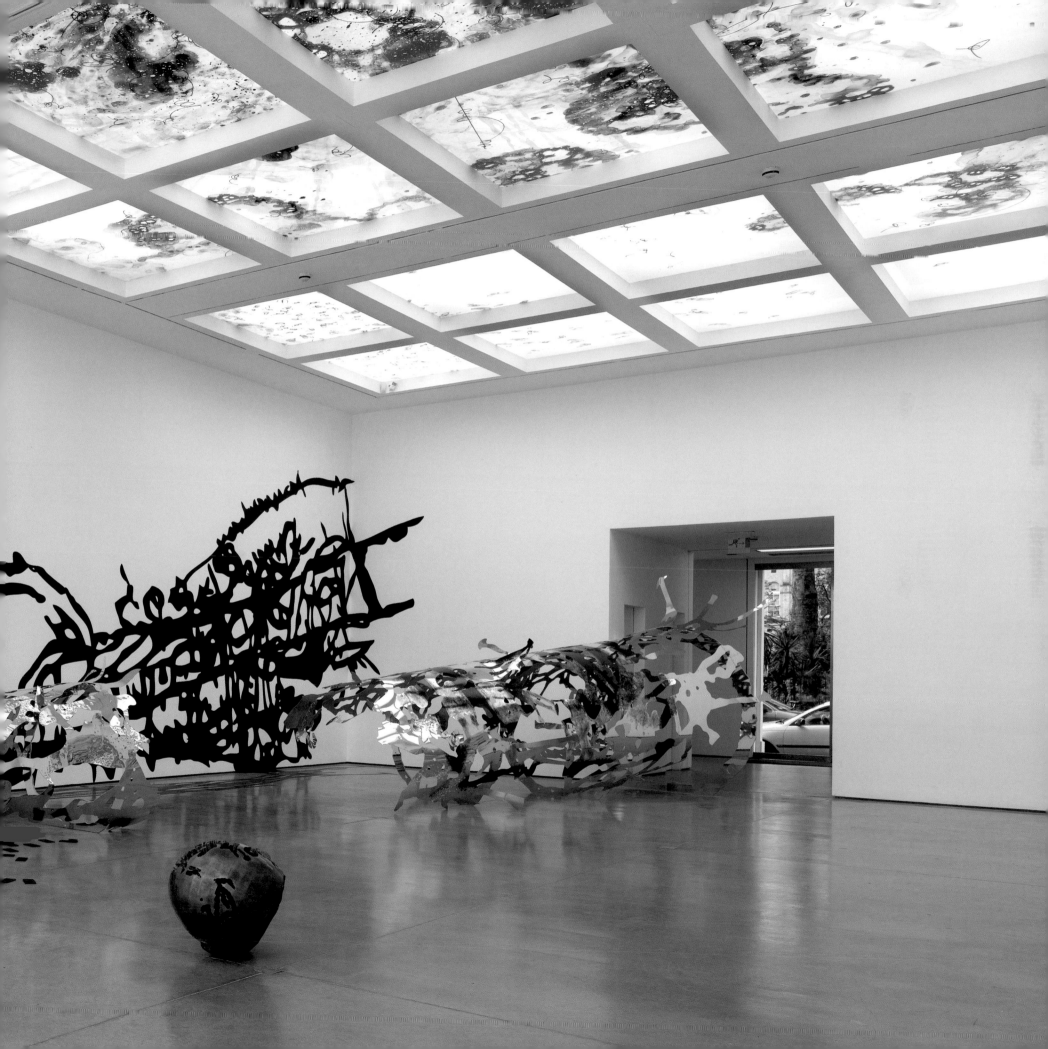

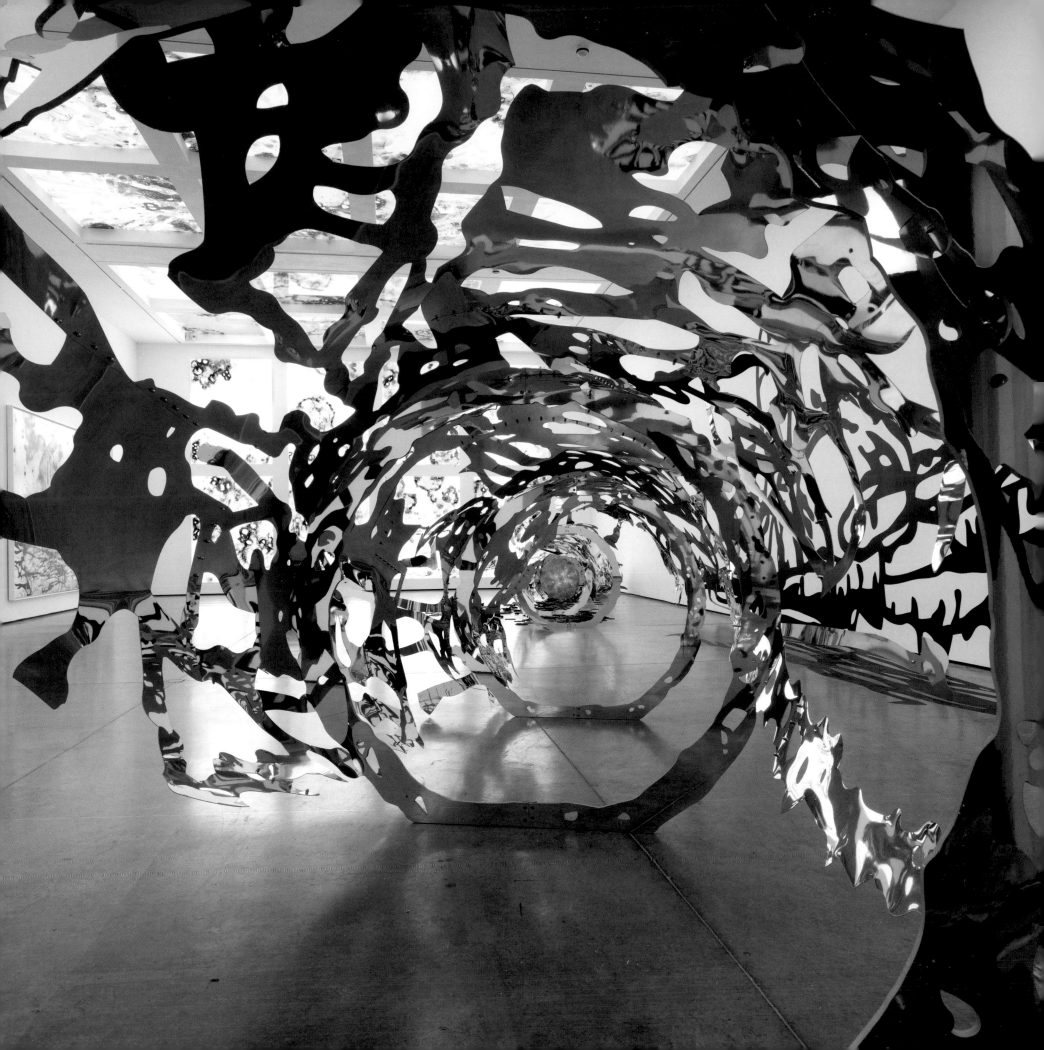

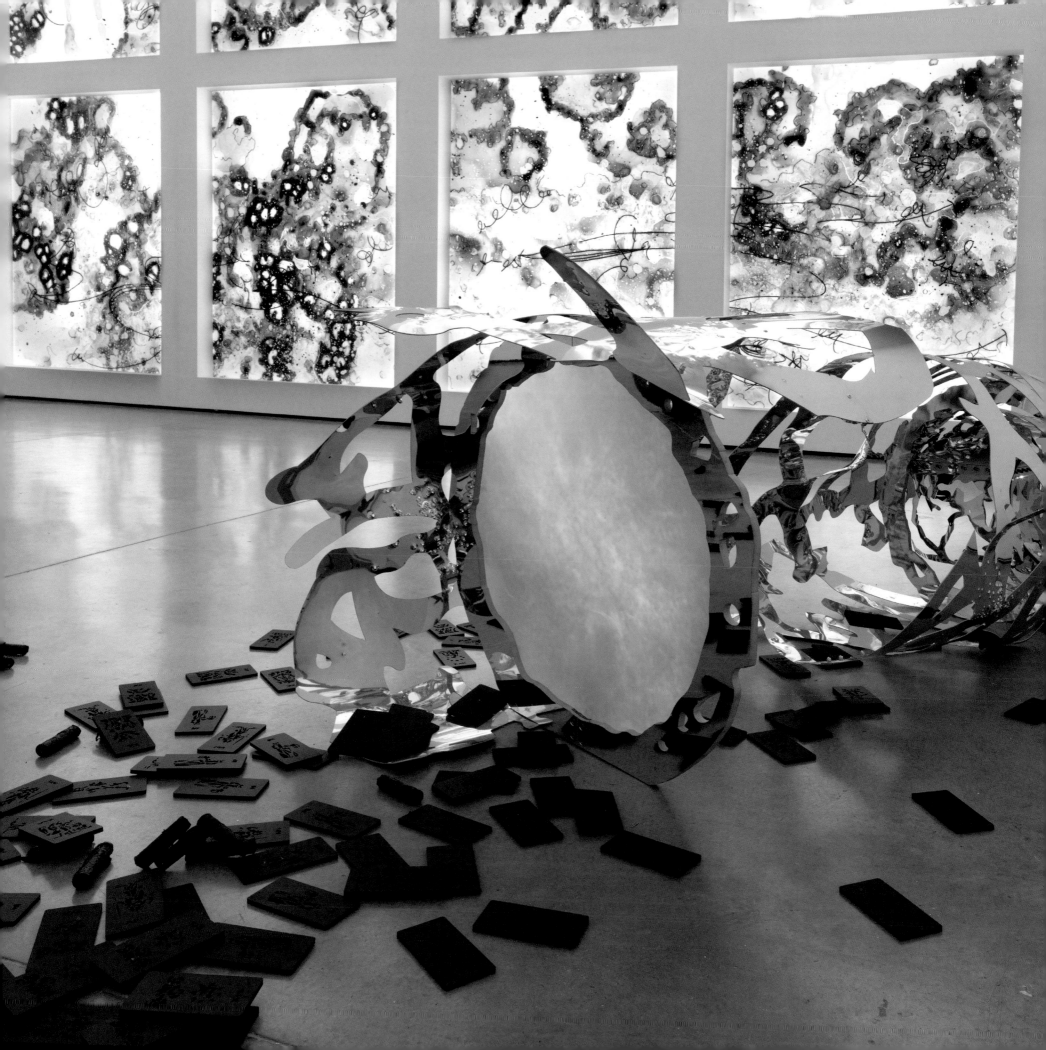

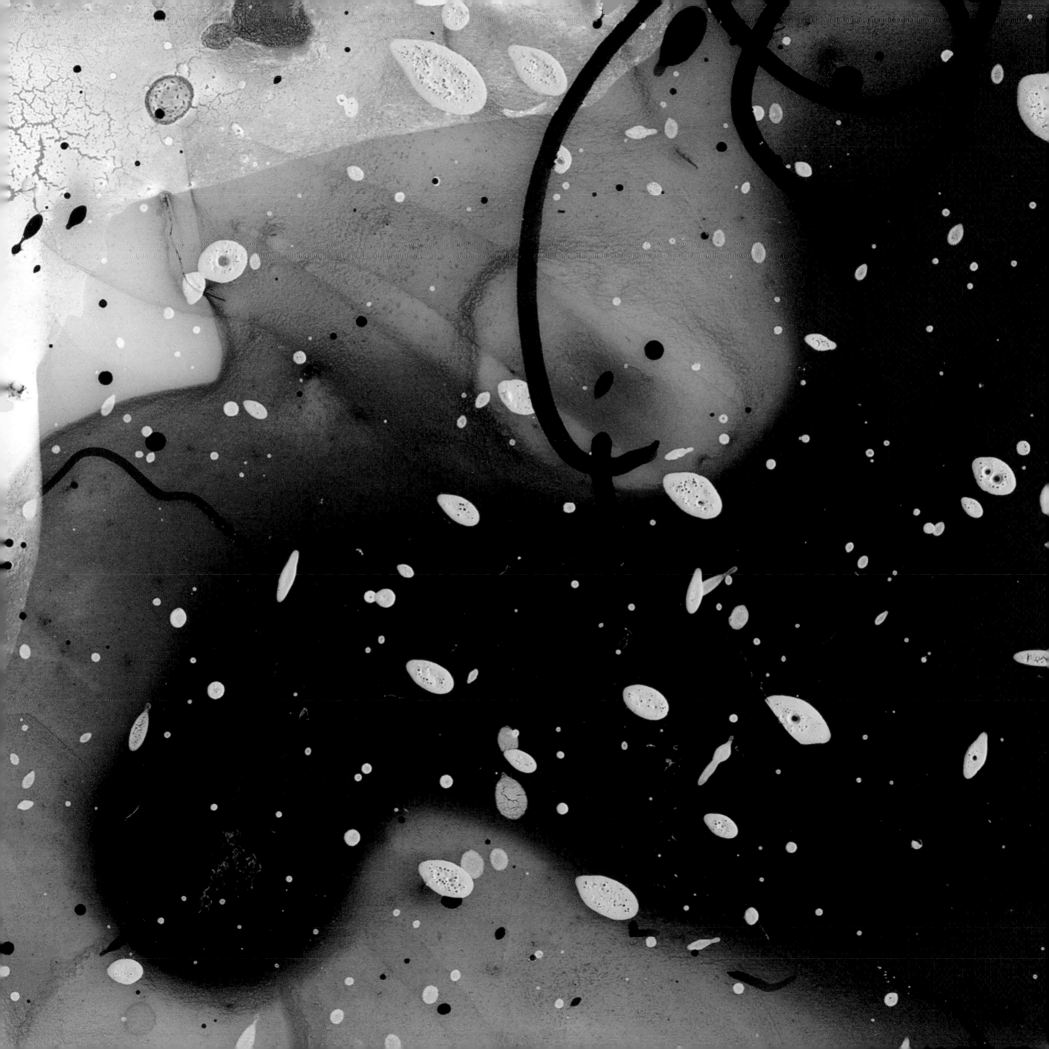

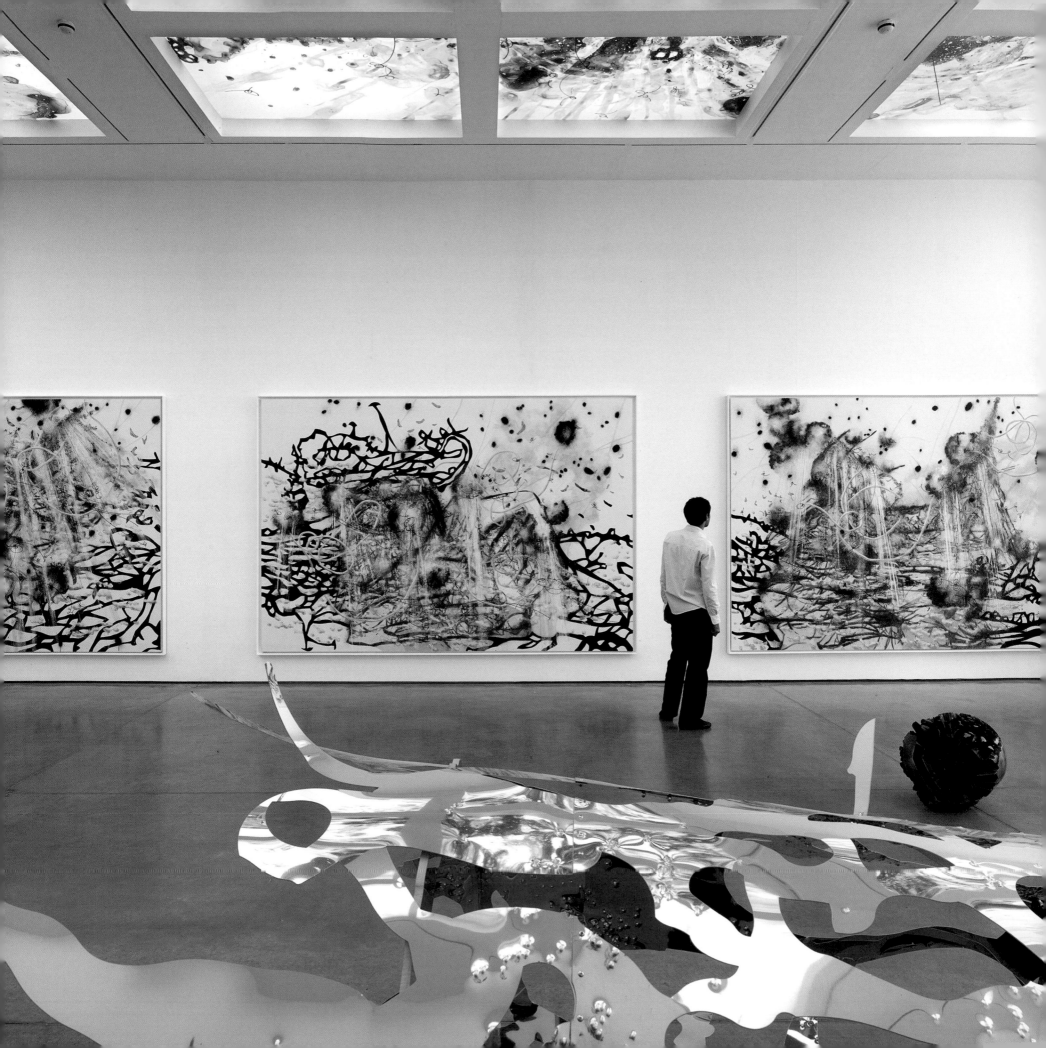

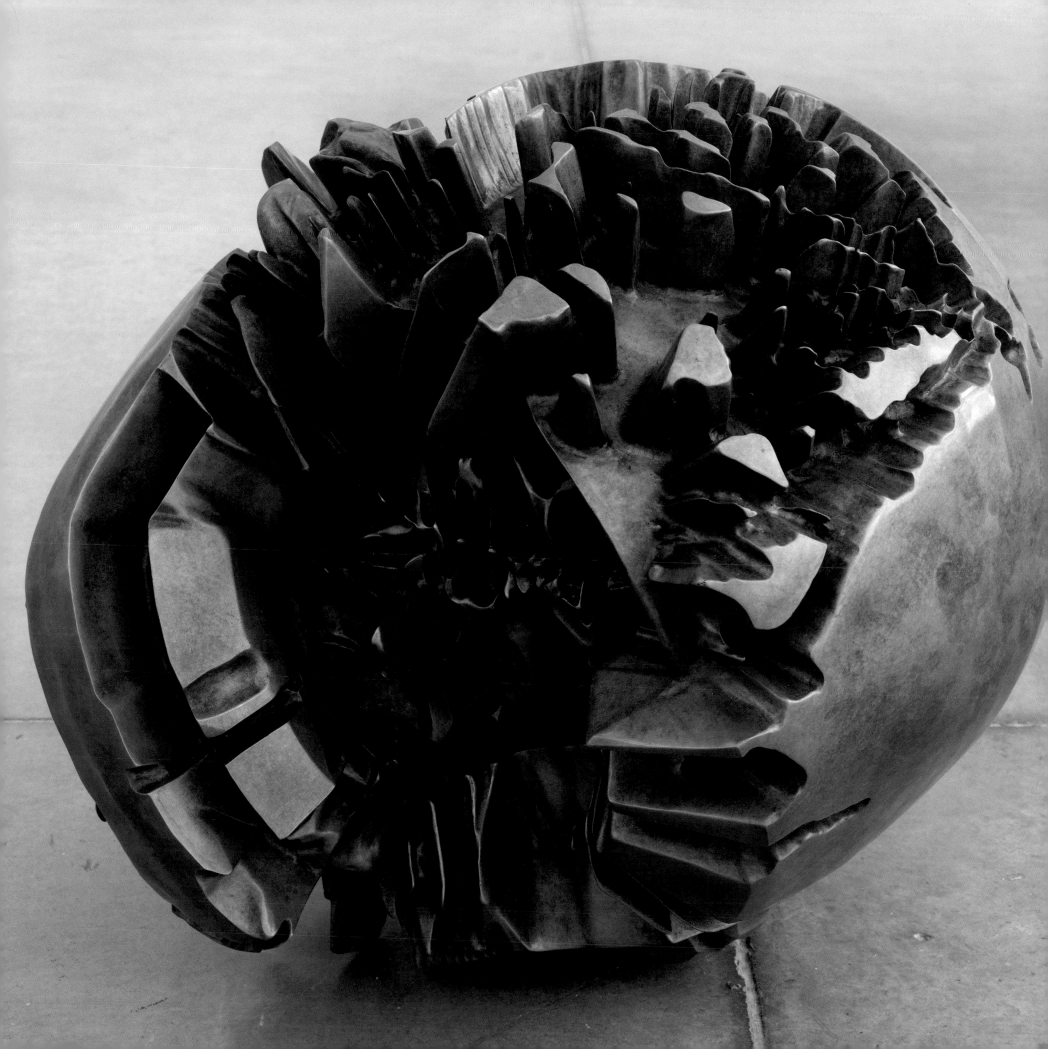

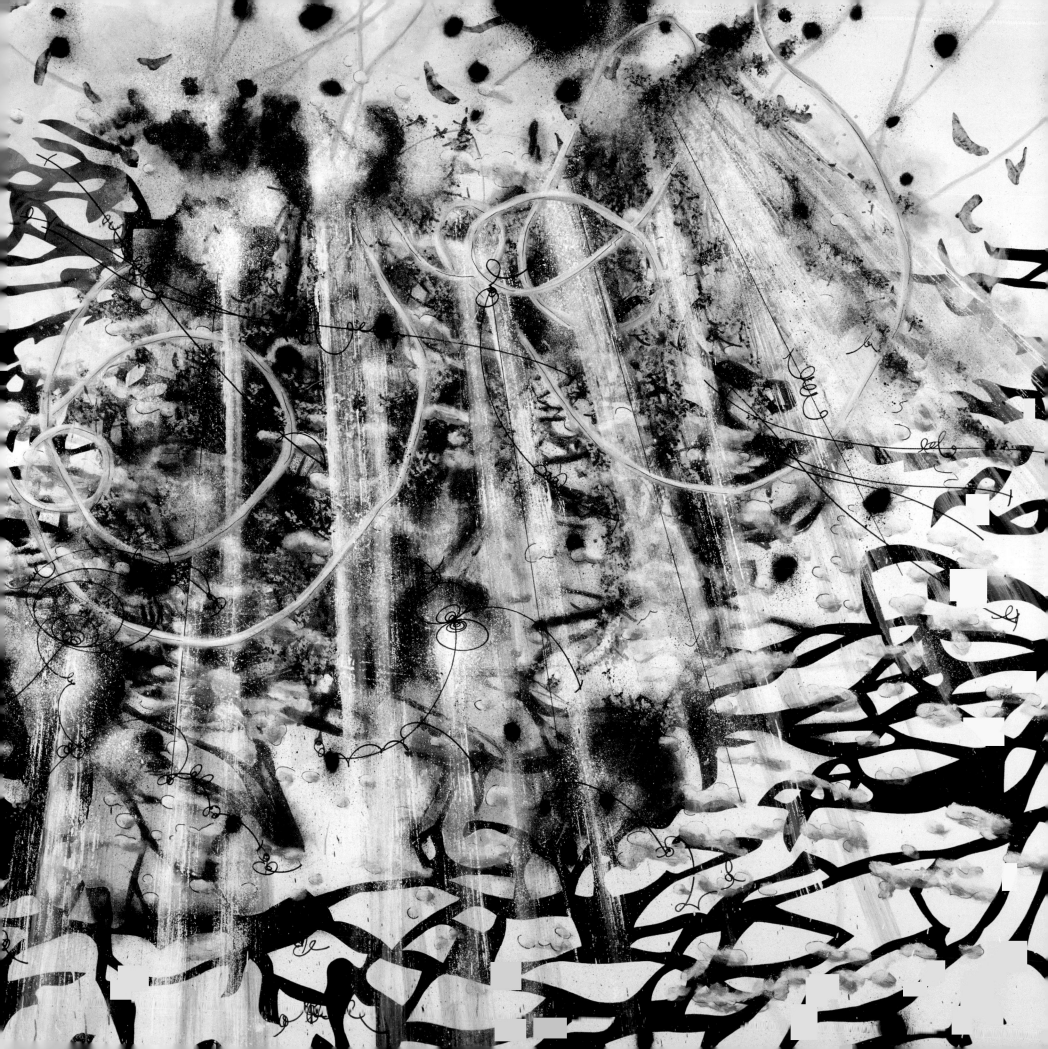

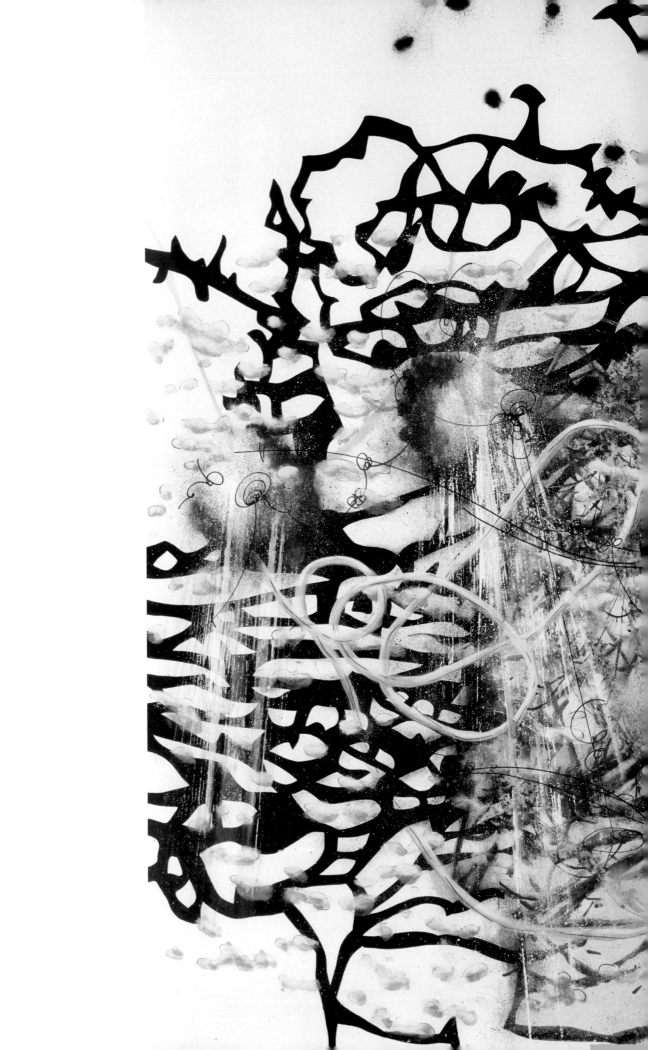

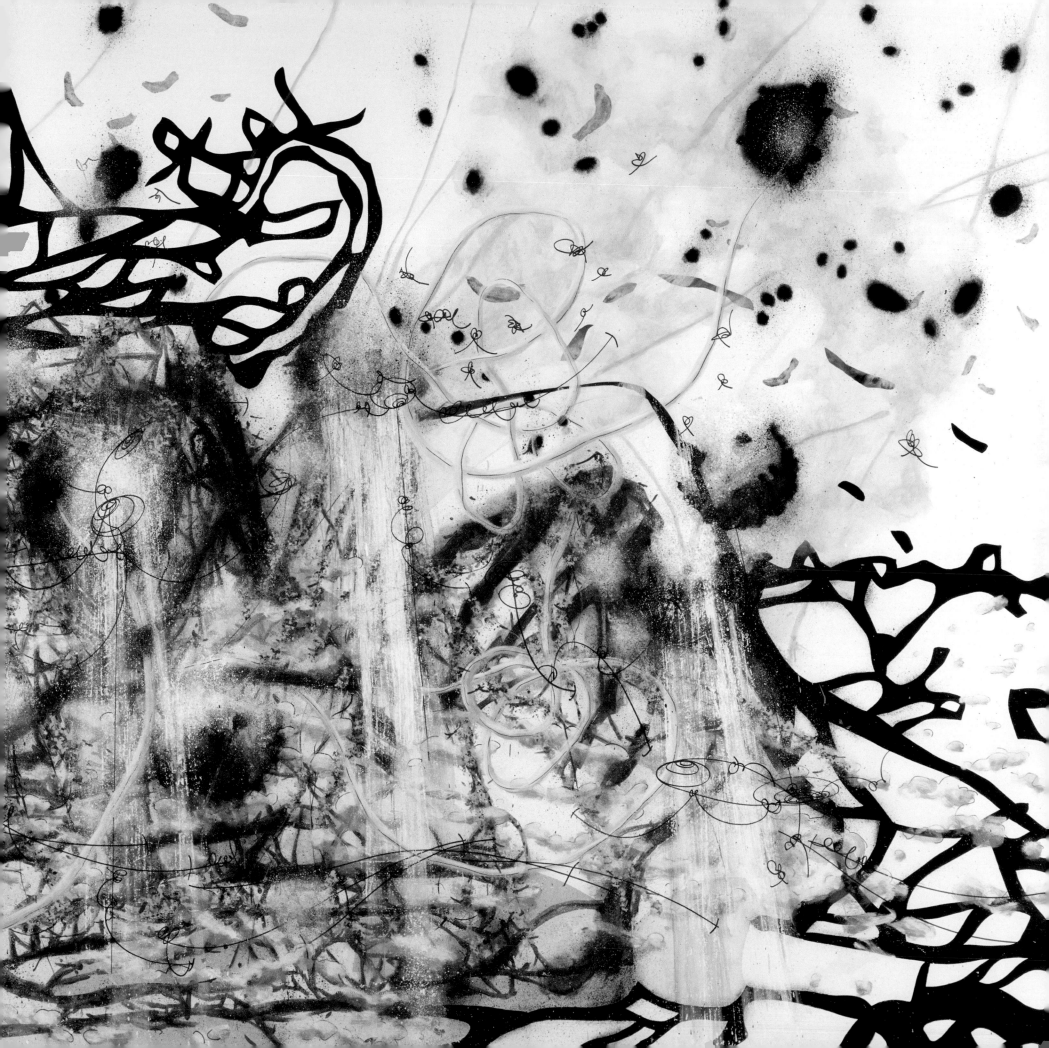

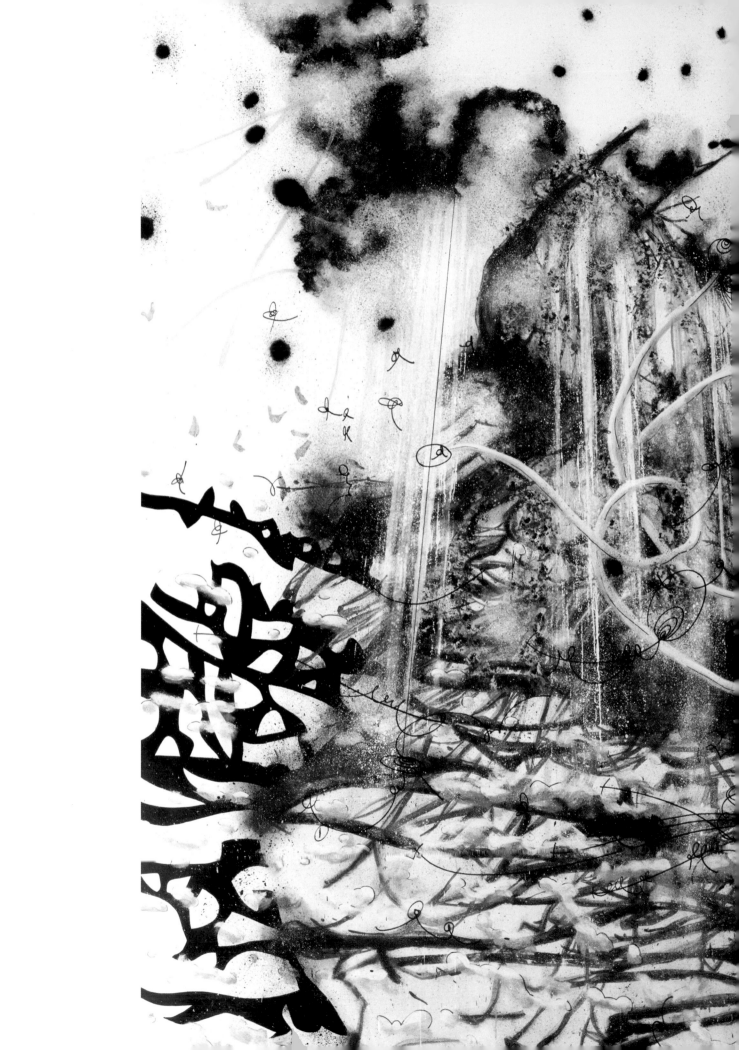

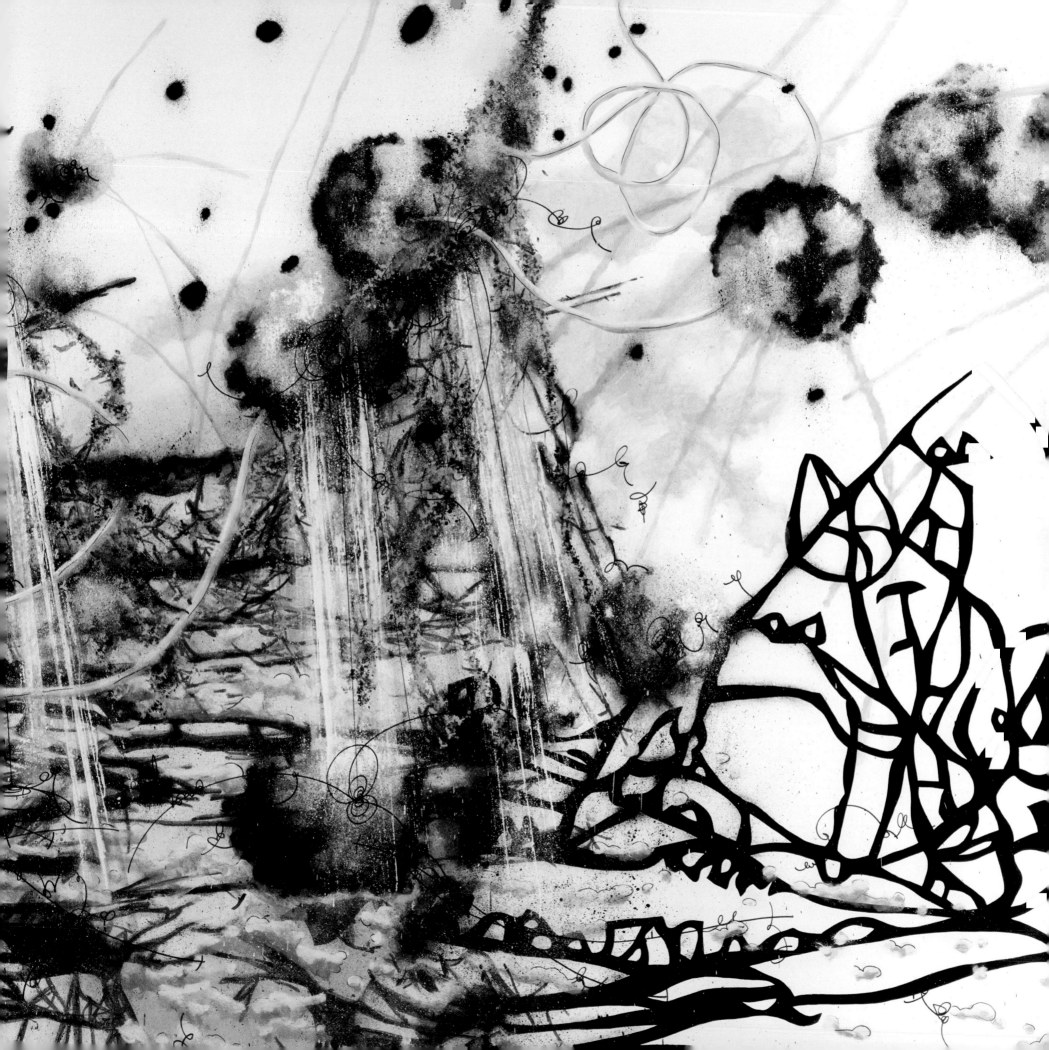

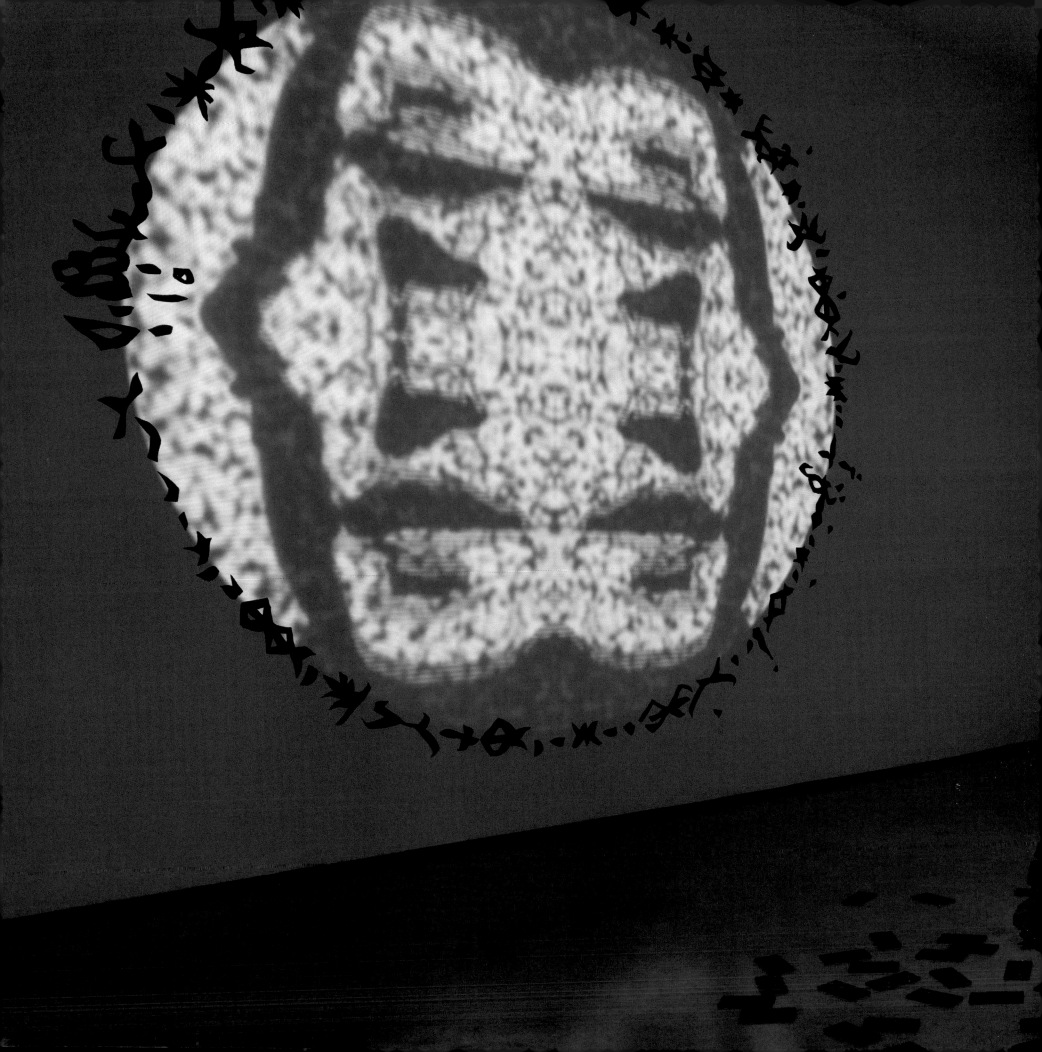

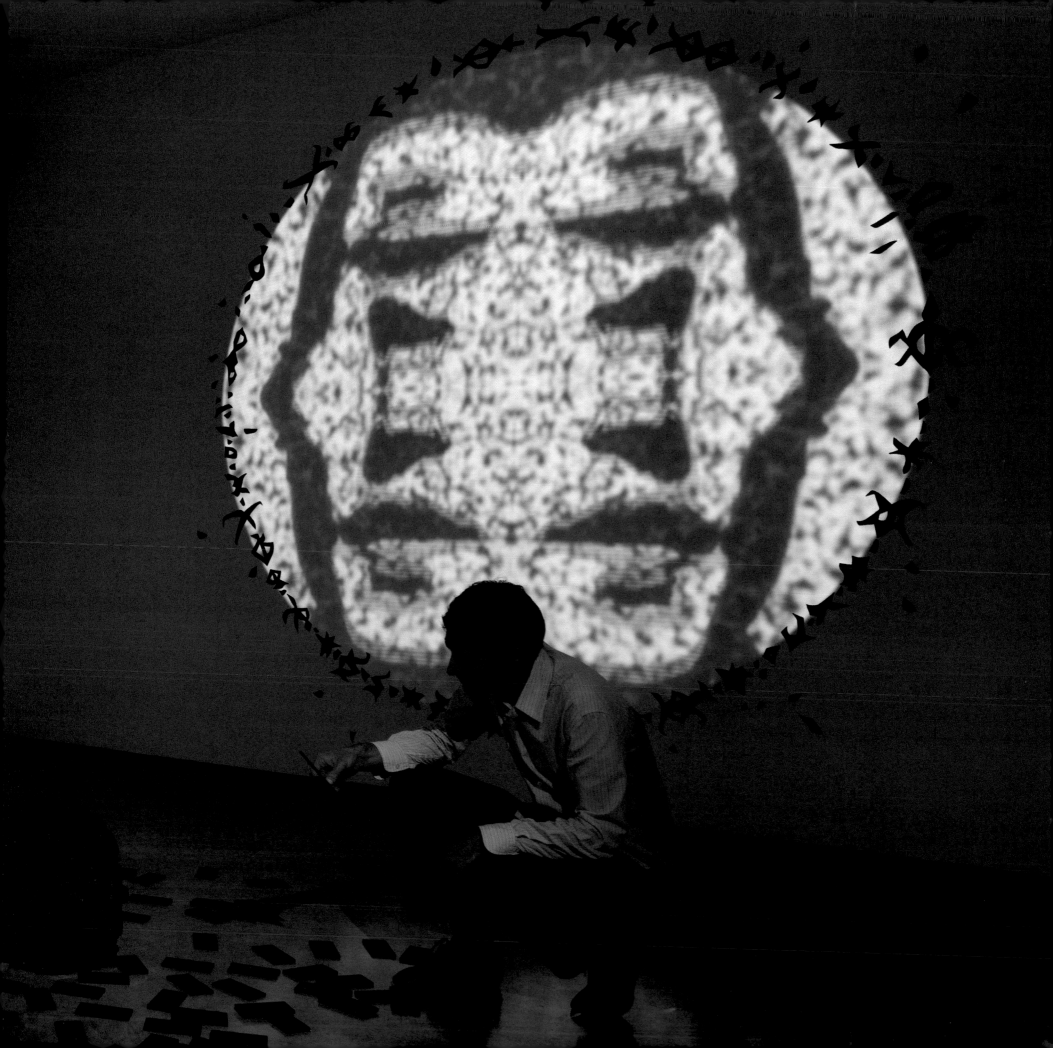

Uncertainty

So the last logical question is, "When is one of these elastic and mutable works done?" When is the artist finished with the information, and how does the viewer know that the image or title will not reemerge? As your mother or your priest might tell you, some questions are best left unanswered, which brings us to the value of uncertainty. Ritchie explains the uncertainty principle, as follows: "...theoretically, an electron *can* be anywhere in the universe. There is no limit to its placement. However, it is *most likely* to be close to an atomic nucleus." It is more useful and accurate to maintain a clear uncertainty about an unobserved particle than to "split the difference" and average out all possible outcomes of the particle's actions and positioning. Because we don't understand the unitary nature of the structure, from our perspective it might seem that two particles wind up in different places, "but if you look at it from a different perspective, for example from on top, you would see that they actually line up perfectly on top of each other—they haven't really gone anywhere different at all. The dimension that is linking these two things is something we don't really understand." This returns us to the question of the cohesion of a work or body of work. By not making rules about naming, scaling, media, repetition, and so forth, Ritchie allows himself some play. By leaving the system open, by not closing down the narrative, or insisting on a particular reading of a given work, he preserves a definitive lack of closure, an artistic version of the uncertainty principle. He himself does not always know for certain whether he has finished with an idea or title or theory, and this leaves a space for his own and the viewer's curiosity. Critics and museums generally have the impulse to identify, codify, file, and categorize art in order to make sense of it (though there are naturally exceptions). While this can be useful, it tends to close down the endless possibilities of a work. To ask the question, "What does it mean?" of a Ritchie work, or indeed any artwork historical or contemporary, is to miss the point substantially. An artwork is a means by which we can explore the meaning of our lives, our experiences, and universal mysteries (scientific or otherwise). Artists offer us tools, not answers. As in other choices that Ritchie makes, like the decision to prevent the viewer from becoming seamlessly immersed in his narrative and world, his refusal to make things simple and pat is actually intended to ensure freedom of thought. Further, it slows the entropy and homogenization that the laws of thermodynamics postulate are the result of work, action, and the redistribution of the energy of a system—it slows the death of his work.

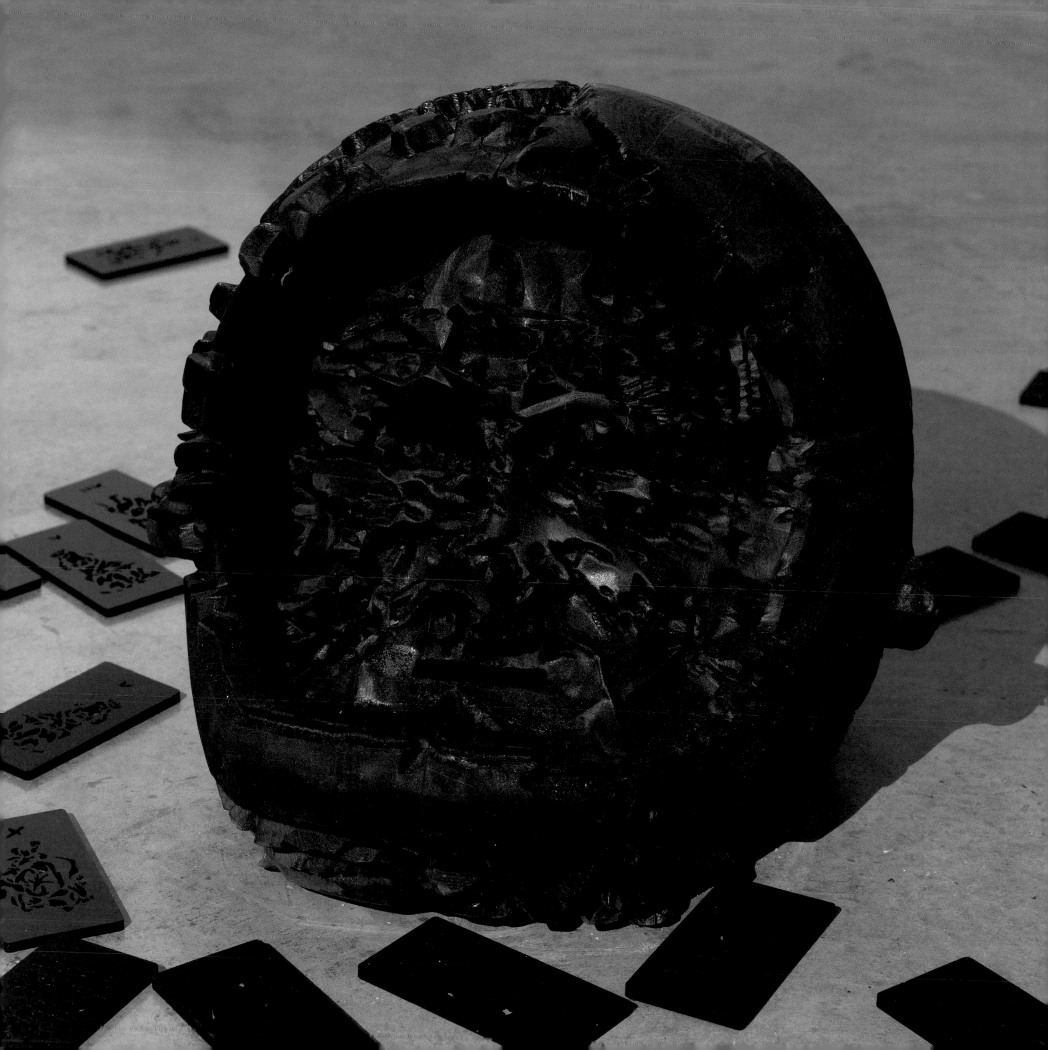

Navigation

The first one-artist exhibition by Ritchie, *Working Model* (1995) at Basilico Fine Arts in New York, presented the viewer with paintings and sculpture, charts and wall-sized diagrams that appeared initially clear, but proved more difficult to decipher than a cursory glance might have revealed. This exhibition served as the coming-out party for his cast of characters, and his sculpture *The God Game* (1995) suggested the role he would play in describing our universe to us. He took the symbols he had created to characterize each group of seven characters, made them into three-dimensional forms, and threaded them onto seven metal spindles in various configurations that hinted at stories and conceptual links without spelling them out in words. The chart of forty-nine characters was shown behind it so that the viewer could at least learn the principles, elements, characters, and concepts he was referencing, even if their connections remained mysterious. We were invited to "play God" with him, creating our own stories about the universe. The large, site-specific wall drawing that spanned the corner of the gallery looked much like a navigational map, where the forms representing each of his seven groups were presented again, with lines drawing connections between them. This exhibition, and the ones that followed in succession, where he wrote catalogue texts that were the beginnings of his narrative, created an atlas of his world—our universe—as he painstakingly charted a course for himself and us to follow. While this process was perhaps as riveting as the early mapping projects of the Age of Exploration, the possibilities for travel were likewise limited by the extent of territory thus plotted: until the full map was drawn, the tourist was trapped. Around the time of the exhibitions *The Fast Set* (Museum of Contemporary Art, North Miami) and *Parents and Children* (Andrea Rosen Gallery, New York), both mounted in 2000, there was a sea change of sorts, and Ritchie took the tools he had created and began to explore the territory that his model had proposed in earnest. He made the shift from mapping to navigation.

Implicit in this shift was a growing awareness of the relationship between the function of his narratives and that of his installations; increasingly, they insisted on a process of understanding the mechanics of the universe experientially and comparatively, between differing systems of explanations, instead of just theoretically, as in particle physics, though that too played a significant role, of course, as one of the systems of explanation in question. An appreciation of the work required a short trip through time and across space within a pathetic vessel that was a body limited by the perceptive abilities of its senses—*Experienced Time*, as in the title of one Sintra work of 2003 suggests, was both the means and the end to appreciating the artist's project. This is nothing very new. People have been experiencing art this way for centuries, though Ritchie's approach and subject matter brought this to the fore in a new way. He suggested the significance of the individual and the value of a subjective perception of the functioning of the universe, both of which have been proven to have a direct bearing on how a phenomenon may be observed—as a wave or a particle, for instance—in quantum physics. Further, his solution to the problem of how to manage the almost violent flow of information that is symptomatic of the digital age is not to try to take it all in at once, but simply to absorb it in pieces as we encounter it. His translation of theory to experience is sometimes very direct, as in *Ezekiel I*, where the ruin of a city, is also a map of the periodic table of elements and in *Ghost Operator* where digital tarot cards disrupt that same animation and force it into the parallel "system" of tarot. Here we "experience" the chart that describes the character of the elements that make up our world being intersected by another system. It is conceived as space that one moves through instead of cryptic notations on a chart. Since we are able to experience it through the senses of sight and sound and the mechanism of imaginary movement, understanding it becomes intuitive instead of coldly calculating.

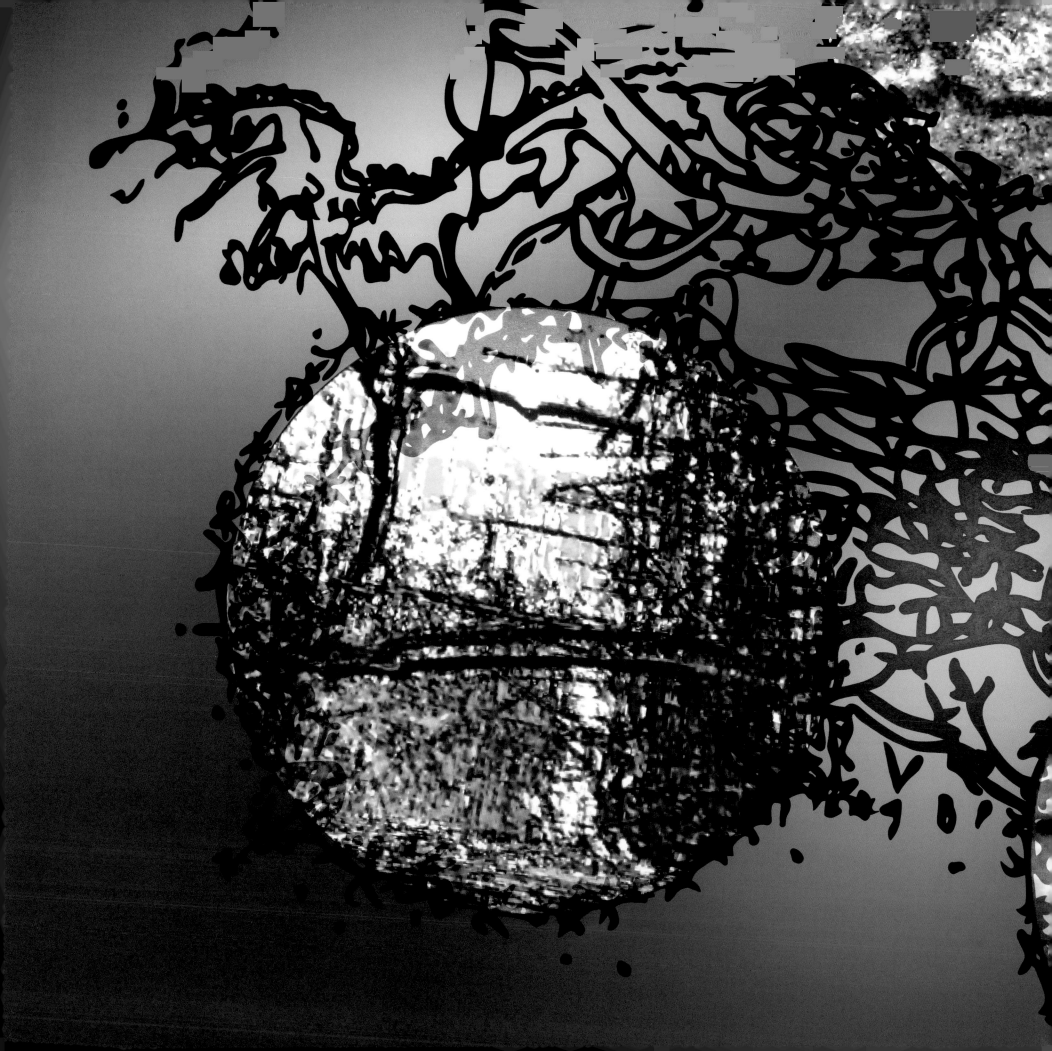

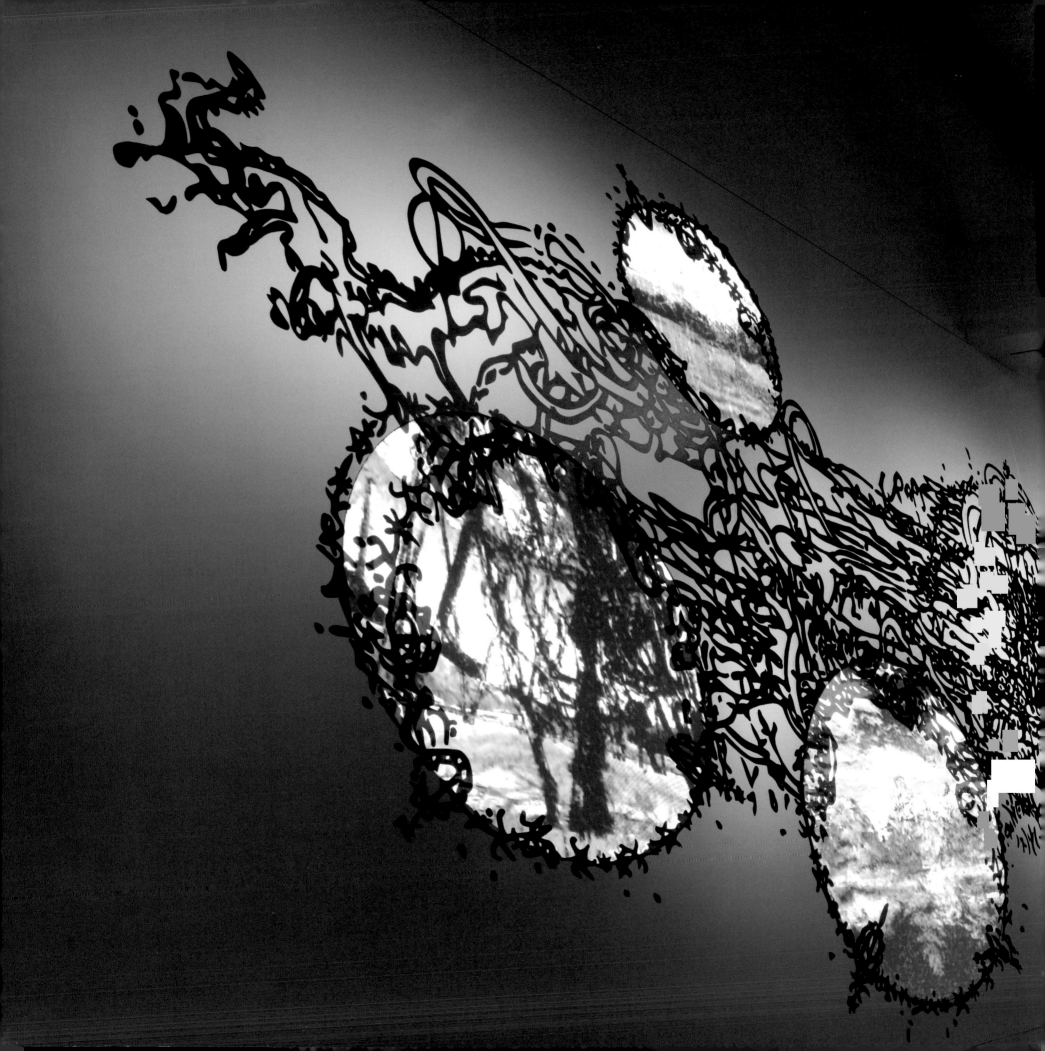

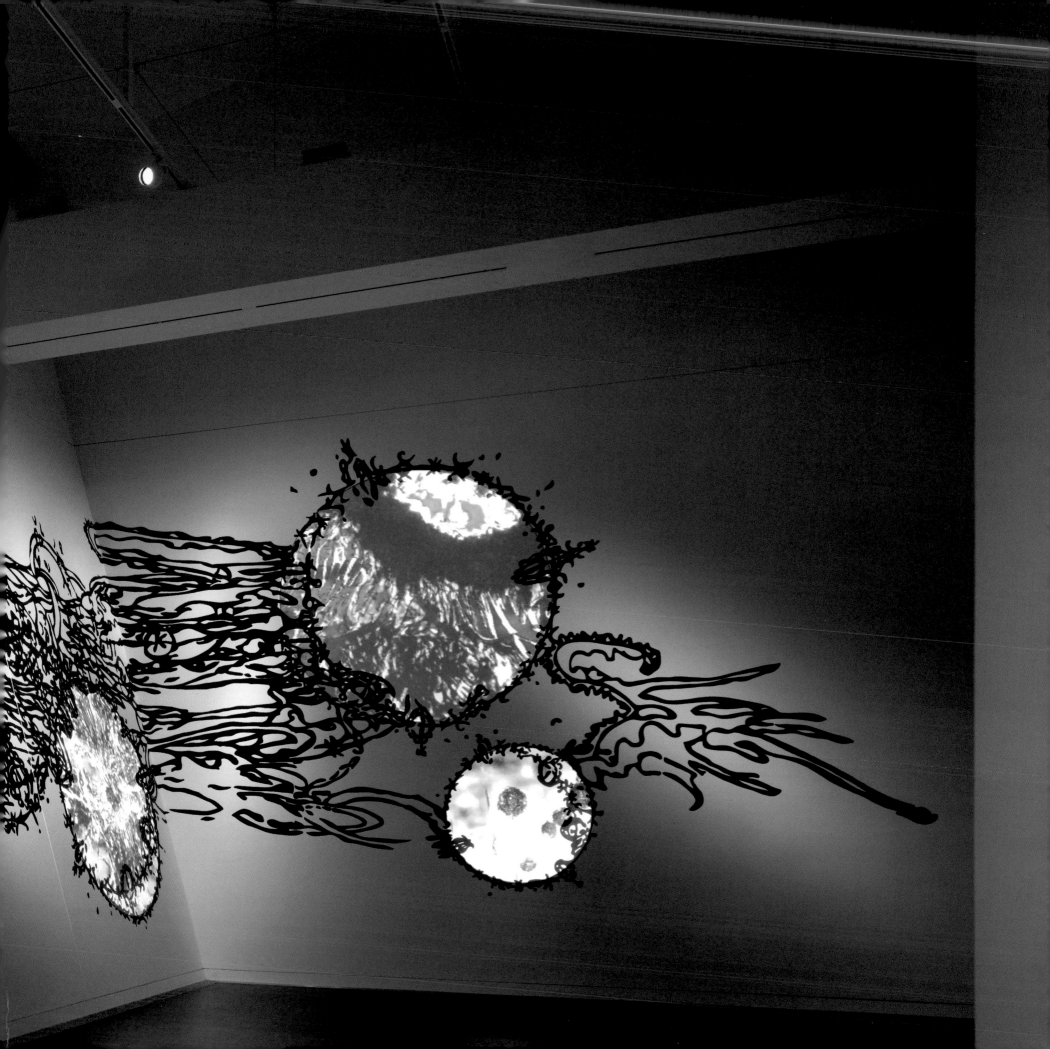

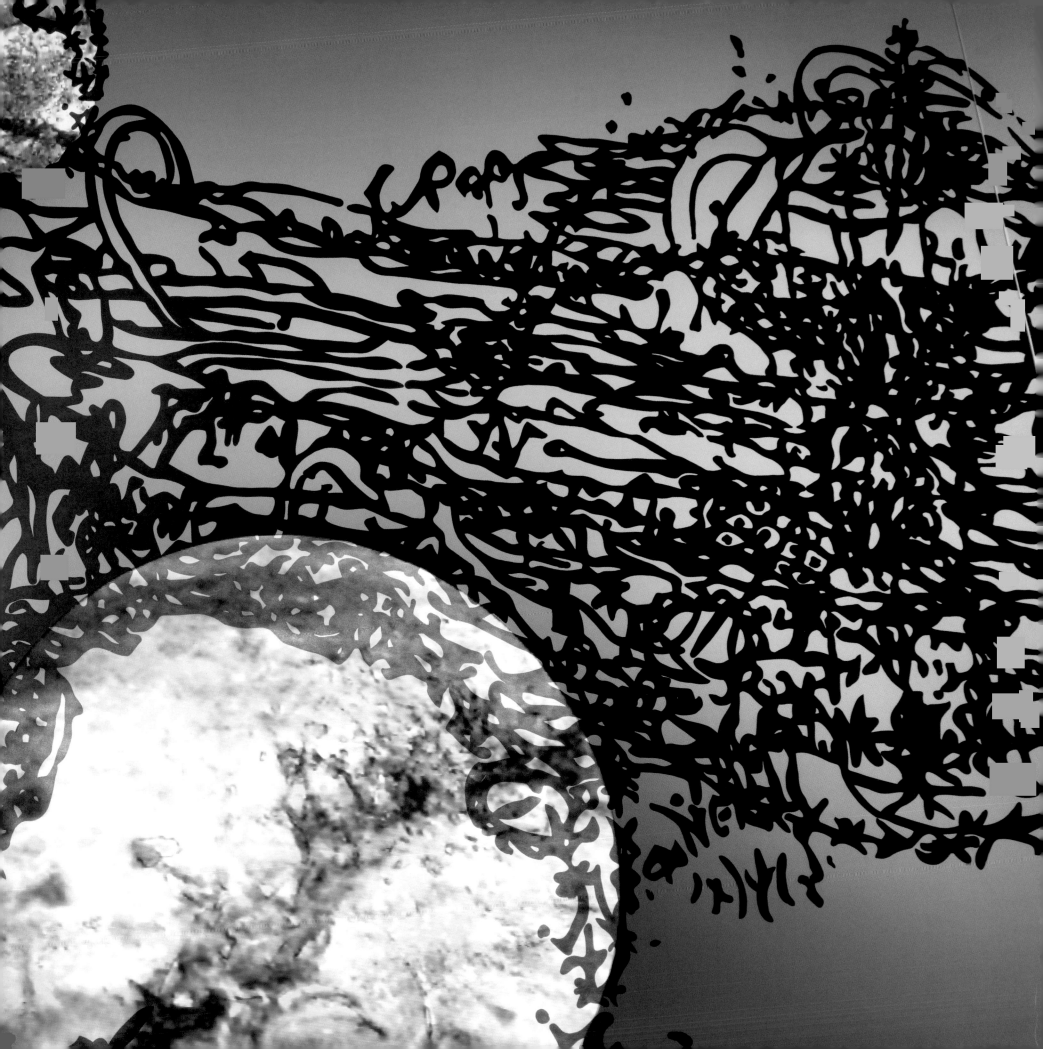

The element of time as a part of the work, another bit of data, another unit of measurement, is foregrounded in the drawings *The Ship of Years*; *Aft*, *Transom*, *Capstan* and *The Ship of Years*; *Prow*, *Anchor, Shroud* (both 2007) and the installations, *Ghost Operator* and *Day One* (both 2008). Theoretical physics and science fiction alike have long posited that time, like space, is a dimension that may be navigated, and though we haven't yet figured out how to accomplish this, that doesn't mean that it can't be done. The navigation through not only space but time that Ritchie encourages, especially in his more complex installations and digital animations, implies just this sort of movement. In *Ghost Operator* he imagines a broken vessel of sorts, *The Holstein Manifesto*, that may have been used by its pilot, the *Augur* (a fortune-teller who reads the language of birds) to navigate the ages, though the drawings make clear in their fragmentary and sometimes amorphous form, he doesn't know any better than the rest of us the form the vessel will take. The use of terminology from old sailing ships evokes maritime history and a navigation of the past—the part of time we can access so far, if only through individual and collective memory (history) just as the fallen vessel with a kaleidoscopic 'trip' projected inside evokes the lost promises of the future. But it certainly doesn't preclude a navigation of the future, as we slowly map out the charts that will enable us to sail the quantum sea. By contrast, the installation *Day One* (2008) presents what might be the start of everything; animations of the proverbial six days of creation, looped inside a gigantic drawing, as if all that was going to happen in the end, was anticipated at the beginning, in a kind of sketch. Ritchie's expedition enables us to reach uncharted areas, discover the unknown or overlooked, and gives us access to the fruits of his travels. Some of the works, like *We Sail Today* (2006), even seem to thematize navigation and exploration, while they also describe parts of the artist's by now familiar grouping of ideas. His voyage takes us to the farthest reaches of outer and inner space, on a journey over real distance but also through computer data, where some of the most significant discoveries lay in the interstices rather than in the data itself. Satellites travel farther than humans can currently go, transmitting their findings back to us, year after year. But what if the data we receive makes no sense? This is what happened when computers recorded an excess of gravity compared to observable matter. The conclusion? "Dark matter," some kind of matter out there the nature of which we do not understand. Exploratory satellites act as weird wormholes in space, able to extend our reach very far, but producing results recorded in a form that is almost so small and concentrated as to be beyond the ordinary imagination—the computer chip. Though the information is of a galactic magnitude, we manage it by reducing it to a form we can process. Ritchie's complex art fascinates in much the same way: he offers us a glimpse of the full extent of things but boils the unmanageable glut of information down to forms that can be digested, if occasionally with the aid of a little Pepto-Bismol. We perceive the way things work in bits and pieces as we navigate his exhibitions, as he himself engages in traveling around the atlas he has made.

Suddenly, there was light, the brightest lig that I think anyone ha it pounced; it bored its It was a vision which w: the eye.
I.I.Rabi

an enormous flash of

ht I have ever seen or

s ever seen. It blasted;

way right through you.

as seen with more than

Works

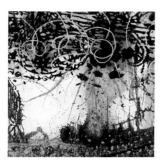

We Sail Today (det.), 2006
Oil and marker on linen
101 x 141½ in. (256.5 x 359.4 cm)
Image: Ellen Page Wilson

Their appearance and their w
Was as if a wheel within a w
As for their rings, they were
They were dreadful.

And their rings were full of e
And when the living creature
The wheels went with them.
For the spirit of the living cre
Was in the wheels.

Ezekiel I, 2006
Lambda print on Duratrans, mounted on acrylic panels,
with aluminum frame and fluorescent lights
45 x 42 x 7¾ in. (114.3 x 106.68 x 19.69 cm)
Image: Matthew Ritchie Studio

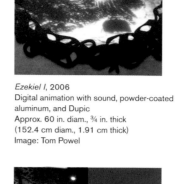

Ezekiel I, 2006
Digital animation with sound, powder-coated
aluminum, and Dupic
Approx. 60 in. diam., ¾ in. thick
(152.4 cm diam., 1.91 cm thick)
Image: Tom Powel

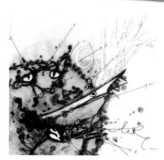

Godface II, 2005
Ink on Denril
12 x 9 in. (30.48 x 22.86 cm)
Image: Matthew Ritchie Studio

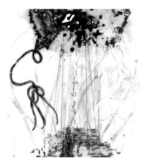

Godface VIII, 2005
Ink on Denril
12 x 9 in. (30.48 x 22.86 cm)
Image: Matthew Ritchie Studio

Installation view: *The Universal Adversary*,
Andrea Rosen Gallery, New York, 2006
Image: Tom Powel

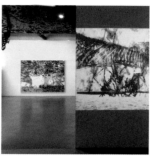

Installation view: *The Universal Adversary*,
Andrea Rosen Gallery, New York, 2006
Image: Tom Powel

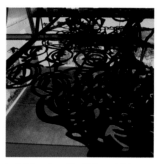

Installation view: *The Universal Adversary*,
Andrea Rosen Gallery, New York, 2006
Image: Tom Powel

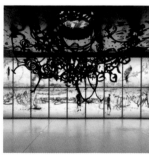

Installation view: *The Universal Adversary*,
Andrea Rosen Gallery, New York, 2006
Image: Tom Powel

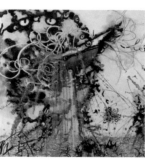

Something Like Day (det.), 2004
Lambda print on Duratrans mounted on lenticular
acrylic panels, with aluminum frame and fluorescent lights
14 ft. 6⅜ in. x 42 ft. 3 in. x 18½ in.
(442.9 x 1287.8 x 47 cm)
Image: Matthew Ritchie Studio

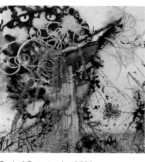

God of Catastrophe, 2006
Oil and marker on linen
102 x 142 in. (259.08 x 360.68 cm)
Image: Ellen Page Wilson

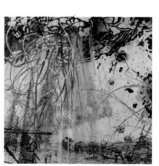

A Personal Virtue, 2006
Oil and marker on linen
98½ x 137½ in. (250.2 x 349.3 cm)
Image: Ellen Page Wilson

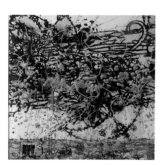

We Will Not Be the Last, 2006
Oil and marker on linen
100½ x 136½ in. (255.3 x 346.7 cm)
Image: Ellen Page Wilson

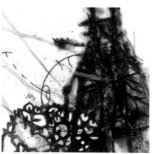

Some Things Will Be Different, 2006
Digital animation with sound
Dimensions, duration, and viewpoint
variable with installation
Image: Matthew Ritchie Studio

Ship of Years: Shroud, 2007
Ink on Denril
12 x 9 in. (30.5 x 22.9 cm)
Image: Matthew Ritchie Studio

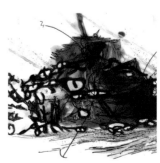

Ship of Years: Transom, 2007
Ink on Denril
9 x 12 in. (22.9 x 30.5 cm)
Image: Matthew Ritchie Studio

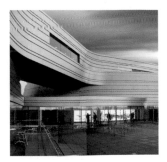

Installation view: *Stare Decisis*,
Wayne Lyman Morse United States Courthouse,
Eugene, OR, 2006
Image: John Carpenter

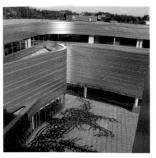

Installation view: *Stare Decisis*,
Wayne Lyman Morse United States Courthouse,
Eugene, OR, 2006
Image: Joshua Jalbert

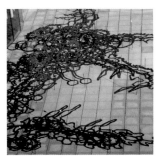

Installation view: *Stare Decisis*,
Wayne Lyman Morse United States Courthouse,
Eugene, OR, 2006
Image: Joshua Jalbert

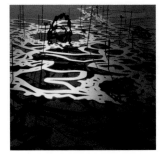

Installation view: *Stare Decisis*,
Wayne Lyman Morse United States Courthouse,
Eugene, OR, 2006
Image: Joshua Jalbert

Installation view: *Stare Decisis*,
Wayne Lyman Morse United States Courthouse,
Eugene, OR, 2006
Image: Joshua Jalbert

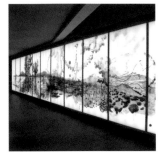

Installation view: *Life, Liberty and Pursuit*,
Wayne Lyman Morse United States Courthouse,
Eugene, OR, 2006
Image: Joshua Jalbert

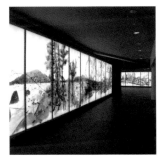

Installation view: *Life, Liberty and Pursuit*,
Wayne Lyman Morse United States Courthouse,
Eugene, OR, 2006
Image: Joshua Jalbert

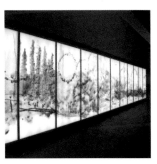

Installation view: *Life, Liberty and Pursuit*,
Wayne Lyman Morse United States Courthouse,
Eugene, OR, 2006
Image: Joshua Jalbert

Installation view: *Life, Liberty and Pursuit*,
Wayne Lyman Morse United States Courthouse,
Eugene, OR, 2006
Image: Joshua Jalbert

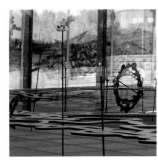

Installation view: *Stare Decisis*,
Wayne Lyman Morse United States Courthouse,
Eugene, OR, 2006
Image: Joshua Jalbert

Ezekiel I (still; 10 stills shown in all), 2006
Digital animation with sound
Dimensions variable with installation
Image: Matthew Ritchie Studio

Installation view: *We Want to See Some Light*,
Portikus, Frankfurt am Main, 2005
Image: Wolfgang Günzel, Offenbach, Germany

close door, monkey dead, 2005
Site-specific collaborative installation
Acrylic and marker on wall
Dimensions variable with installation
Image: Matthew Ritchie Studio

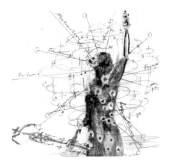

Elector Anne IX, 2005
Ink on Denril
12 x 9 in. (30.48 x 22.86 cm)
Image: Wolfgang Günzel, Offenbach, Germany

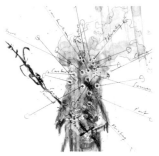

Elector Juliana II, 2005
Ink on Denril
12 x 9 in. (30.48 x 22.86 cm)
Image: Wolfgang Günzel, Offenbach, Germany

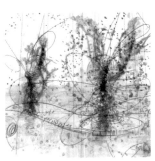

We Want to See Some Light (det.), 2005
Lambda print on Duratrans mounted on lenticular
acrylic panels, with aluminum frame and fluorescent lights
Approx. 8 x 16 ft. (244 x 488 cm)
Image: Matthew Ritchie Studio

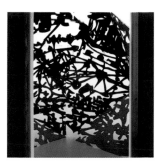

close door, monkey dead, 2005
Sintra
81½ x 77½ x 66⅞ in. (207.01 x 196.85 x 168.46 cm)
Image: Wolfgang Günzel, Offenbach, Germany

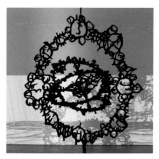

Hyle, 2005
Mixed media installation
Dimensions variable with installation
Image: Wolfgang Günzel, Offenbach, Germany

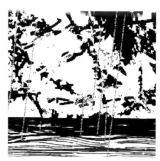

Clinamen, 2005
Interactive digital animation with sound
Dimensions variable with installation
Image: Matthew Ritchie Studio

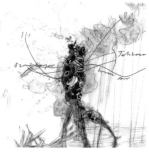

You Are the Weather (Gravity High) for R.H., 2005
Ink on Denril
12 x 9 in. (30.48 x 22.86 cm)
Image: Matthew Ritchie Studio

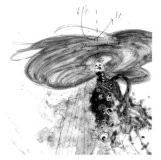

You Are the Weather (Weak High) for R.H., 2005
Ink on Denril
12 x 9 in. (30.48 x 22.86 cm)
Image: Matthew Ritchie Studio

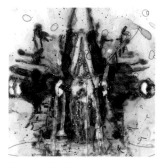

Haruspex I, 2008
Ink and watercolor on Denril
17 x 14 in. (43.2 x 35.6 cm)
Image: Todd White

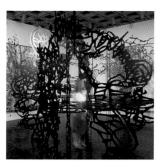

Installation view: *Remote Viewing:
Invented Worlds in Recent Painting and Drawing*,
Whitney Museum of American Art, New York, 2005
Image: Rob Kassabian

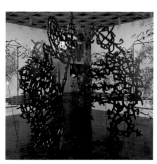

Installation view: *Remote Viewing:
Invented Worlds in Recent Painting and Drawing*,
Whitney Museum of American Art, New York, 2005
Image: Rob Kassabian

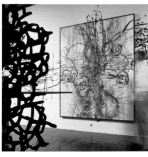

Installation view: *Remote Viewing:
Invented Worlds in Recent Painting and Drawing*,
Whitney Museum of American Art, New York, 2005
Image: Rob Kassabian

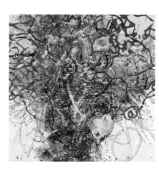

The Measures I, 2005
Oil and marker on canvas
100 x 84 in. (254 x 213.36 cm)
Image: Oren Slor

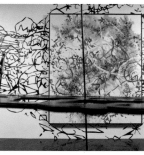

Installation view: *Remote Viewing:
Invented Worlds in Recent Painting and Drawing*,
Whitney Museum of American Art, New York, 2005
Image: Rob Kassabian

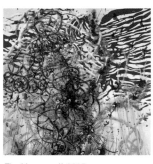

The Measures II, 2005
Oil and marker on canvas
100 x 84 in. (254 x 213.36 cm)
Image: Oren Slor

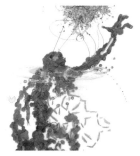

The Dead: Nergal, 2004
Ink on Denril
54 x 36 in. (137.16 x 91.44 cm)
Image: Oren Slor

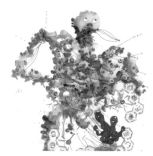

The Dead: Rahab, 2004
Ink on Denril
54 x 36 in. (137.16 x 91.44 cm)
Image: Oren Slor

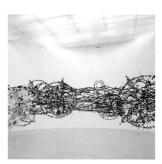

Installation view: *Something Like Day*,
commissioned work for the inaugural
exhibition of the 21st Century Museum of
Contemporary Art, Kanazawa, Japan, 2004
Image: Shigeo Auzai

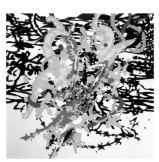

The Sailor Who Fell from Grace with the Sea, 2004
Acrylic and marker on wall; enamel on Sintra
Drawing dimensions variable with installation
Sintra 128 x 107 in. (325 x 274 cm)
Image: Shigeo Auzai

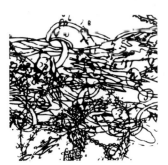

The Last Sea, 2003
Acrylic and marker on wall
Dimensions variable with installation
Image: Matthew Ritchie Studio

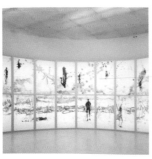

Something Like Day, 2004
Lambda print on Duratrans mounted on lenticular
acrylic panels, with aluminum frame and fluorescent lights
14 ft. 6⅜ in. x 42 ft. 3 in. x 18½ in.
(442.9 x 1287.8 x 47 cm)
Image: Shigeo Auzai

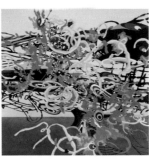

Off the Hook (det.), 2002
Enamel on Sintra, aluminum, and CNC milled foam
head made in collaboration with Grace Dunham, age 10
Approx. 10 ft. 5 in. x 24 ft. 10 in. x 10 ft. 3 in.
(317.5 x 756.92 x 312.42 cm)
Image: Oren Slor

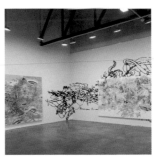

Installation view: *After Lives*,
Andrea Rosen Gallery, New York, 2002
Image: Oren Slor

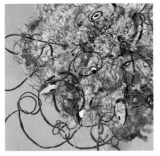

Mastermind, 2002
Oil and marker on canvas
88 x 121 in. (223.52 x 307.34 cm)
Image: Oren Slor

After Lives, 2002
Oil and marker on canvas
88 x 154 in. (223.52 x 391.16 cm)
Image: Oren Slor

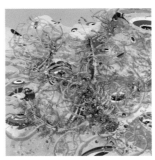

The Eighth Sea, 2002
Oil and marker on canvas
99 x 121 in. (251.46 x 307.34 cm)
Image: Oren Slor

The Main Line (det.), 2002
Acrylic and marker on wall
Dimensions variable with installation
Image: Matthew Ritchie Studio

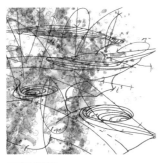

yes/no, 2003
Lenticular print
26 x 48 in. (66.04 x 121.92 cm)
Image: Matthew Ritchie Studio

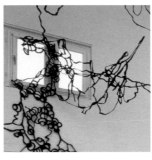

Installation view: *After the Father Costume*,
c/o Atle Gerhardsen, Berlin, 2003
Image: courtesy c/o Atle Gerhardsen, Berlin

Installation view: *Games of Chance and Skill*,
a commission for The Al and Barrie Zesiger Sports
and Fitness Center, Massachusetts Institute of
Technology, Cambridge, MA, 2000–02
Image: Ellen Page Wilson

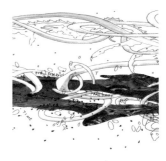

Games of Chance and Skill (det. ceiling), 2000–02
Mixed media, site-specific permanent installation,
a commission for The Al and Barrie Zesiger Sports and Fitness
Center, Massachusetts Institute of Technology, Cambridge, MA
Image: Matthew Ritchie Studio

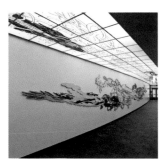

Installation view: *Games of Chance and Skill*,
a commission for The Al and Barrie Zesiger Sports
and Fitness Center, Massachusetts Institute of
Technology, Cambridge, MA, 2000–02
Image: Ellen Page Wilson

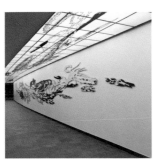

Installation view: *Games of Chance and Skill*,
a commission for The Al and Barrie Zesiger Sports
and Fitness Center, Massachusetts Institute of
Technology, Cambridge, MA, 2000–02
Image: Ellen Page Wilson

Everyone Belongs to Everyone Else, 2000–01
Suite of seven drawings
Ink and graphite on Mylar
22 x 65 in. (55.88 x 165.1 cm)
Image: Oren Slor

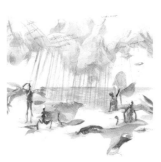

Everyone Belongs to Everyone Else, 2000–01
Suite of seven drawings
Ink and graphite on Mylar
22 x 65 in. (55.88 x 165.1 cm)
Image: Oren Slor

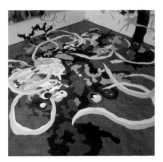

Installation view: *The Family Farm*,
White Cube, London, 2001
Image: Stephen White

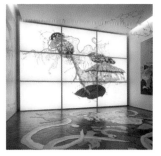

Installation view: *The Family Farm*,
White Cube, London, 2001
Image: Stephen White

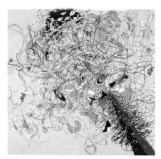

Establishing Shot, 2001
Oil and marker on canvas
72 x 120 in. (182.88 x 304.8 cm)
Image: Oren Slor

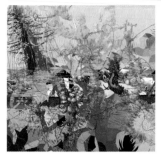

Germinal, 2001
Oil and marker on canvas
72 x 120 in. (182.88 x 304.8 cm)
Image: Oren Slor

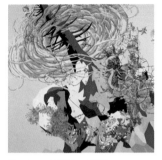

Parents and Children, 2000
Oil and marker on canvas
90 x 120 in. (228.6 x 304.8 cm)
Image: Oren Slor

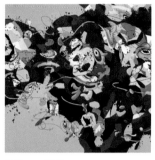

M Theory, 2000
Oil and marker on canvas
82 x 110 in. (208.28 x 279.4 cm)
Image: Oren Slor

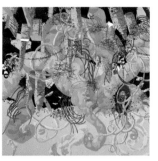

Anti-City, 2000
Oil and marker on canvas
84 x 126 in. (213.36 x 320.04 cm)
Image: Oren Slor

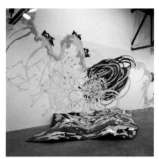

Installation view: *Parents and Children*,
Andrea Rosen Gallery, New York, 2000
Image: Oren Slor

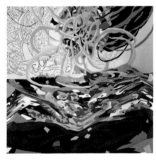

Parents and Children (det.), 2000
Acrylic and marker on wall, enamel on Sintra,
metal armature with enamel on Sintra
Dimensions variable with installation
Image: Oren Slor

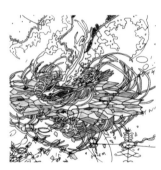

The Swimmer, 2000
Lambda print on Duratrans, mounted on
acrylic panels, in aluminum frame with fluorescent lights
10 x 15 ft. (304.8 x 457.2 cm)
Image: Matthew Ritchie Studio

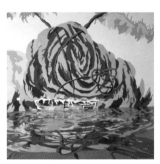

The Fast Set, 2000
Enamel on Sintra, acrylic and marker on wall
Dimensions variable with installation
Image: Oren Slor

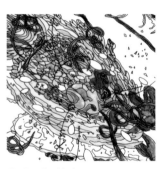

The Fast Set (det.), 2000
Lambda print on Duratrans, mounted on acrylic panels, in
aluminum frame with fluorescent lights
54⅞ x 75⅞ x 6¾ in. (139.4 x 192.7 x 17.1 cm)
Image: Matthew Ritchie Studio

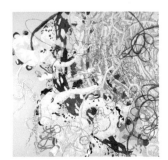

The Edge of Love, 2000
Oil and marker on canvas
84 x 150 in. (213.36 x 381 cm)
Image: Oren Slor

Installation view: *Chapel Perilous* from *Faith: The Impact
of Judeo-Christian Religion on Art at the Millennium*,
Aldrich Contemporary Art Museum, Ridgefield, CT, 2000
Image: Catherine Vanaria

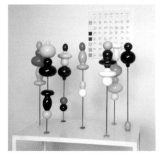

Installation view: *Working Model*,
Basilico Fine Arts, New York, 1995
Image: courtesy of Andrea Rosen Gallery

Haruspex II, 2008
Ink and watercolor on Denril
17 x 14 in. (43.2 x 35.6 cm)
Image: Todd White

Installation view: *Matthew Ritchie: Proposition Player*,
Mass MoCA, North Adams, MA, 2005
Image: Todd Eberle

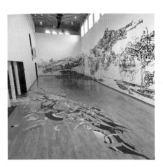

Installation view: *Matthew Ritchie: Proposition Player*,
Mass MoCA, North Adams, MA, 2005
Image: Kevin Kennific

Installation view: *Matthew Ritchie: Proposition Player*,
Mass MoCA, North Adams, MA, 2005
Image: Kevin Kennific

Installation view: *Matthew Ritchie: Proposition Player*,
Mass MoCA, North Adams, MA, 2005
Image: Kevin Kennific

Installation view: *Matthew Ritchie: Proposition Player*,
Mass MoCA, North Adams, MA, 2005
Image: Kevin Kennific

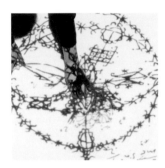

Proposition Player, 2003
Powder-coated aluminum, Minicel foam, rubber, adhesive,
electronic components, one pair cast resin dice, and custom-
designed deck of cards
Image: Matthew Ritchie Studio

The Two-Way Joint (det.), 2003
Lambda print on Duratrans mounted on lenticular
acrylic panels, with aluminum frame and fluorescent lights
120 x 216 in. (304.8 x 548.64 cm)
Image: Matthew Ritchie Studio

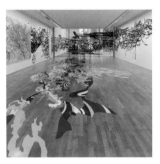

Installation view: *The Guggenheim*,
Kunstmuseum Bonn, Germany, 2006
Image: Peter Oszvald

Digital rendering for *The Fine Constant* (det.), 2003
Image: Matthew Ritchie Studio

Digital rendering for *The Fine Constant* (det.), 2003
Image: Matthew Ritchie Studio

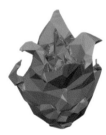

Digital rendering for *The Fine Constant* (det.), 2003
Image: Matthew Ritchie Studio

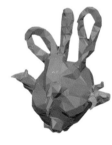

Digital rendering for *The Fine Constant* (det.), 2003
Image: Matthew Ritchie Studio

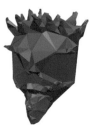

Digital rendering for *The Fine Constant* (det.), 2003
Image: Matthew Ritchie Studio

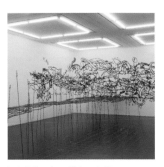

Installation view: *Return to Space*,
Hamburger Kunsthalle, 2005–06
Image: Hamburger Kunsthalle

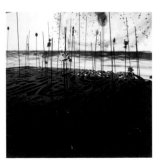

Installation view: *Matthew Ritchie, Proposition Player*,
The Fabric Workshop and Museum, 2005
Image: Aaron Igler

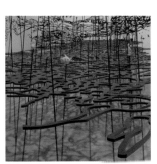

Installation view: *Matthew Ritchie: Proposition Player*,
Mass MoCA, North Adams, MA, 2005
Image: Art Evans

Coffin Weather (det.), 2003
Vinyl decal on wall
Dimensions variable with installation
Image: Matthew Ritchie Studio

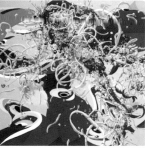

Self-Portrait in 2064, 2001
Oil and marker on canvas
80 x 100 in. (203.2 x 254 cm)
Image: Achim Kukulies

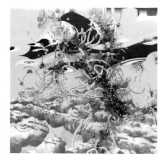

*A Glorious Martyrdom Awaits Us All at the Hands
of Our Tender and Merciful God*, 2003
Oil and marker on canvas
88 x 99 in. (223.52 x 251.46 cm)
Image: Oren Slor

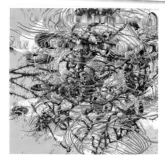

Where I Am Coming From, 2003
Oil and marker on canvas
99 x 121 in. (251.46 x 307.34 cm)
Image: Oren Slor

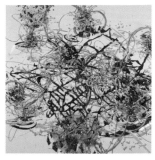

Giant Time, 2003
Oil and marker on canvas
89 x 110 in. (226.06 x 279.4 cm)
Image: Oren Slor

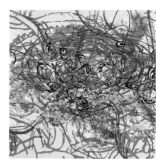

Snake Eyes, 2003
Oil and marker on canvas
99 x 132 in. (251.46 x 335.28 cm)
Image: Oren Slor

Matthew Ritchie and Purtill Family Business
Characters from *Proposition Player* playing cards, 2005
Image: Matthew Ritchie Studio

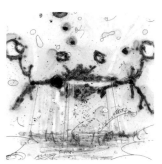

Haruspex III, 2008
Ink and watercolor on Denril
17 x 14 in. (43.2 x 35.6 cm)
Image: Todd White

The Living Will, 2004
Oil and marker on canvas
88 x 99 in. (223.52 x 251.46 cm)
Image: Oren Slor

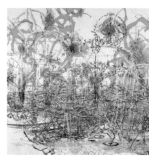

No Sign of the World, 2004
Oil and marker on canvas
99 x 154 in. (251.46 x 391.16 cm)
Image: Oren Slor

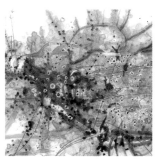

Five of a Kind: The Slow Tide, 2003
Suite of five drawings
Graphite and ink on Denril
14 x 44 in. (35.56 x 111.76 cm) each
Image: Hester and Hardaway

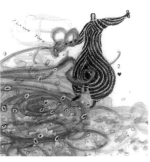

Five of a Kind: The Box Factory, 2003
Suite of five drawings
Graphite and ink on Denril
14 x 44 in. (35.56 x 111.76 cm) each
Image: Hester and Hardaway

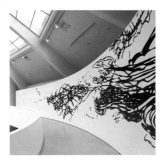

Installation view: *The Shapes of Space*,
Guggenheim Museum, New York, 2007
Image: Tom Powel

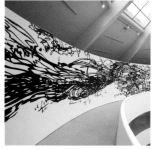

Installation view: *The Shapes of Space*,
Guggenheim Museum, New York, 2007
Image: Tom Powel

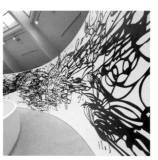

Installation view: *The Shapes of Space*,
Guggenheim Museum, New York, 2007
Image: Tom Powel

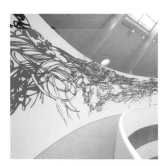

Installation view: *The Shapes of Space*,
Guggenheim Museum, New York, 2007
Image: Tom Powel

Day One (still; 10 stills shown in all), 2008
Interactive digital animation, sound, acrylic and marker on wall
Dimensions variable with installation
Commissioned for *In the Beginning: Artists Respond to Genesis*, Contemporary Jewish Museum, San Francisco
Image: Matthew Ritchie Studio

Fused, 2005
Oil and marker on linen
50 x 84 in. (127 x 213.36 cm)
Image: Andy Keate

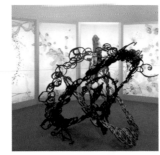

Installation view: *Ice-3* and *Something Like Day* (det.),
Frieze Art Fair, Andrea Rosen Gallery, London, 2005
Image: Andy Keate

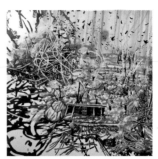

Split, 2005
Oil and marker on linen
50 x 84 in. (127 x 213.36 cm)
Image: Andy Keate

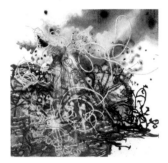

Forge, 2007
Oil and marker on linen
88³⁄₁₆ x 99¹⁄₁₆ in. (223.679 x 251.619 cm)
Image: Jason Mandella

Haruspex IV, 2008
Ink and watercolor on Denril
17 x 14 in. (43.2 x 35.6 cm)
Image: Todd White

After Water (det.), 2005
Lambda print on Duratrans mounted on lenticular
acrylic panels, with aluminum frame and fluorescent lights
Image: Matthew Ritchie Studio

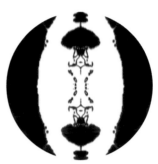

Ghost Operator (still; 10 details shown in all), 2008
Charred wood and pitch with electronic card reader, acrylic
and marker on wall, acrylic tarot cards with embedded
electronic chip, and interactive digital animation with sound
Wooden head: 13³⁄₄ x 14⁹⁄₁₆ x 17⁵⁄₁₆ in. (35 x 37 x 44 cm);
projection: 109 in. diameter (277 cm)
Image: Matthew Ritchie Studio

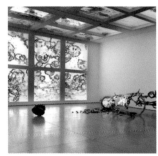

Installation view: *Ghost Operator*,
White Cube, London, 2008
Image: Todd White

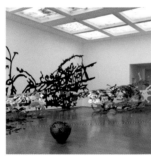

Installation view: *Ghost Operator*,
White Cube, London, 2008
Image: Todd White

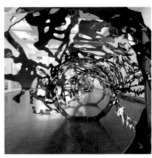

Installation view: *Ghost Operator*,
White Cube, London, 2008
Image: Todd White

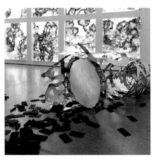

Installation view: *Ghost Operator*,
White Cube, London, 2008
Image: Todd White

The Green Language (det.), 2008
Duratrans Lambda prints in lightbox
32 panels, each 83 x 63 in. (210.8 x 160 cm),
approx. 55 x 21 feet overall (1676.4 x 640.1 cm)
Image: Todd White

The Green Language (det.), 2008
Duratrans Lambda prints in lightbox
32 panels, each 83 x 63 in. (210.8 x 160 cm),
approx. 55 x 21 feet overall (1676.4 x 640.1 cm)
Image: Todd White

The Green Language (det.), 2008
Duratrans Lambda prints in lightbox
32 panels, each 83 x 63 in. (210.8 x 160 cm),
approx. 55 x 21 feet overall (1676.4 x 640.1 cm)
Image: Todd White

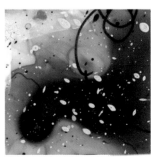

The Green Language (det.), 2008
Duratrans Lambda prints in lightbox
32 panels, each 83 x 63 in. (210.8 x 160 cm),
approx. 55 x 21 feet overall (1676.4 x 640.1 cm)
Image: Todd White

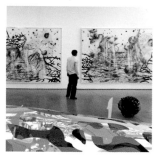

Installation view: *Ghost Operator*,
White Cube, London, 2008
Image: Todd White

Augur, 2008
Patinated bronze
19⁵⁄₁₆ x 19¹¹⁄₁₆ x 20⁷⁄₈ in. (49 x 50 x 53 cm)
Edition of 3 with one artist's proof
Image: Andy Keate

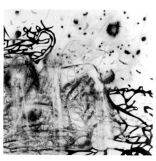

How This Ends, 2008
Oil and marker on linen
96 x 119¹⁵⁄₁₆ in. (243.8 x 304.6 cm)
Image: Christopher Burke

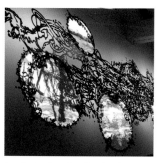

Morning War, 2008
Oil and marker on linen
96 x 142⁷⁄₈ in. (243.8 x 362.9 cm)
Image: Christopher Burke

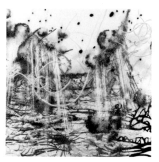

The Salt Pit, 2008
Oil and marker on linen
96 x 149¾ in. (243.8 x 380.4 cm)
Image: Christopher Burke

Ghost Operator (det.), 2008
Charred wood and pitch with electronic card reader, acrylic
and marker on wall, acrylic tarot cards with embedded
electronic chip, and interactive digital animation with sound
Wooden head: 13¾ x 14⁹⁄₁₆ x 17⁵⁄₁₆ in. (35 x 37 x 44 cm);
projection: 109 in. diameter (277 cm)
Image: Todd White

Ghost Operator (det.), 2008
Charred wood and pitch with electronic card reader, acrylic
and marker on wall, acrylic tarot cards with embedded
electronic chip, and interactive digital animation with sound
Wooden head: 13¾ x 14⁹⁄₁₆ x 17⁵⁄₁₆ in. (35 x 37 x 44 cm);
projection: 109 in. diameter (277 cm)
Image: Todd White

Installation view: *Day One* (det.) commissioned for
In the Beginning: Artists Respond to Genesis,
Contemporary Jewish Museum, San Francisco, 2008
Image: Bruce Damonte

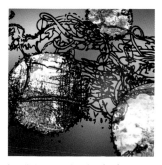

Installation view: *Day One* (det.) commissioned for
In the Beginning: Artists Respond to Genesis,
Contemporary Jewish Museum, San Francisco, 2008
Image: Bruce Damonte

First published in the United States in 2008 by
Rizzoli International Publications, Inc.
300 Park Avenue South
New York, NY 10010
www.rizzoliusa.com

All images, unless otherwise noted, are courtesy of the artist
and Andrea Rosen Gallery, New York

2008 2009 2010 2011/ 10 9 8 7 6 5 4 3 2 1

ISBN 13: 978-0-8478-3108-1

Library of Congress Control Number: 2008930946

Designed by Purtill Family Business
Printed in China

Acknowledgments

With many thanks to:
Elizabeth Grady, Klaus Kertess, Shelley Jackson, Jonathan
Lethem, Ander Monson, and Carter Scholz.

Andrea Rosen, Jordan Bastien, Nen Reyes and Jeremy Lawson,
Jay Jopling, Susan May, Tim Marlow, Alex Bradley
and Susannah Hyman, Lynn Herbert, Daniel Birnbaum,
Laura Heon, Elisabeth Sussman and Stefano Basilico,
James Case, Mike Koller, Kristin Rein, Kirsten Deirup,
Thom Mayne and Morphosis, Garland Hunter and Isen Ritchie,
Christopher Walken, Isabel Venero and Rizzoli, the General
Services Administration, William Caine, the Honorable Mike
Hogan, and Conny Purtill.